QUEER THING, PAINTING

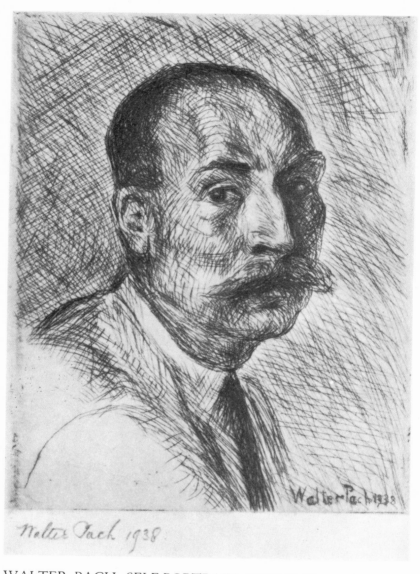

Walter Pach 1938

WALTER PACH, SELF-PORTRAIT, ETCHING, 1938

Walter Pach

QUEER THING, PAINTING

FORTY YEARS IN THE WORLD OF ART

ILLUSTRATED

Essay Index Reprint Series

BOOKS FOR LIBRARIES PRESS
FREEPORT, NEW YORK

INTERNATIONAL STANDARD BOOK NUMBER:
0-8369-2328-6

LIBRARY OF CONGRESS CATALOG CARD NUMBER:
79-156701

PRINTED IN THE UNITED STATES OF AMERICA

TO

EDNA AND ARTHUR STRASSER

CONTENTS

I. "QUEER THING, PAINTING" 1

II. MR. CHASE, ROBERT HENRI, JOHN SLOAN 31

III. ALBERT P. RYDER, THOMAS EAKINS 58

IV. J. PIERPONT MORGAN 67

V. MORIYE OGIHARA 77

VI. CHARLES LOESER, EGISTO FABBRI 88

VII. CLAUDE MONET 98

VIII. PIERRE-AUGUSTE RENOIR 104

IX. HENRI MATISSE, PABLO PICASSO, GEORGES BRAQUE 116

X. JEAN LE ROY 131

XI. THE THREE BROTHERS: RAYMOND DUCHAMP-VILLON, JACQUES VILLON, AND MARCEL DUCHAMP 139

XII. ODILON REDON 164

XIII. CONSTANTIN BRANCUSI, RAOUL DUFY 169

XIV. SEGONZAC, LÉGER, GLEIZES, DE LA FRESNAYE 177

CONTENTS

XV. SIMONNE 186

XVI. THE ARMORY SHOW 192

XVII. JOHN QUINN, JOHN BUTLER YEATS, VICTOR MAUREL 204

XVIII. AFTER THE ARMORY SHOW 217

XIX. MAURICE PRENDERGAST 223

XX. THE INDEPENDENTS 231

XXI. GEORGES ROUAULT, AMBROISE VOLLARD 239

XXII. SOME GREAT COLLECTORS 248

XXIII. ROGER FRY, JULIUS MEIER-GRAEFE, ELIE FAURE 256

XXIV. JOSEF STRZYGOWSKI, BERNARD BERENSON 268

XXV. SOME ART DEALERS 275

XXVI. MEXICO: JOSÉ CLEMENTE OROZCO, DIEGO RIVERA 281

XXVII. GINO SEVERINI, ANDRÉ DERAIN, AMÉDÉE DE LA PATELLIÈRE 295

XXVIII. WILLIAM R. VALENTINER, GISELA M. A. RICHTER, BRYSON BURROUGHS 304

XXIX. LATTER-DAY AMERICA, KENNETH HAYES MILLER, A. S. BAYLINSON 320

XXX. EPILOGUE BY WILHELM BUSCH 329

ILLUSTRATIONS
(in their order in the book)

———

WALTER PACH, *Self-Portrait, Etching,* 1938 *Frontispiece*

A WOMAN, *from the* Fifty Drawings *by Henri Matisse,*
1919 *facing p.* 4

WILLIAM M. CHASE, *Portrait by John S. Sargent,* 1902;
The Metropolitan Museum of Art " " 5

ROBERT HENRI, *photograph by Pach Brothers, about* 1906 " " 20

YEATS AT PETITPAS' *painting by John Sloan,* 1910,
The Corcoran Gallery, Washington, D. C. " " 21

ALBERT P. RYDER, *portrait by Kenneth Hayes Miller,* 1913 " " 52

JONAH, *painting by Albert P. Ryder, The National Gallery,*
Washington, D. C. " " 53

J. PIERPONT MORGAN, *photograph by Pach Brothers* " " 68

MORIYE OGIHARA, *portrait by Walter Pach,* 1907 " " 69

PIERRE-AUGUSTE RENOIR, *photograph by Joseph Durand-Ruel, about* 1917 " " 100

BATHER, *painting by Pierre-Auguste Renoir,* 1916 " " 101

HENRI MATISSE, *photograph by Pierre Matisse* " " 104

PABLO PICASSO, *photograph by Albert Eugene Gallatin* " " 105

GUERNICA, *mural painting by Pablo Picasso,* 1937 " " 112

RAYMOND DUCHAMP-VILLON, *photograph,* 1914 " " 113

ILLUSTRATIONS

THE LOVERS, by Raymond Duchamp-Villon, 1913 facing p. 116

JACQUES VILLON, portrait by Walter Pach, 1932 " " 117

THE PHILOSOPHER, painting by Jacques Villon, 1930,
The Brooklyn Museum " " 148

MARCEL DUCHAMP, portrait by Walter Pach, 1915 " " 149

YOUNG MAN IN A TRAIN, painting by Marcel Duchamp,
1912, Collection of Walter Pach " " 164

PORTRAIT OF VUILLARD, drawing by Odilon Redon " " 165

PORTRAIT OF THE ARTIST'S WIFE, by Raoul Dufy, 1930 " " 196

A SECTION OF THE ARMORY SHOW, 1913 " " 197

MAURICE PRENDERGAST, photograph by M. D. C. Crawford " " 212

CENTRAL PARK, 1901, water color by Maurice Prendergast,
The Whitney Museum of American Art,
New York " " 213

PORTRAIT OF A YOUNG WOMAN, painting by
William Glackens " " 244

GEORGES ROUAULT, photograph by Pierre Matisse " " 245

AMBROISE VOLLARD, drawing by Georges Rouault, 1925 " " 260

DIEGO RIVERA, Self-Portrait, Fresco " " 261

HEAD OF A WOMAN, painting by André Derain " " 292

THE BOX PARTY, painting by Kenneth Hayes Miller, 1936,
The Whitney Museum of American Art " " 293

BLONDE ON CRIMSON CHAIR, painting by John Sloan, 1933 " " 308

GIRL AT A WINDOW, painting by A. S. Baylinson, 1934,
The Metropolitan Museum of Art " " 309

QUEER THING, PAINTING

I.

"QUEER THING, PAINTING"

It would be easy to pile up statistics as to the money value of the art-works in the United States. Turning to Europe and merely estimating the value of the works there would take us beyond the statistician's wildest dreams—even in these days of astronomical figures. With one of our collectors paying over a million dollars for a Raphael, what do the pictures in the National Gallery, the Louvre, the Uffizi, the Vatican, the Hermitage, the Prado, and the rest foot up to? And the price paid for that Raphael (one determined on cool business principles of supply and demand) sinks into insignificance beside the sum mentioned by one of our museum officials for the Hermes of Praxiteles: a hundred million dollars.

The question was whether the Greek government, to replenish its treasury, would consider an offer for the statue. "You weren't in earnest, of course, in talking of that hundred million," I said. "Yes, I was, and that's the sum I actually proposed to them. And for that one work, with its importance, its history, its prestige, I am sure a national subscription here would have brought the money." Perhaps it would, in those pre-depression days, when nothing seemed impossible. But cut that astonishing figure down to any reasonable fraction of it and then see where you arrive, in calculating values for the other sculptures throughout the world

by the Greeks, the Egyptians, the Gothic men and those of the Renaissance.

How much for a Michelangelo? How much for an ensemble of sculpture and architecture by him if, as reported, we paid ten thousand dollars for a bit of paper on which he had made a mere preliminary study? And it was a good buy—at any price.

I could go on. I could give you a sardonic little poem by Georges Rouault in which that admirable painter proposes to pay France's war debt to this country by taking down Notre Dame, stone by stone, and setting it up on the banks of the Mississippi. But the humor with which he presents his suggestion does not sufficiently disguise its ghastliness for me to start estimating whose side of the ledger would be that of the creditor after such an operation—a fatal one for the honor of both parties, if such a blasphemy were ever attempted.

Let me take up one more case, however. To this array of dollars (apparently as useless and as vulgar as most of such imaginings), this concrete instance may give a bearing on certain questions that are both mysterious and urgent. The newspapers were playing up the contrast, some time ago, between the insured value of a collection of paintings by van Gogh—a million dollars, and the amount that the painter received throughout his lifetime for all the pictures he ever sold—about a hundred dollars. To be sure he didn't sell many, but then, too, the collection I speak of was very far indeed from containing his whole work which—had he sold it all in his day—would have fetched the merest pittance. Canvas and stretchers can always be turned into a little money, for other painters can use them again, but the price of them would have been about all that the van Goghs would have brought, down to the time of his death, and afterward.

Please do not think that I am working toward an appeal to pity the poor artists. I have no pity for them; they are happy men —as long as they can be artists. When they sell out, they deserve

no pity either, whether they collect their pieces of silver or whether they remain poor, which most of them do. As I have shown elsewhere, their descent is so gradual that if they are ever conscious of it at all, it is only when they make some chance confrontation of the idealistic strivings of their youth with the things of their later life.

No, the question is as to what they strive for, why the world sets the fantastic price I have hinted at on their production, and how it is that uncounted thousands of men throughout the world today are racking their brains, and eking out the last of their resources in order to make one more, and still one more try for the great prize of producing art.

What is the use of it? In earlier centuries the answer was easy —or seemed so. The great frescoes in the churches were the Bible of the poor, who could get the sacred story from them—get their religion from them—as no preacher (save one equal in genius to Giotto, for example) could give it. And Leonardo tells explicitly that the value of a portrait of your father lies in the fact that you can still see his beloved features when he is gone, or that if you are not able to be in the country, the painter can give you a picture of its woods and skies. And so on.

But today the poor can read, so we need no longer paint their Bible on the walls; the photographer gives you a dozen likenesses of your father for a thousandth part of the price that a crack portrait-painter would charge for one—which, today, would probably be vastly inferior, in the matter of vitality and character, to a Kodak snap, while a visit to any movie house will give you all kinds of landscape, summer or winter, native or exotic, and with effects of light and movement that a painter could not achieve in a lifetime.

And yet he keeps on with his work. "Queer thing, painting," as Turner said at the end of a Royal Academy banquet, a hundred years ago. There had been long speeches about the history of art,

the theory of art, the future of art, and who knows what more, but those three words of the famous landscapist, with their implied statement that art is not a finite but an infinite thing, get deeper into the matter than all the erudition that was poured forth by those orators, their predecessors and successors, in treating the theme.

It is always the artists who get deepest into the questions of art. Why shouldn't they? They think of it morning, noon, and night, waking and sleeping (literally), while other people consider it only once in a while. So that if we want to get light on this enigma of art, and our evolving conception of its value and meaning, the men to talk to about it are the artists.

I have had exceptional opportunities to do that, and I set down here some recollections of people in the art world whom I have known, how they acted, and how they thought. If a mere tithe of the pleasure and profit I have gained from them and their work is transferred to the reader of these pages, I shall be happy to have written them.

Yet I am venturing to believe that there is more to our question than one of pleasure, even if, in order to avoid argument, people offer that explanation for their conduct. "Buying pictures is a matter of habit: you begin, as you do with smoking or drinking, and then you find it's just too hard to leave off." That was the analysis, more than once offered to questioners by John Quinn, who will re-appear in these pages. He had risen to a position of great eminence as a lawyer, and was a power in finance and public affairs, national as well as local. To the men he lunched with daily at the Bankers Club he was the crafty strategist of legal and political campaigns, the hard bargainer, the dangerous fighter, or again the man of unaccountably correct "hunches" as to the action of a senator or a financier, a diplomat or a judge.

Doubtless it was for Wall Street associates that he made up the explanation as to his collecting. Had he gone in for Old

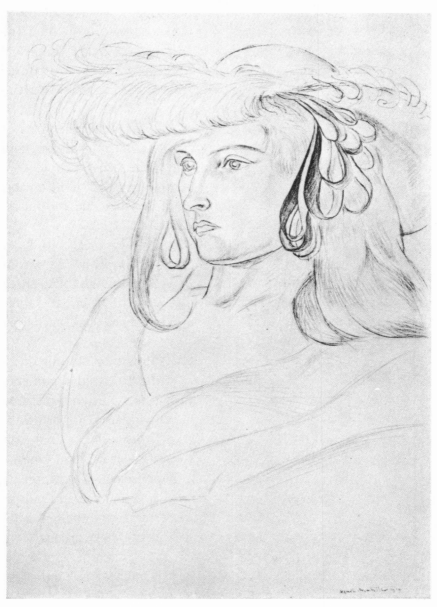

A WOMAN *From the* FIFTY DRAWINGS *by Henri Matisse, 1919*

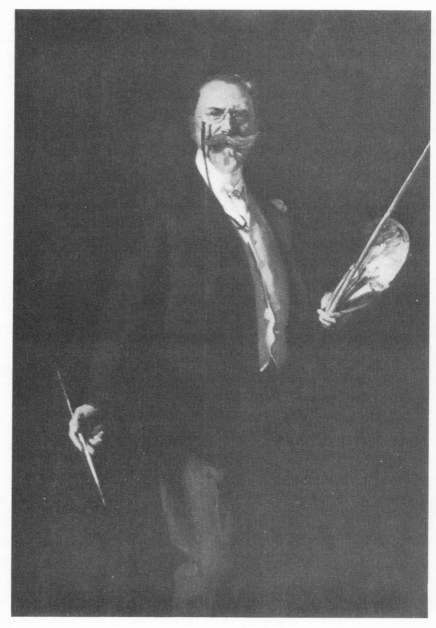

WILLIAM M. CHASE *From the portrait by John S. Sargent, 1902*
The Metropolitan Museum of Art

Masters, like the other lords of his realm, no explanation would have been needed. Such things were a natural and proper appurtenance of wealth—a good investment, if nothing else—one of the safe titles to prestige during one's lifetime and—properly handled— the monument more enduring than bronze after one's death.

But Mr. Quinn's sole interest in buying went out to the things of his own day, not at all to the classics, which he studied at the museums. When a great exhibition of the earlier Italians was on in New York, he said it had no business to be here—that the place to see such things was in Italy, and that the time to see them was the time when they were done, when they were the living voice of their people.

So that this man, with his enormous reading, experience, and influence, brings us once more to the idea of art as an index to life. And I do not mean a sort of table of contents at the end of a book. When I use the word "index," I use it as denoting an element necessary to the proper functioning of society, but one which also acts as a tell-tale, a characterization of the whole. Thus the eyes and the mouth of a man are an index to the workings of his entire system and mind, even while performing their very important services of seeing and speaking.

It is so with art: a vital part of the world's activity at any time, it is also the best means of knowing the whence and whither of things. Everyone recognizes this to be the case with the older arts. They tell us not only of the glory that was Greece, but why and how the country achieved its position. In this respect mankind does not change. It is writing its meanings into the art of our day as fully and as forcibly as ever a period did. It is also writing them just as clearly and legibly. The future will read them with the sureness that we have in reading the significance of a Gothic cathedral. If we are not getting the benefit of such knowledge at present (the time of all times, when a comprehension of our day would be most useful), the fault lies with ourselves. Any aid to

such understanding is of value, and I repeat—the men who know best what they are doing are the artists themselves. Not one of them, to be sure, can see the period as a whole, but each of them accounts for some part of it.

How thoroughly the course of art indicates the course of life as a whole has been clear to me for many years. Having discovered this, as has many another person, from a series of experiences, I cannot do better than relate them here. The earliest of them goes back to the first significant contact with pictures that I can remember. I had always enjoyed them and, living near the Metropolitan Museum, as I did when a boy, I had spent no small part of my spare time in looking at its collections. But until 1895 they did not begin to take on the importance for me that they have since had.

I can date the change in my outlook so accurately because the year was written with my name on the fly-leaf of a book I was given at the time. That book, *The Count of Monte Cristo*, thrilled me as no other had done before. There were grand passages of excitement in *Huckleberry Finn*, which had been my favorite work for a long time (and remained so for even longer), but the adventure of Monte Cristo, sustained through those four volumes, was new to me. And then, with the Count, one made acquaintance with a superior being. Though I never hoped to meet such a paragon of courage, wisdom, and charm in actual life, he was real to me; and at least I could, after a fashion, set my own course along the lines he indicated. This may seem foreign to the account of a decisive contact with the art of painting, but presently you will see what the connection was.

Near the house of my grandparents in Philadelphia there had lived another German-American family named Eble. My father kept up a warm friendship with one of the boys, his schoolmate, who was to become a dealer in antiques. His shop was a palace of magic to me in my childhood, and kind Mr. Eble was untiring in

answering my questions; indeed, he loved to discourse on his treasures (very real ones they were, too) with the numberless visitors, often learned ones, who came to him. His last shop, on Forty-second Street near Sixth Avenue, must linger on for many a New Yorker as a grateful memory.

On one occasion I asked Mr. Eble about a couple of old Dutch pictures he had hanging on his wall: a church interior such as Pieter Neefs used to paint and a portrait of a man, something like a van Moor. I knew such works, in a way, by examples of those masters I had looked at in the Museum. Not that I had looked at them very much: I didn't see why anybody should. They were not "interesting" like *The Hunter's Story* and *The Poacher's Death*, on the one hand, or beautiful like *Graziella, a Girl of Capri* and *Haidee*, after Lord Byron, on the other. Even "interesting" or "beautiful" paintings could not compare in my esteem with those of military scenes; later on, when I started to copy at the Museum, one of my first attempts was a figure from Detaille's *Defense of Champigny*. These pictures have since gone into a well-deserved limbo, all save *Graziella*; there I can still see the same beauty in the model that I used to see, although the picture is as poor as the rest. But in my childhood all New York, except for the few people able to distinguish between the subject of a picture and its art, would have preferred the works I have mentioned to the two at the shop of Mr. Eble.

I did not expect him to possess such grand things as the ones I liked at the Museum, but I did ask why people bought the kind he had. The old gentleman very deliberately took a half-smoked cigar from a tin box, into which he had put it to go out quickly when a customer called (his endless generosity to needy persons made him economical about luxuries), and, apparently reflecting as his vigorous puffs got the "old soldier" into action again, he gave me an answer suitable to the understanding of a ten-year-old.

"Well, you see, I'm an antiquary. Everything here is very old.

Take those swords: they are of the seventeenth century. Suppose a man had those on his wall, and those Delft jugs that have such a nice blue, and that fine tapestry: he would want pictures that went with such things, and so he might buy these, for they are of just the same time."

As people did things for all sorts of strange reasons, I was willing to let them go their own way again in this instance, even though it seemed a poor way, when things as wonderful as pictures were concerned. From that day my name for works in the Marquand and other galleries at the Museum where the old brown paintings hung was "Mr. Eble's pictures," and I called them that for years.

One Saturday afternoon in 1895 (to get back to *Monte Cristo*), having seen my fill of the works I liked, I decided, listlessly, to take a stroll through the rooms of antiquarian stuff. On the frame of a portrait there I read the name "Rembrandt," and I knew I had seen it somewhere before. Soon it came back to me: to give an idea of the Count's fortune, Dumas had had him buy a Rembrandt that the French government had wanted to acquire for the Louvre but had been unable to afford.

I stared at the canvas. It was one of "Mr. Eble's pictures," just like the rest; yet Monte Cristo, the ineffable and infallible, had paid a vast sum for such a thing. He was not a man to be moved by such a consideration as matching the period of old swords or old pots; his lofty mind would demand only the fine things of art. Yet he had bought one of these dull pictures. Something was wrong; two and two no longer made four.

Diligent thinking on the problem for several days brought me to a new possibility: that I had missed something in the picture, that it was not the stupid thing I thought. Saturday was the first day when I could go and see, but when I stood before the Rembrandt again, it was quite as bad as before. If I remember accurately, that mental tussle kept up for over a month, perhaps two

months. At the end of that time my repeated seeing of the picture and the ones around it had brought about the usual result: I realized that they were great. And I believe that never since that time have I taken my lack of understanding as proof that a given picture was bad. Years afterward, when I was having the worst sort of time with the "modern" things that I came on in Paris, instead of slamming the door on such "heresies," I was willing to wait till I could see whether the qualities people claimed for them really existed.

I insist that they were no more a break with the Whistler-Sargent ideal of my training in art school than the Rembrandt was from the soft foolishness of the pictures one saw in the window of every dealer along Fifth Avenue from Twenty-first Street to Thirty-fourth, in people's homes (through photographs if they could not own originals), and in the Museum, where the examples before referred to were so far from being the exception that, save for a few works of the Barbizon School, almost the only valuable possession of the nineteenth century galleries (as I see them now) was the pair of canvases by Manet.

My liking for these came about in a way that almost paralleled my acquaintance with Rembrandt. While I was working on the copy of the Detaille figure that I mentioned previously, a group of young people entered the gallery. Conducted by a teacher who was lecturing on the collections, they stopped before *The Boy with the Sword* by Manet, which hung directly alongside the work I was engaged on. It was a canvas that I had found empty and uninteresting on the few occasions when I had looked at it, so that—compelled to hear the remarks of the speaker—I was astonished to hear him praise it very highly. Noticing the very modish dress of the gentleman and being suspicious of sartorial display, I set him down, mentally, as a person who made his society manner take the place of knowledge of art. I was sorry for the students who were being misled by such a preceptor.

Finally he said, "And don't you see that this and the other Manet are the only pictures here that could hang with the Old Masters, while this [pointing to my Detaille] and everything else in the room are just so much claptrap?"

That was too much. I went over to an attendant to vent my indignation over such words. I asked if he knew what school those young people came from, having a vague notion that it was my duty to write to the head of it and expose the unworthiness of the guide to whom the students were intrusted. The attendant did know the school, the Pennsylvania Academy. "He brings a group of students over from Philadelphia every year to see the Museum; he's one of their teachers. His name is William M. Chase."

If my shock was not as great as when I found myself at odds with my beloved Monte Cristo, I was a badly shaken boy none the less. Mr. Chase was one of the famous artists of America; there was a picture by him in the Museum—one that I still look on with deep respect—and at that time, anybody whose work hung in the Museum was an immortal.

The process of coming to like the Manet was not as long and bewildering as my study of the Rembrandt had been. For one thing, having to make amends for my bad judgment about Mr. Chase himself, I set out to apply his test of comparison with the Old Masters. Rather soon I discovered among them a work that did indeed have a great likeness to the *Boy with the Sword*: the portrait of the young prince by Velasquez. And I discovered, also, that the Detaille and similar works did really fall far below the standard of the things I was later to call classic.

If it was only after a long time that I was to realize what an abyss separates the two types of art, I had already learned two big lessons: that there are things whose merit is so great that it will come into people's consciousness even after centuries (and despite early misunderstanding); also, and this turned out to be even

more important, that men in our own day could achieve such quality again.

At the time of the Manet episode I was not ready to see what I have called its more important aspect. My main preoccupation was getting time to paint—first when I was a college student, then when I started to make a living. The purpose of the painting did not matter, nor did I have any idea about the phases of art having a quality peculiarly vital in a given time. Not since Durand-Ruel brought the first Impressionist exhibition to New York in 1885 had there been anything to face people with the issue of a modern genius. So that when I finally went abroad and saw things of a vintage twenty years later than any I had known at home, I could accept George Moore's words about the "shriek of the decadent."

He wound up his article, dating from 1892 or shortly before, with a statement that France had at last entered on a period of artistic decadence, and said, finally, "for many a year nothing will come to us from France but the bleat of the scholiast." He was right in seeing both school-men and decadents as expressions of artistic poverty; he was wrong in taking Seurat as his illustration of the point—which he did in the body of the article.

Brilliant as he was, and courageous in his defense of the great men of the previous generation, he had lost touch with the evolution of painting. There was excuse, then, for an American living so much further away from the center of that evolution, if he had no idea of the great movement of modern art—of which, indeed, no single example was to be seen west of the Atlantic.

To be sure, a strong philosophic mind might have deduced the theory of change, and realized that so powerful an impetus to thought as the whole nineteenth century had given was not to come to an end overnight. (There just occurs to me a new example of the way things move: Mark Twain's observation that an American in Heaven could no more converse with his ancestors of five or six centuries ago than with the Chinese—so completely

has the English language been remade. One may add, even, that writings of the eighteenth century contain endless pitfalls for us to-day because of the way words have assumed different meanings.)

But of all such problems I was blissfully unaware when I started out for Europe and the Old Masters. It was bliss indeed to see the great works, and I should not have known what was meant had anyone told me that my real study in Europe lay elsewhere—with the new things instead of the old. My first contacts with the great moderns or near-moderns went off very well. In fact it may be of use to tell how I formed acquaintance with Cézanne and van Gogh—not as proof of any special perspicacity or open-mindedness of mine (I have little of those valuable qualities, as I well know), but because of my ready acceptance of the two men illustrates the way in which a grounding in the great work of earlier times carries one on to understand the great work of a later time.

At an exhibition of modern art in Dresden, I came on a picture that appealed to me strongly. In the diary I kept at the time I noted down "superb work by Buzenne (?)," the question mark meaning that I was not sure of the name. I had no catalogue and the spelling I used was the best I could do in reading the signature in the paint. It was many years afterward that the sight of a similar work led me to look up that notation, when I found that my "Buzenne" was Cézanne, and I had the satisfaction of knowing that I had first liked the great man for his art alone, and not for his fame, which was unknown to me.

The same is true in the case of van Gogh. Painting in Holland for a time, I found myself going out of my way, on returning from my studio every evening, in order to take a street where I could see again certain drawings in the window of a bookshop. Finally I went in and inquired the name of the artist. I was told that it was van Gogh, which left me not much wiser than I had

been, since no mention of his genius or even his existence had yet reached me.

I insist that the constant mention of myself in these pages does not make autobiography of the present writing. I am sure that my experience is similar to that of numberless other people, so that what we are engaged on is not the evolution of an individual, but the characterizing of a period—indeed of certain elements of the mind that are found in all periods.

One of these that has been greatly to the fore in our time is the peculiar value of what is modern, the problem that has not been solved previously. To realize this is also to comprehend that relationship between art and life that is so troublesome. Just as the artist gets the clue to his success from great men of the past, men who faced totally different conditions, so in our present-day need to distinguish between authority and tyranny, for example, or between freedom and chaos, we scan the centuries behind us for a basis of judgment on the course ahead. And in doing that, there is no state of mind so exigently demanded as the "non-partisanship"—to use Hamerton's fine word—with which the best students of art allow the works to speak for themselves, instead of trying to make them conform to a preconceived pattern.

The latter process is that of the mind nowadays called academic; and it is the opposite tendency, loosely designated as modern, which has been more and more in the ascendant. Twenty years ago the word modern was, on the contrary, a signal for doubt, if not hostility. The reason for the change is that we are coming to grasp the fact that a thing which is genuinely modern expresses some permanent idea, however new the form in which that idea is clothed. Soon the new and the old are as unshakably linked as were those pictures by Manet and Velasquez that connected themselves for me so surely when I was a boy. From a piece of visible logic like this, one goes on, step by step, with each succeeding problem.

QUEER THING, PAINTING

For some people, the progression will be swifter than for others, but that is not the essential matter. Nor is it connected with the ultimate exhaustion, in almost all cases, of the power to make new advance. That is as much a phenomenon of our mental as of our physical make-up. What is important is a willingness to recognize that past judgments are not final—and to go on to better ones. Modern art, had it no other claim to gratitude, must at least be credited with having taught us the necessity of such openness of mind. Modern life with its terrifying and grandiose possibilities can be dealt with successfully only if we approach it in the same spirit as we have learned to apply to art. And, as we have again and again found that the best of modern art and the best ancient art confirm each other reciprocally, so we shall unquestionably see that the solution of our political, social, and ethical problems will be in accord with the essential findings of earlier thought.

The big difficulty is to see the relationship between old problems and new, whether in the field of art or in the field of affairs. Henri Matisse, in the one piece of writing I know by him, affirms that there is no new truth, that what we speak of so is only the fresh application of ideas long since accepted. Thus, he says, the inventors of the airplane did no more than make use of principles perfectly well known before, but neglected by the less fortunate workers at the problem of aviation.

It was all very well for Matisse to put such wise thoughts into words—running to a good number of pages. I simply could not see—thirty years ago—that they did anything to clear up the mystery of his work, or what my friends the Steins and others could see in such pictures. In Paris the general word for these artists was *les fauves*, the wild beasts, and I was not far from agreeing with it.

The fact that I had liked Cézanne and van Gogh immediately, and that I had felt Picasso's extraordinary quality the first time I saw his work was of small importance. All three represented

earlier conceptions of picture-making. Cézanne was for me a continuator of the Impressionist formula in which he had grown up: I did not see the new values of form and structure he had attained. Van Gogh was accessible enough also in his carrying the painting of light to new intensities, though I did realize much of the poignancy of his expression. Picasso was still preoccupied with earlier arts—Greco, Puvis de Chavannes, Toulouse-Lautrec. All three men were therefore easily connected with what I already knew. Matisse was of the present, and I fought it in my mind, though in the one thing I wrote at the time, I went no further than a statement of conditions in that thrilling Paris of 1907.

Month after month of my first entire year there, I kept up a bitter struggle with the problem. If the new things were right (Picasso was doing them too by that time, under the influence of Negro sculpture) then, I thought, my beloved Old Masters were wrong. A further conclusion, less important for the world, but a more important one for me, would have been that my whole preceding work had been misdirected. I had paid high for it in money and effort; one does not easily give in under such circumstances, as, at later times, I often told people who did not have at stake the thing that such a decision meant to a young painter: for him the whole of success or failure hung on the issue.

That sounds like putting the thing in a pretty serious way—but I was not wrong to take it so. What was a mistake was to think that a break with the past was even possible, or that any credible person considered such a thing. To be sure the Futurists, a few years later, used such words as "Destroy the museums," but even they meant no more, than "destroy the tyranny of outworn forms." Their ideas were weak enough, and the expression of them was worse, but at no time did they say that the ancient things were bad in themselves; they were merely bad in their effect, when people used them as blinders to shut out the living present. I was not guiltless on that score myself, having concen-

trated on the museums with all the hunger for them I had stored up in America, and with only a dawning realization that work entirely comparable to that in the museums was being produced right around me.

By comparable, I naturally mean to refer to its importance, for in superficial aspect it was different enough. What the "wild beasts" had torn away was the outer husk of material imitation, the thing that the photograph could give. Matisse and the rest saw that what is merely the reproduction of appearances can be left to the camera, now that the world has that invaluable instrument to do the work that the painters of former periods were supposed to do. Freed from such irrelevant demands, they had gone on to investigations of form, color, and expression, and with such speed that people who had not had opportunity to see their work regularly were left breathless when confronted with it.

That was my own state and, like other people, I could be helped only by repeated contacts with the new art. As, with those people—or all among them save those who were determined not to see—exposure to fine things meant surrender to them. Since in my case this was not passive surrender, nor the effect of either pressure or blandishments, the conclusion I find inescapable is that works of art really possess certain qualities which, given a fair chance, will bring about similar impressions in everyone at all prepared to receive them. (When people are insufficiently prepared, we know that the most elementary form of representation fails of recognition. Certain African natives claimed that photographs of themselves were not at all like them, and gave as one reason the fact that the pictures were very small, while they themselves—comparatively—were very big.)

This book and all my thinking—indeed, all the thinking of artists in general, I believe—is based on the conviction that the qualities of painting and sculpture are not the relative things that people often call them—"truth on one side of the Pyrenees, false-

hood on the other." Get deep enough into the artist's thinking, take him out of the range of stupid argument (the thing that made John Quinn call his cherished collecting a mere matter of habit), and you will find that certain works are looked on as absolutely and permanently good, and others the reverse. No amount of reading or discussion will enable you to distinguish the one kind of thing from the other, fundamentally opposed though they are. The need is for such opportunity to see them as I had during those blessed years in Paris.

Since returning to America, I have tried to pay up for my privilege by working at various exhibitions of modern art (the first and greatest of them being the Armory Show of 1913). The work of the critic is chiefly that of a signpost, directing people toward the better things. To some extent I am engaged on that here as I set down the talk of men who have had a share—often the most vital share—in the art activity of our time.

Do I know who they are? Am I quite sure that my present-day convictions are not in the class of those I had when a boy—things to be discarded as new experiences appear? My answer is yes, with some minor reservations. For one thing, I write here only of men I have known, the omission of great artists like Maillol, for example—means only that it has never been my fortune to meet them. Other omissions occur because I think certain men I have known would be out of place in the company I am telling about. That they are masters of the thing they want to do is not relevant; year by year a larger number of people see that it was not really a thing worth doing.

I know how considerable, how arrogant, to the minds of many is the claim that one is right. But then my case, or the world's case today, is not that of the boy I was in a city cut off from the vital current of the period and therefore easily misled by superficial ability. Such misunderstanding caused us to neglect a great man right in our midst, Thomas Eakins, whose grand quality I

realized only after his death. But again I had not seen more than two or three of the canvases, and none of the masterpieces, that made the Metropolitan Museum's retrospective exhibition of his work in 1917 such a revelation. And I note in passing that at that time we were in the full tide of admiration for the "modern" men —whose antithesis he seemed to many (and doubtless does today). So that I am convinced, for this among other reasons, that my ideas are not those of a school.

"You really claim to know, then?" All right, I do. (Lots of other people make the claim, but only to themselves.) The one additional statement I would offer here is that knowledge about quality (as distinguished from knowledge of facts, dates, etc.) is always an undemonstrable thing, save to the extent that the ideas of other men furnish corroboration. Also the question of knowing arises only when things have been experienced sufficiently. Beyond a doubt there are pictures ahead (if they have not already arrived) that I shall misjudge. My conviction that I know what I have well observed does not lead me to any idea that I can prophesy, or that I have drunk from the fountain of youth, ensuring an ability to keep on assimilating new-found values.

Once more, in appearing to discuss my own case, I am examining a general issue, that of the basis for our ideas. The cocksure tone of authority formerly used in uttering "final" decisions as to what is art, and what is not, was wrong; we say what we know, and the future decides as to the intelligence behind that knowing. Otherwise we have no choice but that of the defeatist who takes "you never can tell" as his poor motto. The museums, even, the places to which people quite properly look for guidance, are addicted to what I cannot call less than evasion. They point to the number of mistakes in the past and, abstaining, or thinking to abstain, from judgment, admit works merely on the basis of some mysteriously arrived at count of the persons in favor of them. Of course they do not carry this policy to its logical con-

clusion, else they would throw out their classical works and re-place them by those of the magazine illustrators: the latter would be chosen by an overwhelming majority if the matter were left to a full popular vote.

No one who knows the taste and preferences of the persons in control of museums can imagine for a second that they refrain from enforcing their ideas. By their choice of exhibits they affirm the rightness or at least the superiority of certain things, which is what they should do. Indeed, the more uncompromising they are, and the more conviction they put into their collecting, the more character it will have. When the time comes for a revision of their judgment and the wrong acquisitions have been elim-inated, a residue of permanently desirable things will be left. It is safe to say that they will be far more numerous than those result-ing from the automatically fool-proof schemes that are supposed to take the place of sensibility, intelligence, and experience. Those are prime qualities for the making of works of art and they are practically the sole ones for selecting works of art. What we need is more of such qualities in our officials, and we are getting them—if a bit slowly.

The scheme now in vogue of treating the museum as an ex-pression of popular (or semi-popular) taste gave us the placing of a Besnard in a recent show called Renoir and his Contempo-raries. No one could deny that Besnard was a contemporary, but Renoir himself denied the other painter the right to be mentioned before him. So gentle by nature that he often said he did not know a given man's work in order to avoid expressing an adverse judgment when his opinion was sought, Renoir's tolerance did have limits, and Besnard's adulteration of the art which the Impressionists had carried to perfection went beyond the endur-ance of even the kind old painter. "Don't talk to me of that man," he exclaimed hotly, not to myself, but to the friend who had been so unlucky as to bring the name into a conversation.

There were other "contemporaries" of no better quality in that show, and if it is contended that their presence was needed to give a true picture of the period, I reply that the picture was utterly untrue. For if men of the Besnard type made up five per cent of the exhibition, they accounted for more than ninety-five per cent of the production of Paris in their time. Since this was a Renoir show, the only thing to do was to leave it to him and the men he believed in.

That, of course, presupposes knowing who they were. And so I get back to the question of the men included in this book. My "knowing" about them is not a matter of purely individual judgment. As I have said about the statements in former writings of mine, I base my ideas, to some extent, on my experience with the men of whom I am telling. It was the slow, collective pressure of conviction by the artists that brought men like Cézanne and van Gogh from their apparently hopeless neglect to their immense prestige of today. In fact it is always the ideas of artists, influencing those of collectors, critics, and museum men, that decide the various issues of art. The selections and omissions here may be looked on as those which would have resulted could I have obtained the advice of the men I write on, and could the older of the artists have had more opportunity to round out their opinions.

For example, Mr. Chase once gave a groan of dismay as we stood together looking at a Picasso drawing in the window of Sagot's shop in the Rue Laffitte. One of those marvels of incisive characterization and of draftsmanship dating from the "Blue Period" of Picasso's art, it was—I am quite positive—the first example of his work that Mr. Chase had ever seen. Will any friend of our painter-collector affirm that he would have continued hostile to such things had he seen more of them (without the complications of the Spaniard's later evolution)? No, the Greco-Goya-Degas formula of the Picasso of 1903 would have

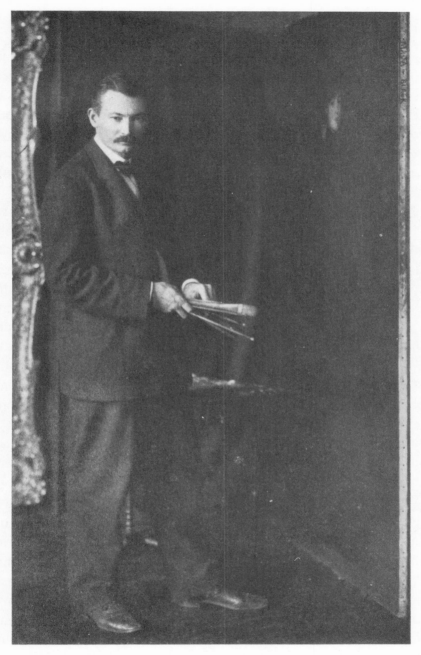

ROBERT HENRI *Photograph by Pach Brothers, about 1906·*

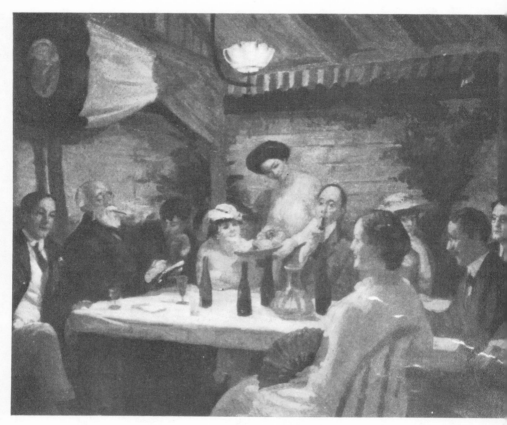

YEATS AT PETITPAS'

*From the painting by John Sloan, 1 9
The Corcoran Gallery, Washington, D*

exactly suited Mr. Chase's ideas, had they not been outraged by the things he was seeing in Paris and had he not thus been rendered suspicious of every newcomer.

The matter was put into a neat *boutade*, almost an epigram, by Jacques Villon when going over a big book on Ingres. Coming on a schematic drawing for one of the compositions, and noting the geometry behind the dashing lines which wove a design out of figures without faces, or indeed any semblance of anatomy, Villon remarked with mock-bewilderment: "But why is it that Ingres does not like Matisse?" "Because he died too soon," I answered.

That was uncontrovertible, Ingres having died two years before Matisse was born. He was eighty-seven years old—and would have needed to live perhaps fifty years more in order to know the art of Matisse. But even had the two men been of the same time and not merely of the same type, special openness of mind and special opportunities would have been needed for Ingres to follow the logic of Matisse and to see what the other was driving at. Were Ingres alive today, I would ask—as in the problem of Mr. Chase—whether he would not by now be an admirer of Matisse. For my own part, I cannot doubt it: Villon's observation as to the essential likeness of the two arts being based on more than superficial elements. Let anyone who questions this look at the Matisse book of *Fifty Drawings* of 1919, and say whether they are not in the best tradition of Ingres's purity.

Time is the one thing necessary to bring competent and sincere men together in their ideas of art. This is proved by their practical unanimity about the things of the past. One may have an individual preference for a Chaldean head as compared to an Egyptian head, or for Rembrandt as compared to Rubens; yet everyone knows that all four are great art. Since there is such a thing as truth about the past, then, there is truth about the present also. No one who bears the scars of those struggles I have

told of—and many more—will say that the truth is easy to know, but the longer one struggles with the problems of art, the more worth while they seem, the more they appear to include all others.

Perhaps, on this score of inclusiveness, it may be said that I carry the matter to the point where it is unintelligible, when I have a realistic painter as one of my heroes and a maker of abstractions as another. But as Marcel Duchamp once said of this very matter, "The real question is elsewhere." He did not tell us how to locate his beautiful "elsewhere," somebody objects. Artists never tell, if I may paraphrase Disraeli's answer to the question about the religion of sensible men; he had said that they are all of the same religion. Essentially all artists are, too.

And that brings us back to the old Roman and his *Ars una*, the wisdom of which I found out during those years in Paris. A Realist and a Cubist? Why not? Marcel Duchamp's brother, Duchamp-Villon, the great sculptor of the Cubist group, had protested at the Autumn Salon against the attitude of its jury toward the work of Rouault, a man of very different characteristics, had secured a proper placing for his pictures, and, to a large extent, had insured their success. Later, in writing me about the exhibitions in America, he defended men of apparently hostile tendencies and again affirmed that the differences in schools (the *species milla* that completes the Latin proverb referred to) were totally irrelevant to the issue. Nothing, therefore, could be more unfounded than an accusation that men of this type are building up a "modern academy."

A modern attitude toward the museum is a different matter. It means subordinating lesser considerations, like period and materials, to the idea underlying art, both ancient and modern, for they are indeed one. That is a tall order, you say, this focusing on art itself. It is, but we have a right to make such a demand, not from any single museum, but from all of them together as they correct one another's mistakes by giving prominence in one

place to what is neglected in another. The way to such a result lies along the lines of better appreciation by the public: when it demands true judgment from the museums, it will get it.

As one comes to know the men of the present time who appear in these pages, as one grows more conscious of things they have striven for, one is also moving toward the modern attitude toward the museum, and is assisting in its work of leadership. In the past it was for many just a convenient place to deposit treasured (or perhaps unsaleable) possessions after the decease of relatives. Too often treated in the same spirit by those who directed it, the word museum has at times suggested a contemptuous rhyming with "mausoleum."

But the museum is a place of life, not of death. Nor is it like a mere dictionary, in which to look up correct spellings and definitions. Such things change, in art, as time goes on, and an idea that was once exact or even inspired becomes the worst of bores if people try to apply it to unrelated matters. That is what Whistler meant with his "Why drag in Velasquez?" when a lady had compared his work with that of the Spaniard—whom he admired more than she did. Picasso rebelled in the same way when a man said "You used to draw like Raphael"; the reply was "I have never had anything to do with Raphael." And when attention was called to his debt to the African Negroes, he calmly and transparently fibbed, "I don't know them."

No matter in the whole range of art is at once more delicate and more important than our relation to the masters—ancient and modern. And so it will be worth while, in approaching the men I have known, to glance at the state of appreciation in the years we are considering. I shall call them pre-war, war, and post-war. The years of the "war" are not quite those of the great European conflict. What I call the pre-war time ended with the "Armory Show" just the year before 1914, but if we look on the period back of that as the age of innocence, when America knew nothing

of the great forces which had silently been gathering momentum in Europe, their crashing into consciousness did not cease with 1918.

The near coincidence of the great International Exhibition of 1913 with the outbreak of the international war must not cause us to forget the fact that both events had been preparing for many years previous.

By chance I had been in Europe pretty steadily for the ten years before the war and as early as 1904 had begun my acquaintance with the work of Cézanne, in the way I have related. But in America perhaps not a hundred persons were at all aware, in 1913, of the immense evolution of European art since the Impressionists made their relatively short step from the preceding schools. At a time when Diego Rivera had finished with Cubism, in the narrower meaning of the word, he once remarked that the movement had marked the biggest advance in art understanding since the Renaissance. It will therefore be seen why an explosion was produced when the Armory Show revealed to America the developments of which the country had been kept ignorant during thirty years. If Cubism was what climaxed the matter, Cézanne, Seurat, van Gogh, and Matisse were almost as unfamiliar. And the war years in art, as I call them, went on till much later than 1918. Perhaps they are not yet over. Perhaps only those who realize the completeness of our change of direction can comprehend that any turning back to nineteenth-century conditions is impossible.

Rare indeed are the people of the older generation who have realized this. The tragedy of Versailles was that the treaty-making there was in the hands of men like Clemenceau and Lloyd George who wrote out the future (or thought they could write out the future) in terms of the past, instead of seeing it as a new time.

For a new time it is, and we must keep that fact before us if we want to understand the reactions of men brought up in the culture of pre-war days, even those who possessed a deep culture.

"QUEER THING, PAINTING"

In 1908, when I talked to Renoir about Matisse, the older man, though too wise to condemn an art of which he had not seen very much, really hated it in his heart, according to the words of one who knew him intimately. Ten years later, Renoir had come to feel that Matisse was a painter of important achievement. But then such self-renewal as the master kept up to the end of his seventy-eight years is the privilege of few others besides men of his exceptional genius. Moreover, this was in France, where the great current of the time was sweeping ahead with its maximum of force.

In America our problem still was (and, to a large extent, still is) that of building up a knowledge of the past. Over forty years ago, a critic like Berenson could arise here and rapidly mount to a position of highest authority in Europe; but the country as a whole, during his youth, was densely ignorant of the ancient schools of Italy, which he wrote on; and all our work in the museums and universities has gone but a limited distance in correcting the state of affairs. It is, of course, the most obvious truism to say that America has other things besides art to think about.

But Europe has also, when you stop to consider. In fact, most Europeans care no more about art than most Americans do. Still, in the old countries, that minority of people to whom art is a vital matter is a far larger minority than our own, and they are backed by a strong tradition of popular respect for the arts, a thing still foreign to us over here. Whether you start with figures like the thirty-five thousand people in the art trade in Paris and the forty thousand artists in the city, or whether you think of the way that millions of peasants in Greece, Italy, Spain, and other countries of the Old World have some sense of art from the churches and other relics of the past, you at once have before your mind a host of reasons for the different status of art on the two continents.

[25]

The difference is not all in favor of Europe. That more is done for the artist and art-lover there is certain. But much of it is very badly done: witness the abominable "governmental" art in every land, and the fact that the men of genius have been neglected or proscribed by officialdom for a hundred years. We shall presently hear Renoir saying that government influence is the chief corrupter of public taste. Then, too, if our museums will never even approach those of Europe in the quantity of their treasure, the matter of quality does not stand in quite the same way. The Old World heaped up its collections pellmell with whatever came from old castles and churches, from chance finds or excavations, etc. The New World, creating its museums at a time when a whole new science and literature of the arts was available, has had the opportunity to select what is essential in the still large residue of accessible things.

Wild mistakes have been made here and are still being made. It is heart-breaking to many of our museum officials to see great opportunities lost while vast sums are squandered on inferior or worthless stuff. In my book on Ananias, a personage whom I hold responsible for many evils in the modern art-world, I give two examples of the way that the Germans—with far greater museums and far less money than we—carried off two important Greek sculptures that we should have had. The year after I wrote of them I was visiting the Kaiser Friedrich Museum in Berlin. Coming on that masterpiece of Georges de La Tour, the *Saint Sebastian*, I found that it had been bought at public auction in New York, after having formed part of an American collection, and that our museums had lost it for the country through failure to realize its value, in some cases, though in others, lack of funds prevented its purchase.

Yet, on the whole, our record has been a good one; we started with nothing but the instinct we brought with us to the virgin continent, and we have provided our people with really marvelous

opportunities to know the extent of art in the past and to divine its possibilities for the future. And that last magical word, so large a part of the religion of America, explains, potentially at least, the biggest advantage that we have over our cousins abroad. The matter is not certain: Europe has come triumphantly through crises more desperate than that of today, and our own achievement is perhaps not yet sufficient to justify prophecy. But we have done things and produced men. In offering such small help as I have for a record of them, I must remind the reader that they, like the Europeans in this book, are not to be understood without reference to the conditions of the period. So that I propose now to go just a bit farther with characteristics of those three divisions of time suggested before.

I have already mentioned America's unawareness of everything new in Europe after 1885, the year when Paul Durand-Ruel brought to this country the first show of the Impressionists. But I have not indicated how much we had done with our acquisitions of pre-war days, nor need I do so now. Every visitor to American museums can see for himself what admirable men had developed here, and how the thin trickle of the current coming down to the mid-nineteenth century from our fine Colonial painters had expanded anew, as artists like Winslow Homer and John La Farge reached their maturity.

I offer these names of men, whom I did not know personally, as a reminder of what had been accomplished in the preceding century and the first years of the present one. And in recalling those two painters, I would also suggest contrasting temperaments, the self-reliant, self-absorbed nature of Winslow Homer, who retired in later years to the rocky coast of Maine, to be alone with the elements, and the eclectic, receptive nature of Mr. La Farge, open to new ideas until the very end of his long life. He wrote me several times asking me to come and tell him about

the new schools in Paris, but illness compelled him to call off our various appointments.

Perhaps no great purpose would have been served had he been able to receive me, perhaps the only result would have been temporary, the old artist being insatiable in his eagerness for new understanding. But I had heard him speak at the opening of an exhibition, years before, and recalling his words of welcome to a young painter returning from Italy with a fresh influence from the Primitives (whose influence was seen but little at the time), I still think that the man who had written in such illuminating fashion on arts in the wide span from Rembrandt to Hokusai might have said valuable things about the "new Primitive," as Cézanne called himself, and about the great movement stemming from Cézanne.

It was not the questioning, receptive spirit of John La Farge that predominated in those days; it was the confident positivism of Homer. The country was prosperous and expanding, the great collections of Mr. Morgan, Mrs. Gardner, Mr. Widener, Mr. Havemeyer, and Mr. Frick had been formed or were forming. Mr. Carnegie's millions were bringing books to any number of towns throughout the country, and bringing pictures from every land to the yearly International at Pittsburgh. Why bother about what the latest cry in Paris might be? One man gave an answer or the material for an answer—Alfred Stieglitz, who showed a number of groups of the "modern" work in a tiny gallery on Fifth Avenue, where he had begun with exhibitions of photography, in which field he had achieved preëminence himself.

And the answer to that "Why bother?" grew clearer and clearer. It was because ideas were at work in the world that made the older formulas for painting and sculpture unserviceable for the new generation. They were still valid for the artists who evolved them: Renoir and Monet, Redon and Rodin, among the older men, were going on with the beautiful arts they had always

practiced. Indeed they were carrying their work to its culmination, unlike the late Byzantine painters, who continued with their style for centuries after Giotto had made his break from it, and when school after school had succeeded him. If, in Greece and Russia, the externals of Byzantine art remained unchanged, we can certainly not say that as to its strength. The school weakened progressively and, in places like Italy and Spain where live arts grew up, it died. Our English tradition that produced such admirable results with Copley, most of all, could not hold up against the more vital painting of the Continental Schools, when Americans came to know them.

A reviewer has just remarked, "What would novelists do if they did not have the conflict of the older and younger generations to write on?" The answer is, of course, that significant as the theme is, there are others to be studied. And, though not the whole question about art is whether it is modern or the reverse, one may say that if a given art has never been modern—i.e. expressive of the vital impulse of its period—it has never been good and never will be good. The further issues as to its Classical or Romantic quality, its national flavor, etc., are to be discussed only after we have determined that it is alive.

That central question in the case of the modern art of our time, was the cause of what I call "the war." It is over now, even the most unreconstructed among pre-war persons being forced to admit that the thing lives. And so the really interesting matters are all post-war. Some of them are to be discussed only by people of the oncoming generation, the men who are evolving new ideas today. It was already magnificent for Renoir to see that Matisse— thirty years younger than himself—was a real painter; no one could fairly ask any reason for his opinion; indeed, there are precious few reasons to be had for opinions on art, and no proofs. You cannot prove the rightness of even Rembrandt or Shakespeare. Most people say they are great, but there have been serious objec-

tors, and unanimity itself may be only a temporary affair, to be abrogated when the world changes its mind.

But some post-war ideas are not the sole privilege of the new men. For example, the more recent valuation of the art of Thomas Eakins, while it was largely brought about by the "moderns," has spread to a far wider public. And, as with all valid ideas, it was no new thing even when it most appeared so. There were a few men to appreciate even such impossible-appearing artists as were Corot and Cézanne, in their earlier days, and a number of people —in Philadelphia, especially, where Eakins' work was best known— called him a great painter in the days when he was looked on as dull or academic by the majority.

So that, however convenient our divisions of the periods may be, it is poor art-appreciation indeed that is a slave to chronology and judges a man by his importance for his time. It is his importance for all time that we want to know. I believe I give no ground for an accusation that I think my own convictions are to be those of posterity. But since source information about artists is valuable, I do not think it a waste of good white paper to put down the following record of men who—at the least—have played a rôle in our time, and in some cases, a supremely important rôle.

The order in which the figures appear cannot, evidently, be kept strictly in relation to their place in the development of the period, but, in general, I think its history will unfold somewhat as indicated by their place in these pages. So, looking back to a representative of painting that gave to America such ideals as Velasquez, Whistler, and the Japanese, let us begin with William M. Chase.

II.

MR. CHASE, ROBERT HENRI,
JOHN SLOAN

═══════════

THE LADIES LOOKED AT EACH OTHER, LOOKED AT ME WITHOUT MY recognizing them—as indeed I had no reason to, and then looked back at each other—as if mutely saying: "No. You ask him." To end the embarrassment, I started to turn away, whereupon— moved by one impulse—both asked together: "Who was that gentleman you were just talking to?"

"That was Mr. William M. Chase."

He always produced an effect, and I had been asked, on various occasions, who he was, but this particular time remains in my mind because of the droll way that the two strangers were overcome by their curiosity. It started usually with his hat, the top-hat more worn thirty years ago than in these informal days, but Mr. Chase's topper came from abroad and had an almost straight brim, at right angles with its stovepipe; only Oscar Hammerstein, in New York, had one like it. Then there were the white spats, that were foreign-looking, as also the wide, flowing ribbon to his eye-glasses; there was the big emerald in the ring about his necktie; and there were the great mustaches brushed upwards like the tusks of a wild boar, for which the explanation was not the famous mustaches of Kaiser Wilhelm, but those of a number of the citizen soldiers that one sees in the great groups at Haarlem—where Frans Hals established for Mr. Chase the

ideal of all painting, one that was not eclipsed, even, on the visits to Madrid, before the wonders of Velasquez.

The king, the cavaliers, and the court painter himself, so sensitive as an artist, so proud and yet appealing as a man, had their share in the externals of Mr. Chase's make-up, as they had in dictating the course of his art. Together the two things were in reaction against the look of both the dominant business class of the nineteenth century and the Bohemian class of the Romantic Period. Against the former lords of creation (unless they were buying pictures—his own or such as he approved) Mr. Chase could speak in bitter railery, with almost Socialistic allusions to their uselessness, while of the velvet-coated, pipe-smoking, guitar-playing artists of the "Old school," he would say, "They wear their hair long for the same reason that they wear their hats long."

He was a success, you see. You had to see it, as the ladies at the exhibition had to see it, and him—though he was quite a short man. And in his early days, as he often told, people couldn't see him at all: he was so shy, he had been so poor. To the end, his "grand manner" was a defiance of that past when, as the shoe-dealer's son from Indiana, he had suffered agonies at the hands of a "society" he despised. It did not buy pictures, or not enough to make up for its insolence when it called at the old studio on West Tenth Street, where his gifts as a portraitist brought him a pretty fair living—in later years an income sufficient for the big family he raised, and almost sufficient for the collecting that was one of his deep interests. Many a dull portrait was hammered out —conscientiously, competently— (when he would have loved to be painting a still-life), because it meant another thousand-dollar bill or two, with which to bid in the auctions at Christie's, on his summer excursions to Europe.

All of which unites, in my own mind, to form a memory of one of the vivid personalities of the American scene, and one that was typical of it in many respects. William M. Chase was an artist

honored in various European capitals as he was in his own land, fervent in his love of his calling, a force for the recognition of its importance, and a factor in the development in America of better judgment as to art. The swaggering pose that he struck before the world was taken in self-protection, even as his friend Whistler wore his monocle, and the white lock, like a knight's plume, in his curly hair, so as to outface the aristocracy of England in distinction—and arrogance. Mr. Chase used to tell of some young artists who had seen Whistler "carry on" before a fashionable crowd in Venice and who, visiting him in his studio, were puzzled to find him the simple, earnest worker that he was. Finally, one fellow naïvely remarked that he was so different from what they had thought at the time of their former meeting. Whistler understood the allusion. "Oh, those damned monkey-shines? You see that door to my studio, do you? Well, when I pass through it I leave all that business outside."

And so with Mr. Chase. Year after year, it was one of the traditions of his school for some student to ask at a public criticism, "who is the greatest American artist?" in order that the teacher might once more give his famous answer: "Modesty forbids me to reply." Perhaps it was the true word spoken in jest, true enough, in his own opinion, to keep the jest within the bounds of reason. Yet I doubt that he ranked himself above Alden Weir, certainly not above Whistler, and he had an appreciation of the stature of Eakins, Ryder, and Homer. I fear, however, that his admirations among his compatriots included another name which overtopped all the others, for him—that of Sargent. And so, beside the man who loved art, we were forced to recognize the man who loved success. It was not Sargent's big income from painting that impressed him, nor even his position in the world of his patrons—great lords and ladies, generals, presidents, and financiers. More tempting, doubtless, was his prestige among artists, which led Mr. Chase to suggest to Sargent that he become

president of the Royal Academy—an "honor" that the famous man might easily have attained, but which he had the saving grace to shun.

No, the success that Mr. Chase admired in Sargent was that of the man who painted his picture with easy and consummate assurance. Such a *tour de force* as the portrait of Mrs. Wertheimer included the genuine values of character—racial and personal, composition in the fine placing of head, bust and accessories, and a certain quality of color. To these Sargent added his bewildering exactness in the notation of minutiæ. "Don't you see her dark skin under the rouge she wears?" Mr. Chase exclaimed about this picture, just as, before his friend's portrait of Henry G. Marquand, he would point out the peculiar look of a person hard of hearing that the painter had caught. Such attention to his sitter might seem to give to Sargent the merit of absolute and humble observation that delights us in the Primitives. Indeed, when, in 1904, Mr. Chase saw the great exhibition at the Louvre that so vastly increased our knowledge of the French Primitives, he said, "Those were people who didn't go in for the cleverness that we see so much today."

And yet if he could stand spellbound before those flawless things by Clouet, and pay his hard-earned money to own one, he could also be caught by the quality which, after seeing them, he deprecated. Beside the solid things in Sargent's art, above them in Mr. Chase's opinion, as one is almost compelled to admit, was his uncanny technical adroitness. The wicker chair in the Robert Louis Stevenson picture where different colors were swept in with one brush-stroke—there was "painting" for you! and George Moore—who was all right in praising Manet and Whistler—was all wrong in pointing out Sargent's "vulgarity"! That it stuck out like the proverbial sore toe was something that Mr. Chase could not, or would not, see. The insolent superficiality of the form under the trashy color and the flashy brush-strokes told that the

observation of nature was really nearer to the color-photography of Meissonier and Fortuny than to the grand simplification of van Eyck or Fouquet. But those men and, still more, the great Tuscan masters, were far from the consciousness of the art schools in Paris and Munich, where the two American painters had studied, and the insufficience of their grounding in the classics became only the more apparent as they advanced in years and in skill.

That people, even his own students, whom he loved, were going over to George Moore's opinion of Sargent—in small numbers at first, more rapidly as time went on—was one of the chagrins of Mr. Chase's later life. He and the rest of the group who returned to America in the late 'seventies and the early 'eighties had brought with them ideas that differed so much from those of the older school that, thirty years after they had founded the Society of American Artists to combat the narrowness of the Academy, Mr. Chase, the first president of the society, still thought of his ideas as radical—correct but "advanced."

Always at the back of his mind were such episodes as the buying of the two great Manets that, for so many years, were the only representatives of their school in the Metropolitan Museum. "I was walking along the Avenue de l'Opéra one day in '82," he would tell, "when I happened to see Alden Weir driving in a cab. I hailed him, got in, and heard that he was going around to look for pictures for a man named Erwin Davis in New York. 'Well,' I said, 'let's go out to Manet's studio and get something from him.' 'Manet!' said Weir. 'Do you know *him*?' 'Of course,' and I gave the cabby the address. Well, when we got to the studio, there was Manet, seated in his chair, painting away, and a whole crowd of people in the room, looking on. That man could paint! Weir was delighted, and before we left we'd bought the *Boy with a Sword* and the *Girl with a Parrot*."

Apparently Mr. Davis was not so delighted, for the two pic-

tures were soon turned over to the Museum—which for over thirty years showed its own resentment against them by a contemptuous biographical note in the catalogue. Both the American artists, however, were unfaltering in their devotion to the magnificent works. "Don't you see," Mr. Chase would say, "that they are the only things in this gallery that could hang beside the Old Masters?"

Right as he was in the words themselves, he was wrong in the direction they pointed. For Manet does not look backward so much as forward. And that was what Mr. Chase failed to appreciate. To him the group of men to succeed Manet were already suspect. He could recognize the luminosity obtained by Monet and Pissarro, he could even stand Renoir, in the earlier works of that painter, but his real feeling as to the Impressionists broke forth when he thought of their technique. "Somebody said their things looked as if they were made to scratch matches on, and I said, 'Yes, by George! and I think they've been doing it.'"

But Claude Monet was still a considerable person. The real trouble came when Mr. Chase discovered Cézanne, the year after that artist's death. He came to Florence in a rage over the perversity of Paris—that was actually buying paintings by the "idiot," as he called the—to him—utterly unknown man.

And then came the business with Charles Loeser. At the Café Reininghaus on the Piazza Vittorio Emanuele, Mr. Chase had been telling of the pictures he had recently bought. Loeser, who was at the table, said something which indicated that he had pictures, too.

"Oh, you collect, do you?"

"A little, when I can."

"And what do you collect?"

"Oh, anything—from walking-canes to castles." This without any emphasis, and with an English drawl on the "cahstles."

Mr. Chase went around to investigate that collection, the very

next day. In the evening he was boiling over: the house of his new acquaintance simply bristled with Cézannes.

"I told that young man," (Loeser was over forty) " 'Sell the stuff now while you can still get some money for it. You won't, if you wait long. People won't ever take to your Cézanne in any numbers.' And do you know, he just twiddled that little mustache of his and said in his confounded way, 'Well I never did think he's be popular with the mahsses.' I ought to have taken my hat and walked out of the place. Do you know what he meant by 'the Mahsses'? He—meant—me!" And off he stalked to the next table to relate the shocking story again.

His latter years were embittered by it—and its successors. The new heresies broke out in always greater number, in new galleries, in museums, in books of increasingly respectable size and semblance. If a pupil or even a friend had anything to do with what was called "modern art" (what should have been called the public enemy, to Mr. Chase's thinking), he struck him off his list—"and he won't be missed," as he would grimly quote from Gilbert and Sullivan.

Why did he take it so hard? Why did he, who had done so much to bring his generation to appreciate better things, resent the following of his own example by the men who meant to the world a new advance? The answer is that when he found himself relegated to the "old school" he did not really believe it to be the school of Velasquez and Hals; he felt he was being classed with the professors at Munich against whom he had revolted in his youth, or the "buckeye" painters of America to whom he had been the *enfant terrible* on his return home. The moral of which is that we must build up a tradition that will let a man feel secure in his achievement, even if the world moves on to new forms.

Fortunately Mr. Chase had much reason for such consolation and, if he realized that many of the artists represented in his collection—men like Boldini, Alfred Stevens (the Belgian of that

name), and Vollon were outmoded—which he probably did not see, his own painting stood secure of its place in the history of American art. So much at least may be said today, even if a far longer perspective will be needed before an even probable estimate of that place can be made. And it is his painting by which he will be judged. He himself said that he would not mind if he were remembered for his pictures of fish. But that was in the later years when such works were having their great success, and most of the dignified portraits like the *Lady with a White Shawl* at the Pennsylvania Academy and the *Lady in Black* at the Metropolitan Museum, were well behind him. The undeserved silence in which they generally stand at present far outbalances their vogue of forty years ago, and indeed that glorious period, the nineteenth century as a whole, is absurdly misunderstood today. But when a judgment of the time is once thoroughly established, it is more than safe to say that many Chase portraits will be found among this country's really distinguished contributions to the record.

And aside from this, the essential part of his life work, there was the only less important matter of his personal influence. The number of pupils whom he had in the thirty-odd years of his teaching was very considerable, for he was active in the big schools of both New York and Philadelphia; for years he had a great following at his own summer studio at Southampton, Long Island, and on a number of occasions he had classes in Europe. They were composed, in the main, of American students, who came from all over the United States to work with him; but also his reputation in various European countries brought him pupils from the studios of former colleagues in Germany and England.

And that fact tells something about the rôle he played in taking America out of the provincial state in which he found it— say at the time of the great Centennial of 1876. The now famous museums of New York and Boston, to say nothing of our other

cities, were not yet founded when that old World's Fair in Phila-
delphia showed to the country the most important gathering of art
works thus far seen here. The local tradition of painting, which
had reached an early flower with Copley and Stuart, was seen to
be lagging far behind the achievement of Europe, above all of
France, then at a high point in the greatest century of its art.
The English strain in our painting had run down to exhaustion
even earlier, and new inspiration from the Continent was needed.
Among those who brought to us its ideas, Mr. Chase was one of
the most important. His personal vigor and even his intolerance
were immense assets to the country when faced with the problem
of setting its art on a firmer basis.

The new influences that came in after the Centennial were
from the more mature periods of art, though, to be sure, men
like Rembrandt and Titian had been studied before. The chasten-
ing power of the primitives was still a thing of the future. Indeed,
Mr. Chase saw Florence for the first time when nearly sixty years
of age, too late to open his mind to the tradition—and the grandeur
—of Giotto and Masaccio. Day after day he came to look at the
great Signorelli I was copying, and at last he inquired, "Whatever
made you select *that* picture to study?" He returned to the Vene-
tians, whose work he had seen in their city when he had visited
it, a quarter of a century earlier. But even the splendors of Titian
allowed him to sigh for the "fine painting" of Velasquez and
Hals and one evening, at the Café delle Giubbe Rosse again,
showing some reproductions of the Haarlem master, he said,
significantly, "Lest we forget!"

The vitality of the North, expressed in that magical brushwork
of Hals, corresponded to the ideal of rapid, efficient action that
dominated so much of the later nineteenth century. No wonder a
Cézanne could remain cloistered and unknown throughout his
long life. His art looked clumsy, as it searched out the form and
composition of our Greco-Latin heritage, something which official

French art misrepresented so pitifully as to bring contempt not only on the decadence of the *École* but on its sources as well. Bouguereau discredited Raphael. And Cézanne's color, as we see especially from Matisse's development of it, was built on an understanding of the action that the various primary hues exert on one another, the reverse conception from that of the Japanese screen, for example, where the colors are absorbed by the unifying tone of the gold and silver, or the black of lacquer.

But the period was captivated by the mysterious splendors of the Far East and by its serene craftsmanship. "Artistic" things were too often placed higher than significant things, though what gave us the esthete, in the lower order of dilettanti, also gave us real lovers of beauty.

Mr. Chase was one of them—and one of the most fervid. As you entered his studio, little swinging hammers were set in motion to produce a pretty harmony on the strings of a harp-like instrument attached to the door you had just pushed before you. From the anteroom, itself, well furnished with gleaming old brasses, you got a glimpse of a Rembrandtesque interior, with pictures that the old seer of Amsterdam would not have disdained. In his passionate collecting Rembrandt had given Mr. Chase an additional reason to venerate him. Even his bankruptcy brought him a bit nearer to his American emulator. Prodigal in amassing stores of picturesque things—and works by the masters quite in the manner we know from stories of the great Dutchman, he loved him none the less because, as he always maintained (on what authority I do not know), Rembrandt was a Jew. The historic house in the Ghetto where the master lived was certainly in the hands of Jews again when Mr. Chase used to visit it—to buy just such bits of Oriental or ancient art as had brought on the financial downfall of the artist who had found so many models in that unchanged quarter of Amsterdam.

If Mr. Chase could be captivated by objects that merely

gleamed and glowed, he took his portraiture too seriously to be misled as to the deep things about men and women that it is the artist's business to record. "Students," he would say in impressive tones at the opening of his school, year after year, "you are entering the most ancient profession that gives us the history of our race, and you are entering the most honorable of all professions." Here was no mere defiance of the bourgeois, here was the profound seriousness of the man who, in the first decades when Greco emerged from his centuries of neglect, could respond instantly to the depth revealed by the Cretan mystic.

And so, considering the collections that Mr. Chase formed for himself and others, his great service to this country in obtaining its first works by Manet, the "modernist" of his day, is balanced by his purchases of Greco, who is perennially modern. The great *Nativity* in the Metropolitan Museum was secured very largely, at least, because of Mr. Chase's vehemence in defending it, despite what seemed a high price in 1905.

But beside the works by Greco and Clouet that I have spoken of in his collection, beside the Rembrandt and the Tintoretto he had, there were works by men of his own time, and they far outnumbered the older things. Often they were by very young men— perhaps the first things they ever sold. He wanted to keep in contact with youth; it was part of his deep-seated Americanism to believe in it and in the future. If he looked back to his own youth and still saw its idols as the modern giants, he looked steadily to the future when he thought of his painting. There was always the picture still to do, and he kept at work, trying for something better than any he had done before.

And so, to the end, within its noble old Spanish frame, the famous blank canvas stayed in its place on his wall. It provided the opportunity for him to give his own answer to a question he liked to hear. If the answer was always ready in the same form,

it was none the less genuine in its expression of his feeling about his work.

"Which do you consider your greatest picture, Mr. Chase?" the visitor to the studio would say.

"It is there"; and he would enjoy, each time, the inquirer's mystified look as he pointed to the big blank expanse of canvas in the half-shadowed corner of the room. "I have painted that canvas a thousand times—and no brush will ever touch it. I sit here, when the light fades, and on that canvas I do my best work —the pictures that form in my mind. Then I try, next day maybe, to do them with actual paint, but those things I have dreamed within the walls of that old frame are always ahead of me. Only the artist himself can see his masterpiece."

Which is true, to be sure, of those pictures that never are painted. But when time has winnowed the best of Mr. Chase's work from the great quantity he produced, people will be happier for seeing what he did paint.

If Mr. Chase more than any other artist in his generation, represented to America a new understanding of the continent of Europe, Robert Henri personified that form of tradition which in later days was to be called modern. When he came back to this country, just at the turn of the twentieth century, it was with his head full of the painting of the Impressionists, the sculpture of Rodin, and the drawing of Daumier. He fitted them all in with his rich store of memories of the older masters, Spanish, Dutch, and Italian, and of his wide reading, of which he could speak with gusto. Among the writers whom he liked to quote were Emile Zola, Guy de Maupassant, and others who had meant much to the Paris he had known. The attitude toward life of nearly all his favorites was tinged with that revolutionary unrest which has become more and more the keynote of the whole world. Henri felt it strongly, and it came out in his conversation,

backed by citations from Walt Whitman or from Jean Jacques Rousseau.

His own warm personality reflected the mood of the various artists and philosophers I have mentioned, and he was quick to see the parallel lines along which the two types of men proceed. Himself an artist and a philosopher, the kindling fire in his eyes told of the man with a passion for beauty, while the words he chose—or that he poured forth almost independently of so cool a thing as choice—proved that he needed to revalue art-works in terms of their meaning. He had, for example, a deep enjoyment of color, but to see Japanese prints as decorative notes would not satisfy him.

"That's the kind of idea I've come to destroy. Art isn't something to make pretty spots in ladies' boudoirs. What kind of man do you think it is who is willing to spend his life matching ribbons and wall paper? Is he a man at all? I tell you art is something important or it isn't anything. It wants to have some of the soil in it, or of blood or brains or all three. Decorative spots! Tell that to Goya when he is looking at a woman, tell that to Michelangelo when he is painting that Christ of the *Last Judgment.* Here, look at this photograph of it; don't most of the other painters make Christ look like a mutton-head? That's because they were thinking about decorative spots, or soft spots, to rake in some money from a job. Most painters just want to get in where it's warm. But you take note of this: the ones we really care about, the ones that last, are the ones that keep hammering away, whether they have things easy or not."

There was a big public to listen to such talk. The number of artists was growing; there were hints about a great activity in Paris; the older exhibitions were beginning to feel the stir of a new resentment against merely academic painting; Alfred Stieglitz was soon to supplement his research into the possibilities of photography by giving exhibitions of drawings and of paintings in a

small gallery; the Havemeyer collection, long the only great gathering of modern art in New York, was finding emulators. In a word the twentieth century was preparing to declare its independence from the nineteenth. The change might well have come about when the Metropolitan Museum replaced its Hudson River School curator of paintings by Roger Fry; but the great English critic was soon ousted, having naïvely imagined that an expert was wanted there, and having visions of going onward from the great early Renoir that he had acquired.

Yet if any real movement on the part of the older generation remained out of the question, there was a progressive temper to the younger men, and Robert Henri was their prophet. I have said something of his speech, but he was above all a painter, and a leader in a new group of painters. Among these, William Glackens, John Sloan, and George Luks were old comrades, trained like himself in Philadelphia. Thomas Anshutz, a pupil of Thomas Eakins, had carried onward the older man's deep study of anatomy, imbuing Henri and the rest with a love for the science and for the master to whom America owes it best knowledge of natural construction. Then there was Maurice Prendergast, who had been with Henri in Paris, who had indeed preceded him there and who, like their friend Arthur B. Davies, had an idea of the importance of Cézanne. If they did not get the ultimate thing in that master (and who has done so even thirty or forty years later?), it was much for America to say that several of her artists had felt the power of the man at a time when his neglect by Paris was such as to hide away from most people the profound meaning of his message. It was enough for the first generation of Cézanne admirers that he departed from the commercialized painting of the Salons more than anyone else. Of our people, only Mr. Prendergast understood, in a more exact way, the constructive as compared with destructive values of the man.

And destructive values exist and are real. The roots and stumps

of dead ideas had to be blasted out before a healthy crop could be raised on our soil. And Henri had the dynamite for the job. Tall, broad-shouldered, and a bit rough in his ways, he could make convincing allusions to the men with revolvers he had known in the Far West of his youth. Jesse James was pretty nearly a hero to him. Something of the fascination, of the sense of danger and adventure of the old West hung about his talk and flashed from under his dark brows—that would relax a moment later as a smile warmed his rugged face. And the same drama of contrasts played over his painting—fierce assertion, harsh oppositions of light and dark, and then suavities and something that amounted to tenderness, especially when some feminine model stirred his sense of the mysterious life of women. About a favorite Utamaro print he would say, "Don't you see how she caresses her hair, and how lovingly her other hand rests on her neck?"

No decorative business there—it was all romance to him, though his art was drawn from realistic sources and though he struck a note of realism altogether, in a time that demanded change. He demanded it himself and opposed anything that would cause it to cease. If a new grouping of artists was proposed, he would be the first to warn against the dangers of institutions. "You form a society: that limits you. Adopt a name, and you've limited yourself again; draw up a constitution and by-laws and you've made a groove, a rut, that hampers your growth. You think you can fix your course and move straight along on it. But sometimes the important thing is to strike out sidewise."

All this distrust of fixity, of rules, came from a premonition, such as is frequently observable among artists, of something science discovers later on. In this instance it was an understanding that the rôle played by the unconscious in our lives had been vastly underestimated. Manet, the painter whom Henri had studied most of all, I think, used to say, "Every time I start a picture, it's like throwing myself into the water without knowing

how to swim." Perhaps no single work by the French master would suggest such an idea to an observer without very special training—so magical is the skill with which his improvising brush controls the rich material of his pigment. And it was the same trust in the virtue of necessity that gave to Henri a large part of his philosophy.

"There was an alley where we liked to play baseball, when I was a boy," he used to tell. "It was against the law to play there, and the fellows near the street had to watch out for the cop. But one time the warning came a bit late, and one boy got shut off from escape. The rest of us had run away safely, and when we turned around to look, there was the cop going into the alley. We all lost our breath—'Johnny's caught.' But he wasn't. He was so gripped by fear that when he had raced down to the high fence at the end of the alley he just leaped it, which no one ever dreamed could be done and that none of us could do afterward, without that drive of danger behind us. And that's what makes the wonder of painting—it does miracles when there is a need for them."

Later on, he was ready to investigate the miracles and try to find out the causes behind even their phenomena. He devised schemes of line construction, and discovered that any picture that had pleased him previously conformed to some geometrical law. Also color appeared to him, in his later years, less purely the thing of sentiment and instinct that he had thought it and taught it to be.

So that by his very change of ideas he remained consistent, for he had, as I have told, steadily asserted the right to change. When the more daring innovators of the Post-Impressionist and Cubist groups appeared, he was not in the least shocked, though—like everyone else of his generation—he was disoriented for a time, at least. In Paris, at the Autumn Salon of 1912, when the new men were taking some particularly violent steps, he was pretty

doubtful about them. But then, catching sight of a "traditional"—and weak—picture, he said, "Of course, if that's the alternative, then I'm for these new chaps."

Unlike many men who have attained positions of authority before they are forty years old, Henri did not see things as finally settled, even if he was ready to contend rather stiffly for his own opinion in a group of his equals or his juniors. But he knew something of his previous errors, as when, during an early stay in Brittany, he had been at an inn with Gauguin, and failed to see why the young Frenchmen around him made so much of that painter. He could be bitter, long years afterward, about the way that he and so many other pilgrims to Paris had been misled about the art of their time by their teachers at the big schools. "We never were allowed to hear about men like Cézanne and Gauguin," he said, but he might have added a statement, which would be incredible were it not attested by Signac's book, that as late as 1884, so good a Parisian as Seurat knew nothing of the Impressionists.

So he was all for bringing things out into the open—going to the full length of the theory when the American continuator of the society of Signac and Seurat, the Independents, adopted Marcel Duchamp's idea of hanging exhibits in alphabetical order, to give the last blow to the jury system.

Some artists longed for a more tidy and "harmonious" aspect to the exhibition and, one year, a return to the workings of a hanging committee was tried. In order to facilitate a homogeneous grouping of exhibits, the artists were classed, roughly, as classical, realistic, abstract, etc. Henri found himself hung with the realists, and he came to the annual meeting in one of his fighting moods.

"My work is not realistic. My work is pure abstraction. I abstract from what I see—men, rivers, lights, women—the ideas of those things, and that's what I paint. I refuse to be grouped with

people who paint mere things. I deny anybody's right to put me in a group at all."

It was one more assertion of the individualist that he always was, more strongly than anything else. One can scarcely lay the blame on that quality of his if he allowed himself too much of paternal indulgence toward his followers, like Bellows. The latter's weakness he saw at the beginning, when the newcomer from Ohio naïvely offered a variant of the Gibson Girl as proof of his ability—which was unquestionable. Bellows was meek under the scorn which the teacher heaped on his effort, and, for long years, was the most docile of students. To see that his mind underwent no essential change during this time, to realize that the care he had lavished on his pupil could not bring any real depth to the mind that had expressed its quality from the beginning, would have demanded the severity of a Brutus—and Henri had no such Roman strain in him.

More than in his mistakes about the many younger men who followed him, one sees indulgence in the later painting of his own life. He had worked hard, and doubtless felt the right to relax a bit, as appears from the pictures he did in Ireland during his visits to the estate he acquired there. Digging to deeper levels was of the past for him, but the new ore he was now smelting ran to a pretty thin stream, though with a "freedom" and an "ease" that seemed to many the evidence of a lifetime's fulfillment. The passing of the years works against such an idea: it is the earlier, more searching things that appear, increasingly, to be his best.

If the insistently personal quality in his art was not upheld by more of those general ideas on which all production is based at times when the world moves with a single faith—as in the great day of Egypt, of Greece, or of the Gothic peoples—the fault was not his own but that of a period which imposed individual instead of collective control on its talent.

Comparison between the two types of world-idea is useless,

or worse; and to point out that a Cézanne, for example, with his Catholic conservatism, his inexorable search for the principle underlying the chaos of sensation, is still a man of our individualistic period, is probably no more than an explanation of the fact that his period—as a whole—rejected him. And even France could bring forth only one such man during his generation. We cannot imagine such an art as his arising in the America of his time: it had not the museums to educate it to the idea of so impersonal a thing as law in art. Cézanne had a soil fertilized by centuries from which to bring forth his great painting; but if our chances for producing a work of such scope and weight are today far better than they were, it is in large part because of the continued pioneering of men like Robert Henri. Recalling both his features and his kindly humor, John Sloan linked him, years ago, with a hero of both artists, when he nicknamed Henri "the Emancipator."

When people talk of the present vogue of the American scene in our painting, one is perplexed to hear it treated as a new thing. For over a hundred years, as was shown at the Whitney Museum's exhibition of American genre painting in 1935, the artists of this country have been interested by the scenes about them, and the very best of our masters have depicted them. Or if the older painters seem remote, how can the portrayal of our surroundings be regarded as new when it has been the steady concern, for some forty years, of a man who is still with us and indeed at the height of his powers, the one who has, in fact, done more than any other to make us see the great things that America can do for those who study the life around them? Perhaps the answer is that for all the preoccupation with our cities, our landscape and people which has made John Sloan pass his entire life in his native land, the national note has never been urged by him as the explanation of his qualities. These are intimately connected, it is true, with his knowledge of his themes but, even more, they de-

rive from an intensifying consideration of the nature of his art; and that marks a difference in outlook between him and some of the men whose "Americanism" is so much thrust forward today.

John Sloan is a graduate (though the word is subject to correction) of the old Newspaper School of artists, a race that scarcely exists any more; the camera and the modern reproducing processes have taken their place—after a fashion. It is, in the main, a good fashion, for most of the old news drawings (things done on the spot of the battle or the murder—or made to look so from reports reaching the office) were pretty crude. And certainly for speed, accuracy, and cheapness, the present-day method is far better. But the old school produced such splendid men as Constantin Guys in France and Winslow Homer here. The former was a graphic reporter of the Crimean War, the latter did the *Harper's Weekly* drawings at the front in our Civil War. Incidentally he got from them the material for a number of the celebrated paintings of his later years—when *he* had graduated.

Sloan never has graduated completely, thank goodness, for we still see the rapid incisiveness of the reporter's judgment in the pictures he is doing today, like the *Tammany Hall* which has recently entered the Metropolitan Museum. It is the third of his paintings to receive that honor, a signal one, even if work by younger—and slighter—men is getting such recognition, too. To see a Sloan there after passing through the room of Old Masters, or coming from the great French pictures of the modern time, is to feel that his work is in a place where it belongs, but it seems a far cry from there to the grimy offices of the old Philadelphia *Press*. Yet it was in the latter place that not only Sloan but two of his neighbors at the Metropolitan got a good part of their training: William Glackens, whose *Central Park Snow Scene* exhibits the journalist's observation, despite all its painter quality; and George Luks, whose work always retained the alertness so necessary to the newspaper man.

MR. CHASE, ROBERT HENRI, JOHN SLOAN

As Sloan is the kind of graduate who forever returns to the reporting that was his first and best school (he is mostly self-taught), people can still get him to do illustrations. Occasionally, even, a publisher does so, if he is canny enough to be undaunted by Sloan's Fifth Avenue exhibitions and by the list of museums that have his paintings. It is one thing to have a show on the Avenue, it is quite another thing to make money. And though Sloan has always made a living from his work (and taken a rich toll from life while doing so), he is so far from wealthy that when invited to accept work from the government two years ago, when it wanted to get well-known names among the artists on its pay-roll, he was able to qualify on the basis of a low income. And a government position is quite in line with Sloan's ideas; it is something he believes in for every worker. With it the artist can do his work, independent of individuals who think they want something he is not interested in producing. What bothers these people, in Sloan's own case, is that he refuses to stand still, to keep on turning out Sidewalks-of-New York pictures, where the drama and humor of his earlier work were his chief stock in trade. Now that he is so determined to get to a better kind of painting, in order to carry out his ideas, and is making original research into methods and principles (I say now—when he is sixty-seven, but it is already many years since the big changes began in his conception of art) they can't make out what he's driving at, or why he should be driving so hard at all.

A Mug of Ale at McSorley's, with its recalling of the good-fellowship at that old-time bar; the Haymarket with its bright flowers of the pavement; the Dust Storm with its arresting glimpse of the people caught in the gray cloud that whirls round the Flat Iron Building; Roof-Tops, Summer Night, telling of the city folk who swelter under the heavy sky of August; Putting Out the Light, with its nobility of gesture in the woman who reaches up to the gas-jet above the conjugal bed—all these scenes,

and scores of others, Sloan had recorded on canvas or the etching-plate. What more did he want? There is no end to the fascinating things one may see—and he was so splendidly equipped to set them down for our enjoyment.

But was he? The knowledge he had down to twenty years ago, say, was ample for the task he saw before him at the time. Whenever a job of illustrating was done he would work with gusto at painting, as long as his funds held out—or a bit longer. But the financial problem, growing easier with the passing of the years, turned out to be a small one, in reality, as compared with the problem of the picture itself. Robert Henri, returning from Paris, had brought back a revolutionary vigor in his painting. It went far beyond the subtleties of the Whistlerian tone—poetry, which had been the first reaction of the "Philadelphia bunch" against the deadness of the academies. William Glackens pointed even more clearly to the modern movement in France where, with Maurice Prendergast, he had been discovering something of the genius of Cézanne. Like Henri, like Glackens, Sloan knew that in the Pennsylvania Academy where they had worked, Thomas Eakins was showing anew what genius is. But it was with old methods. These younger men needed something more related to the exciting ideas that were in the air. Joined by other rebels like Arthur B. Davies and George Luks, they gave a show in 1908 that aroused New York as no work by Americans had ever done before.

The response to it showed that there were numbers of men eager to help break through to the public which, itself, felt the impulse toward a freer art. And so 1910 saw a first "Independent Show" with Sloan doing the lion's share of the work on it, as he was to do again when the movement had taken on its definitive form in a society allowing everyone to exhibit without the control of a jury. Meanwhile the same "independent" crowd had organized the famous Armory Show of 1913, and the lid was blown off of America's isolation; we had been made aware of the seething

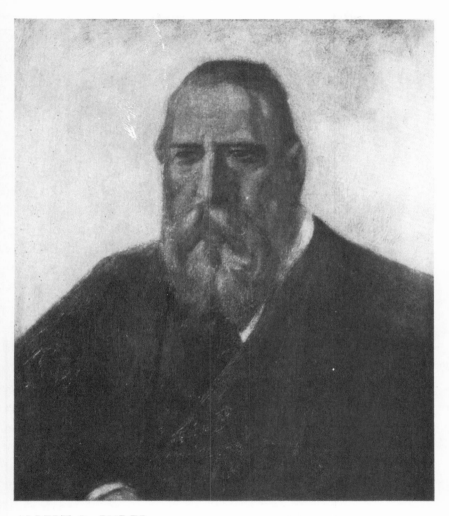

ALBERT P. RYDER

From the Portrait by Kenneth Hayes Miller, 1913

JONAH *Painting by Albert P. Ryder, The National Gallery, Washington, D.*

modernism of Paris. To that city went every youngster who could get the price of a trip—and many an older man besides. Sloan stayed in his Twenty-third Street studio and fought out the new problems with the materials he had made his own.

True, he did go to New Mexico some years later; and perhaps the Indian dances at the various pueblos he came to know from repeated visits, were more foreign to the man of our Eastern cities than anything he would have seen in Europe. At first they were part of a spectacle, like the red desert of the Southwest. He had painted landscape before—as at Gloucester, Massachusetts, where he had gone in the summer. But the big spaces of the country around Santa Fé, the clear light and the dazzling color there were more akin to the painting from Paris, which he perfectly well saw to be the vital thing of the time. Soon also the beat of the Indian drums got into his blood, and when he painted the *Snake Dance* or the *Eagle Dance* it was with a sense of the design that goes into the folk drama of the oldest Americans, and that shows in their potteries and weavings.

Sloan had brought home echoes of the genius surviving in the desert people: painting done by young men and women of the pueblos with colors obtained from the white men. The pictures were exhibited at the shows of the Independents and they created a sensation—one that was small, however, as compared with the one that he and Mrs. Sloan, allied with Miss A. E. White, witnessed at the Indian Tribal Arts Exhibition when their championing of the old race on our soil led to that revelation of its art.

Perhaps it was not only the painter who responded to the genius of the red people, but the fighting-man that Sloan has never ceased to be. He has fired up so often against injustice in one form or another that the newspapers usually find some epithet like "Tabasco-tongued" to precede a mention of his name. Long before the fight to give freer opportunity to the artists was won (as it is, though never permanently won) there were all sorts of

roads to freedom that tempted him. One of them was Socialism and, if the main token of that was his work as art-editor or chief cartoonist of *The Masses* (the first paper of the name), he did not stop there, but did active work in politics, once even running for office as judge.

The fever of the war put an end to *The Masses*, which had come to be regarded as too militant in its pacifism, and then, too, Sloan was finding other causes equally worthy of his interest. Chief among these was the Society of Independent Artists, with which he has been so closely identified since its founding in 1916, and which has elected him as its president each year since the first one, when William Glackens was its head. While the society is unconnected with the famous French body of the same name, it was organized to carry on the work which in Paris, brought such men as Cézanne, van Gogh, Seurat, Matisse, and Derain before the public at a time when no other exhibition of consequence would accept their work. The same slogan which has done such good service in France since 1884—"No Jury, No Prizes"—has had its effect here, and already it would be a long list that one would have to draw up if one attempted to name the American painters and sculptors who have been brought to the notice of collectors, museums, and dealers by the institution to which Sloan has devoted his energy.

In the early days there was much difficulty in understanding its purpose, especially among the older artists, who were willing, in many cases, to be associated with the "radicals," but who were troubled above all by the system of hanging, which groups men not according to their school or reputation, but according to the letter which begins their name. It is the final step in eliminating judgment by committees and in making the public decide what work it wants—or does not want. "You mix things all up," said one old painter. "When a person goes into a fruit store he doesn't want to pick over a whole barrel of stuff to separate the oranges

from the lemons." "Yes," replied Sloan, "but there you're dealing with things outside of the realm of opinion. In art, when one person thinks he has a fine juicy prize, I may think he has simply picked a lemon."

And the longer he stays in the game the more important he finds the difference between good pictures and bad, the more he feels that there is a revolutionary power in art. The war had its effects, most of them harmful, and Sloan hated it as he hates all war that is not for ideas. When ideas are in question, you know what you're fighting for, and the old instinct of combat in us has a purpose.

But Sloan's painting is always his deepest concern, and his output and intensity might easily cause an observer to think he had time for nothing else. Yet because of the stimulus for his painting itself that he finds in the other fields of human effort, he has never let himself get closed off from them.

It was a great night in Henri's studio when John Butler Yeats, who had just arrived from Ireland, told us of the new drama and poetry in Dublin, and read us *The Playboy of the Western World*. He did so with a power and beauty that it has probably never had in any other rendition. During all the years that the great old philosopher-artist-story-teller was in New York, he was at Sloan's house as much as he was anywhere else, and there is nothing but pure gold in the memories he left of talk about life and art and the people he had known during his own long span: his son "Willie" (the poet and senator), John M. Synge, George Moore and the rest. Henri had to go to Ireland to see the people for himself. Sloan remained in New York again, and painted *Yeats at Petitpas'*. The picture is in the Corcoran Gallery at Washington, and, if it contains a historical record of the group of interesting people who loved to listen to the raconteur and sage in that past of twenty-five years ago, (Alan Seeger, for example, before he made his "rendezvous with death"), it also contains a

curious glimpse of what was then the future: the portrait of Van Wyck Brooks, who sits at one end of the restaurant table, would serve today as a very good likeness of his son Charles.

All the foregoing may be taken to mean that the technical changes in the painter's work have not been made at the expense of that enjoyment of life which first delighted his public. But some people are troubled about the lines that appear in many of Sloan's later pictures. "He was so natural before, why does he want to make these new difficulties?" He didn't make them; they were always there. Only it needs a deeper reading of the classics, Rubens and Rembrandt, for example, to see how rich the problem of painting is, how rich in difficulties for the artist—and in satisfactions for the public, when it follows him in his triumph over the difficulties. And the public always does follow, after more or less time.

That queer cross-hatching it boggles over is part of the inveterate draftsman's portrayal of a world where color and form and light are big "features," in the front-page stuff that keeps pounding over the wire into the composing-room of his studio—what was once his office at the newspaper. I said that he never quite graduated from it. The difference is that he is an editor now, instead of just a reporter. He ties his stuff together in relationships that escaped him in the days when he could see only details. The feat may be accomplished in a plate like the recent one of Washington Square, where we get all the things we like to be reminded of: the girls with their Easter lilies crossing the wet pavement in front of the arch, or it may have less of apparent human interest, as in a painting of city houses with the Elevated winding through them, or it may be done in a nude with the drama running from top to toe, and carrying over into the objects about the room. A portrait is news, if you get the full story into your lines. And as an occasional observer, during over thirty years, in that very indepen-

dent studio-office of Sloan's, I am able to affirm that his lines were never before so charged with meaning.

And in saying so I am merely acting as the spokesman of a group too numerous to mention in detail. Suffice it to tell that the artist's pupils, besides the men older than they who have followed Sloan's example, include many of our best and best-known workers. The late Glenn O. Coleman, to take one example, would never have produced his poignant scenes of New York without the impetus toward such drawing and painting that Sloan had given.

More remarkable, perhaps, is the recognition in foreign countries of the art we are considering. On several occasions, when French critics have studied our work, their choice has gone out spontaneously to Sloan as the most significant American painter of today. This would certainly not have been the case had he only the illustrative phases of his work—striking as they are—to recommend it. Those Parisians, living in a city that is interested in art, judged his work for its value as art. If our public is still incompletely equipped to take quite this point of view, I think we need not be entirely regretful of the fact.

For there is a value to what may be called unconscious appreciation—liking things for qualities that are real but other than the essential ones. The form and color which guide men experienced in the study of the masters are not always recognized by laymen. Yet they can feel the genuineness of an artist's response to the life they know. That splendid approval has unquestionably been accorded to Sloan, these many years. If he sees further than his public and is adding factors to his work that he did not perceive before, his very doing so is the best reason to believe that he will carry along the legion of his earlier friends and show them how America is to be enriched as its painters deepen their tradition and, through it, take their place in the unbroken line established by the great artists of the past.

III.

ALBERT P. RYDER, THOMAS EAKINS

WITH THE PASSING OF TIME, IT BECOMES CLEAR TO MORE AND more people that American art has been distinguished by two main tendencies—that of the realists and that of the visionaries. Our earliest master of first rank, John S. Copley, already tells in unmistakable terms of our demand for the positive things of sight, while, on the other hand, men like Washington Allston, Thomas Cole, and George Inness show the fascination for Americans of the world of the mind; among our writers, of course, this characteristic would be even more striking.

I am convinced that these two tendencies reached their highest expression in Thomas Eakins and in Albert P. Ryder. Of the former I have a strong personal impression from the one time I saw him, and it is supplemented by many visits to his house in the years since his death. With Mr. Ryder I had a happy acquaintance covering the last eight years of his life.

A hermit, living in one of the very poor neighborhoods of New York's lower West Side, Ryder had become an almost legendary personage: so few knew him, though I never heard of his making difficulties for anyone who wished to call at his studio. It was the strangest I have ever seen, simply the back room of a tenement house. To reach the space where he sat before the window and worked, one had to get around shapeless piles of clothing, books, and furniture, the path through the small mountain

[58]

range they made being dug with a shovel out of the strewn ashes that choked it.

I think that was Ryder's definition of "fixing up the place," for I could see no other evidence of such an operation when I first brought my wife to see him. He had asked to be notified in advance of her visit, saying that he did not often have ladies to call, and I was afraid the old gentleman was going to take a lot of trouble. But there were still the mounds of old clothes (all he had ever owned, one would imagine), and the same unsavory brew simmering on the little coal stove, to furnish the artist with occasional draughts of a thick fluid that was food, drink, and medicine for him. Even stranger were certain other details of his housekeeping, but I need to make an effort of memory if I want to bring them back now, for the impression of the man himself quite effaced that of his surroundings.

It was not his patriarchal beard that you thought of, nor the long strands of his hair, always looking as if tossed by a gale. I cannot recall anything individually arresting about his eyes, his voice, or his carriage, which was indeed rather bent and stooping, hardly the kind of thing to impose the image of one forever turning his gaze up to the far depths of the heavens. But that was exactly what Ryder was always doing, with the eyes of the mind if not with those of the body: it was the impression of the seer, the "Druid of eld" that he made on you, even when his talk was of everyday things.

Best of all was when he talked of his work, as he was perfectly ready to. Then one felt that all the supernatural quality in his moonlights, stormy seas, and myth-figures still had a firm basis in the realities of nature and art. The most visionary of his creations—the *Macbeth and the Witches*, the *Jonah*, the *Race Track*, where Death rides alone at last—were based on experience. They began with studies from things seen, the skies, the ocean, and people, to go on gradually to more inclusive aims. But as they

added their new values they continued those already in hand. Of a certain picture he once said, "You mightn't think it had much of drawing to it, but it has what might be called an air of drawing." Play with the words if necessary and say that it contained drawing of the air (of space and depth), but note that these pictures with all their striving for the expression of thought were not like disembodied spirits supported on nothing, but thorough records of observation. He might have said with Odilon Redon, "I have tried to put the real at the service of the unreal." The result with both masters was the superior reality that we designate as fine painting or great art.

As did Redon, also, Ryder allowed memories of the great museums to play a constant part in his thinking. Once after I had called to say good-by, on the eve of sailing for Italy, I heard a tremendous clatter of hob-nailed shoes on the iron bindings of the stairs, just as I was about to leave the house. Looking around, I saw Ryder hastening down at top speed. I started back toward him, and he said: "Oh, I was forgetting to tell you to give my love to that Rembrandt in the Pitti Palace."

Visits in earlier years to the great galleries of Europe that remained thus vivid in his memory resulted in convictions about the form of pictures as well as in that mystical quality for which the painter was most noted. About his celebrated work, *The Temple of the Mind*, he told that, at one stage of his work on it, there had been a bridge that led out of the region of the temple. It suggested the idea that when once a person had crossed that bridge, he could never return. "It was a pretty allegory," said Mr. Ryder, "but that bridge with its horizontal line never seemed to suit the picture. I wanted an upright and thought a fountain might give it. I remembered a fountain I had seen in Florence and put that in, which is what you see today."

It was reasoning such as that which gave to Ryder's work a sureness of foundation sometimes overlooked by people when

they see only the tonal qualities of his work. The latter could be imitated—and were, as I know from seeing any number of forgeries, at small auction houses near a place where I lived for a good many years, later on. But the design of the pictures was a deeper matter. He told me that it was his practice to work it out, by a series of modifications of the original sketch, before coming to the question of color, which, as he affirmed, would be wasted if the underlying composition were not right.

This purposeful realizing of the pictorial structure was what most appealed to Roger Fry when he came to write his splendid article on Ryder for the *Burlington Magazine*, and I think it was somewhat the same quality in our painter's work that impressed Odilon Redon as strongly as it did when I once showed him some reproductions after Ryder. One other appreciation by a foreign artist remains in my mind, that of Diego Rivera. He said that were Ryder a Frenchman his work would be accounted one of the marvels of our time. Perhaps in that remark there may have been something of the Mexican painter's idea that the French have had so great an amount of credit for the modern achievement that no outsider can get along without the hall-mark of Paris; but there is no doubt in my mind of the fervor with which he admired Ryder's art.

He would have loved it even more had he seen the place whence it came, and known the man who produced it. The mystery of art's relation to its environment can rarely have been deeper than it was with the man who realized his golden dream-pictures in that sordid tenement house. It was home to him, and when rich friends supplied him with a "proper" studio near by, he stuck to the old place. On his letter-box were the words "Uncle Ryder," the name by which the slum children knew him and were proud to greet him. For I was assured that, despite his strange appearance, even the toughest kid of the neighborhood knew that this man must be treated with respect. He told me of the fine talks on

philosophy and poetry that he had with the old woman who kept the news-stand, and to a poor, tuberculous seamstress in his building, his "little orchid" as he called her, he presented a picture for which the dealers would gladly have paid thousands of dollars. But Ryder felt that the girl needed it more than other people, since she might not be about for long and ought to have something nice to look at while she still lived.

To Rivera, in his placing of art above money, the thing that the old painter told me about a picture he once brought out would have been no less sympathetic. "I was foolish enough to sell that canvas to a man who wanted to get it some twenty-five years ago, and at first he was so unreasonable, always trying to take it away from me. But lately he has been very nice,—he asks for it only about once a year."

In some cases, it would have been a service to the artist to take the things away from him, for he often continued to paint on them long after the original idea had been exhausted. Thus, having been advised to make acquaintance with his picture of *The Tempest*, I finally got him to show it—only to see a canvas almost pot black with overpainting. The figure of Prospero was outlined on it with the garish white of chalk, in the hope that a new start might lead to the result that the artist had been dreaming over for many years. As the work had withdrawn into separate elements of mind and matter, so Ryder seemed a creature of the elements, making no distinction between comfort and discomfort, riches and poverty, fair weather and foul.

A man who knew him told me of seeing him standing on Broadway, apparently in meditation, and oblivious to the pouring rain. "I went downtown, transacted my business, and on my way back in the street car, happened to glance at the spot in front of Wallack's Theater where I had seen Ryder an hour before. He was still there, his old carpet slippers on his feet, still thinking, and still paying no attention to the steady downpour."

ALBERT P. RYDER, THOMAS EAKINS

Or perhaps he was aware of it and wanted the sensation of it, as Walt Whitman wanted to feel on his skin the salt water of the sea that he sang of. Even more akin to Ryder was the man whose name Lewis Mumford has coupled with the painter's, that of Herman Melville. Both submerged in the metropolis, the two visionaries had the same love of the ocean and the sailing-ships that braved its terrors. In his boyhood at the old whaling town of New Bedford, Ryder knew such men as went on the quest of Moby Dick, and doubtless heard such tales as the great writer used for Omoo and Typee.

Not less powerful in imagination than the writings of Melville, a Ryder canvas like *Jonah*, tells to the fullest extent yet reached by any American of the fascination for our countrymen of the world of the mind that I spoke of at the beginning of this chapter.

We have seen how Ryder's appreciation of the great works in Europe continued with him throughout his life, and this also is a parallel with what we know of Melville. I would recall those lines from the recently published diary of the writer's Mediterranean journey, wherein he observes that after seeing the great Pyramids, all other architecture seemed to him like the work of pastry cooks. Extreme as the last words are, they show how responsive to the grandeur of Egypt was that other American artist of an earlier day. If it is impossible to imagine Ryder as swept out of balance by even the infinite power of the Pyramids, his favorite interest was in the vast elemental things, as we see in his visions of the sea and the sky. Yet we must not forget his love of Chaucer and Shelley, his *Constance* being an illustration of the former poet, and his *Pierrette* a figure of such balance and exquisiteness that it is quite worthy to stand with the creations of the lyrical genius of England.

How different was the great realist of that America of Ryder's time! Thomas Eakins was born only three years before him, but

the pictures of the two men stood in sharpest contrast with each other, more even than did the houses that saw them created. Instead of the New York slum with its iron rumble of the Elevated, imagine the quiet dignity of an old private house in one of Philadelphia's lovable streets, where old brick and white marble tell of modest but stable prosperity.

On the door is still the metal plate saying, "B. Eakins," just as the painter's father put it there. There was no reason for the son to change it when he became the owner of the house. Still less would Mrs. Eakins have considered touching it after 1916 when her husband died. Everything about the old house tells of his presence there, his pictures on the walls, his studio with sketches that served for great pictures and that pointed his way to new ones, casts from his rare sculptures, and the casts of Barye's works that he brought back from his early stay in Paris.

Best of all, since the place has so much the feel of living about it, Mrs. Eakins keeps on painting in her studio there—and keeps on making progress. Even before she studied with the man she was later to marry, she had had a serious grounding in her art, and pictures that she did fifty years ago are solid in workmanship as well as beautiful in sentiment. Inevitably they suggest the pleasure to be had from constant association with them, and it is from first-hand knowledge of their place in more than one collection that I can testify to their fulfilling this rôle in an artist's production, which is, finally, its essential rôle.

One of the ways of judging a painter is by his influence. It may be immediate, it may be delayed—even for centuries; but the decision of artists is always the abiding one, and so we can tell much about a given painter by what others of his profession gain from him. A number of distinguished men studied under Eakins, or (like Henri and Sloan) were under his influence when they were young. The difference of their work from that of the teacher might seem a sufficient proof that he knew how to respect the individual

characteristics of those whom he formed. It is, however, only when we see the painting of Mrs. Eakins that we realize how completely the wisdom of the instructor addressed itself to impersonal principles, how thoroughly it abstained from exacting or even encouraging imitation of himself. Eakins demanded exact study of the model, he hated "the average kind of thing," telling one of his students, Charles Bregler, that it was "simply appalling." He thus told the secret of his own work also, and what made imitation of it futile. He knew that if other artists gave a thoroughly faithful rendering of the thing they saw, they would necessarily include the results of a different sense of life.

And so Mrs. Eakins, by continuing her intensive observation of people and things, followed the precepts of the man with whom she lived in daily association, one whose powerful work might well have overwhelmed a talent not safeguarding by support from nature. Today, when much of our thinking is devoted to arts for which nature is only the starting-point, it is instructive and helpful to have near at hand an example of such fulness of art expression within a realistic outlook.

Is it only an ex *post facto* bit of imagining on my part that makes Thomas Eakins, in the one personal recollection I have of him, *look* like a realist? His rugged figure suggested tussles with the positive things known by the sailor, the hunter, the swimmer—and the artist was all three. His massive head and strongly-cut features might well have belonged to one of those masters of surgery, of mathematics, of physics whom he delighted to paint and to converse with, meeting them a good halfway through his own experiments in science. His voice had the steady insistence one feels in his search for character; his hands, when he gesticulated, were firm if unimpassioned in their movement, quite of the character one would expect from a man accustomed to feel the substantiality, the resistance and the swing or pressure of objects. Only his eyes—and I noticed them several times—calm and steady

though they were, had a way of looking beyond his interlocutor, and I can see them now (aided, I will admit, by reminders in Mrs. Eakins' portraits of him), looking beyond the physical exterior of things and people and penetrating to the deeper reality in which all phenomena are sharers.

Thus there is a bond, after all, between the two American artists representing the two tendencies I spoke of at the beginning. Ryder's world of vision is opened to us by a rendering of the weight and movement of salt water, the fullness of light as the moon silvers the rim of torn clouds, or by his sense of the movements of human bodies, as in the awestruck Magdalen before the risen Christ. Eakins, whom we first think of as the draftsman, the painter, the man who deals with the realities of the material and intellectual world, looks beyond them as his science peers into depths of mystery no whit less profound than the night skies and the enchanted seas of his poetic contemporary.

IV.

J. PIERPONT MORGAN

WHEN MR. EAKINS, IN 1881, PRESENTED ONE OF HIS PICTURES TO the Metropolitan Museum, he was following the custom of the artists of the time in supporting the still new gallery that they believed would do so much for the cause of art in this country. It is, therefore, appropriate, at this juncture, to recall the collector who did most to bring to us the great things of Europe and who advanced the position of our museum as no one had ever done before. Indeed, it seems unlikely that in the future anyone will ever contribute to the collections and prestige of the Metropolitan in a manner even approaching that of J. Pierpont Morgan.

His epoch was one in which big things were done. He saw the immense expansion of commerce, industry, and railroading, in the decades after the Civil War, and it was his genius for finance that, with his standing in the country, made possible such organization as that which he effected for steel production, for the merchant marine, and other activities. His biographers have told that what interested him in such operations was not the amount of money he could extract from them, but the satisfying of his sense for a rational consolidation of power. Much of it remained in his own hands—to be used, for example, at the request of President Cleveland when the latter needed gold to save the national credit. Mr. Morgan acted also to bring order into the chaos of the coal industry when Theodore Roosevelt, as president, was failing to

settle a gigantic strike at the mines, which threatened the country's supply of fuel for the approaching winter.

A man who could do things like that, whose influence extended over a large fraction of the resources of the whole country, was not to be thought of as possessing merely national importance; and indeed his relations with European finance and politics were so considerable that more than once the claim was made that no sovereign or government could undertake a war without weighing the question as to which side of the conflict Mr. Morgan would be on. By nature a man of few words, and hating notoriety, the isolation in which he lived made him an almost legendary force during a great number of years; so that it was reserved for very few people to know him as a man of simple, human impulses, capable of strong affection and almost boyish humor, and equally capable of the vigorous decision and singleness of purpose demanded by his affairs. One of those who knew him best has said that no great gentleman ever lived who had finer manners than his, and with the people whom he could trust he remained completely approachable and cordial.

And so it was only that "ogre-myth" spread about him by the little men whom he terrorized, which left me unprepared for the natural life of his household as I saw it on one of my first visits there. Mrs. Morgan, coming to the landing of the stairs, called down "John, would you step here a moment," and it seemed to me, as to my father whom I was helping to deliver some photographs, that all the glamor of the great house was a fiction, and that we were in just another American home—as we were.

Yet the world was right in thinking that no other house in America was like this one, no other reached out so far and conducted things on such a scale. Everything about Mr. Morgan's thought and action was marked by the same largeness, and so when he came to indulge the passion for art-collecting that had been developing in him since his student years in Europe, he did

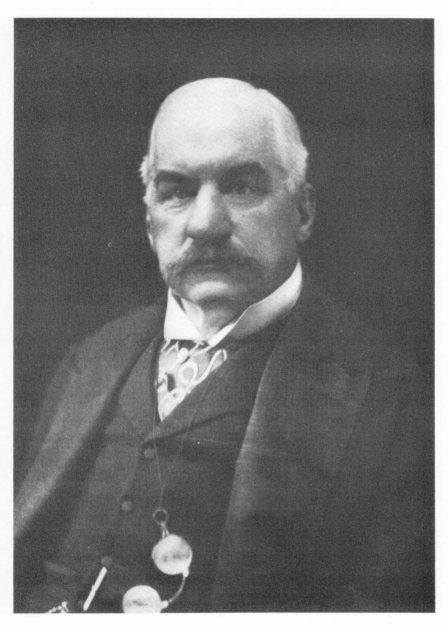

J. PIERPONT MORGAN

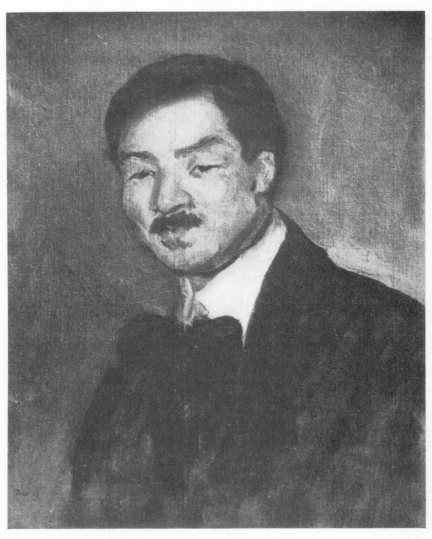

MORIYE OGIHARA *From the portrait by Walter Pach, 1907*

so with the vision of a Medici, or almost that. For as John Quinn once pointed out, the renown of the great Italian bankers does not rest on the fact of their amassing the wealth of art works from the time before their own; the collections which now make up by far the greater part of all the museums of Florence are testimony to their judgment in employing men like Signorello, Michelangelo and Raphael, in short the artists of their day, those whom the Renaissance, with almost infallible taste, designated as the moderns of the time.

But America was not ready for that final step in connoisseurship which brings forth the patron, the man who says to the artist "Carve" or "Paint," seeing in advance the splendid result ahead. Before that could be, there was needed, in this country, a better acquaintance (often a first acquaintance) with the things which would induce in it the standards indispensable for recognizing the true inheritors of the past.

Only those who saw Mr. Morgan's possessions as they were shown at the Metropolitan in the years just after his death in 1913, and who can supplement that memory by a knowledge of the treasure in his library, are able to appreciate the imperial scope of his collecting. At the museum, there still remains enough, in all conscience, to tell the character of his mind, but previously there were the Italian bronzes and majolicas that today form the basis, if not the whole, of several important collections, the Chinese porcelains, the Fragonard room now at the gallery of Henry C. Frick, and numberless things which we see enriching museums in various parts of America and Europe.

When such assemblages of art works are mentioned, certain persons are always ready to say: "Oh, he bought what the dealers sold him; he didn't know about such things himself. Anyone with money could have done what he did." But that is not so. Lawrence Binyon has lately affirmed anew that the true and the false in art never fail to declare themselves for what they are; and so one can

tell whether a man appreciates things—or is buying them just to be like the great lords of the past. Mr. Morgan, spending hours of delight over his possessions, arrived at such judgment about them that the dealers became mere coadjutors of his, instead of being the masters they often are with collectors (who are, of course, deftly guarded from feeling the bit and spurs that guide them).

What would one not give to have been present at the conversations between the financier and such a man as Wilhelm von Bode! That master of museums, to whom Germany owes the whole conception of her vast public galleries, was fitted by his unequaled experience to be a guide for the greatest of collectors. Merely the titles of the books by the Berlin savant tell of the breadth of his knowledge, and one can imagine how Mr. Morgan listened to the brilliant connoisseur—and moved on to his own range of acquisition. Including only a part of it would be Oriental art, masterpieces of Castagno (or Pollaiuolo), Raphael and Rubens, incredible Gothic treasure, examples of the Merovingian art now so zealously studied in Europe, Byzantine objects that are surely unequaled by any in private hands, beside Greek and Assyrian and Egyptian works. To Mr. Morgan the Metropolitan Museum owes also the purchase of one group of works that render it unique anywhere, save for Naples. Neither London nor Paris can show, as does New York, the glorious painting which, in classical times, rivaled the sculpture of the Greeks. To be sure, Pompeii was at a considerable remove from Athens, and it came too late to represent the classical world at its best. But, as only the Greek paintings preserved for us by Vesuvius have survived (or but little more than those), any capital of Europe may envy us our possession of those frescoed walls from Boscoreale. It was characteristic of him to want around him something Pompeian for his personal pleasure, and so he retained in the Library the lovely Eros of the torch race, and a pair of silver cups with cranes, similar to those in the Boscoreale treasure at the Louvre.

J. PIERPONT MORGAN

Men do not rise to the opportunities offered by such things unless they have in themselves a sense for quality. Pierpont Morgan had it, as I know from at least one personal experience. It dates from a time when I accompanied my father to the office on Wall Street. After autographing a portrait for a relative of ours, Mr. Morgan looked at it fixedly and gave vent to a low roaring tone that had made more than one man hesitate about returning to the lion's den.

"Hum—hum; I notice you can make very nice photographs of me—when they're for other people. Why don't I get them as good as this?"

"I'll tell you why, and I've told you before," said my father, who knew the fe-fi-fo-fum business too well to be taken in by it. "You don't get work like that because you won't give me the chance to do it. You send up for a quantity of pictures to be made right off, instead of letting me take my time and work slowly. You always say you have enough, and that I must not make more until you tell me to. But it's just a matter of looking ahead and not waiting until you need them." And he went off with orders to make up a stock of the carbon prints, which did take time to produce—and which were to be kept on hand regularly.

Mr. Morgan did not have one of father's ordinary (but by no means bad) prints before him for comparison, when he discerned the superiority of the one he was autographing. Perhaps he had not seen one for a week or a month; and not one person in a thousand will retain such a sense of quality in prints that he will at once realize the difference between one produced in routine fashion and one that has been the object of special care. But the old collector did have that sense of quality. He applied it to bronzes, to faiences, to paintings, and so there were but few things which he passed upon and which afterward turned out to be "wrong ones." This faculty of his had a curious minor applica-

tion to his smoking; by smelling a tobacco leaf he could tell just where it came from and of what quality it was.

But far more important than his sensuous response to things was his intellectual grasp. That was what gave to the various groups of collections he owned their almost uniformly high level, despite their wide range. Yet the limitation I have noted before must be mentioned again in this connection: Mr. Morgan's interest was in the art of the past, in things that had been carried to a clear and logical perfection. When he left that domain, to deal with the evolving, unsettled art of the modern world, as he did on very rare occasions (like that of buying a big canvas representing Napoleon at St. Helena), his failure was complete. It was not more so than that of other great collectors of the time. Cornelius Vanderbilt, for example, to whom we owe our magnificent fresco by Pollaiuolo, also gave us *The Horse Fair* by Rosa Bonheur. A study of such disparities in appreciation would be significant, as including many of the leading figures of the period and thereby showing that such a stage in our evolution was a natural consequence of conditions. We had to serve an apprenticeship at discerning the true values in art before we could see them in modern works as well as in ancient ones.

The present day, with its enormous interest in the moderns, is sometimes glibly patronizing as to the earlier time. Buying the pictures of Matisse and Picasso, it forgets that it learned of their position from books, or perhaps simply chooses to ignore the fact and ascribe its choice to native penetration. Even when that is to be admitted, there remains the certainty that the past is a far wider field than the present; and if alertness and openness of mind are needed to recognize the beauty of things not yet passed on by the centuries, the same qualities condition our seeing of what is great in the art of the past. Not everything in it is great, to say nothing of the always present difficulties represented by forgery and misattribution.

J. PIERPONT MORGAN

The aid to taste and knowledge afforded by the Morgan Collection was, however, but part of what its creator gave to the public. Before he became president of the Metropolitan Museum, various far-sighted and unselfish men had been building it up from its small and difficult beginnings. A history of the United States, to deal with the essential advances of this country, would have to give a large place to their devotion. They had confidence in a future that was harder to imagine than the part of it represented by our work in science, in education and the like. Those were practical things and could be appreciated. Art was foreign, it was for women, or for strange people who busied themselves with matters esoteric and almost suspect.

Mr. Morgan's example went an immeasurable distance toward discrediting such an idea. When there was a general realization that art was a prime interest with the great financier, the pivot around which so much of the country's industry and commerce had to swing, when men saw him taking hold of the museum, they gave it and the force it represented a respect that was new to them and to the country. A new chapter in American life had begun.

Mr. Morgan did not merely lend his name to the work. He was active among the trustees, and at public functions he fulfilled his rôle as president by meeting visitors at the head of the stairs, with a handshake for each who was presented to him, accepting the gaze of the crowd which he ordinarily avoided. The mere fact of his making these receptions an occasion for his rare appearances before the public had an enormous effect. As one society leader put the matter, "We have two Metropolitans now, and I would no more miss the opening of the Museum than that of the Opera."

No one imagines that the world of music and of art is defined by the persons who occupy the "Diamond Horseshoe" or those who attend the receptions at "the other Metropolitan"—the more democratic of the two, since it is open to everyone. But, at a time

when government support in America would have been unthinkable (and disastrous, probably, had the politicians been willing to give it) the support of society was of great value. Speaking with even more effect than that of "elected persons," it added the prestige of wealth and rank to that of the quiet devotees of the finer things, the artists, poets, and collectors who had done the pioneering of the museum.

Mr. Morgan had been an early sharer in that work: his associates in it were themselves men of too great importance to have made him their president merely because of his position in the world or because of his great collections. They knew the worth of his genius, and their judgment was vindicated by the great strides which the museum made under his guidance.

As always silent about his plans, he showed what he had in mind only after it was accomplished. Once, in my newspaper days, I called on him with the hope that he would make an exception and tell something of his projects for the Museum through the weekly for which I was writing. It was one in which Mr. Morgan had taken a financial interest, out of friendship for the owners. The editor thought, therefore, that between that fact and the great man's cordiality to my father, an authorized article might be obtained. I sat for three whole days just outside his office, where kind Mr. King, his secretary, let me wait, in the hope that a postponed appointment might give me time for a talk with him. Through the open door I could see him at work, though I was of course out of earshot for the long succession of financiers, savants, and the rest who came to talk to him. Finally my turn came, but Mr. Morgan was adamant: it was for the museum to make its own statements. He might buy, he might advise, but the policies of the institution must not be interfered with by personal talk, even from its president. If there was no mistaking the finality of this pronouncement, neither was there any doubt of the warmth in the handclasp with which he sent me off.

J. PIERPONT MORGAN

And so, at the museum everyone on the board and on the staff went to work with renewed zeal. Collectors who had been hesitating as to the disposition of their possessions felt a confidence in the management of the galleries that they had not known before. Sir Purdon Clark, the director who took office under Mr. Morgan's leadership, introduced a spirit of friendly coöperation that had been conspicuously lacking under the autocratic régime of General di Cesnola, his predecessor (who had, however, rendered great services to the institution). Best of all, the coming of Roger Fry, at Mr. Morgan's invitation, gave us a taste of the most advanced European judgment on art. If, as we shall see, the country was not ready for it and let the great connoisseur depart, his influence continued, through his effect both on his associates at the museum and on the public.

The country was not ready for what Mr. Morgan foresaw. Even the exhibition of his stupendous collections left people in need of years of education for so much as a realization of what they were to be heir to. The great Raphael madonna, with its centuries of ownership by kings adding to the general authority of the name, was easily accepted as a thing of fundamental importance. But Gothic art was still strange here; Mr. Marquand, whose glorious paintings had initiated a whole generation into the quality of the Old Masters, had possessed fine ceramics, but when they were sold at auction, only a few persons relatively, had been able to profit by the opportunity to see them, and so Mr. Morgan's group of Tuscan and Umbrian majolicas came as a revelation.

Men's horizon was immeasurably widened. It had been dominated by a limited number of painters and sculptors. Not only were whole new schools brought into our ken, but we were made to see how the spirit of a people expresses itself (often in the most delightful and most significant fashion) through what we had complacently termed the minor arts. That of the enameler would probably have been one of them. Yet with Mr. Morgan's Byzan-

[75]

tine enamels, one found oneself before things of the profoundest impressiveness. But I must resist the temptation to review those astonishing galleries. They are still there, or by far the larger part of them, and every visitor to the museum can imagine, if he does not remember, the effect they made when first shown.

What is relevant for my purpose here, is to indicate the light they throw on the character of the man who brought the collection together. The course of such a one is beset with every kind of intrigue, and not a few have lost interest after discovering how much of worthless dross is palmed off in the name of art. Only those who see past the ugly and poor things, who know and can keep before their minds the work of the masters, will persevere with the difficult if fascinating problem. J. Pierpont Morgan's faith in great purpose and great achievement is registered throughout the long roll of works he made his own by means of love and study—far more than by means of his wealth. It was his wish that his treasure become the possession of the whole public. Legally it did become so when the present Mr. Morgan carried out the ideas of his father: in another sense, it never ceased to belong to the men who created it and to those who share their understanding. The collector of the works proved by his choice that he was of that company, even as, by the destination he assigned them, he showed his belief in an answering genius among his compatriots.

V.

MORIYE OGIHARA

———

THE STRANGE MIDDLE GROUND BETWEEN PAINTING AND POETRY
on which we saw Ryder, with his very personal, almost musicianly
art, will serve well as a place on which to meet a beautiful figure
who comes back to me as I recall the first decade of the present
century.

Among the young men who flocked to the art school where
Chase and Henri taught were fellows from Canada, from the
South, from Down East, and from the Pacific coast. But there
was one who came from even farther off, from Japan. His per-
sonality was what first attracted me to Moriye Ogihara. But I was
ripe for an acquaintance with him based on the mere fact of his
race and profession, for I had come to be deeply interested in
Japanese art in my college days and had even, under the guidance
of Bashford Dean, secured from Japan a couple of books on the
language and writing of the country, my object being to teach
myself enough, at least, to be able to read the inscriptions on the
prints and paintings, as an aid to understanding the art of them
and perhaps becoming an expert on it.

Clearly, then, it was an adventure for me to make friends with
a Japanese possessing brilliant intelligence, the poetic sense of his
people, and—as it turned out before his short life ended—some-
thing very near to genius for the sculpture which finally replaced
painting as his work. We made friends and we remained friends.

More than once in our later years in Paris he would say, "Little brother, I can talk to you better than to any of my own people here. They have not been in the West long enough to know what all this is about. They imitate, they want you to think they have a grasp of things, they want me to, and then they don't like it when I tell them they understand nothing or next to nothing. It takes time to understand. They work, yes, but it is from the outside. They don't really get the Western ideas, and they don't get Western art."

He had been in America and Europe for seven or eight years, and that made the difference (aside from native intelligence) between him and the others, whose stay was rarely for more than two or three years. Perhaps we shall one day learn how much of the present condemnation of Japan's course in China, a phase of her relationship with the West, is due to action on the part of those Japanese who have the misunderstanding of the Occident that Ogihara regretted so much among his countrymen. Not that a deeper knowledge of Westerners would lead to any belief in the rights of weaker peoples, but we know that some Japanese are today opposed to the aggression committed by their rulers, and I believe that Ogihara would not have condoned it.

He had the qualities he would have needed to resist it—hatred of stupid wrong, and an unbelievable tenacity; with both went the gentleness and sympathy of his generous nature. The latter qualities predominate in most of his works, but in others a fierce rebellion cries out; and in both types alike there is immense knowledge and strength.

He had paid for all these things with the years of work that he demanded of his countrymen. The son of farming people, he had come to America with what seemed a small fortune to them, slowly amassing the sum under Japanese conditions as they had done, and without any realization of prices in the West. He was to have sought work in New York, so as to support himself while

going on with the art study he had begun in Japan. But the compatriots he found here had nothing but domestic service to propose to him. It was acceptable to themselves, but Ogihara's proud and free spirit rose against it and he postponed the offered servitude from week to week, and from month to month. Finally his money began to give out, but it was unthinkable for him to ask further sacrifices or debts from the people at home who had made their enormous effort for him. Renewed search for jobs was of no avail; always he was told to be a servant.

And so he saw that he must starve. But it would not be in the city. The country was like what he knew at home: dying there would be like dying at home; he must get away. Going to the Grand Central Station, he laid all his remaining money on the counter—even the pennies, and said "Ticket." The clerk asked where he wanted to go, and again he said "Ticket." Finally the man found one for just the amount he was offering.

The conductor of his train told him where to get off. It was at some small town and soon he was in the country. Spring was in full bloom, there were flowers on the fruit trees, it was just like Japan. He walked until darkness came, when nature was even more beautiful than before. And then a wonderful thing happened: fireflies came out, "the souls of the ancestors," according to a Japanese idea. He was happy for the first time in many months. His own people were around him and he went on, reciting old poems to himself, until he needed to sleep, when he lay down on soft grass, just like the grass at home.

All the next day he walked ahead, hungry and somewhat weak, but still happy; and at night there were more fireflies. The following morning he felt too exhausted to rise from the ground when the sun awoke him. He thought he would soon be dying and started to drowse again. When he opened his eyes next time, a man was bending over him and saying things. Evidently realizing something of the state of the young Japanese, the other lifted

him up, put him into his cart, and took him home, where he was given some warm milk. Then he slept again and next time when he awoke two or three people were there. The upshot of the matter was his being put on a train that brought him to Newport, Rhode Island, where the Fairchild family, friends of his rescuers, took him to live with them.

They had been told of his case by a telegram, and they made him feel at home. There were works of art in the house, some of them from the Orient. There was a nice son, Nelson Fairchild (later on to die in China, as a United States consul there), and with him Mori was soon on friendly terms. He worked happily for the family, without any sense of inferiority, and in due time the kind people sent him back to art study in New York and then (I believe) to Paris.

It was in Holland that I ran across him again, and glad I was to see him. We kept in touch after he returned to Paris, where I joined him, a couple of months later.

Once he had me come to his studio for dinner. Its frugality—and I fear I ate most of his rice and sardines—was so extreme that I needed more food at a restaurant after I left him, to make up for what a day of walking in the cold and dampness of November had done to my inner man. But he lived for years on his lean rations, always stretching out his finances for a longer and longer stay, more and more study; and his death, according to the analysis of compatriots of his, was due to the weakening through privation of a once powerful constitution.

Long before that, his work had taken on the strength of which he was slowly depriving his body. In America, under the inspiring guidance of Robert Henri, he had given free play to the expressive side of his art, and drawings of immense fineness, of delicate sentiment and humor, were the result. I remember one such drawing, a nude of a woman, that remained hanging for years in the school studio. Henri said that only a Japanese could have done it.

MORIYE OGIHARA

In Paris, Ogihara gave himself the double task of academic discipline in a severe atelier, and of widening his understanding of art. He succeeded with both ends of his program. For several years he stood first in the annual competition at the Académie Julian, after which he thought it unfair to compete, and abstained from doing so, feeling himself a graduate who was simply profiting by the chance for a studio and models at low expense.

To be sure, there was an added price, of which he became more and more aware. The continual drive for anatomical exactitude carried on by the professors led him to such knowledge of bones and muscles that many a time, as he said, he would put them in when they were not to be seen in the model. The very proficiency for which he got prizes was threatening to blind him to a deeper sense of nature and of art.

It was for such reasons that he sought the influence of freer masters, above all Rodin. I had myself called on the famous sculptor years before, partly to see more of his work than the few things then shown at the Luxembourg, partly in the hope of buying a cast of something by him. An illustrated article in an American magazine, two years earlier (I have it yet) inspired me with an immense enthusiasm for the man whose *Balzac* had just been refused by the authorities, and I had been naïvely disappointed when he told me that the difference in price between a work in marble and one in plaster was simply that of the stone and a workman's wages for the cutting. So that my early ambitions as a collector had a setback. It was more than made up, however, by later visits with Ogihara.

Never very sure of his French, even after years in Paris, he wanted me to go with him to Rodin and to Bourdelle in order to be sure of grasping the full meaning of their words. His English was good, and with me, moreover, there was more chance for repetition and explanation. Rodin was pleased when Mori told him that he had come to realize the insufficiency of school study

through his observation of *Le Penseur*, his favorite perhaps of the master's works—one from which he made a copy or adaptation of his own.

"Then he is my pupil!" exclaimed Rodin, and as Ogihara assented with pride only half concealed by his almost childlike happiness over the remark, the old Frenchman took fire in his turn and added, "Then it is only right that I show him wherein my sculpture differs from that of the academies."

Picking up some clay, he started to work on a head that was in progress. "There is a profile," he said; "now this one must go with it," and he suited the action to the word. "In the academies, the thing does not move, it is all from one viewpoint; there is only one profile; nature has infinite profiles." Soon he was absorbed in his modeling—and the interpreter was needed no longer. He did not go home on that account, and when Mori and I did take our leave, my friend was radiant over what he had seen.

We told Bourdelle about that marvelous demonstration of Rodin's modeling but the grudging response did not at all echo our enthusiasm. "Rodin is an intimist. I am quite the reverse; my work is directed to the impersonal, the monumental." There followed some explanations about a figure he had cast at Reims, to preserve it from complete deterioration on the cathedral (this was, of course, years before the war wreaked its infernal havoc there). Bourdelle more than intimated that he was the continuator of the principles on which the great Gothic men had worked and there are some gleams of the great past in his production. But thinking of the wealth and generosity of the older sculptor's art, Ogihara remarked suddenly, as we walked home that evening, "First comes the big man and makes things, then comes the little man and makes rules."

We were still in a day when men were making "things" (we are yet, though the pace has slackened, it seems to me). But how

busy men were also in making "rules." Those principles of the Gothic artists, the "secret" of Greece, the wisdom of the East, and soon, the magic of the African Negroes, all these were added like so many heady liquors, to the feast offered by nature.

Simple and sober by temperament, Ogihara partook sparingly of the intoxicants. He went to the Louvre, for both its Oriental and its Occidental treasures (which he related through their essentials), he kept a weather eye open for emerging forces in our time, but he refused to be rushed off his feet by the new things that were gathering always more momentum at the time.

His final departure from Paris drew near at the end of 1907. He was going home by way of Italy, Greece, and Egypt. The sight of those three glorious lands was to be the crown of his long experience of the West, and his letters or post-cards during the journey told that the plan was a success. How we worked toward it! What consultations with travel bureaus interspersed our final visits to the museums and exhibitions! It was the year after Cézanne's death, and the Autumn Salon had a great retrospective of his work. Before a solemn view of the plain of Aix, Mori observed, "That is deep—like a Ruysdael." A few days later we were at the Louvre, and he said, "It's funny, here with these grand Dutch things, Ruysdael and Rembrandt, my mind goes all the time to Cézanne." Still finding relationships when he was seeing the primitives of Italy, he wrote me that he understood better what our friends, the partisans of Matisse, saw in that disputed painter, to whom he was moving not much faster than I, who was still having a difficult time with the work of the *fauve*.

Had Ogihara remained in Paris, I know that he would have vanquished the problem of understanding Matisse, if only through the admiration he had for Maillol. At first, probably, he did not see that the beauty which impressed him in the sculptor's work came from the same sources as the beauty of Matisse's art. For both, Gauguin had been a liberating influence, both had seen the

immeasurable superiority of Cézanne, both were being led on to the Greeks. The more radical mind of the painter followed the Greeks back to their early and fundamental things: a few years later, when he had a garden at Issy-les-Moulineaux, casts of the archaic figures from Delphi rose in their majesty from its lawns. Maillol kept to the later schools, with their more realistic formula, and so was accessible to people who had not yet penetrated to essentials, to the structure and expression that are so amazing in the "primitives" of Greece (and that are still present, indeed scarcely weakened, as long as the art can be called Hellenic). I recall a little Maillol bronze, of a girl playing with a crab, that Ogihara coveted at Vollard's gallery. We asked the price, which, low as it would seem today, was too much for my friend's slender purse. But the important thing is that he wanted it, and for the same reason, I am sure, that made the old Renoir exclaim that at last he had been in Greece—because he had seen Maillol working at the sculpture in his garden!

Once I said to Arthur Frost, a son of the fine old illustrator who had brought his family to Paris, "It's like living in Athens at the time before Phidias!" I do not hold to that comparison as rigorously exact nowadays; it couldn't be so. But it was a time of great expansion, and big things were ahead. Ogihara would undoubtedly have been a sharer in them; as it was, he carried on, in Japan, something of the splendid impetus he brought with him. I cannot say just how much he accomplished. In the short time he had to live, barely two years after his home-coming, he was recognized as his country's best sculptor in the modern period, according to what Japanese have told me. I myself know only a few illustrations in the book about him which his admirers published after his death, but among the late works are things of such unmistakable power and beauty that I am convinced of the success—however brief—of the effort that Mori had earned with his enormous preparation.

Rodin, Bourdelle and others were likewise impressed with the man's results and I was sorry I could not add their testimony to the letter in which I had told at length of our friend's years in the Occident. But it had been written long before, in reply to the one with the grievous news of the sculptor's death, and the reproductions which gave us our first knowledge of Mori's work at home were part of the book—where my letter was already in print.

Mr. Fujikawa, a young sculptor then in Paris, had helped me gather material for the book, and I asked him whether my pages (which were in English, the only part of the volume in European characters) appeared elsewhere, in the Japanese text. He gave a cursory glance at a section or two of the book, probably so as not to answer me offhand, which would have been a reproof, and then said, "No, it is only in English. It would have been impolite to translate it, not impolite to you, I mean, but to the readers. All educated people know English." (Considering the things that the East might teach us, I am glad for myself that our own definitions of politeness and education do not demand a knowledge of Oriental languages.)

Perhaps, since Japan does read our books, the present lines may be of use to some art-historian of that country. He may assure his people that Western artists of the first rank really did give a high place to Ogihara's work, even if on the insufficient basis of a few photographs. Doubtless there are but few works from that brief period after Mori's return. But they are so vastly superior to the earlier things reproduced. Those are enough to tell why the young Japanese triumphed in school competitions with the strong section of the world's youth which studied in the Paris of thirty-odd years ago. The later work was not only beyond school concepts; it was not only art, it was proof that an Oriental could hold to his birthright of ancient culture and yet assimilate with it the teachings of the other side of the globe.

QUEER THING, PAINTING

And that brings me to some lines in the Ogihara book which I find on re-reading the letter in which I told of his life in Paris. There was a sort of improvised club of the Japanese of the city (about sixty in number then). They met, and certain of them even lived in some disused railway building that a French admirer of the East had secured for poor students. Oftentimes I was invited to the dinners there that one or another of the boys would laboriously prepare from ingredients as similar as possible to those of Japan—whence *sake* was obtained for special occasions, like farewell parties for men who were returning home.

Every evening had to have a session of story-telling, which was a dead loss to me, despite attempts by Mori or some other to translate rapidly, so that I might follow. And despite that politeness of theirs about languages, their command of French and English was not equal to the strain of rendering their tales in those tongues—an absurd thing to have attempted anyhow, for they were among themselves, and I the only foreign guest.

That did not mean that I was to be left out entirely. If I could not follow their stories of the old fun and fighting, I could tell some of ours, and was pressed to do so. Knowing that many of their tales concerned the great samurai, I rummaged in my memory for something of a parallel and came back to college days under Adolph Werner—the "golden Werner," as he was to almost six decades of students for whom he interpreted the German classics at the College of the City of New York. I selected part of the Wallenstein story, and came to the point where Max Piccolomini, warning the great field marshal against treachery to the emperor, gets the reply:

Schnell fertig ist die Jugend mit dem Wort
Das schwer sich handhabt wie des Messer's Schneide.
Aus ihrem heissen Kopfe nimmt sie keck
Der Dinge Mass die nur sich selber richten.

MORIYE OGIHARA

I dare say my translation of the resounding lines was poor enough, but its effect on my small audience was not less than electric, as I well recall. I had to stop while the passage was retold in Japanese for one or two who had missed something in my English. "Just like our stories—oh yes, just the same people and the same stories. It is wonderful."

Ryder (to come back to him) might have painted the scene— that smoky old car-barn with a group of young Japanese artists and scholars getting excited about the drama of a German poet, though of course the national phase of the thing stands outside the field of painting. In fact, as this memory proves, it stands outside the field of all art. What is significant in this glimpse of the early years of a great Japanese sculptor is that he and his friends saw past all the poor distinctions of nationalism and stood face to face with themselves in the tale of the far-away people. And it was not a seventeenth-century tale for them; it was twentieth-century, their own time. I referred previously to the old Roman with his *ars una*, and its rightness is borne out once more. My friend Jean Le Roy, of whom I shall tell presently, once wrote a poem called *Moment of Light* (Wallace Stevens has published a translation he made of it). The light is that which illumines the mind of a living man. And if it be real light that has flashed for a Schiller—or a Jean Le Roy, it will not be extinguished when carried across space and time.

VI.

CHARLES LOESER, EGISTO FABBRI

IN THOSE DAYS I WAS SEEING A GOOD DEAL OF A MAN, NOW GONE, who knew that the real question about a work is whether it contains art, and not what its period or provenance may be. This was Charles Loeser, an American who settled in Florence just after graduation from Harvard in 1886, and who returned home for the first time thirty-five years later. His earlier quarters in an old building near the Uffizi, and later on, those at his villa out near the Piazzale Michelangelo, were filled with the treasure of painting, sculpture, ceramics and art of every kind that he had amassed in years of impassioned collecting. Among many visits I have made in the lands of fantasy, few have been more delightful than the ones on which I have acted as cicerone for Mr. Eble, the New York antiquarian of my boyhood, imagining rambles through Carlo Loeser's possessions, and proudly showing my early mentor that his guidance among such works had not ceased to live on in my interest.

Whenever I reach one point in these visits, I have to stave off trouble. Remembering the perturbation of Mr. Eble's customer, William M. Chase, when pictures by Cézanne were discovered on the wall, I have devised all sorts of conversational bypaths in order to get around objections that I fear my old friend would have raised. Catholicity (and it was a pet word of Mr. Chase's) is a very fine thing, but it must have its limits. "And don't you

see that's just where you're wrong, dear boy," as I remember Loeser to have said, on another occasion.

We had been working over his collection of drawings, some two thousand of them at that time, and it may not have grown very much later on. "You don't find things any more nowadays," as he so often said, meaning, of course, that latter-day prices have grown prohibitive; fine things are always coming on the market, and sometimes supreme things.

I was going to need work when I got back to America and, my painting not being anything to depend on for a living, I thought of a museum position. "Perhaps I'd do well to specialize on drawings, people want specialists at home." "And that's where *they*'re wrong," said Loeser; "it's as if one could tell good meat from bad, but couldn't tell good fish from bad."

The analogy is picturesque and tempting, but like so many, it does not run true in all cases. One may be able to distinguish so subtle a thing as the difference between Rubens and his pupils and find it enormous, as it is. Yet faced with Chinese paintings, one of them from a great artist, the others centuries later but done with the Chinese faculty for repeating ancestral achievement, one may find oneself unable to tell master from imitator. Even Oriental experts are baffled by such problems, and before the endless mass of painting from China, a dealer remarked, "We buy such things by weight."

Again an illustration needs to be corrected. I was speaking of Loeser and his possessions, and they were not drawn from the impersonal arts of Asia but from those of Europe, where evolution does not turn backward even when, in the Renaissance, a sculptor could be nicknamed "Antico" because of his success in doing things like the ancient ones that the soil of Italy was giving back to the light. His work was of its time, however much his idea was the antique. And just the insight needed to recognize such characteristics was part of the goal which my friend had set him-

self. A man of ample means, his collecting was no mere pastime, however absorbing; he was one of those who, first digging to the essentials of the masters for their own pleasure, have opened the eyes of the world to the nature of its art.

I remember his showing me two very slight drawings, one Florentine and one Venetian, and his pointing out how, little as there was on the two sheets of paper, one could clearly distinguish the way the precise, descriptive mind of the Tuscan went to outlines clear as those of a crystal, both at the edges of the figure and inside the contour, where drapery, etc., were defined with the same sharpness; whereas the Venetian mind diffused a gentle glow, suggesting color, over the whole of the generalized form.

Sometimes, as with a bronze Venus of the fifth century, B. C., Loeser would refuse to make distinctions. "Greek or Etruscan, who shall say? They were pretty close together. It doesn't matter. But you should have seen what a success she had when I showed her at Burlington House last year." He was at home on old Bond Street, on the Rue Laffitte, and at every place in Italy where art treasures might turn up. But he knew so well how often they turned up because they had been planted, that he would tell Americans, "Don't hunt masterpieces in the hill towns here; you'll do better in Hoboken."

Yet if the art shops along the Via Tornabuoni and the less public spots where their wares were planted for "discovery" were just places for tourists to get souvenirs more or less skillfully imitating antiques, the scholars of the world had a permanent rendezvous in Florence; and the infinite spoil in Italian churches and museums drew a stream of visitors who provided a resident with the finest sort of talk. I can say this because creative artists often called at Loeser's place, and so he got the pithy observations that only they could make, though for the most part his contacts were with museum men, critics, dealers, and collectors.

Questions of real moment were discussed, such as that of

attributing a marble he had. He asked me about it on an early visit of mine and, if every reaction could indeed have some value in settling the problem, I am convinced that the question in his mind was more as to my capacities than as to the origin of his work—about which he was perfectly convinced. I had heard nothing about it, and so was starting "from scratch." The name of Michelangelo was the only one that seemed applicable, as I stared at the piece; but how would one be seeing a work by the supreme master in private hands? Why, if it were real, had not one heard that such a stupendous find had been made? I said I did have an idea what the thing was, but that I did not like to utter a first impression, which might pass away and would doubtless seem absurd.

"No, give us just that," said Carlo Gamba, of the Uffizi, who was Loeser's other guest at lunch. "Very often one comes back to first impressions, only to find that they are the best."

"On that basis, I'll say what crosses my mind; in fact, I can't get away from the idea—that this is by Michelangelo."

"Precisely," said Loeser, "and now you'll see that you were right to follow Count Gamba's advice: this is the San Giovannino that the old records tell us of Michelangelo's doing for Bologna, and that has been lost from sight ever since. Always trust your instinct when it gives you a clear signal."

I believe in that motto, even though I have no assurance that the case in point bears it out. I did not hear the little St. John talked of again until after Loeser's death; he had bequeathed many things to Harvard and there was a question of getting them to America. The Italian law provides that works of art can be removed from that country only with governmental permission. This is not granted save for things that the national collections can spare, and even then an export tax is imposed. Loeser had directed that it be paid in terms of objects, including the Michelangelo, which he designated for the galleries of Florence. The

government contested his rating of the marble I saw so many years ago, and the matter was still under discussion when I last heard of it. Perhaps it still is.

If such a case will convince practical-minded people of the concrete values involved in such discussions as were vehemently pursued around café tables, in studios, and in museums, a thousand other questions would appear futile and sterile to a simply infinite degree. But as the scientist must make countless experiments, most of them negative and unrewarding, in order to get at even a fraction of the truth he seeks, so the men who would solve the questions of art need unending patience with their work and eagerness for every bit of new light on it, if they are to read the past, and so give us our best guide to the future.

In my Ananias book, pleading for rightness of judgment as to the things which enter the museum, I called that institution the mariner's compass of art. Falsify its indications and you throw us out of our course—perhaps on the rocks. To me there is no more fascinating scene in art history (or—perhaps narrow-mindedly—in all history) than that of Louis David seeing the Elgin marbles when they were brought to London. He was in his seventies, a time when people are to be excused if they fail to recognize newly discovered truth and, moreover, the old painter had been living on the idea of the antique which had been before his eyes since boyhood. But it was the antique of the Roman copyist. Here, in these works from the Parthenon, was Greek art—and at its apogee. In his excitement the veteran of the Revolution showed that he was still worthy of its renewing power by writing to Baron Gros, his great pupil, that the whole basis of their conception of art must be revised.

No less a change in our vision could be made, was made, by our discovery of Cézanne. Had Mr. Chase been able to profit by the sight of the Cézannes at Loeser's house, as David profited

by the Greek things in London, he would not have been mystified
by my spending months over a copy after Signorelli.

I had seen the picture (one that Michelangelo emulated)
on my first visit to Florence. But being completely unprepared
for the art of the masters of form, I had not given much attention
to the work. I recognized it as a thing previously seen, when I
returned, three years afterward, but I did not recognize my seeing
of it: my eyes had changed. I had become aware of Cézanne's
quality of form and design, and spontaneously—more to myself
than to the friend who stood with me before the great *tondo* of
Signorelli—I exclaimed, "Cézanne!" Only later on did I learn
how deeply the modern master admired the old Tuscan. Since I
have acknowledged my earlier obtuseness, I do not think I am
offering myself as a model here: what seems to me the valid point
in the incident is that modern art is quite as useful in throwing
light on ancient things as ancient things are in showing us what
is right about our own time. Indeed it seems to me that in a
normal world, where people understood and enjoyed the art of
their time, it would always furnish their approach to the less
known things of distant periods and places.

For Loeser, America was a distant place, and when he re-
turned there after over a third of a century abroad, he found out
how distant he was in time. New York had all been more or less
like Washington Square when he had left it, and if he had some
notion of the change in architecture, something he could follow
in the illustrated papers he received, the change in ideas, in tempo,
and in maturity was something to which he never quite grew
accustomed. Florence had been the world-capital of criticism for
him, and when he uttered his ideas with the air of certainty that
had enraged Mr. Chase, people answered him back—the upstarts!
The museum, which had been a puling infant in a city of the
hinterland when he left in 1886, had grown to enormous size and
importance. If it still bore the stigmata of youth, the men there

were better aware than he of what it needed—and were sometimes better versed than he as to works in it belonging to the very schools that he had studied so hard. My admiration for his attainments did not decrease as I saw his bewilderment before the new city here; what I see in it now is a reminder that one is never too far advanced in art to renounce humility as a primary need in one's attitude toward the subject.

Fundamentally Loeser had that, and I recall the way his ready talk was silenced as he bent over a Cézanne in the collection of John Quinn. He himself had been one of the pioneer buyers of the master's work and he might pardonably have reminisced over the days when he and Egisto Fabbri had bought great things at Vollard's first little shop, in the earlier nineties, and paid a hundred francs apiece for them—as he had bought Grecos in Madrid for but little more. But unlike those collectors who attribute an artist's rise in esteem to their own activity, he knew that all the credit for the change was due to Cézanne.

Mr. Fabbri was another one of those early ones in the field who maintained the finest attitude toward his possessions, and toward those who cared for them. I had often heard of his collection in Paris, and finally, on the recommendation of a friend of his, wrote that I should like to see it. A courteous reply led me to an old studio building in Montmartre, where, after a climb of six flights of those stairs which afford Parisians such healthy exercise, I found myself under a skylight, and before an easel on which a good picture was in progress. Though I remonstrated, Mr. Fabbri took it away, saying I had come to see Cézanne's work and not his, upon which he brought out one magnificent thing after another by the old painter of Aix, rounding off the feast by a few other things, including some drawings by Ingres.

On later visits, I did manage to see more of his own excellent work, but he was terribly severe in his self-criticism and told me he made periodic destructions of nearly everything he painted.

CHARLES LOESER, EGISTO FABBRI

We found, in the late spring of 1912, that we were both going to Italy for the summer, he to paint in Florence, I in Arezzo, where I had always wanted to spend a long time and come to know Piero della Francesca. As Florence was on my way, and I was going to stop there for a short time anyhow, Mr. Fabbri asked me to call on him.

The address he gave me proved to be that of a palace, and I was a good bit in doubt as to being in the right place when I asked for him of the footman in livery who opened the great door for me. But the man went off with a reassuring "*Subito*," and presently my friend appeared and led me to the interior. We passed the portrait of a lady, the Marchesa R. as I later identified her, and presently another one—the Contessa P. "Those are your work, aren't they?" Mr. Fabbri assented. "Well, you're doing good things of them," I said. "I don't wonder that the family are having you paint more. Just the same, it's big luck, falling on a job like that. This is a grand place you've got into, and those look like nice women to paint. How did you ever hit it off with them?"

"Oh, I didn't tell you. Those are my sisters; I live here." He was just as simple as he was in that little one-room place in Paris, or when he climbed my own stairs in the Rue des Beaux-Arts. But it took me some time, even so, to get it through my head that the hard-working painter of Montmartre who had been able to buy Cézannes when they were sold for next to nothing, was the same person as this inhabitant of the grand house in Florence. Loeser told me soon after who he was:; the son of an early partner of J. Pierpont Morgan's. He had been brought up in New York, which accounted for his perfect command of English, and had studied at first under our excellent painter, J. Alden Weir. Allen Tucker has memories of him from those days, but while Mr. Tucker's beautiful pictures descend in a straight line from the Impressionistic studios of his youth, Fabbri felt the call

of his Italian blood and went back to Florence where men like Andrea del Castagno led him to the renewed study of form that centered in Cézanne.

He spoke of a child in his family who used to cut silhouettes out of paper—and got strikingly clear and functional outlines in doing so. "Later he went for instruction to an artist who taught him about shading, and in a short time all that instinctive feeling for contour was muddled up with a conventional skill in imitating the lights and darks. The other day—to pursue the same question of our modern misunderstanding of line—I was at San Lorenzo and looked at a big drawing of one of Michelangelo's figures that a man was doing there. The drawing was all muddled up with dark masses and reflections that made the marble look real enough to hit with a hammer; the Michelangelo of the chapel looked, by comparison, like the pale white ghost of a fresco."

During the war he paid a visit to New York, and built a residence for his sister-in-law. He took me up to Ninety-fifth Street, near Fifth Avenue, to see it, one of the finest buildings in New York, as it seems to me. "I did not know you were an architect," I said as we wandered from one beautifully proportioned room to another. "I'm not," he replied; "this is the first thing I've ever done. But essentially, fine architecture is only fine drawing. If you can distinguish a head that's well drawn from one that's drawn with mere correctness, you can distinguish between architecture and what's merely building.

"This house is frankly Florentine in its general lines. But one need not always create a whole new style. How often has it been done? There are certain types that reappear with new vitality when the time demands them, as, for example, the fine things that are called Colonial in America, but that are simply a revival of the Greek. You can't force a modern style into existence simply by making claims that you're doing something original. Look at the Futurists in Italy: they talk about demonstrating the life that

is in the country—they would come nearer to demonstrating that it hasn't any life, if their work were not so empty of everything but bombast. They're trying to do things they don't know about at all. They had better leave off worrying about the tyranny of the past and get ahold of some living idea, ancient or modern, and go on from things they do know."

VII.

CLAUDE MONET

TEN YEARS PREVIOUSLY, WHEN I HAD CALLED ON CLAUDE MONET, he had also insisted on painters doing the things they know. With him it was above all a matter of subjects, and one's intimacy with them. A third man to express such a theory, many years later, was Matisse and, as an admirer of Monet, he was glad when I told him that, unknown to himself, he had been repeating the ideas of the older man. My one visit to the latter has remained very clear in my mind, but I prefer to transcribe the record of it I made at the time, when my friends in Paris were skeptical about his receiving me. Ordinarily I should not have made any attempt to call on the famous man; but I had promised to write him, and I did.

"Claude Monet?" I had been told, "you won't get to see him; lots of people have tried. Oh no, Monet shuts himself up in his studio there in the country, and only his old friends get past the door."

Nevertheless it was from one of these same old friends that I bore a letter to the painter, and I had confidence in it. The scheme was to bring Monet to America. A French statesman who had visited our country a short time previously had conceived the idea, and laid the matter before his friend, the great veteran of the Impressionist School. A note from him asked me to come to his house.

CLAUDE MONET

I took the train from the Gare St.-Lazare. Westward it sped, and the glimpses of the Department of Eure, now with a view of the Seine, now with fertile meadows, again with low, strongly marked hills and groves of poplars—were a fitting prelude to the landscapes I was to see a little later in Monet's studio. Even more so was the country between Vernon, where one left the train, and Giverny, some three miles away, in which village the painter had his residence.

The Seine cuts its broad silver swath through the fields, a line of graceful poplars guards its edge, then comes a narrow strip of grassland, then the highroad—of that clean, smooth type that never fails to delight the traveler in France. Well back from the road and separated from it by the big cheery flower-garden with its white fence, stands the house of Claude Monet. It is long and low, a solid, comfortable place.

I entered; a large light studio was before me, the walls completely hung with pictures whose radiance made the place still more light. Madame Monet was there and a young granddaughter. Monsieur Monet took the letter, read it—sometimes aloud for his wife's benefit when a phrase especially pleased him, and then said, "How nice he is!" Then after consideration: "But I am old now, to learn another country. One must know a place thoroughly before one can paint it. That's why I stay here in the country where I was born. I know it." So Monet would not go to make a record of America, though he expressed a desire to visit it. "The chances of life are many; I should like to see your country; perhaps I shall yet." We spoke of American painting; of Winslow Homer, whom he knew and admired through that painter's nocturne in the Luxembourg; of Chase whose fame was well known to him; of Robert Henri, of whom he wanted to know more—writing down the name so as to inquire for his picture *La Neige* at the National Museum. Once more I spoke of the Senator's recommendation that he paint our country, especially "the incomparable

harbor of New York, and that furnace of human activity, Pittsburgh." I reminded the artist of his views of London. "But I knew London a long time, and had for a long time wanted to paint it. So, too, with my work in Norway."

Then followed some reminiscences. "I remember, once, as a young man, going through the Salon with Courbet. We saw one canvas after another of the Orient, of the desert, of caravans of camels, Arabs on horseback, Courbet looked at them without remark, read the French names of the painters, and finally burst out, 'Then those are men without a country!' It is difficult to get the spirit of a new land. Why do the Americans come to France to paint? Have they no landscape at home? Why do they go and make all those pictures of Brittany, its costumes and its people, whom they do not understand? Why do you, a painter, come here?"

"There are the museums; we have not those at home. One must not only have the landscape, but learn from the masters how to paint it."

"Good—but not in the schools. It is not for the schools that you come?"

"No, not at all."

"Very well, then. The schools are no good. I am against teaching. It is from nature that we must study. Some time ago they wrote asking if I would teach an art class, which would come to Giverny. I wrote back, 'No; I have, myself, too much to learn for any such amusement as that.' There are two cases: if a young man feels the sacred fire—let him work, let him study nature." Then a terse phrase: "*S'il a quelque chose dans le ventre, il trouvera les moyens*"; which an American might have put thus, "If he have something to say, he will find his expression for it." "On the other hand, if it's a simple desire to be an artist, he can go to school if he likes, see whether that helps him—only the *métier*,

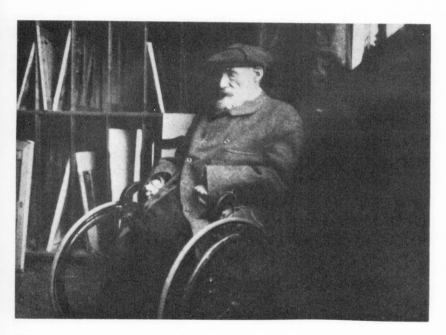

PIERRE-AUGUSTE RENOIR *Photograph by Joseph Durand-Ruel*

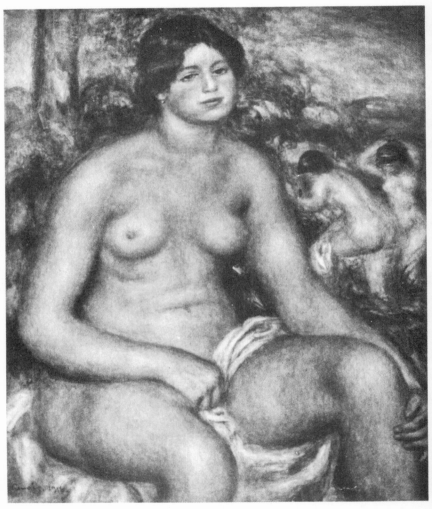

BATHER

Painting by Pierre-Auguste Renoir, 1916
Courtesy of M. M. Durand-Ruel

the processes, can be taught. When he has learned all that a good teacher can give him, still the whole question lies ahead."

We went through the studios, for there are two, besides a sort of bungalow immediately on the river: the impression of nature must be kept fresh, direct.

Monet was an artist who could admire the work of other men. He possessed pictures by Cézanne and cared highly for them long before the world at large did. The walls of the passage-way leading to the second studio were closely hung with Japanese prints, fine ones.

The pictures in the first great room were nearly all recent; in this studio (light as the other was) were works of many stages of his progress. On an easel was a picture of a cathedral doorway and part of the façade. "That is one of the Rouen series, is it not?" I asked. "Yet; it will soon go away from me. My first order from the government," he added with a slight smile. "But what does that matter? When Renoir was decorated by the state, I wrote him, instead of congratulations, a letter of jokes. 'Do you think,' I wrote (and it was the fraternal *tu* that he used) —'do you think that the bit of ribbon you are to wear in your buttonhole will help you wear better that real glory which you know is yours, when you think back over your life and the work you have done in it?'

"Work; that is the thing!" I could well believe he meant that phrase as I looked at these crowded walls; and thought how little, after all, of his production was there. "Work, work—and never think of the money. Unfortunately, we have to, at times. When we were young fellows, we often had to sell for a few francs canvases which we should not have let go so easily. But it was necessary then. Renoir had to go through that, and Manet—no, not Manet, for he had means; but Sisley had to, I had to. Ah, we see too much of this thing—the work of a young painter re-jected by a buyer, perhaps the very man who, when the artist

has made a reputation, pays a great price for it—out of *snobisme*."
(Was the twinkle that came for a moment to the dark, earnest
eyes caused by some personal recollection, or by the thought that
he, a man "not of the cities," as he had said, was using an English
word that had become very chic on the boulevards?) "But that
is what the young painter must expect—to eat tough meat
(*manger de la vache enragée*) —and he may be glad to have that—
and work. But there, too, is the reward, a great one. We want
our bread for the morrow, but with that and the satisfaction, the
happy feeling that we are doing our best, what more do we
want?"

It may be that some of the canvases that date from that early
period were ones which he had to dispose of before they satisfied
him, but one that is now before the public surely never fell within
that category. It is a little still-life which hangs in the Decorative
Arts Museum of the Louvre as part of the collection of Moreau-
Nélaton. It seems as fine as a Teniers. "That little still-life? Oh,
that's a very old one; I painted it when I was, I think, either seven-
teen or nineteen years old!"

Monet knew Whistler. "He was a true artist—of great talent.
But it was a petty spirit he showed in saying those brilliant, cruel
things." More pleasant were the memories attached to a large
canvas of his which attracted my attention as being a figure sub-
ject, something not common with this painter. The group of
ladies whom one sees on the bright green turf and the sandy walk
are painted in as pure a light and with as much frankness as it
would seem possible to get. The style of their dresses, however,
proclaims the picture as belonging to a decade long past. It is,
in fact, of the early 'sixties, and no less important a thing than
the painting which represented Monet at the historic Salon des
Refusés. Connected with it is a story of Edouard Manet. "It was
at a time when the picture hung at a dealer's, that I took a walk
one evening, and saw Manet seated at a café on the Place Pigalle.

He pretended not to know I was there and said to his friend, 'Have you seen that picture that's exhibited in the Rue Auber which makes it seem the Old Masters were thinking of painting in the open air?' Nevertheless," and Monet's quiet smile once more illumined his ruddy face, "he painted in the open air himself, later on."

Sometimes the great artists of quite recent times seem as remote from us as those of the distant past. Yet here, in the words that Monet said to me, Edouard Manet became a living person again, instead of one whose life ended in 1883. Delacroix's death befell just twenty years earlier, yet I knew two men who had spoken to him. Nay, an old sculptor living near my friend Villon only a few years ago had studied under David's great pupil, Rude, who died in 1855. The work of these masters is evidently what counts, but there is a bit of a thrill in coming into contact with people who knew them. It is a way of increasing our realization that the things we love in the museums were produced by human hands like our own, and not by demigods, as the masters may easily come to seem.

VIII.

PIERRE-AUGUSTE RENOIR

If any modern painter seems a demigod to the world of today, it is Pierre-Auguste Renoir. I am sure that the beauty of his work—something to place beside that of the supreme colorists of all time—must make him appear more remote and mysterious than Monet or Rodin, his exact contemporaries. In genius he was impressive enough, but in person he was the simplest, most accessible of men. As I had written for the old *Scribner's Magazine* the account of that visit to Claude Monet, which occurred because of his friend's desire to have him see America and paint it, people encouraged me to try calling on Renoir. It appeared that no one had got him to speak for publication since 1878, when his brother, to help the painter to badly needed success, had written an article on him. Vollard and Meier-Graefe were preparing books founded on intimate conversations with the great artist, but their writings were not given to the public till some years after the time I speak of—1908.

It would have been enough for me just to have caught a glimpse of the man whose beautiful "Liseuse" I had copied in the Luxembourg, but when I presented myself at his apartment, in a quiet street of the Montmartre that he had always loved, he made me welcome, bade me stay, and expressed an almost boyish interest in the idea of speaking for an American audience.

Eager as I was, it took long before I felt that the material

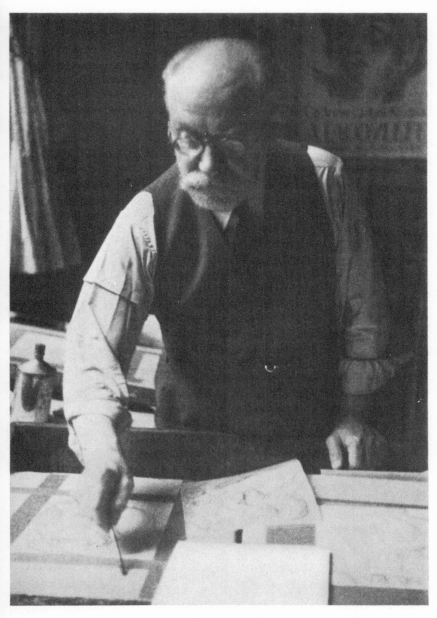

HENRI MATISSE *Photograph by Pierre Matisse*

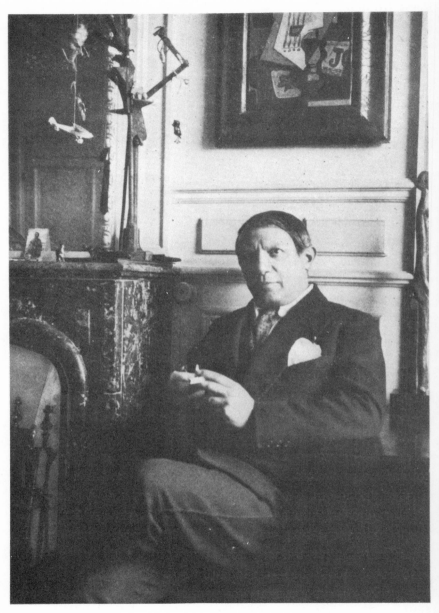

PABLO PICASSO *Photograph by Albert Eugene Gallatin*

PIERRE-AUGUSTE RENOIR

I got from repeated talks could safely be made into an article. There were other visitors, his son Pierre, already on the stage, and later one of the best French actors, M. Gagnat, the collector, who was devoted to him, and then Vollard, who was none too favorable to the idea of my writing. Once he suggested that, for my article, I simply interview Gabrielle, the model for so many of Renoir's pictures and, at the time, general caretaker of the household. She was a dear, as good to the old man as she was inspiring to paint; if we stayed too long, she would rattle the dishes or otherwise disturb him until we took the hint and left. Once she followed me to the stairs and asked if I could not do something to dissuade Renoir from working at the sculpture which he had begun on and which she feared would be too much for his strength. I was too happy at being received to dream, even, of telling the great man what he might or might not do.

Within a year or so afterward, his work in clay was ended by an increase in his infirmities. When I first knew him, he could still walk with the aid of two canes. Then the terrible rheumatism from which he suffered—often in the cruelest way—made all locomotion impossible, though he could still use his hands freely. Later on again, these were too crippled for him to model, though by attaching his brushes to a little clasp he continued to manipulate them, and with a mastery that actually increased until his last days, in December, 1919.

I do not know whether anyone has told in print of the production of the later sculptures, so I relate the wonderful tale here as his son Pierre gave it to me. Renoir had for so long had the ambition to work in the round, he was so enchanted with his progress in sculpture, that even when he became the "Raphael without hands" as Meier-Graefe called him in the last years, he refused to give up. Providentially, a young assistant was discovered, a Mexican, who was so sensitive to Renoir's thought that he could execute it in modeling under the master's guidance but

without a word being said, neither artist speaking the other's tongue.

A sketch on paper or canvas by Renoir would furnish the general set-up of the mass of clay. With a light wand the old man would indicate how the work was to continue, at one place making a mark on the *maquette* where the ready modeling tool of the young sculptor was to cut away an excessive volume, at another place showing by a pass through the air how the contour was to swell out by the addition of more material—which the nimble fingers of the assistant molded on until the desired form was achieved. Then the figure would be turned on its pedestal and would need trimming down to compensate for an excess invisible from the other angle. The wand would again travel lightly down the surface of the clay, the tool in the firm hand of the young man following and scraping to the desired depth.

"They communicated by grunts when the thing got so close to the definitive result that it grew exciting," as Pierre Renoir described the scene. "My father would say, 'Eh, eh, eh—aaah! ça y est,' and the sculptor would be making his little jabs with the tool, so much like my father's brush strokes that you'd think the work came from his hand, as indeed it almost did; and they would be working together so closely that the young chap would say 'Eh? eh? eh?'—only with a note of interrogation that made you feel he was responding to those other grunts and did not propose to go too far by the thickness of a cigarette paper."

Elie Faure wrote, in *La Sainte Face*, that he had seen two miracles in his lifetime. One was the Battle of the Marne, in which he fought from the beginning to the end, when the French, "covered with mud and blood," to use his words, turned in their retreat and hurled back the invading colossus. But a greater miracle, when he was on sick leave, a couple of years later, was the sight of the old Renoir whom he visited in the south of France. A mere cinder of a man, to such a state had his malady burned

him away, the fire in him glowed only the more clearly as he pierced below the outer dross of appearances and gave the world those supreme things of his last years. Like all the very great men, Titian and Rembrandt, for example, the deepest understanding of nature coincided with a grasp of the mystery of painting that only age could bring.

In Renoir's case the change in those last years was so enormous that if one does not know (or follow) him in that final evolution, one's idea of him is imperfect, even wrong. Vollard showed me a group of pictures dating from the last months of the master's life which reveal his moving on to an incredibly new vision once more. While they are still unknown to most people, enough of the late work has figured in exhibitions to tell how profound a genius underlay his painting. In the early years, it seemed just a homage to the beauty of nature, especially as revealed in women. But long before his death his art had far outstripped the impressions inherent in his models although, to the last, he depended on them for inspiration. If it was to Cézanne that we turned for the clearest demonstration of the esthetic properties of the picture, if, in his painting, they were more the result of conscious research, there was no doubt in the minds of artists that the same qualities sustained Renoir's glorious rendering of his subjects. Only, as he tells, his reliance was on instinct rather than analysis.

It was largely to find out about such matters that I went to him, and so my topics of conversation were indicated before I would make my visit. As I transcribed the record of my talk with Monet, I now give the salient features of those hours with Renoir, as I wrote them down each time at the nearest café, where I would go so as to let no new impression come into my mind and perhaps cause me to forget something. Try as I would, later on, I was never able to make an addition to the notes, which I merely joined together, as if all the talk had taken place on a single day.

"There are things about your work that we should like to know. When we find the colors in such perfect relation to one another, we wonder how you arrive at such a result. When you have laid in the first tones, do you know, for example, which others must follow? Do you know to what extent a red or a green must be introduced to secure your effect?"

"No, I don't; that is the procedure of an apothecary, not of an artist. I arrange my subject as I want it, then I go ahead and paint it, like a child. I want a red to be sonorous, to sound like a bell; if it doesn't turn out that way, I put more reds or other colors till I get it. I am no cleverer than that. I have no rules and no methods; anyone can look over my materials or watch how I paint —he will see that I have no secrets. I look at a nude; there are myriads of tiny tints. I must find the ones that will make the flesh on my canvas live and quiver.

"Nowadays they want to explain everything. But if they could explain a picture it wouldn't be art. Shall I tell you what I think are the two qualities of art? It must be indescribable and it must be inimitable. Take a thing like the Eiffel Tower. It's not art because it can be duplicated by anyone who has it described to him, and who knows how to make such things. But you cannot make any more Titians, and you cannot copy Notre Dame. There is the Pantheon at Rome; they thought they could make a copy of it in that votive church at Naples, opposite the Royal Palace, but the Pantheon is a great thing, and that church is a dead thing. So when they try to build like the Parthenon, they find that those lines which seem so straight and regular and simple are very subtle and hard to follow. The more they measure, the more they realize how much the Greeks departed from regular and banal lines in order to produce their effect.

"So in our Gothic architecture: each column is a work of art, because the old French monk who set it up and carved its capital did what he liked—not doing everything alike, as results when

things are made by machinery or by rules, but each thing different, like the trees in the forest.

"The work of art must seize upon you, wrap you up in itself, carry you away. It is the means by which the artist conveys his passion; it is the current which he puts forth which sweeps you along in his passion. Wagner does this and so he is a great artist; another composer—one who knows all the rules—does not do this, and we are left cold and do not call him a great artist.

"Cézanne was a great artist, a great man, a great searcher. We are in a period of searchers rather than of creators. We love Cézanne for the purity of his ideal. There never once entered his mind any thought but that of producing art. He took no heed of money or of honors. With Cézanne it was always the picture ahead of him that he cared for—so much so that he thought little of what he had done already. I have some sketches of his that I found among the rocks of l'Estaque, where he worked. They are beautiful, but he was so intent on others—better ones that he meant to paint—that he forgot these, or threw them away as soon as he had finished them.

"I so much like a thing that Cézanne said once: 'It took me forty years to find out that painting is not sculpture.' That means that at first he thought he must force his effects of modeling with black and white and load his canvases with paint, in order to equal, if he could, the effects of sculpture. Later, his study brought him to see that the work of the painter is so to use color that, even when it is laid on very thinly, it gives the full result. See the pictures by Rubens at Munich; there is the most glorious fullness and the most beautiful color, and the layer of paint is very thin. Here is a Velasquez" (he reached for a book of reproductions after that master, and hunted out a late portrait of the little Infanta); "it is a perfect picture. See that dress with all the heavy silver embroidery that they used in Spain at the time. If you stand away from the painting, it gives you the impression of the weight

of that dress. When you come close, you find that he has used only a very little pigment—a tone, and some touches for the metal. But he knew what the painter must do. Cézanne was a man of big qualities and big defects. Only qualities and defects make no difference. What counts is always that passion of the artist, that sweeping men with him.

"The person who goes hunting for defects is the professor. He thinks himself very smart when he says: 'There is a foot that is not well placed.' He finds them in Rubens and in Velasquez. I have always loved Giorgione's *Concert Champêtre*, in the Louvre. Once, as I stood looking at it, someone said to me, 'That woman's arms are too short.' I had never thought of such a thing. But that is what the professor thinks of. He does not see how the work of the master is made up of good qualities and of defects, how every part of the picture should be as it is, for it is impossible to take one part and say, 'This produces the effect.' If you observe the great painting by Veronese, the *Marriage at Cana*, you will find that the lines are not according to the rules of perspective, and he has made the figures in the different planes quite different from the proportionate size you would expect; but those people are in their place, everything has its true importance, and the picture is a great decoration. It is rare—that sense of great d coration. Rubens had it; Delacroix had it.

"If it had been that *Concert Champêtre* that was stolen instead of the *Joconde* I should have been more disturbed. Of our Leonardos I like better yet the *Virgin with St. Anne*—those two women, how feminine they are! And the mystery of that background! The *Joconde* is a great picture, but almost too beautiful. The Giorgione is unique, unparalleled."

"Have you found, M. Renoir, that your opinions of the Old Masters change much in the course of time?"

"No—only for some pictures it takes very long until one reaches the judgment one finally holds. With some pictures I do

not think that I realized their true beauty till I had known them for thirty years—the Poussins, for example. The greatest works reveal a new beauty each year I come back to them. There is the *Marriage at Cana*. I admired it when I was young; one can scarce avoid doing so; one knows that it is a great thing. But it was only at a much later time that I could feel I had something of an intimate understanding of it—of the way he has controlled the architecture of that enormous picture, and the way all those brilliant, even violent colors work together without a break.

"Titian is a man who always stays great for me. His painting is a mystery. Raphael's you can understand, and you can see how he worked (that doesn't mean that you can paint Raphaels). But you can't tell how Titian worked. No one ever painted flesh as he did. And then that *Virgin with the Rabbit* seems to have light coming out from it, like a lantern. It seems to rise above painting.

"There is nothing outside of the classics. To please a student even the most princely, a musician could not add another note to the seven of the scale. He must always come back to the first one again. Well, in art it is the same thing. But one must see that the classic may appear at any period. Poussin was a classic; Père Corot was a classic. When I was a student, Corot was unknown, Delacroix and Ingres were laughed at; the men considered great were Scheffer and Delaroche. That seems strange today, but it was really so. And the thing that corrupts taste is government patronage of art. Here is a case within my immediate knowledge. A rich banker had chosen among the most illustrious painters of his time to have the portraits of his family painted. These portraits are criticized, and he replies very sagely: 'I know about finance; I don't know about painting. If those portraits are bad, it is through no fault of mine, for I looked through the catalogue of the Salon, and chose the painter with the most medals, just

as I would do in buying my chocolate. If I had gone to the painter you recommended, people would say I was trying to economize.'

"The bad system begins in the schools. I was in all of them and all were bad. The professors were ignorant men; they did not teach us our trade. Even today I do not know whether my pictures will last. When I have noticed them yellowing, I have tried to find out the cause. I have changed the colors on my palette ten times and I cannot be certain yet that I have arrived at a choice that will yield a permanent result.

"Now this was not always so; it is only since the Revolution that the principles of the old masters have been swept away. Look at Nattier's pictures—how well they are preserved; then look at what follows and you will see what I mean. The Old Masters were taught each step of their trade, from the making of a brush and the grinding of a color. They stayed with their teachers until they had learned well the ancient traditions of the craft. And the tradition has never been an obstacle to originality. Raphael was a pupil of Perugino; but that did not prevent his becoming the divine Raphael."

M. Renoir once told me of a young frame-maker who applied to him for advice as to how he could make better frames. "I told him some things I knew about how the beautiful old frames were made, and he went off to have a try at it. Some days later he came back and said, 'Monsieur, I don't earn my nine cents an hour making frames like that.' 'My little friend,' I answered, 'when one is trying to advance, one doesn't estimate the progress by the number of cents one earns per hour. For twenty years my pictures did not sell, but I kept on with them. If my lunches were light, and my daily expenses very small, that was not the question that I considered. It was what I was doing in my painting.' "

One other little remark seemed to me to show the spirit of the man. "Sometimes I talk with the peasants down there in the South. They say their lot is an unhappy one. I ask: 'Are you sick?'

GUERNICA

Mural painting by Pablo Picasso, 1937, Spanish Pavilion at the World's Fair in Paris

Photograph by Dora Maar

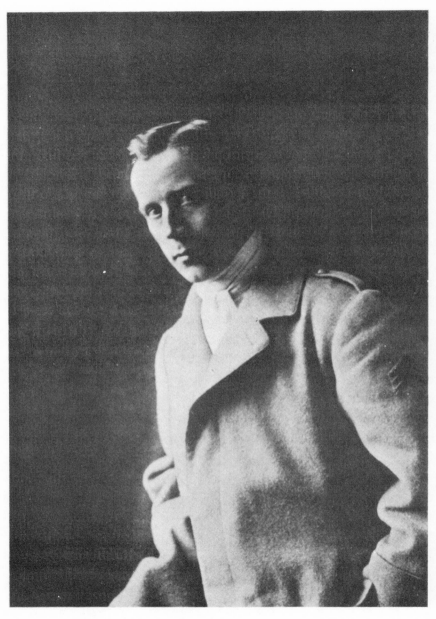

RAYMOND DUCHAMP-VILLON *Photograph, 1914*

'No.' 'Then you're fortunate—you have a little money; if you've had a bad season you don't suffer from hunger; you can eat, you can sleep, you have work that takes you out into the open air, into the sunlight.' What more can anyone want? They are the happiest of men, and they don't even know it. After a few more years I am going to leave my brushes and do nothing but live in the sun. That suffices."

. We may be happy that he did not carry out the momentary fancy of laying down his brushes. He never tried to; indeed, the last words he spoke were about arranging some flowers to paint, as he continued to do in imagination until that last little flicker of the divine fire in him went out with the word flowers—and no more fitting one could be thought of for his dying breath. It was the divine fire that burned in him, if ever a mortal had the Promethean gift, and that is why he could speak so convincingly about the great men. If I had got no more from him than the passage above about Poussin and Corot, where he begins with such simple certainty in his statement—"There is nothing outside of the classics"—my visits would have been richly rewarded. Indeed, I know no other words of his that seem to me so important, unless it be those in a conversation with Meier-Graefe that I have quoted more than once—and I make no apology for repeating it for the reader here.

Discussing with the German critic the matter of art study and condemning the schools, as we have just heard him do—and as we heard Monet do—he sets Meier-Graefe to questioning what the alternative would be. "Nature?" He hesitates; Cézanne and Monet, among his old comrades, had always talked of studying nature. Finally he speaks out, bravely refusing the great word: "No, nature brings one to isolation. I want to stay in the ranks."

"But if it is not before nature that the young man becomes an artist, where is it?"

"Au musée, parbleu!"

QUEER THING, PAINTING

That faith in the Museum was not more typical of the man—nor more French—than his wanting to stay in the ranks. To the end he remained the simple workman—like Barye. I have always loved the story which Charles de Kay tells about the burial of that glorious sculptor. A couple of years before his death he had been elected to the Institute—which meant that its representatives would attend the rites for him. The procession was also "graced by an escort of soldiers." Numbers of the most celebrated painters were present. "But these might have come to the funeral of any distinguished artist of their acquaintance. There were other mourners on the Quai des Célestins that day.

"The French workman was there in his blouse, but in scattered groups. He did not make his appearance in force until the march to the grave was taken up. Then the blouses began to issue from workshops and factories until it was plain to the world that somebody more than commonly dear to the artisan world of Paris was passing to his last rest. The artists conducted Barye but the artisans followed. They knew that in him the highest rank of the artistic career had been entered by way of the jeweler's bench and the foundry. . . . They knew, of course, that Barye was well thought of under the Napoleonic revival of 1852. But they were also certain that, as in the origin he had sprung from the people, so to the last he had remained a people's, without ever becoming a popular man. His head had never been turned by honors and favors from the great."

The latter statements are true of Renoir. If, in his case, I cannot match the story of Barye's funeral, I have a memory that is to me just as fine. In October, 1914, when the Germans were still but a short distance from Paris and the people were anxiously scanning the military bulletins that were posted at intervals, I saw a small group of workmen, in the same blue blouses as those of Barye's time, standing before an art dealer's window to look at a Renoir. At a moment of tension they were enjoying the beauty

of his picture, whether or not they happened to know that he was of their class. He was so, and to the end he kept by him some objects in porcelain which had been the craft through which he came to art, as the casting and chasing of precious metals had been Barye's approach.

Renoir stayed "in the ranks" then, and his talk continued also to have the raciness of the people—even as it kept the flavor of the rough Bohemian studios of his youth. He loved good cooking and good wine and good cigarettes (like Monet, sticking to the Caporal tobacco that everyone in France can buy). The love of Wagner's music, of which we have heard him speak, made him follow the composer to a retreat in Sicily in order to paint a sketch of him—all he was given time for, but a precious thing even so. Of course the great passion of his life was what was to be seen au musée, and to the end he regretted that he had never been able to visit Greece. But like Barye again, whose art descends from that of Athens in a way that I think I have proved (see *L'Amour de l'Art* for November, 1932, if you are curious), like Delacroix, whose painting is likewise to be related to that of the Greeks, Renoir showed more and more, as he advanced in years, that he belonged to that purest line of the European genius. A short life, like that of Seurat, might give us the noble and rich art that he produced, but it has not the rounded perfection of Renoir, who, as we know, aspired to go on even more.

IX.

HENRI MATISSE, PABLO PICASSO, GEORGES BRAQUE

———

THE "PLUS ULTRA" OF RENOIR BECAME THE NEED OF OTHER MEN, consciously or unconsciously. The period was being hurled along by the impetus of the older generation and the responding strength of the newcomers. How could an American, whose country had for so long been out of touch with the great modern effort, understand the movement with which Paris was seething? Only a few Parisians, mostly artists, were abreast of the new ideas. Someone said at the time, about Matisse, "He would have starved anywhere save in Paris, and he came near to starving there." One important reason why he did not was the Stein family, the household in the Rue Madame—Sally and Mike Stein, and the latter's sister and brother, Gertrude and Leo, in the Rue de Fleurus. To be sure, a number of the best artists in the city were saying that Matisse was the big man, Vollard had given him a one-man show, moved by the same sensitive reaction to the ideas of talented advisers that had made him take up Cézanne. And there were small dealers who swore by Matisse. Yet it required a very real perspicacity on the part of Mrs. Stein and then the others of the family to see his merits.

I first met him at their villa at Fiesole. He had been seeing the Giottos in Padua and was in awe of their simple grandeur. He ran down to Arezzo for a day and returned with enough admira-

THE LOVERS

By Raymond Duchamp-Villon, 1913

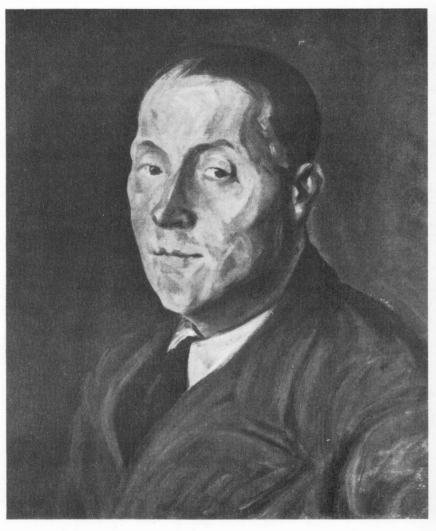

JACQUES VILLON *From the portrait by Walter Pach, 1932*

tion for the perfect art of Piero della Francesca to last a lifetime. Indeed, it may not be mere fantasy to see those two contacts as offering definitive ideals to his work: sometimes he will run on with technical achievement so consummate that people think he has surrendered to the pleasure of an always more facile *tour de force*, but sooner or later, his seriousness drives him back to memories of the Romantic, expressive art that utters its deep cry in such a work as Giotto's *Death of St. Francis of Assisi*.

It was such a tone again that came from the throat of "the wild beasts" as Matisse, Rouault, and the others were nicknamed. I have a distant mental image of Rouault's pictures at the first Autumn Salon I saw, that of 1905, but I cannot recall an impression of Matisse—probably because he made none on me. His work was just too incomprehensible for one of my background, at the time. It was only when I settled in Paris for my first long stay that I had the necessary opportunity for repeated seeing of the things and for a relating of them to arts that could explain them, where before I was holding to the masters of chiaroscuro—a technical element of no use to Matisse in his investigation of pure color. It was a help then, though I was obstinately slow about accepting help, when Sarah Stein made a comparison between the color in Matisse's work and that in the enamels of the Byzantines.

The generation of today should have an easier approach to such an art, for it has the opportunity to know the great color of Byzantium through the marvels in the collection which J. Pierpont Morgan gave to the Metropolitan Museum. Not only were they not there during my early years, but nothing of their ideal was considered, in America or elsewhere, though it was foretold by the clarity of Renoir, above all; once more we see how profound was his understanding when he assigned to the Museum its rôle as the teacher of art.

Of course he did not mean only the things already in the great

galleries: a work has the same qualities whether it hangs in the Louvre, in the shop of a *brocanteur*, or in the house of collectors of the vanguard, like my friends. I remember how, in 1912, when I had left the Steins' apartment in the Rue Madame with Arthur B. Davies, that extraordinary appreciator made a respectful bow to them—on the other side of the door. And indeed it was an immense service they rendered—not so much to Matisse and Picasso —as to the innumerable visitors who came to know the work of those artists at the Saturday-night gatherings in both the Stein households. If Gertrude and Leo have since gained fame by their writings, it is to the other side of the family that go some of the most grateful memories of those days.

They were such stirring days that I wrote about them to Guy du Bois, who had been my schoolmate in Henri's class and who was, at the time, the art critic of one of the New York papers. He replied with an urgent request for an article on Matisse, and I set forth to renew the acquaintance formed during the preceding summer in Italy.

The painter's studio on the Quai St. Michel, overlooking Notre Dame, had things to show that helped me not a little to understand what he was driving at. His own explanations of his evolution supplemented the works, first the ones of a naturalistic type, then the ones making a close analysis of color, that he had pursued according to Signac's method of breaking up the tone into its component hues; later on the new synthesis of them, which he had accomplished under the inspiration of van Gogh, principally. So far I could follow, but the stage he had reached at the time, that of Expressionism, as the Germans called it, was still baffling for quite awhile. It was one thing for me to feel the passion of Giotto (or some of it) before the frescoes in Florence, it was an entirely different thing to recognize the emotion in this unfamiliar conception of the picture.

Even so my article was not too bad, as I still think and as

others have said, and it might have been published had I not accompanied it with photographs. As du Bois told me afterward, once the editor got his eye on those, he decided very sharply that such insanities were "unavailable"—even for the sensation-loving pages of a Hearst Sunday supplement. There had to be at least a semblance of intelligibility to things.

When I reported this to Matisse, in somewhat more circumspect language, he merely smiled and shrugged his shoulders. He knew the value of his work and could wait for it to triumph—as he was certain it would. Perhaps the Flemish strain in him (he is from the northeastern corner of France) gives him his almost phlegmatic patience with people. I say this though I have little faith in racial traits as explanations of character; but in any case his good humor was undisturbed, and our relations continued most pleasant over the years during which I went at times to the Monday afternoons when he received at his studio.

I often wonder what it would have meant to my work had I had the sense to profit by his atelier, during the short time that he accepted pupils. They were the cause, very largely, that I did not go to his school. That looks like a bad reason today, but they were (with exceptions) a bad lot, the wild-eyed type—largely non-Frenchmen—who apparently looked on Matisse as crazy, and who wanted to be the same way.

In vain he would explain to them the steps by which he had reached his art: his years at the Ecole des Beaux Arts and then under Gustave Moreau. The latter had sent him to the Louvre, where he had made admirable copies of Philippe de Champaigne and Ruysdael, Chardin and Barye. (Years after the time I speak of, one of his largest and most "daring" compositions turned out to be merely an adaptation of an old Dutch still-life, a de Heem, just as, a couple of years before, a picture that the jury of the Salon had rejected was built around the *Bacchus* of Leonardo da Vinci.) It was in vain that he recommended the students to

draw from the Mars Borghese, after he had obtained a cast of that severe masterpiece for the studio. The neophytes were convinced that he was holding back something, that he had some private device for getting the effects which set Paris by the ears. Unable to cope with such misunderstanding, Matisse closed the school.

Speaking of one of the most assiduous of his former pupils—who had, however, turned ingrate and was speaking ill of him—the artist said: "I never had any resentment about that; what made me furious, what made me ashamed of my stupidity, was the thought that I had been so simple-minded as to believe myself capable of making something out of nothing—which, all the time, is what I really knew him to be."

In the earlier days, when Matisse's position was one of notoriety rather than fame, visitors often appeared at his studio on reception days to see what he really looked like. They were always reassured by his appearance. His big forehead, serious-looking eye-glasses, and full, brown beard caused him to be nicknamed "the German professor," before the war. And then, he was married, had three children, lived in pleasant and comfortable surroundings, without any terrifying objects about; indeed I remember seeing a copy of Plutarch's *Lives* on the table, and it looked as if it had often been read.

The contrast between such things and what might be expected of a "wild beast" would sometimes embolden a caller to reveal something of his previous notions. "We find you so different from what we expected, M. Matisse; in fact it has really been a pleasure to meet you. There is just one thing we don't understand yet, and that is your pictures. Would you mind explaining them to us?"

Without a twinkle of his rather heavy eyes M. Matisse would assure them that nothing could give him more pleasure than to explain his pictures, only—

"Only, you see, I want my explanation to be of some use to you. One can say so many things without really clearing up the mystery of an art. So won't you help me by letting me know the type of explanation you would find useful? For example, there is the painting of Rembrandt. Do you like that?"

"Oh yes, indeed!"

"Splendid! I do, too; so I shall be the more able to follow when you explain to me what you find good about it. Then I shall have a sort of model in giving you the account of my own work. Now what makes you like Rembrandt?"

"Why, it's because his pictures are so wonderful, because they are beautiful!"

"But you are not explaining. You are merely asserting things. That would not clear up the difficulty if you were speaking to a person who did not understand the pictures already. Try to make the matter plain to such a one."

"Well, it's so simple: the work of Rembrandt is deep, it is noble—that light and shadow—those rich colors, those . . ."

But at this point the visitor would probably become aware that his flounderings really had advanced the solution of the problem by not so much as a hair's breadth, and would let the matter drop.

Matisse's fundamental belief is that there is no such thing as essential change. Appearances change, men learn certain things (we were speaking of the early work of Cézanne as compared with his late painting), but the man is the same, and it is the man that counts. He showed me his first picture, a thing he did in the small town he came from, and at a time when he had never met an artist. A book had given him certain rules for composing still-life objects into a design, had told him what colors to buy, and the effects of their combination. His result was an "old-fashioned" imitation of a bit of nature. The canvas remained at

his home until after his father's death, when it came to him with other household effects.

"Shall I tell you what I thought when I got that picture again, after thirty years without seeing it? Well, I felt a discouragement such as I have rarely known. It seemed as if I had not made one step of progress. Every quality I have ever obtained is in that canvas, at least in embryo. And when people speak of certain arts as primitive, they simply show their insensitiveness to the grand expression in such work; if they saw that, they would realize that the form and color were perfect in their relationship to the idea of the race. Here is a masterpiece of Persian ceramics," and from its bed of cotton in a box he took a small glazed object; "It is in monochrome, but do we miss the display of color that other Persian works offer us? We do not, because the design that is so delicately incised here tells us everything that the art of the country had to say at that moment.

"There are times when even very great arts are unacceptable to us, because we are pursuing some line of development in which they have no place. How grateful I am to Courbet for reorienting me in the Louvre! It was memories of old days there that made me buy these, and now he brings me back to Rembrandt."

"These" were two particularly glorious Courbets that the painter had acquired with the first large sums that he earned, a study for the *Demoiselles de la Seine* in the Petit Palais, and a *Sources de la Loue* similar to our own great picture from the Havemeyer Collection. People hostile to Matisse (a type far rarer now than at that time) seized on his buying them as a sign that he had never been in earnest about his own painting, that he would soon be doing "serious" things like Courbet. But he continued along a line as straight as ever, only, as he said, it was now quality of color that interested him, whereas his need to clear out blackness (which age, chiefly, had given to the Old Masters

he had followed) had previously made him resort to quantity of color.

If his development has indeed followed a single and personal line no one can say that his course has been a rigid one. He investigated Cubism not simply through repeated seeings of the work of Picasso and Braque nor through discussion with the painters who frequented his studio, but through experiments of his own along the lines worked out by his juniors.

But their formula was not for him. When I described the inclusion in one picture of various elements of a scene, as one of the Cubists had told me he had put them in, the separate times and places being accounted for simultaneously, Matisse answered: "I call that materialism. If your man saw his subjects with sufficient clearness and intensity, his vision would be rendered in such fashion that the spectator would feel every element composing it. He would not be puzzled with all those crossings of line and planes."

"Such things have been used in art a thousand times," I reminded him; "see how much they constitute the effect of architecture and . . ."

"But we're talking of painting," interrupted Matisse, and I think he was right there. One goes off to analogies with other arts when one breaks down on material for discussing a subject in its own terms. But then, as Préault said so well, "One never discusses art save with people who are already in agreement, and then it is a matter of nuances." To one of Matisse's deep-rooted faith in the unchanging character of things, the mind of Picasso was particularly disturbing, for the Spaniard made the most radical changes—and constantly. The two men were unconscious rivals for leadership over a number of years; or let us rather say that it was public favor that fluctuated between one and the other, for each was interested in his own work almost to the exclusion of worrying over what the other was doing. Still, the acclaim of one's

contemporaries is a matter that the artist can scarcely be indifferent to, and there is never a lack of gossipy persons to report what dealers and collectors are saying. That does not tend to concentration on one's own work.

As the years pass and Matisse's position becomes more and more secure, he withdraws, progressively, from the bickerings of Paris, and lives most of the year in the south of France. The climate and the quiet there permit him to work with the regularity that is the painter's ideal, and when he comes up to the capital it is for short stays, visits with old friends, a few exhibitions, and the Louvre. Lately he had a cast made there of a very early Greek figure that he wanted to keep by him, and that was doubtless an influence on some recent sculpture of his own. It is the finest and most complete sculpture he has ever done. On one piece he told me he had been at work unremittingly for a year. To the hasty observer it might seem a mere sketch, but then the hasty observer, whether a mere outsider or some little man of his own profession, is of less interest to him every year.

As I have said, there are spells when he is content to let off steam in a series of lightly handled works, the reflex from such intensive study as we have just seen him giving to his sculpture. "I should be exhausted if I kept that up all the time," he once said, "even as I should be emptied if I did not go back to things where I can charge myself again by digging in." So the little men can have their little say, every few years, about his "decadence." Having wormed out of a visitor the name of one such critic of his work, he laughed and said, "Oh, if you knew what I think of *his* pictures!" It is a period when one must preserve a fund of such indifference, and yet—and yet things are happening and one must not be premature about shutting one's mind to the developments round about.

On this score I am reminded of the first time I talked to Picasso. It was at the Steins' and we were looking at a big Matisse

on the wall. "Does that interest you?" asked Picasso. "In a way, yes" (this was on one of the first occasions when I saw such work), "it interests me like a blow between the eyes. I don't understand what he is thinking." "Neither do I," said Picasso. "If he wants to make a woman, let him make a woman. If he wants to make a design, let him make a design. This is between the two."

And so the alternatives were established: nature or art, Picasso was already started on his quest for art—as opposed to nature. "All our work is a lie," he said, using the word in its Spanish sense of illusion, "a lie that renders things more truly than when we tell the truth about them."

He had been through a schooling that gave him his phenomenal ability to "tell the truth"—i.e., offer naturalistic representation of things. At the age of twelve he had his diploma from a severe academy in Spain, having satisfied the professors as to his full knowledge of anatomy, perspective, and the rest. At fourteen he had painted important pictures, and I know of no parallel for that in art history. Other men have done magnificent drawings when they were boys, but painting is a more complicated business, and to have done what he did at that early age meant that he was a prodigy, a thing rare in painting—which thereby differs from music.

Precious years on his own soil fixed Greco and Goya as lifelong ideals for the young Spaniard. At first he followed his ancestral masters literally, doing Grecoesque old beggars, like the *Blind Guitarrist* now in Chicago, and Spanish types and scenes of the more earthy quality, recalling those of Goya. But as the years went by and he saw more deeply into the nature of art, the influence of the two old masters who are so specially his own became more a thing of essences and principles. Cubism with its rejection of the world of material appearances may be said to derive, spiritually, from Greco and that mysticism of his which

made Catholic Spain take him away from the opulence of Venice, for he brought with him the clear memories of early Christianity, the result of his years with the Byzantine painting of his native Crete.

The power of expression thus transmitted to Picasso relieves his art, even when most "abstract," from the reproach of being merely decorative and, fortifying it still more along these lines, is his heritage of Spanish realism. One sees it again in the man he once described to me as "somewhat his pupil," Juan Gris. I met that fine artist but once, yet I felt the intensity of his spirit, the absolute purity of character which kept him from compromise, and so delayed his acceptance by the buyers—whose slowness, in his regard, was partly the cause of his too early death, to which the privations he underwent contributed grievously. In him, one sees the realism of his country as one does in those colored sculptures of ascetic and haggard saints, whose eyes of glass turn heavenward in their moments of vision.

With Picasso the relation to reality is somewhat more along lines of human character, as it is with Goya, and already a number of writers are commenting on the parallelism between his etched protests against the iniquity of the present civil war and the terrible plates in which, a century ago, Goya cried out against the bloody "disasters" due to the invaders of that time. I know only by reproductions the mural in which Picasso tells of his country's sense of outrage over the destruction of Guernica by Franco and his foreign allies (or employers), but in its tragic epitome of heroic resistance to the brute—shown as a savage bull—it may well be the greatest work of the artist's life so far. It certainly contains so much of faith and power that, in itself it is sufficient to clear our period of any charge of lightness or of defeatism that could be brought.

Among the hundreds of thousands in Paris who visited the Spanish pavilion at the World's Fair of 1937, the number of per-

sons who were swayed from Fascism by Picasso's work is open to a certain doubt—one which will, of course, never be resolved. For a great majority, probably, the strikingly new formula of the artist was a barrier to understanding. In their case his style defeated his purpose, at least for the time being: it often occurs that a work of art—even though incomprehensible—remains in the mind, and produces its effect years later, when people are apt to remark that it was not the same as when they first saw it, transferring to the object under discussion the change in themselves.

It is certain that great numbers of people did get a tremendous impression from the Guernica picture and, as they include the artists (who would not have responded to propaganda painting of the photographic sort), the work may well accomplish more, through its enlisting of a small army of supporters and interpreters, than it would have done had it thus been immediately intelligible to the crowd.

Picasso's earlier painting has had such a history. Personal as it is, the principles it contains have been accessible to artists in every country of the world, and not less than thousands of them show its influence or that of the man's associates and imitators— of whom the list is a long one in itself. A marked man in his own world, even when he was passing through years of bitter poverty, he is extremely conscious of his position and, while nobody can be more amiable, even cordial than he, one does well not to deceive oneself about his delightful manner. It is his means of paying off in advance the people who would get something from him in the way of pictures or ideas. Of the latter he has apparently an inexhaustible supply—and he is frankness itself in admitting that he often gets them from others. His work would tell that to anyone who knows not only his two Spanish forebears but Puvis de Chavannes, Cézanne, and van Gogh, not to mention the men of his time from whom he accepts freely. A certain group of his drawings bore inscriptions in his own writing: "In the manner of

Redon," "In the manner of Toulouse-Lautrec," etc. And as to the men around him he will say, "Since I give them so much, isn't it right for them to give me something?" Unquestionably it is.

Sometimes, however, one has a feeling that he goes too far along these lines, that his work is too much a matter of transposing what others have done. But very great men have had such a characteristic. Delacroix accepted with complete freedom the hints—or more than the hints—of Rubens and of Géricault. Ingres drew so heavily on Raphael for the Madonna of the *Vow of Louis XIII* that he felt constrained to answer criticism as to the picture, saying, "It is mine; I have put the mark of my claw into it." For truly original artists the matter of originality is one that preoccupies them the least. If Picasso has the quality which the French call *muséal* in works of the "blue" and "pink" periods, if Braque and others replace the *Musée* later on, no one can look at an ensemble showing of his work without a conviction that it is profoundly his own.

The mind that made it so is as quick about general ideas as it is with the specific ones he picks up for his painting. Questioning me once about a difficulty I had had with a certain critic, whom I will call L., he got the quotation from the latter which I had objected to: that Cézanne was of no more use, a sort of "squeezed lemon," to be exact. "Well," said Picasso, "if Cézanne is a squeezed lemon, you may be sure that M. L. has never had a taste of the juice."

And that is where the difference from his own case shows so clearly. He has tasted the juice not only of Cézanne, from whom he got the fundamentals of his idea of construction, but one after another of the men before or around him has furnished flavors or even solider material for his astonishing product.

To sum up the case, I will repeat a sentence that Braque once spoke to me in discussing those early days of Cubism when he and Picasso were advancing step by step together. Telling of times

when they would go over the works that were accumulating at the back of the little shop kept by Kahnweiler, the brilliant young German who before the war (as he is today) was defending their art and that of Derain and Vlaminck, Braque recalled more than one occasion when he or his friend would be puzzled about a picture, and one would say, "Did you do this or did I?"

Braque can afford to tell that today when his art and Picasso's have come to stand a safe distance apart. The big frame of the Frenchman never could have been mistaken for that of the little Spaniard, and even less could the latter's nervously mobile features have seemed akin to those of Braque, who radiates calm and good humor, even as his pictures seem effortless in their reliance on the good ground of France and the logic of all the solid men who have built upon it. But the fact remains that two painters seemingly so different could work together in genial harmony.

It is because of the impersonal nature of the art on which they were engaged. Often one has difficulty in saying at once whether a given canvas is by Monet, Sisley, or Pissarro (and that must have been far more true back in the 'eighties, when the things were done). For the same reason Braque and Picasso looked alike: the intellectual content of both schools occupied the artists, and only when they had sufficiently mastered the technical problem did their personalities give a special aspect to each one's work.

Picasso keeps careful note of the stages of his research. "What is that—your signature in Chinese?" asked Gino Severini one day as Picasso was showing us certain recent studies bearing marks of a somewhat cryptic appearance. "No," replied Picasso; "that is a shorthand I have for the day, month, and year, so that I can get these things back into their exact order, if I have to look over them some time and have lost track of what I was working out." So that with his Spanish mysticism there is logic, organization, the thing that made the *conquistador* sweep over the New World

when, after his heroic voyage into the unknown, under Columbus, he fought his way to mastery of the splendid empire of Mexico. No wonder, then, that a modern Mexican, Diego Rivera, should call Cubism the greatest advance in our thought of art since the time of the Renaissance.

X.

JEAN LE ROY

———

If it was painters who, most of all, expressed that move-
ment of the world's mind that Picasso and Braque initiated (after
getting a strong hint for it from Derain), the thing was too much
a matter of the general need to be confined to the graphic and
plastic arts. Before me is a poem dating from the early days of
Cubism and, as I have no command of the technique necessary to
translate it into the only form which could do justice to its ideas—
its own form, that is—I reprint it in the original. It is by Jean
Le Roy, of whose writing Picasso retains the warm memories
that go out to an early comrade-in-arms, for the poet was recog-
nized by painters and sculptors as representing their own ten-
dency—that of finding in an intensified statement of the mere
existence of things a sufficient motif for the work of art.

Relief des choses

Pour le plaisir des yeux,
la petite cité qu'on peut voir tout entière,
arrange en gradins ses maisons de pierre
sur quatre plans
comme un groupe figé devant le photographe.

Des lignes s'enfuient,
des lignes s'avancent,

des lignes reposées s'étalent
horizontales,
d'autres dressées en l'air s'élancent.

Des courbes parfaites
de courtes fenêtres
paraissent rouler d'un mouvement éternel;
des angles grêles
mêlant des lignes qui passent
écorchent la part d'espace
donnée à mes yeux.

Des surfaces s'allongent
tendues comme des linges,
des blocs se carrent.
Et le volume des maisons
s'incarne et s'incruste fort et profond
dans mon regard,
et s'y installe
comme dans un mur un moellon.
Le relief des choses me mord
net et brutal.

D'un large toit en pente, sort
une fumée qui s'insinue subtilement dans l'air diffus.
Mais ce corps qui est moi, ce corps se sent aussi
un relief dressé
Sur le sol où pèsent mes pieds,
mon corps se pose et prend sa place.
Je suis un morceau d'univers
comme un mica dans un granit,
et si dans cette chambre ronde
où l'air se moule autour de moi
mon corps chaud venait à manquer,
un vide existerait au monde
dans l'espace déconcerté.

JEAN LE ROY

Ainsi pénétrant de toute leur masse
au coeur même de mon regard,
les choses du monde se gonflent.
Ainsi, au coeur même du monde,
volume clos qui prend sa place,
je présente mon corps et le dresse et le carre.

O solidité des trois dimensions,
ô plénitude et profondeur de toute chose!

During the war I read these lines to a group of French artists who did not know the work of Le Roy. They immediately recognized the kinship of his ideas with their own, and were pleased at the new confirmation of their own idea that a geometrical, impersonal rightness was the demand of the time. Of especial interest to them was the fact that Le Roy was hardly more than a boy, twenty years younger than they, on an average. If it is a great encouragement for the artist, in his early stages, to get the approval of older men, it is also precious for the latter to find that the new generation has an intuitive perception of the matters that were laboriously worked out by themselves. As in their own case a "modern" form had been arrived at through a logical evolution based on the classics of their race. When a crack-brained attempt to discredit Racine had been made by a writer of pseudo-revolutionary tendencies, Jean had been a leading participant in the meeting at the Odéon which spelled the failure of the abortive idea. Not hostility to the great past, therefore, but an eager pride in it and deep understanding of its essential elements underlay the writing of "Relief des choses."

Chance had thrown me into the way of knowing that poem and its author. In 1910, my evenings being free, I decided to look into a night school where one could, without expense, study all manner of interesting things, my choice being for courses in literature, composition, and public speaking, as an aid to my knowledge

of French. I discovered that the school occupied the building of
an abandoned convent in a very poor part of the city and that it
was conducted not by any government agency but by one of the
two groups of volunteer teachers, who for the last hundred years,
nearly, have been giving free classes to people who would not be
reached by the regular system of the city. And so I found myself
among young working-people of both sexes, peasants doing their
military service, dressmakers, office assistants, and the like, beside
some older people—a watch-maker, a carriage-painter, and a post-
man, I remember, who wanted to round out the more or less de-
fective schooling of their earlier years. They read at home, they
worked in the classes, and they discussed the problems of the
different courses so ardently that nearly every evening, well after
closing-time, the janitor had to turn out the lights on them to clear
the building.

Once I took a Norwegian diplomat to visit the school. He was
in bad humor about Paris, having had one disagreeable experience
after another with its men and its women. Yet he knew the
fascination of the city—and could not reconcile it with the un-
worthy character of its inhabitants, or such as he knew of them.
The evening in that poor quarter opened his eyes. For after hear-
ing a classic play analyzed and fought over with vivid intelligence
by that crowd of simple folk whom he would never have en-
countered otherwise, he said, "Now I know what makes the beauty
and strength we all feel in Paris."

And it was in that school that I first became aware of the
genius of my friend Jean Le Roy. I had known him as the young
nephew of some people I used to visit, just a high-school boy who
got interested in my account of the people I had discovered in my
evening class. Finally Jean went along to it and, himself taking
part in the discussion, was at once recognized as possessing the
clear mind, the swift, strong sense of logic and significance that
he was later to show in his writings. His first accolade for the

qualities came from these working-class students, and it was only confirmed when he met a more sophisticated public, as he soon did.

There was a cabaret, in those pre-war days, that kept up the old tradition of such places. For the cabaret as a species of theater with hired entertainers is a comparatively recent development. Formerly it was a place where poets and musicians forgathered to exchange ideas and get an audience, picking up what material advantage they could, often just food and drinks—with always the hope of reaching outside patronage which would pay. That was the character of old Frédéric's place, and it was astonishing that it kept up amid the commercialism of twentieth-century Paris. The walls were crowded with paintings and drawings by the artists who came there; among them was a fine Picasso of his early Bohemian days, and when Frédéric finally sold it to a German picture-dealer, the price he got was a thousand times what it had cost him in hospitality to the painter, some ten years before. No one grudged him his profit, however: he really was hospitable, and he really did appreciate talent.

He saw it in Jean Le Roy the first time the boy entered his smoky establishment. Being informed that the new visitor wrote poetry, he called on him to recite. Jean got red and looked anxiously toward the door. But it was too far away, the place was crowded, and there was no chance to hang back (when old Frédéric called on anyone he just had to do his stuff). So Jean rose from his seat, part of the way, and in a half-stifled voice spoke some of his verses. A round of hearty applause from the whole crowd was the answer, and when Frédéric called for an encore Jean stood up firmly on his feet and his voice was steadier as he recited a second poem.

A few minutes later a gentleman stepped up to our table and, with excuses for his intrusion, asked Le Roy if the two poems he had spoken were published anywhere. Jean got red again as he

said that it was not. He might have added that he had never sent his work to any magazine or publisher. The gentleman then produced a visiting-card on which his name was followed by that of a minor but well-considered review, of which he was the editor. "Of course we can't pay much for your work, but if you cared to publish those poems with us, we should be very much pleased to have them." And so, on the same evening, Jean Le Roy found his first audience and his first publisher.

Just before the war the things he cared for had so far grown in number that there was enough to fill a slender volume. It appeared, paper-bound, under the title *The Prisoner of the Worlds*. The prisoner is Adam, referring to a line from Verhaeren, the great Belgian being at that time a particular admiration of Jean's and having written of Adam—man, that is—living as a "captive in divine chains." If the compliment to the veteran is to be taken as at all explaining the letter of praise which Le Roy received from Verhaeren, no such reason applies in the case of Maeterlinck, who also sent lines of warm encouragement; it had nothing to do with Gustave Kahn's article in a powerful literary review, where the eminent critic declared that a new genius had arisen. And, best of all, Debussy wrote Jean a letter. One of the poems of the *Prisoner* had taken as its theme a composition by Debussy, and the latter wrote, "I look forward with joy to the time when it will be I who shall inspire myself for my work from yours."

Now when things like that are written to a young fellow still at law school, they tell of what goes on in a Paris no mere tourist ever gets a hint of. He might better get it at home, where, quietly reading the work of the good French writers, he might suspect that their excellence is due, in part at least, to a solidarity of talent, the older men welcoming eagerly new recruits of merit, the young fellows well knowing which of the older generation are their masters. And on the whole, that is the case, with respect to both the seniors and the juniors; and the same holds true when

we consider the painters. There are envy, injustice, and misunderstanding, to be sure, but those unhappy things diminish in just about the proportion that we get to the men at the head of their professions. Once we reach them, we find people who see that their job is not to fight against other people, but against the difficulty of their esthetic problem. That sometimes makes it hard or even impossible for them to recognize success along lines too far from their own, but it generally makes them feel the excitement of coming upon the fire of talent.

Jean Le Roy furnished that excitement. But then, very shortly afterward, the world was swept by another sort of fire—that of the war. While in training for his position as an officer, Jean wrote of the War, and he still did so when he got to the front, as he had been eager to. A year or so before, in one of the poems of the *Prisoner*, he had described a great line of men reaching back into the dark past, another line going out to the blinding light of the future, with, between them, the present, his own generation, like an arrow at the angle of a tense bowstring, ready to launch into space. Well, they were launched now, and he was of those who were not to return. He was the greatest single loss of the War, I think, with Duchamp-Villon who died in it shortly after he did.

At first we had only the bare news that Jean had fallen during the big German attack on Mont Kemel in the spring of 1918. So many of his regiment had been lost during that sustained offensive, almost the end of Hindenburg's desperate attempt to break through to Paris, that it was long before we got details. Then came a letter from a man in the company Jean had commanded after his captain had fallen. It told that Jean had kept their machine-gun in action as long as his ammunition held out, when, new supplies being impossible to obtain and the enemy still advancing in great numbers, he had ordered his men to save the gun while he and a few others covered their retreat. As the writer of the letter withdrew, he looked back at the dwindling group of

comrades who were assuring the escape of the rest with the precious *mitrailleuse*, and he could see the young lieutenant, a revolver in each hand, firing at the oncoming invaders, until he fell with a bullet in his forehead. He was the gentlest, most sensitive boy I have ever known, but it is not uncommon, apparently, for such natures to reveal also a strain of the heroic, when the hour of need comes.

During the first years of the conflict he had written, "I am sorry for those who have not seen war," and the sentiment was echoed years later, by that young American who said, on hearing a veteran's plea for peace: "Your generation has had its war. Why shouldn't we have ours?" Le Roy gave the answer to that boy, and to the boy he once was, in a poem, "Flesh and Steel," that he wrote toward the end of his career. It tells of a heedless child pulling a grasshopper to pieces and watching it squirm as he tears off a wing, a leg, and finally the head. In the same way, said the poet, the war was cutting, with "monstrous ease," through the young bodies of his friends. And with that ugly image went memories of Paris, and walks and talks on the asphalt of its streets. Often they had led us along the Seine, past the Morgue, where a poster on the wall had sent me to the quiet evening school which had encouraged Jean in the writing that gave his name to the world. And now that the world is moving toward a new choice between peace and war, it is worth while to recall a big man whose death was—even so—only an infinitesimally small part of the loss in that last orgy of destruction. Everyone knows the magnificence with which men rose to their part in the fighting, and the new generation could do the thing again. So it does not need to prove itself. What is hard to know is the quality of people who in the everyday activity of peace time are building up their city through the things—like the genius of Jean Le Roy—that are burned down in war.

XI.

THE THREE BROTHERS:
RAYMOND DUCHAMP-VILLON, JACQUES
VILLON, AND MARCEL DUCHAMP

―――――

I HAVE MENTIONED THAT OTHER GREAT LOSS OF THE ACCURSED War years, and so I shall tell now of Raymond Duchamp-Villon. He was the second in age of the three extraordinary brothers—a year or so younger than Jacques Villon, and eleven years older than Marcel Duchamp. It is their family name that the youngest of them has retained. The oldest, who had completed his studies as a lawyer, assumed the name of the old French poet when he felt his vocation for art so much the strongest thing in his life that he must give up all else to follow it. The second brother had studied medicine and begun to practice, before he became convinced that his real career lay elsewhere; and when he threw in his lot with sculpture he accepted the name to which Villon was already giving a modest fame, and hyphenated it with Duchamp. When the third brother joined his two elders, it no longer appeared worth while to the young librarian of Sainte-Geneviève (as he then was) to take a pseudonym.

They are Normans, of Rouen, a city that their grandfather, an engraver, had celebrated in many a plate, still preserved, from which Villon has struck off excellent prints. Marcel once told me of an exhibition of the Impressionists which came to Rouen when he was a boy. "They were very good pictures, by some of the

great men of the school, but after I had enjoyed them I was done with that. I knew that when other pictures were to be painted they must be different." How did he know? Just by native intelligence, or because this was in France? I think it was partly for the latter reason, because in that country some echo of the great activity of Paris would reach the provincial city, whereas in New York in 1903, the year when the Monet and Pissarro canvases were seen by Marcel in his home town, the Impressionists were the last word of modernity for even the art students among whom I was then working.

At all events, when Duchamp-Villon began to carve, he did so in complete disregard of the art of Rodin, the sculptor of the Impressionist school—whose work he did, however, consult later on. His first definitive sculpture, already a splendid thing, was hacked out of a block of stone during a vacation in the Norman country that has always remained dear to the family. The model was an old peasant of their acquaintance, and to this day Villon will say, "That's just as he was!"—on catching sight of the work again.

A large torso of a nude woman comes next in his production. Its celebration of the anatomical beauty of the human body is such as one might expect from a man in whom the qualities of the artist coexist with those of the scientist. More than one person has declared the work superior to any that Rodin ever did in the same vein, and during the years which saw him produce the *Age of Bronze*, the *Thinker*, and, above all, the *Man Walking*, he gave the world some things that are magnificent in their poetry of the bones and muscles. But his later art shows that his sensibility was moving toward the surface of his sculpture and was to find its goal in that rendering of the light on flesh (in flesh, one might almost say) which tells of his closeness to the painters of his Impressionist school.

Duchamp-Villon's genius moved away from the surface, to

investigate—always more deeply—the laws of structure, and the expression possible through it and through rightness of proportion. These, among other matters, led him to architecture. It came as a striking and, for him perhaps necessary, contrast with the studies of young women he had done a couple of years before —things of immense tenderness in their rendering of feminine charm. It may have been with a backward glance at such inspiration that he once said to me, "It is almost droll, the pleasure that I have in making simple, square blocks work one with another until I have found an exact relationship of forms and dimensions."

Here, besides the reaction from surface beauty, was something outside that cult of nature which had borne such marvelous fruit in the art of Renoir, for example, whose magic often causes us to think that his flowers or his nude girls are the reason for our delight in his pictures. The period was becoming conscious of its means, as we saw in the words previously quoted from Picasso, wherein that brilliant intellect declared the need of distinguishing between nature (the things outside us) and art which, to cite Leonardo's dictum once more, is a mental thing. Delacroix in his meditation on nature observes that she offers no example of the straight line or the regular curve—that such things exist only in the imagination of man. For him they were what we of today call abstractions; and so it was logical that architecture, the least imitative of the arts, should become a passion with Duchamp-Villon as he went, with his period, from creation through visual impressions to an organization of the images within the mind.

But there was another reason for his new enterprise. For a long time artists had been coming to feel that individual work must, in our time, be supplemented by a collective effort. Nearly thirty years before 1912, when the great experiment was tried at the Autumn Salon, van Gogh had foreseen the need of a communal art, had written of it in clear terms to his brother, and had tried to start a community of artists by having Gauguin come to

live and work with him. The attempt which met with such
grievous (but far from useless) defeat in the earlier time was
evidently ready for success in the years before the War. A large
group of the younger men found themselves collaborating spon-
taneously for the production of an art to which each one might
contribute according to his talent.

Someone was needed who should both lead the work and give
it an ensemble, the traditional rôle of the architect. All turned to
Duchamp-Villon, both for the schematic quality in his sculpture
and for the unshakable integrity he had always displayed in
handling the problems which arise when artists join in association,
so as to achieve a common purpose. The result justified their
choice to a degree they could scarcely have hoped. The house
they built within the Grand Palais was a resounding success. The
painting and sculpture within its walls, the ironwork at the win-
dows, the wall paper (among the most delightful things in the
whole art of Marie Laurencin), the furniture, the glass (by
Marinot—finest of modern *verriers*), the very initials on the writ-
ing-paper which lay ready on the table, all told of the fresh, inven-
tive inspiration which was passing on to the crafts after having
produced vital results at the hands of practitioners of the major
arts, often the same hands that were now turning to this new
employment.

One felt, the moment one saw the façade executed from
Duchamp-Villon's plaster model, that here was something which
continued good French traditions—the style of the house in no
way contradicted that of thousands of others along the streets of
Paris or the provincial cities, the chairs were comfortable to sit
in, the pictures were pleasant to the eye and full of meaning; and
at the same time there was the excitement of new adventure, new
discovery. Or was it old discovery?—as old as the beauty of day
and night. Since the house was to be lived in at all times, the
energy of the sun and its rays surmounted the whole as a decora-

tion in the cornice, while over the door were quieter forms of a nocturnal character. One cold day the sculptor noticed in his garden how the water dripping from the trees was turning into icicles. Immediately he got an idea for those triangular ornaments hanging from the balustrades of his house at the Salon. Here was, anew, the history of the *guttæ* on classical buildings, or of the honeysuckle that became the volute in Ionic and Corinthian capitals. Everyone admires their grace in the great buildings, everyone who has seen the life in the forms there feels how poor a substitute the endless modern repetition of them affords. But few have drawn the conclusion which such a contrast imposes. It is that the great ornament of the past was creative; and the same quality will have to be reached before modern ornament can have a possibility of satisfying us like the ancient forms.

Michael Stein (who was to commission from Le Corbusier, a few years after the war, one of the most important works of that modern architect), was enthusiastic over the perspective opened up by Duchamp-Villon's house; he saw in it important solutions for the problem of building with cement. And as was written later on by André Salmon, probably the best of living critics in France, "The War of Cement was declared, and it was not the false traditionalists who came off victorious in it, although the vanquished, not being thoroughly dead, continue to groan. It was the audacity of Duchamp-Villon which decided that good war."

The artist, though he did take interest in the possibilities of cement, would not have let his architectural work be limited to that material, nor did he dream of applying himself to decoration. What he cared for most was sculpture in the round. And so, after his death, when Villon and I had published a volume commemorating his work, Elie Faure exclaimed, "Now I understand everything that has been happening. One man after another has

based his work on that of Duchamp-Villon. The whole architectural sculpture of the modern school is here."

Already in 1913, when he got back to his more personal expression, after the heavy work with the building, he carried on into a series of bas-reliefs the lesson he had derived from the ornament, the wall spaces and other matters of practical construction. The group of artists who used to gather on Sunday afternoons in Duchamp-Villon's studio and discuss the work in common were well acquainted with the small menagerie that carried on the cordiality of the household. There was "Omnibus," a heavy old collie who was immortalized in one medallion, there were the Siamese cats, one of which luxuriously curled up, looks out with an inquiring stare from another irregular circle, a pair of pigeons were the motif of a third, and all had the humor or other character of those humble friends. But the great work of the series was *The Lovers*, and there all of the sculptor's passion for life surged up as he rendered the gently insistent gesture of the man and the yielding ecstasy of the woman.

When he went on again to "higher mathematics" (John Quinn's term for such things as *The Horse*), he had behind him work of such poignantly human appeal that all the severe geometry of that last great work of his could not blind any experienced observer to the expressiveness that underlay the intellectual feat. A long succession of studies from horses was a prelude to the work, in the months before the outbreak of the war. And when, as a cavalry officer in the conflict, he had daily acquaintance with the movements of the animal, he used his increased knowledge to modify the sculpture. It was already nearing completion when he was mobilized and, as he was at first stationed near Paris, he was able to return to his studio on brief leaves and so complete the work.

On one such occasion I brought Henri Matisse out to Puteaux, the suburb where the two brothers lived in pavilions adjoining

the same garden (Marcel continued to reside in the city). Matisse was making gingerly approaches to the Cubism that the younger men were developing, and he wanted to talk to Duchamp-Villon, who, as he said, interested him the most of all his group. He asked about the ideas underlying the evolution of *The Horse*. There was much consideration in those days as to the analogy of movements in different bodies, just as in the work of an earlier sculptor, Barye, there is continual allusion to comparative anatomy. For example, Elie Faure, from whose mind the practice of surgery was never absent even when he was moved by art, once observed that the front paw of the big cat in Barye's masterpiece, the *Jaguar and Hare*, could easily pass as a human forearm. And the convincing naturalness in the *Centaur* by the same artist tells of the power to unite disparate forms just as Duchamp-Villon showed it in *The Horse*. Here the union was not of man and animal, but of sentient creatures and the machine.

Two years before, in the first of those letters to me which form a chief part of the text of the memorial volume I mentioned, Duchamp-Villon had written: "The power of the machine imposes itself upon us and we can scarcely conceive living bodies without it; we are strangely moved by the swift brushing by of beings and of objects, and we accustom ourselves, without knowing it, to perceive the forces of the former group in terms of the forces they dominate in the latter one. From that point to an opinion on life such as would make it appear to us merely under its form of superior dynamism, only one step remains to be taken— and it is a short step,"

Such were the ideas that he offered to Matisse in explanation of the explosive yet balanced power that the painter recognized clearly in the flying lines of *The Horse*. "It's a projectile," said Matisse several times, as he continued to turn about it and see the way its harmony was maintained from every viewpoint. Duchamp-Villon was not quite sure whether the word was fully applicable.

A projectile was, after all, a man-made thing, with an uncompli-
cated curve of flight, and he spoke of the varied rhythm of the
horse's pacing and trotting. Matisse went away with a strong feel-
ing of the man's sensibility, as he said at dinner in Paris that
evening, what he feared in the new group was the submerging
of every sensuous quality in the rising tide of intellectualism.
We spoke of Mallarmé's poem, "Un Coup de Dés," and he said
"Mallarmé could permit himself such things." Nevertheless, when
he came to illustrate Mallarmé, years later, it was the mood of
L'Après Midi d'un Faune that appealed to him, and not the other,
more abstract work that meant so much to the younger generation.

The visit to Puteaux with Matisse was one of the last I made
there during the lifetime of Duchamp-Villon, for I had to return
to America soon afterward. His letters gave glimpses of the war,
into which he went always more actively, until a fever contracted
from ceaseless work with the wounded got into his system and
wore it away—even his strong physique having to yield to its
ravages; he died shortly before the armistice. Throughout the
years of fighting he never relaxed in the thought of his work and,
when he could find time and materials, would continue with
sculpture; lacking that, he would draw—as he did in planning a set
of modern chessmen. Of Professor Gosset, the celebrated surgeon
who tended him in the last months, he made a small but magnifi-
cently expressive study in clay that, as he wrote me, he meant to
develop during his convalescence. It never came.

In the last year before the War he had worked on a project of
architectural sculpture for a college in Connecticut. The trustees
of the institution refused it in favor of a scheme that would cost
them less, though their architect did his best to show them the
error of such reasoning. If I have sometimes written or spoken in
anger over bad decisions in art—things due, as in this case, to the
men who flatter ignorance and false taste—it is with memories of
great lives embittered or lost. Barye, whose genius for the monu-

mental we know from a few things, had to continue with little figures (glorious though he made them!), while mediocrities were given the big commissions for sculpture in preference to him. Had Duchamp-Villon come to America to do the work that went to some commercial decorator, means would doubtless have been found to keep him here, instead of letting him furnish one more victim in the mass-murder. I share his profound conviction as to the rightness of the cause he fought for, but there is also the testimony of his continuing his work in art during the war to prove that he knew wherein his service to the world was unique. On the battlefield he could have been replaced by numberless men among the millions who fought; in his own field, he was the greatest man of his time.

There may perhaps be a case to parallel that of the three brothers about whom I have started to tell, but should there be one, it escapes my memory. There were the brothers Le Nain, the three admirable painters of the seventeenth century, but only one of them was of the first importance in their period. If Duchamp-Villon was the greatest of latter-day sculptors, as is believed by many, if Marcel Duchamp carried the idea of his school to a point unattained by any other of the painters loosely called the Cubists, the third brother also occupies a place in the foremost rank of his generation. Only the future can say how the epoch compares with that of the brothers Le Nain, whether the classicism of the period of Louis XIV is more wonderful than the inventive art of the modern day; my point is simply that we have here three brothers who are all great artists.

"We are the severest critics of one another," as Duchamp-Villon once remarked, and in the early years of Jacques Villon's work, it may well have called forth criticism from his two juniors. He had to make a living, after throwing over his work as a lawyer, and the handiest way to get the wherewithal for even a modest establishment in Montmartre was to do illustrating. There were

drawings à la Steinlen for popular novels, and there were sketches for the comic papers. Then he began to etch, and profited by the new vogue of color prints for which Toulouse-Lautrec, among his models, had created a public. Some of these plates tell already that Villon was an artist and not merely one of the swarm of school followers that every Parisian success calls forth.

Some of his early things do suggest such a career and in the light of what has followed I look on them as among the most hopeful documents that I know. For if Villon could come up from the gutter art of those desperate struggles to keep alive by commercial work, then there is a chance for everybody, if only he have ideas, and persistence in following them. To be sure, the swifter rise of the sculptor brother, less than two years younger than himself, must have given him a fresh incentive to advance. And both of them were left breathless when Marcel Duchamp, a decade later, went off on his meteoric career.

Villon plodded on from drawing and engraving to painting which partook of the Impressionistic light and color of the school around him. At one time he lived in the same building where Renoir had his studio, and it is certain that he got something from the proximity of that veteran. When the Autumn Salon was founded in the first years of the present century, he and his brother Raymond were among its charter members. Later on, its modernism became attenuated and conventional, but in the early period of the Salon, it did stand for all that was daring in the tradition of Cézanne, van Gogh, and Gauguin. The achievement of those colorists meant too much to Villon for him to let his painting turn to the monochrome of Picasso and Braque, when Cubism appeared. He was the one man who combined it with a full gamut of color. Villon had been approaching a non-realistic art along his own lines, as one sees from a series of drawings and etchings in which the forms are turning toward the spherical. It was Villon's equivalent for the logic that made Picasso approxi-

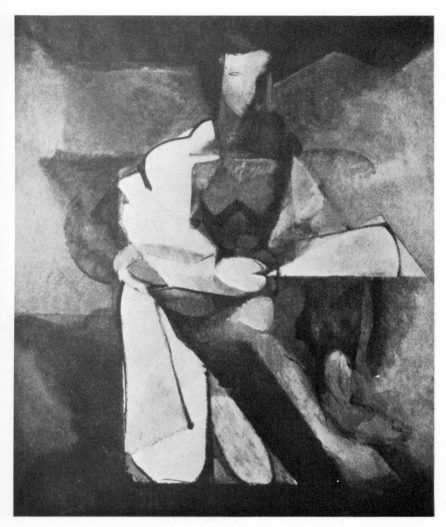

THE PHILOSOPHER　　　　*Painting by Jacques Villon, 1930*
The Brooklyn Museum

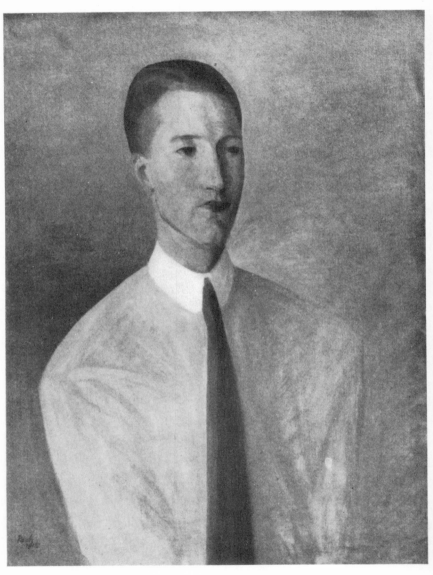

MARCEL DUCHAMP *From the portrait by Walter Pach, 1915*

mate the cube in his organizing of volumes, and perhaps the difference between the two geometrical figures may be accepted as typical of the men's natures: Picasso, as rigorous as his land of harsh contrasts could make him, might cut into flesh with the angular forms of his incipient Cubism, while Villon, with French suavity and sentiment, would be drawn to the constant turning of the sphere. In very late pictures of his, the form is resumed, after thirty years, sometimes as a terrestrial globe that he will introduce into a still-life.

Another typical element in his work is his scientific analysis of color. Since Delacroix, painters have been trying to get at its laws, often with the help of the spectrum and the gradation of hues obtained thereby. Americans may take a legitimate satisfaction in the rôle which Ogden Rood's book, *Modern Chromatics*, has played in French artists' study of the subject. The volume is one of Villon's favorites, and he says that all later research is influenced by it, directly or indirectly. The intellectual working out of a problem of color on a canvas is not unlike the solving of a game of chess. All three of the brothers were inveterate chess-players, with Marcel, as I shall show presently, giving to the possibilities of the game a most extraordinary intensity of thought.

For Villon its fascination was more limited. Though he went on progressively to an art that explored the full scope of abstraction (the form of thought where pure mathematics and pure science move with the disinterestedness of the chess figures), the world was always a warm and human place for him. He likes people, he likes children, no day was complete without a walk in company with Babbling, his gay, shaggy Airedale, and he loves the trees and flowers of his suburban, almost provincial home. I remember the special poetry of accent with which he once exclaimed, "I adore the springtime!" The words had no trace of the banality they might have had, coming from another person.

And so his art has gone on with the steady course of the sea-

sons and with the sentiment of things in nature, no matter how much of thought he mixes with his paint. Called to his regiment at the very outbreak of the war, he saw some of the most desperate fighting, until the government realized that his more valuable service would be as a *camoufleur*, in devising the protective mimicry of form and color that should make cannon and tanks as nearly invisible as might be. Once he had been transferred to that corps, gentle Gaby, his wife, and the others of his family, were relieved of the dread occasioned in them by his long period on the line of fire.

When he finally got back to his studio it was to resume his work very nearly where he had left off. Indeed, on a visit I made to Paris shortly after the war, he seemed the one man who had kept up the spirit of the old days, and that impression deepens as time goes on. In the tremendous post-war boom of painting (till the depression came) Villon was untouched by the rush for markets that hurried so many of his contemporaries into over-production, often of a hasty kind. He kept on making a living with engraving, of which he is the most remarkable practitioner alive. At times he has worked for publications like *Architecture*, for which he executed plates of great intricacy and effect, or again he has worked out color-etching after the successful painting of his day, or the time just before it. His interpretations of Manet and Cézanne, Matisse and Picasso, were amazingly close, and yet his own. Their success led to further work of the kind, his modesty permitting him to reproduce the pictures of men younger than himself and often far from being his equals in talent.

I think it was this gentleness in the man, and his recalling the simplicity of a less "modern" time that got people into the way of referring to him as "*le père Villon.*" The friendly appellation sticks to him despite the sense of youthfulness that goes with the ruddy Norman complexion and the lively frank eyes of his un-Parisian type. It is only the commerce and politics of the capital

from which he stands aloof, however; no one is closer than he to the ideas that give to the city its character as the focus of the world's art activity. The big galleries along the Faubourg St. Honoré and the Rue La Boëtie proclaim that activity, but most often the place where it really occurs is in quiet studios far from the center, like the one back of the garden at Puteaux.

Sitting under the big tree there, I have thought on more than one Sunday afternoon, that no other place I have ever known can tell so much of the contrast between the outer tranquillity of a life and its intensity within. Everything seems peaceful and simple and healthy—which is indeed the case. A few old friends drop in for a cup of tea and a chat with the family about personal affairs or the interesting things in the newspapers. One might be a hundred miles away from Paris. Yet the proximity of the town with its intellectual and artistic drive is an essential element of Villon's world. An hour before the little tea party gathered, he may have been pulling prints from a plate, and furrowing it with new strokes of dry-point that tell of some audacity which none of his contemporaries has yet risked. For a week he may have been brooding over a fiercely difficult problem, and then, returning to the human society he loves, be as blithe and debonair as ever.

Few things do more to define the idea the French have of civilization than their deftness in associating pleasantly with persons whose opinions are different from their own. From a visit just after the war I recall one of Villon's superiors in the field, a general, who expressed much astonishment that the police allowed the production of *Phi-Phi*. It was the kind of observation one might hear in the depths of the provinces from some worthy burgher returning from the capital—where he had not failed to test his virtue by exposing it to the naughtiness of that tuneful operette (of enchanting memory).

Or, later, when we had gone to hear Marcel's friend Mlle. Parysis sing at a music-hall, what fun there was over our attempts

to recapture the gay couplets of *Les fraises et les framboises*. *The Gauloiserie* of the song looks back to the qualities of those ancient inhabitants of France whom Julius Cæsar did not quite understand. Some modern people have done no better—even in Paris itself. Painting a pretty model there, just after the evening when we sang the ditty in question, I told about it to the girl, only to see her put on an extra layer of decorum as she said, "That is not a song for proper society."

So Villon and his kind stood reproved by the little *femme sérieuse* as she called herself—not quite accurately. They were accustomed to reproof from the adherents of *la peinture sérieuse* (which does not quite deserve the title, either), and neither condemnation afflicted them beyond measure. For the tradition of French gaiety is bound up, through Molière and Watteau, with so much that the "unco' guid" regard as lightness or worse that it need not even call to mind its great classics in order to follow its adorable line with unconcern as to accusations of lacking seriousness. Had Manet not seen the stupidity of his teacher's reproach, he would not have told, later on, how Couture had warned him that he would never be more than the Daumier of his time. As for Constantin Guys, that other newspaper artist of the mid-nineteenth century, he was not even a painter, as people said. But then years later, it was discovered that his painting quality was startling in its anticipation of that which Cézanne got in the heavenly water-colors; and Meier-Graefe challenged anyone to show anything nearer in style to the horses on Athenian vases than those drawn, innumerable times, by Guys.

I have already spoken of the little men's charge of lightness against Matisse when he relaxes into graceful work. And of course for Dufy, with his particularly Gallic quality, there will never be an end to the reproach that he just turns the things out in defiance of all the rules of sober effort. How badly such criticism understands France—even when the strictures come from within the

country. What lamentations over "decadence," that no battle of Valmy in the time of the Revolution, no battle of the Marne in our time, will cause such critics to distrust. "You do that to amuse yourself?" was one of the questions put to Renoir about his painting till almost the end of his life; and he would always reply: "Oh course. Why should I do it if it didn't amuse me?"

All the artists that I have just mentioned show that the spirit of the work and its technique are inextricably mingled. So also for Villon: what seemed to be "arid" researches into form and color are necessary to his expression, and turn out to be as "natural" as that disarming smile of his. In one room I know, there is a canvas that might seem at first glance to represent some strange sort of airplane. But let yourself be caught by the mastery of color in its violet and green, and you will see that the previously un-known harmony of the two striking tones is a result of observation which did not end with a rendering of light: the succinctly treated figures in the design are of human beings whose impressiveness has found a worthy response in the painter, who now appears as "serious" as anyone could desire. In a picture hanging near by, a similar play of tones is so seductive that I have seen people who would go no step further with the artist accept the fact of his marvelous sensibility. "But that head hanging in space—for I sup-pose it is a head—why does he have to do a thing like that?"

"You pay him a great compliment, and a deserved one, when you say he has to do it so (please don't withdraw the words, even if I am taking them in a slightly different sense) ; if he could have done it any other way it wouldn't be good. You have hit the mark; it's inevitable as it is, in the way that the Sphinx is inevitable. Lose the size of the Egyptian work through a photo-graph and, by the same means, eliminate the color you like in this work of Villon's: you will see that the expression remains in both, and that it has the same quality of enduring."

Or, in another collection, take Villon's portrait of that admi-

rable sculptor, his friend Pommier. The picture was exhibited with *The Constructor* as its title, and the upturned head might be that of one of the workmen of the old cathedrals, looking to the figure he has just set in place, half as decoration, half as a supporting element in the building. The man who owns the picture sees it as reaching out to more than material construction. The splendor of the red and green in the background is full of the rich warmth of the world that is being rebuilt by this bearded man with the kind, steady eyes.

Did Villon plan such a scheme of expression when he painted the picture? I'm sure he did not. He had before him a fellow craftsman, with whom he was in sympathy; he had to investigate certain relationships of light and darkness, space and solidity; the overtones, the meaning, and the music of the work, added themselves unconsciously, as his technical effort advanced. Like his brother Raymond's head of Baudelaire, this portrait does indeed look back to the Gothic men—and forward to the men of the future, who will find their ideals forecast here as we see our own in the things at Chartres and Reims. Having recalled my quiet friend in one of his moments of powerful achievement, I feel free to speak of a thing less weighty at first glance, one that has come to hand since I started the present book.

Itself a book, another memorial to one of the men who fell in the War, the poems by the latter which it contains are accompanied by a series of illustrations such as Villon is always willing to return to. Only instead of the casualness of those early drawings of his, these are impregnated with deep thought. He has followed the inspiration of the poet, but he has also followed his own, the conception evolving in the quarter century since the verse was written.

Not only he, but all the big men of his time, have been illustrating these fine editions with prints that are originals, instead of the reproduced things of commercial publishing. Not the least

of our proof that the world continues to need art is the series of volumes where the beautiful paper and typography unite to give us the text to which Bonnard responds with the enchantment of his lithographs for *Daphnis and Chloe*, Dufy with the masterpiece of all modern wood engraving—the images for the bestiary of Guillaume Apollinaire, and Rouault with the tragic gleam of his plates for Vollard's *Ubu Roi*. These books are to be placed in the glorious line that comes down from the far past of the illuminated manuscripts, that, in their freshness, often give us a clearer sight of the old centuries than do buildings or paintings. When a later day looks back to our own, it will form part of its idea of us from Pierre Corrard's volume with its etchings by Villon. The tradition of a far past and a near past is preserved by them as they connect once more the shadow and sunshine of the visible world with the dark places and the light of the mind.

With the third of the brothers I believe one reaches the farthest limit of our time in situating art in its position as an absolute, a "mental thing" unconditioned by material support. It is more than twenty years since Marcel Duchamp has painted, and that fact has not ceased to trouble those who admire the things of his earlier period. Various explanations are advanced by one person or another for the phenomenon of his withdrawal from the field and, at times, in the first years, I used to argue with him about it. Once he replied, "I have not stopped painting. Every picture has to exist in the mind before it is put on canvas, and it always loses something when it is turned into paint. I prefer to see my pictures without that muddying."

Perhaps that is an accurate analysis, perhaps there are factors in the case that the artist is not himself aware of. One man of keen mind sees the matter as a result of the world's new demand for visual realism in painting, a thing to which he believes that Duchamp was unable to adjust himself. That would put him in the position of a runner who cannot start afresh on a new course

when it is entered upon by other men; they, however, had not put into their previous effort the overwhelming intensity that had carried Duchamp so far. Again, there is the analogy with Arthur Rimbaud: after that genius had produced the dazzling poems of his youth, he ceased to write, seeking forgetfulness of his literary career—so rich though so brief—in the commercial routine of a colonial retreat.

Be the parallel between the two men right or wrong in explaining (for one or the other) the later silence so nearly unique among great artists, no doubt exists in the minds of a growing number of people that the pictures painted by Duchamp in the years before 1913 stand with the greatest art of modern times.

My first realization of that quality in them dates from the showing in 1912 of what was then the new movement. The exhibition took as its title *La Section d'Or*, that mathematical relationship which Pythagoras tells us the Greeks got from the Egyptians in order to give a logical harmony to architecture and sculpture; the Renaissance in turn revived it with important results, and it has gone on—through the workings of instinct or of intellect—down to our own day, when the appeal of the abstract made it serviceable once more.

All three of the brothers participated in the show, Duchamp with the series of pictures like the *Nude Descending a Staircase* that were later to arouse such astonishment in America. An English friend who had accompanied me on one visit to the exhibition in Paris, said in a letter, the following year, "You remember the pictures by Duchamp? the ones I found the hardest to understand? Well, they have been in my mind again and again since then, and now I am convinced that if I could see that show once more I should like those things the best of all in it."

The lady had not seen them anywhere else meanwhile, but the intensity of the movement in those days prepared persons of discernment to recognize new genius in a short time. And a year

was a very short time for a layman like herself when faced with things as original as Duchamp's. Of the people—between a quarter and a half million—who saw them the following season at the Armory Show, I talked with only two individuals, Arthur B. Davies and Manierre Dawson, who appreciated the genius in the work. That does not say that no one else did, though I was in charge of sales at the exhibition, and so was likely to meet anyone especially interested. All four of Duchamp's paintings were bought by collectors, but I have reason to believe that in the case of three of them the notoriety thrust upon the works had as much to do with their sale as their intrinsic merit, which was not absent, however, from the minds of the purchasers,

In the fourth case, I knew that the matter stood differently from the moment Mr. Dawson bought the picture. To anticipate on the account of that epoch-making event, the Armory Show, I recall very accurately my first meeting with the young architect, as he was at the time. He held in his hand a catalogue of the exhibition; the back page was almost covered by the list of pictures that interested him, and he wanted to know their prices. He did not buy before taking a few days for further study and reflection; at the moment he just wanted to know what lay within his means. I could not recognize that fact at first; numbers of people asked prices out of mere curiosity, or to get an extra thrill out of their contact with the crazy stuff, as they privately considered it.

So that when the young man asked me about a picture costing $50 and, immediately after, about one costing $50,000, I looked at him a bit sharply. If he was considering the work of a young unknown, why should he be asking about a great Cézanne, the highest-priced picture in the show? Wouldn't his next words tell of ironic satisfaction over my being taken in by a hoax? A glance at his earnest face gave me the answer: he just didn't know about reputations and their market value; he just liked both pictures.

And he was right, for both were good. He bought the Duchamp for the same excellent reason. It seems to me not less than axiomatic that the one valid reason for buying a picture is a conviction that it is good.

Someone may object that the numberless persons who look at popular magazine covers are just as convinced that the pictures there are good; the deduction drawn from the fact is that my test is no test, that "everybody has a right to his opinion," and that I am merely presumptuous and arbitrary in claiming special value for the ideas of a small minority—the one I happen to belong to. We are back before the question of proof in art. I have already ruled it out, though I am willing to risk just one reminder —that everyday experience ought to prevent the advancing of that argument about the magazine-cover people. They are in the position of a four-year-old child before a printed page; the child may have the most beautiful mind in the world, but not yet having learned to read, it can form no idea of what the page says. Since the world has taken countless centuries to evolve the form of expression known as works of art, it is absurd to judge them by the standards of people who simply recognize a given color print as an image of a sailboat, a pretty girl, a man on skis, or some other attractive subject.

With the two men best prepared to follow the art of Marcel Duchamp—his brothers—appreciation came only step by step. I remember Duchamp-Villon's showing me a study by Marcel that marked a big new departure. "We looked at it, Villon and I, and we said, 'You are going pretty far.'" He was; he was going to cross the line that marks the separation between painting done from nature, or even derived from nature, and painting whose forms are neither imitated nor remembered nor yet adapted: for once a man was going to create in his own image, which is to say that of the mind. Heretofore such a privilege had been that of the gods alone.

DUCHAMP-VILLON, VILLON, DUCHAMP

I am not saying that the work of Duchamp transcends that of the other masters. With the traditional formula of the artist, that of representing the things he has seen, results have been attained from the time of the Chaldeans onward to that of Matisse and Derain—which are beyond discussion or comparison. No one with any real experience of art tries to determine whether a Gothic figure "transcends" a Greek figure or *vice versa*. But one can say that with Gothic art certain aspects of the mind are brought into our consciousness as they had never been before, even by the Greeks. And when Duchamp painted for us his drama of the forces of stability and instability (which is my interpretation of the canvas entitled *The King and Queen Surrounded by Swift Nudes*), he was dealing with ideas that only our age with its new conceptions of space and reality could imagine. It would no more be possible to use the symbols or, if you prefer, the means of the Gothic time for our needs than that glorious period could use the imagery of the Greeks or the Chaldeans.

You say that when we go to the museum we pass without a jolt from one to another of those past epochs. I agree and, having spent much time with their production, having some of it before my eyes when I look up from this page I am writing, I can register here at least one man's certainty that the transition to the best modern work is as natural as the step from the pantheism of Greece to the ideals of Christian art, contradictory though they may at first appear.

When I was lecturing at the University of Mexico, I hit on a comparison that had some effect with the students. To describe the course of modern art in its going to the point of abstraction and then to its subsequent evolution away from that point, I re-called an ambition of nearly every young man in the Valley of Mexico, that of going to the top of Popocatepetl. The eternal snow crowning the ancient volcano is visible across a whole region which is still dominated by the great spirit of the ancient peoples.

QUEER THING, PAINTING

To make the dangerous ascent of that peak, one of the highest
in the Americas, is to visit the old gods in their dwelling-place,
and to receive new powers from them, in the pure air and the
fierce light of this ice world in the tropics. When you go down
the mountain you are no longer the same man. But it is hard
breathing up in that thin air, and there is work to be done below,
where men can live.

My own explanation about Duchamp is that he is the man
who has stayed on the heights—after the moment when the others
have passed on. For him they have gone back, and when I have
asked him from time to time what he sees in the later art of Paris,
he answered, "Commercialism—from top to bottom." I have not
pushed forward to the matter of exceptions, which I believe he
would have to allow. I prefer to hear people say their say in even
extreme form and then, for my own purposes, make what allow-
ance seems necessary. Villon, who has been as puzzled as anyone
else about Marcel's employing of the recent years, will say, "It is
his decision, and we must respect it. The course he is following
is not an easy one, and if he takes it, he has his own reasons."

I shall try to give reasons of my own for thinking that the men
of today have not retreated, but gone forward from that fierce if
inspiring climb among the crags and snows a quarter-century ago.
For some there was nothing there save sterile rock. In Duchamp's
own work there is a flowering of beauty as real as any I know.
After Mr. Dawson had lived for years with the picture he bought,
he wrote me, "It looks like a Rembrandt," and it does have that
sense of rising from the darkness to a climax in the light and then
receding again into the shadows, which is the impression we
almost invariably get from the old master of Amsterdam. And
he, by the way, was for centuries a baffling mystery to the people
who saw art only in terms of the Classical school. Human tragedy
they might admit as existing in the art of the Dutchman, but

[160]

beauty was another matter, reserved for the Greeks and for Raphael.

So today one can get some agreement as to the intellectual side of Picasso or Duchamp. But to look on their works as a Critique of Pure Reason is to fail before the essential quality of the Spanish painter and to miss the grandeur of the forms in the *King and the Queen*, and the previously unachieved harmony of the color. To speak of it to Duchamp makes him uncomfortable; of a very distinguished colleague whom he considers too conscious of the charm of tone and surfaces, Marcel exclaimed more in disdain than in admiration, "He is like a pretty street girl."

Another phase of the man's work and character attaches to a pleasant memory of the Armory Show. One of the interesting people I met at the time was an old Irishman, formerly a carpenter, who had become a bartender in the saloon where we used to go for refreshment after the long days at the exhibition. The artists had enjoyed the shrewd talk of the nice old boy, and he had arrived at quite a paternal friendliness toward his unaccustomed visitors. Finally he wanted to come over to our side of the street and see the show that everyone was discussing. Most of it made little impression on him, as was to be expected, but the fellows who were taking him about counted on the now famous *Nude Descending a Staircase* to elicit some special remark. He looked for a good long moment at the canvas and then said, "Well, that fellow certainly knows how to paint."

I don't think it was the unexpected tone of admiration that made the simple words stay in my mind; it was the way in which the old workman recognized the quality of exactness and efficiency that is in the performance, something overlooked by the thousands who puzzled over the esthetics of the picture or the meaning of its title, and so missed the fact that Duchamp is the born painter, the man who could go through art school like a breeze and come almost at once to masterly, finished works.

QUEER THING, PAINTING

It was against both his artistic sensitiveness and his manual skill that he revolted. "I want something where the eye and the hand count for nothing," he said to me the year after the Armory Show, as we rambled for half the night around the streets of Paris. To be sure, there had been plentiful abuse of retinal sensibility as well as of virtuosity. One led to the kind of thing a woman does in matching colors at a ribbon counter, the other led to "stunts" as foreign to the purpose of art. Yet a disembodied spirit was also something outside the ken of painters, and I could not help thinking that Duchamp was pointing pretty much that way with his rejection of faculties the artist has always trained.

"If you let go the physical elements of painting, after having banished visible nature from your work, what remains?" I answered, "You enter a sort of Nirvana; that is simply contemplation you propose, if you don't give forth, by means of the eye and the hand what you have in your mind."

By degrees the thing worked out so, his thought turning always further away from the beautiful painting that had held him for a few years. As Villon said, his course was not an easy one, and I always looked on his feverish absorption in chess as a sort of opium to still the need for painting that every practitioner of that art will feel if he tries to give it up. Duchamp asserted, not merely for himself but for all of us, that the time for painting was over, just as mosaic, once a great art, had fallen to be a commercial craft. He tried experiments in mathematics and optics; one of the latter he applied to the cinematograph with really extraordinary effect.

But even this might mean some concession to the beauty of things seen, and in chess he was free of that. The intensity with which he threw himself into the game carried him to several championships, made him the rival of the greatest players of his time, and contributed to prevent its becoming crystallized in certain fixed series of moves, as it threatened to do when the

analysis of thousands of games seemed to indicate that the possibilities for new development were exhausted. Men in different parts of the world were trying to break the deadlock. If they have succeeded in doing so, it is doubtless an achievement, but one that can scarcely be offered to art-lovers as compensation for the painting they were entitled to await from Marcel Duchamp. He is still interested in phases of the subject, as was shown but a short time before these lines were written, when he took an active part in planning and executing the effects obtained by novel means at the exhibition of the Surrealists, those latest workers at the problem of relating mental and physical things.

From the beginning Duchamp has been conscious of his rôle in modern art, as is shown by a conversation reported to me by the late Frederic C. Torrey, the San Francisco dealer whose firm did so much to develop a better understanding of art on the Pacific coast. Mr. Torrey, who had purchased the *Nude Descending a Staircase* at the Armory, went to Paris soon afterward and interviewed the painter of his picture.

"The work of your group derives from that of Cézanne, does it not?"

"I am sure that most of my friends would say so," answered Duchamp, "and I know that he is a great man. Nevertheless, if I am to tell what my own point of departure has been, I should say that it was the art of Odilon Redon."

The reason for this has been given by the older painter in words, those of that beautiful book, *A Soi Même*, in which he does indeed seem to talk to himself; but without that, there was his very considerable production to bear him out when he wrote that for all his study of nature, no effect he has ever produced can be attributed to the physical properties of the artist's equipment. "The plane of the artist is not outside him, but within his mind," as I recall his saying to some people who once called on him. Duchamp is one who took him at his word.

XII.

ODILON REDON

━━━━━━

TODAY, WHEN REDON AND RENOIR AND RODIN ARE SLIPPING AWAY more and more from the realm of living men, to join the masters of the past, it seems fabulous that I, who have not yet been called old, should have spoken with them face to face, sat down to table with them, and heard them discourse on the merits of a bottle of Bordeaux or a cigarette. One comes back to that matter of the contrast between the intensity of the inner life and the simple, everyday pattern of the outer life. Marcel Duchamp, so terrifically absorbed and aloof in his painting, is the most natural and human person to meet—which fact quite bewildered people in America when he came over here. They had expected some necromantic phenomenon and here was a well-bred, good-looking young fellow, ready for a lark, or a quiet talk, or a game of billiards. And his master, Redon, who in plates dedicated to Goya and to Poe, had vied with them in the portrayal of strangeness and horror, was a charming old gentleman, living with his wife and son, cordial and courteous people, like himself.

I never was at their country place, but I am sure that in his garden, with the flowers he so often painted actually blossoming from the earth before him, Redon must have expanded again. As it was, I have one token of that naturalness of his when I remember Madame Redon's simple pride as she said, "If he paints a bouquet, it is always I who must arrange the flowers for

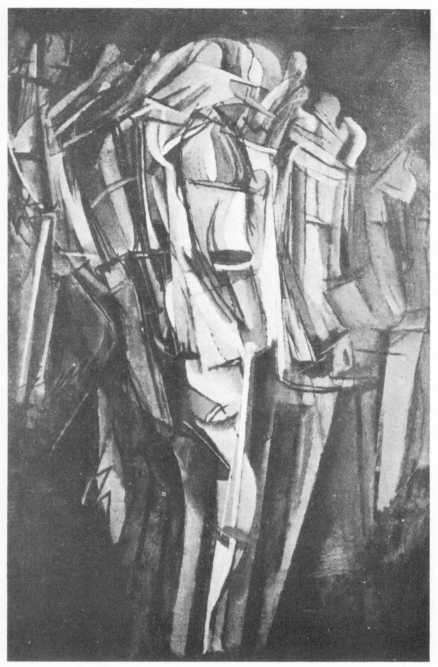

YOUNG MAN IN A TRAIN *Painting by Marcel Duchamp, 1912*
Collection of Walter Pach

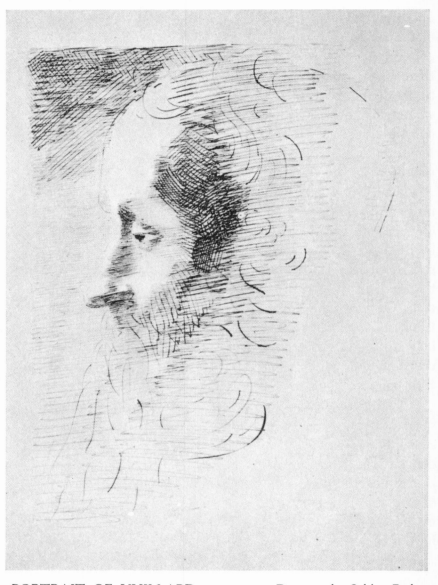

PORTRAIT OF VUILLARD *Drawing by Odilon Redon*

him; no one else can do it rightly." And the big sea-shell he fre-
quently introduced into his compositions was there on the table
of the apartment—which differed so little from numberless other
comfortable family places of an old-fashioned kind. And when
there was a gathering in the evening one put on a dinner coat
to go there, and shortly before midnight, when everyone would
want to go home, modest but pleasant refreshment was served
by Aurélie (I think she was called), the simple and pleasant
bonne from the town that takes its name of Redon from the ances-
tors of the painter.

There would be talk about Mallarmé and the wonderful eve-
nings at his house when he read to a spellbound group of friends.
Or someone would sit down at the piano and play a composition
by Brahms, which would be a little bit in homage to Redon him-
self, for he had been one of the first persons in France to recognize
the merit of the composer and to urge it on the directors of con-
certs. Or he would take us all back to 1875 as he told of meeting
Edouard Manet. "It was at the funeral of Corot, and I remember
how distinguished he looked as he stood somewhat away from
everyone else, and how he kept tapping his especially neat shoes
with his little bamboo cane."

Or, the talk turning to the new artists of the day, Redon would
speak of the far greater ease they had in getting before the public—
a facility that some were abusing. Yet he had unbounded confi-
dence in the generation at its best and, having heard such remarks
as the one in which Duchamp acknowledged his debt, he said
once, "They are a bit terrifying with some of their theories and
in the lengths they are going, but no matter: when they say I
have a share in their ideas, it gives me pleasure." Juliette Roche
(later on Mme. Albert Gleizes) would say, recalling those days,
"When I want an image of youthfulness, I think of Redon."
He was over seventy at the time when I saw her at his house,
but her words ring true for my own memories. As the best works

of art never grow old, so the best artists, renewing their ideas and keeping up their sympathy with the young men, have the faculty of retaining the waters of youth in their own nature.

Beside Duchamp, Picasso was of the men who looked to the work of Redon for guidance; their conception of the mind as the stage on which their subjects are seen could scarcely have existed without him. But they were not of the first generation that consulted him. The whole splendid group, including Matisse, Bonnard, Vuillard, and the gifted but unhappy Sérusier were deeply influenced by Redon, particularly in the field of color. The decorative painting of later times owes him very much. For example, let me cite one of its early masterpieces—and still one of its best—the series of four large panels which Bonnard showed at the Salon of 1910. They held their own with Matisse's extraordinary works, *La Musique* and *La Danse*. The latter were shown at the same place that year, after which they went to fulfill their purpose as decorations for the house of Stchoukine in Moscow—in which city they now stand with the chief possessions of the great modern museum of Russia.

And among the pictures which Matisse bought for his father were some by Redon, to whose color he gave the most eager study. He would have liked to retain the works himself when settling the estate. But it was too hard to distribute among the family, and so he sent the Redons to America for sale. One of them is the magnificent *Head of Orpheus* now in the Cleveland Museum, which acquired it from the heirs of John Quinn, that great collector having bought the work and others from the Matisse family.

I observed once before in these pages that it means much to an older artist to find the young men turning to him, and we have just seen how Redon appreciated his own acceptance by the rising generations. But even without that, one can feel a measureless certainty that he would have gone on with confidence as to his work. There had been so many years that he had to do without

admiration from any considerable number of people. In one of Cézanne's letters there are words of warm approval of Redon—as a painter and as a partisan of Delacroix. But these letters were published only after Cézanne's death, and before that his opinions were known to the fewest people.

One faithful group of art-lovers had given Redon their support for many years—those of Holland. Mr. A. Bonger, the brother-in-law of Theodore van Gogh, owned a large number of pictures by the French mystic, and one of the Dutch critics had called Redon "the Rembrandt of France," which gave the painter real happiness. For his two favorites among the Old Masters were Rembrandt and Leonardo. Among the moderns, his lifelong choice was Delacroix; a copy of a canvas by the great Romantic never left its place on his walls from the time in his youth when he made it till the time of his death. When I began my small collecting with the purchase of a Delacroix lithograph, he expressed great pleasure in seeing the plate again.

For all the color in his master's work and, one may add, for all the color in his own, he had an almost religious love for the beauty of black and white. "The art of suggestion" was a phrase that meant much to him. And perhaps more than the realization of color he loved the evocation of color, as the magic property was contained in the sonorous depths of charcoal and of lithography. The beauty of Seurat's handling of black and white appealed to him at once, and he bought a number of the younger master's drawings in the days when almost no one else cared for them.

Such neglect was partly explained by Seurat's early death. But Redon, until nearly the end of his long life, had only a small public. He regretted it and made repeated efforts to reach a larger number. Yet the fact that a visionary art like his own was isolated in an age of positivism gave him also a special pride in continuing a tradition made glorious by so many men in the past. He admired

painters like Pissarro and Cézanne and did his share in his genera-
tion's work of investigating appearances. But his talk and the
essential quality of his art were concerned with the phenomena
behind appearances. And though he delighted to produce designs
for the Gobelins tapestry looms and for stained glass, he always
insisted on an expressive quality even in decorative works.

Some of Redon's compositions concern Buddha, and admirers
of Oriental philosophy have claimed to see expressions of their
beliefs in the painter's work. But it is only in the matter of subject
that his pictures lend themselves to such interpretation. In spirit
and technique many a Mont Ste. Victoire by Cézanne suggests
the art of the great Chinese landscapists or the other seers of Asia
more than does the art of Redon, which is as European as that of
Dürer. The latter's "Melencholia" was the single work in which
Redon saw the ideals of his life most completely summarized,
and for all its looking out to the great mysteries, the print by
the German master remains essentially non-Oriental, as we recog-
nize at once if we recall the way each of the material objects in it
is worked out with scientific realism.

So with Redon: his most unearthly fantasies, the cause of his
being aligned with Oriental thought, are closely linked with such
observation of the full range of physical appearances as are charac-
teristic of the race which worked out perspective, chiaroscuro, and
anatomy, i.e., the European race. We know that Redon's means
of inducing what he called the "ebullition" of imaginative work
was to seat himself for a day or two, or even longer, before some
well-known object—that sea-shell I mentioned previously, a cup
and saucer, or an old tree trunk with its rough bark—and render
every detail, every phase of it with relentless accuracy, and with
all the technical resources that Western painting has accumu-
lated. He remains a man of his own country even when he looks
farthest beyond its borders.

XIII.

CONSTANTIN BRANCUSI, RAOUL DUFY

FAR MORE THAN WITH REDON, OUR THOUGHT TURNS TO THE
Orient when we come upon the art of Constantin Brancusi. I had
seen sculpture by him at the exhibitions of the Independents,
but I did not know him personally until the time when the
Armory Show was being prepared. I was sent to him by Alexandre
Mercereau. The writer had made a long sojourn in Russia as
director of a movement to unite the culture of that land and his
own, and so he had reason to be especially attentive to new talent
in Paris. It had deeply interested his sensitive mind even before.

Brancusi was not new in Paris, but he was known to a rather
limited circle. For fifteen years his training—first in his native
Rumania, then in France—had been in what he called self-abuse.
It had not embittered him; he was too sure of having overcome
his difficulties to bear real resentment toward those who had
misled him—and who were their own victims, more even than
their students were. But what did result from the immense strug-
gle Brancusi had gone through was a complete obliviousness to
any standard save his own. Such absorption in his particular prob-
lem, such unconcern as to what anyone else might think, were
needed for a man to keep on year after year perfecting his egg-
shaped sculpture, polishing his metals or his marble, and seeing
the design that must be given to a piece of wood in the markings
he found on it—the work of time or weather, or the trace of its

original growth. No American Indian could be simpler than this sophisticated Parisian when a walk by some stream in the country showed him a stone worn by the waters to a curious shape which, in his later use of it for carving, he felt bound to respect.

The result, to which he would give a fanciful name, according as the object suggested a human being or an animal, might provoke hilarity at an exhibition, but that did not disturb Brancusi. He insisted that simple people understood his work, and he positively beamed as he told of hearing a young workman describe to an older one a visit to his studio, where the boy had had to deliver something.

"In the corner was a great big stone, a figure; I don't know what it meant, but it said 'Hoo!' so you were almost scared; but I liked it." And Brancusi would repeat that "Hoo!" again and laugh in joyous triumph over this vindication of his art.

As Rodin's favorite executant, he had made himself a master of every subtlety in the craft of sculpture; his skill with its complications, like the academic knowledge gained in his early years, no longer furnished any problem for him. I have seen photographs of some of the anatomical studies he made in his youth, things of such accuracy that they are still used in demonstrations at the medical school of Bucharest. The man was evidently gifted to an extraordinary degree from the start, and as he doubtless possessed already his present faculty of tenacious application, the resulting efficiency is nothing to cause astonishment. John Sloan remarked at the end of the war that he was pleased at the defeat of Germany, because it was the defeat of efficiency. That is the artist's feeling about the quality. For Brancusi it is a cause of disgust, or would be if he could not excuse it through the ignorance of those years. Today there is nothing farther from his interest than the deadly proficiency of the man who has schooled himself to faultlessness.

"They are all alike, those people, and that is not the way the

world is. In a field there are white flowers and blue ones and yellow ones—there are even green leaves. Those thorough people— they would make everything blue or white—or something just as dreadful as what you get when the surprises of life are abolished. To me, one of our gypsies sawing away on his fiddle means much more than that famous conductor of an orchestra I was dragged off to hear the other night. How he threw himself into paroxysms, bending to this side and that, what an abominable sense of strain he produced! I felt sorry for him. Now when we had our evenings with Henri Rousseau, the *douanier*, everything was so simple, so gay. He had nice little songs of the people, he told about the forests of Mexico and the big flowers and the wild animals, just as you see them in his pictures. Everybody enjoyed himself, everybody was friendly; there was none of this terrible thing in Paris that fills people with jealousy and hate and intrigue. I think people have to be educated up to such artificial ideas, just as they need a course in gymnastics in order to do their artificial-looking pictures. A little milliner who takes some straw and a bit of velvet, a gold clasp and a bow of ribbon makes something that never existed before, has pleasure with it and other people share her pleasure. There is already art in what she does—why do people want me to think about Michelangelo when I have good natural things around me to enjoy? Anyhow, what does he do, that Michelangelo? He shows me his bare stomach and tells me he is very strong. Is there anything nice about that? And all those artists who sweat over their task and then offer the world a thing that is not so good as the object they worked from! It is not true what they do; at best it is raw material—a beefsteak from the butcher's. That is not what I want on my plate at table."

And so the tirade runs on, half joking, half serious. Or rather, he is serious even when he jokes. I am not of the right temperament to accept his references to Michelangelo, whatever the degree of humor with which they are uttered—and Brancusi's

humor is delightful. But the point is that between the philosophy in the words I have quoted above and the conception expressed by the *Sleeping Muse*, the *Mlle. Pogany*, and the later works, there is complete accord. Only a man so indifferent to accepted opinion that he has forgotten what it is could come out with his paradoxes about the gypsy fiddlers, orchestra leaders, milliners, and the rest. (In calling them paradoxes, I do not deny that they contain phases of truth.) Only a man leading Brancusi's magnificently self-centered existence could go on, year in and year out, with his few motifs and bring them to always new perfections.

Along their own lines they are irreproachable. And I maintain that all works of art must be considered along their own lines. You may show that one Florentine is superior to another, but when you attempt to show that a Florentine is superior to a Venetian you are comparing arts that do not admit comparison. Brancusi was badly upset when he found that the conditions of our insurance policy prevented his sending the originals of his work to the Armory Show. He hated to be represented by casts, after having lavished so much care and skill on the surfaces of his marbles. Another sculptor, on hearing of this, remarked, dryly, "That is his weakness; any piece should support judgment from a cast." Taken rigorously, the words of the latter (a man of admirable attainments) are the truth. But they are not the whole truth. A cast from a work carved in marble is a reproduction, and no reproduction can show the full beauty of the original, unless to a person who knows the entire range of a sculptor's achievement. Fortunately we had one Brancusi marble in the show.

And, unparalleled as is his treatment of materials, his work does not stop with surfaces. The tombstone of *The Lovers Reunited* is a new and most noble conception of the ancient theme of the shaft. The *Sleeping Muse* is simply bewildering in the subtle way it turns at every point, approaching the non-human quality of the geometrical figures and yet keeping both a recollec-

tion of some lovely head seen by the sculptor and a sense of his own gesture in evolving the work. Later, in moving away from the danger seen by modern artists in the two sources of beauty just mentioned, Brancusi has risked even greater impersonality; it needs no malice toward his works to suggest likening them to such objects as a bowling-ball or an ostrich egg.

But always some particularity brings one back to the man, that worker in the wooden shoes, living by himself in what seems a stone quarry, eating from plates on an old mill wheel (I think it is) that serves as a table, and seated on a great oak beam he has saved from some noble house that was being torn down. A Spartan? Yes, in his rejection of soft and trifling things; but taste the coffee he makes from the powder his little Turkish grinder gives forth, walk with him by the sea and hear his praise of it, sit with him afterward over the bottle of wine that no one can select better than he, and you will realize that the sun of the Orient warms through his seeming asceticism and makes it rich, just as his frugal use of forms and surfaces in his sculpture mellows them with a quality too fine to be called royal: theirs is a luxury for which kings may envy peasants, men who live, like Brancusi, close to the earth and its fruits, its good odors and its trees and the music in their leaves.

Brancusi finds everything he needs in Paris, and he would not exchange that city for the rest of the world. Dufy goes all over the world—to England, to Sicily, to America—and his painting seems at home everywhere, but he also must return to Paris. Even if his Norman birthplace is always *mon pays* for him, even if his grandfather wrote the family name with a double f, having been a Scotchman, Raoul Dufy is a Parisian, with the alertness of the capital, its humor, its love of good food and good wine, and above all its unchanging belief in the reality of art. Was not this last-named characteristic of the city one of the chief reasons why Heine felt in place there? It was said of him that he could

joke about any subject save two—his mother and the cause he was fighting for. In France he found a people who looked on art as something worth fighting for, and though they could joke as fiercely as himself, anyone at all to be respected had the good taste to keep art out of the category of subjects offering a fair mark for the *blagueur*. That slang word does not apply at all to Heine or to Daumier. Seurat, again, may cause a broad smile with his clown in *The Circus* and with all the funny little people in the audience there, but the term to describe the quality of these three artists is *spirituel*.

I think the word is the hardest in the French language to find an equivalent for, whether in our own tongue or any other. Probably the nearest thing to it in English is "witty" and, as William C. Brownell has remarked, that is a wretched translation. It does apply at times, but *spiritual* never does, or so nearly never as to make the resemblance of the two words, when printed, a permanent warning against such pitfalls for the amateur Lavengro. Nowhere should his speech be clearer than in matters of art, and as the best definitions there are the ones obtained from examples, I would suggest that to understand the word *spirituel* the thing to do is to look back over the course of literature and painting in France—above all, taking note of La Fontaine with his wisdom, his grace, his gallantry, his seriousness, his feeling, his freedom, and all the other things that make up his *esprit* (mind, spirit, wit, are probably the first words for that in the dictionary); then work back to the men who did the more intimate sculpture on the cathedrals, and forward again to Watteau and Houdon (with that smiling portrait of his wife), and see also that the *touche spirituelle* may be found in the very handling of the paint by Renoir, all athrill though he is with the beauty he celebrates throughout his lifetime.

So I am giving Dufy a big tradition to live up to when I call his art *spirituel*. It is so, and in the truest line. But there is also

another tradition which it represents, one as often misunderstood as that gaiety in his work which the superficial take for lightness, giddiness even. I admit that much of his exuberant production has gone out to the world too quickly for the public to relate it with the more sober examples of his art. The too slender things will be forgotten, however, just as one rarely hears the painter reproached nowadays with his work as a designer of textiles.

As often as that was thrown up to him, I doubt that he himself ever saw it as a reproach. Yet in the earlier years when I called at his studio, one always saw bits of silk from the dyer's, or samples of his printed linens, the *toiles de Jouy*. Originally they got their name—if I am not mistaken—from that town on the road to Chartres where one may lunch so admirably. People have been known to stay so long at table there that they reached their destination too late to see the cathedral, and were obliged to stay a second day. (They were sufficiently rewarded.) At all events I can quite believe that the same genius which gave us the beautiful designs at Chartres was still at work long afterward, in near-by Jouy. And yet with such history back of the decorative arts, people have tried to make light of Dufy's painting because of his work with textiles!

Does anyone say that in the great past the artist of the cathedrals—the sculptor, or the man who told the sacred story in the windows—was not the same one who produced the objects of applied art? I know more than enough examples to demolish the claim. If I refrain from giving them, one reason is that, for the purpose, my list of even the very great names in all the countries would be a mere fragment. So the best way is to be categorical and say that the person who sees separation between the major and the minor arts is so far from the traditional view that he represents the modern decadence, an actual and widespread thing, unhappily.

As in every question of art the decisive criterion is that of

quality. It comes to appreciation only by slow degrees, and so Dufy's prodigal hand can give us the superb drawing and color of one work after another in a New York exhibition that is on as I write these lines—with, I am told, not a picture sold there. *Quelle blague!*—to glance back at the other French word I used before. The joke is not on the painter, but on the public at large. It is the public that needs defending, not the artists. The latter always contrive to live somehow and to go on with the "queer thing" around which this book turns.

Dufy contrives to live very well indeed, and I don't mean simply from the material standpoint. Though he is still in the old studio building in Montmartre where he has been for so long, it is not for lack of money to splurge. But who wants to do that? The old house is delightful; he is at home there. And the important thing is what talk one has over the excellent table set by Vollard; what that wonderful old connoisseur thinks of the etchings which Dufy brings along for the latest of the beautiful books that the dealer-publisher is engaged on, whether that mysterious person will bring out from his hiding-places a Degas or a Cézanne that even the intimates of his *hôtel* have never seen before, at this late day, and whether in an access of the generosity of which he is capable, he will not let go a water-color or a *sanguine* by one of the masters. To come home with a thing like that under your arm is to live—if you have the definition of living that Dufy has and that Paris has.

XIV.

SEGONZAC, LÉGER, GLEIZES, DE LA FRESNAYE

IT WAS, ESSENTIALLY, TO GET A BETTER DEFINITION OF LIVING that the Armory Show was undertaken. America was living off the canned foods of art, the things held over from years before. It knew, vaguely, that there was fresh fruit, fresh meat on the tables of Paris, and it wanted its share. So a special interest attached to the purposes of a new association of painters and sculptors. It had planned a big exhibition where the hundreds of artists excluded from the old Academy shows might get their work before the public; but it also set itself to end the reign of ignorance as to modern art that had prevailed in America since the bringing over of the Impressionists, almost thirty years before.

Alfred Stieglitz, in what he called his "tiny laboratory," had shown drawings and water-colors by Cézanne, Matisse and Picasso, and so a few artists knew at least the direction that the great movement of the time was assuming. They addressed themselves to me, since I had been living in Paris, to aid in obtaining a worthy representation of the men I have been describing in these pages. Arthur B. Davies was the head of the enterprise—in the sense of doing its best thinking, and not alone as furnishing initiative and money. For years he had hated the petty politics of New York art circles and, even more, the indifference there toward the important tendencies and men. My acquaintance with him had begun a number of years before, after he had noticed an

article of mine on Cézanne, the first to appear in an American magazine. Some two years after that, in 1910, we had both been interested in what was called the Independent Exhibition (unconnected with the society later to arise and continue the No Jury movement that, beginning in 1884, had done such valuable work in France). The chief effect of the gesture of 1910 was to demonstrate the extent of progressive sentiment in America and to bring together the men who, in 1912, organized the Armory Show.

Most of them were interested merely in getting a wider audience for their own work or, at most, in providing better conditions for the young men who were coming forward with a genuine contribution to offer to the art of the country. Mr. Davies wanted much more. For years he had browsed in shops where foreign books and magazines were to be seen, and so had accumulated a most surprising fund of knowledge as to developments in Europe. His acquaintance with the French language being limited, he had asked me, on various occasions, in the first years of our acquaintance, to make translations of articles that interested him through their illustrations. I recall, for example, a series of them in quite an obscure Parisian review, in which Armand Seguin, a disciple of Gauguin's, told of that artist's school in a little village of Brittany.

Therefore, when Mr. Davies came to Paris for a week in the autumn of 1912, he was remarkably prepared to make decisions as to the painting and sculpture that we saw there together. When we called at Brancusi's studio and he saw that hermit, so intent on his job, so oblivious of all the machinations of the *arrivistes*— the people whose one goal is material success—he said, "That's the kind of man I'm giving the show for." And on the spot he bought for his own collection the exquisite little *Torso of a Woman*, the marble I spoke of before as representing the real quality of Brancusi's art at the Armory. It can be seen, though

with difficulty, among the works by the sculptor, at the left in the photograph of the Armory Show here reproduced.

Another visit to a Paris studio, among the many that Davies, Walt Kuhn (the secretary of the show) and I made during that week, remains in my memory because of the light it throws on the logic of the French in deciding the money value of works of art. Today Dunoyer de Segonzac is one of the most successful of living painters; his splendid work has developed steadily, and honors and financial reward have kept pace with it. But in 1912, when he was still under thirty years of age, his career was barely started, though his painting was already fine. When we were noting down the prices for his pictures, Segonzac caught a little start of surprise in Davies' expression and interpreted it correctly.

"He thinks I am asking too little?"—which I translated for Davies, who said that he had, in fact, found the prices very low, adding that it would be better not to raise them, however, as he would have a better chance for sales if he kept below the figures that other artists were demanding. I told this to Segonzac, who gave Davies a friendly smile in order to offset the disagreement in his reply.

"Please explain to him that I don't name those prices to compete for sales, but because my work is today worth no more than that, commercially. I have been selling for only a couple of years; I have only a few buyers. If I should be killed by an automobile, for example, the people who have bought my work would lose their money, because I haven't enough reputation to attract new collectors if any of my own wanted to realize on his investment. Later on, when I have ten, twenty buyers for every one that I have now, there would be no difficulty as to a purchaser's getting back what he has paid, because my pictures will then have a solid market value."

This healthy, confident young man, talking of his possible death in terms of its effect in dollars and cents on the status of

his pictures, gave me an insight into the solid basis for the art business in France. There, as elsewhere, one can find examples of the hocus-pocus of social talents, salesrooms, and other irrelevant matters. But the core of the question is merit—what had taken us to the studio of Segonzac and what he, with his direct, unemotional words, was evidently relying on to insure his future.

Everywhere among the artists one felt the same conviction: that if their work could be seen it would find appreciators, their own belief in it inducing the conclusion that others would see its quality. When Matisse came to America, many years afterward, he was asked what should be done to raise the level of understanding here. He replied: "Give exhibitions, and then more exhibitions, and then still more exhibitions." He was expressing the same confidence in art and in the public that Paris showed in 1912. The only enemies of the artist that it recognized were ignorance and indifference—and it would spare no effort in combating them.

One dealer, it is true, raised the issue of America's unpreparedness as to modern art; he was loath to let his pictures be used as a means to attract a merely gaping crowd. I was able to convince him that he must do his share in educating a new public; after the show had made its great success, he confessed freely that his earlier lack of confidence had been a mistake.

Some of the artists felt that their work would be compromised in the eyes of people not accustomed to it by the presence in the show of pictures they disapproved. But on the whole—indeed without exception—they were willing to let their production be its own defender. And that is significant when one considers that the modern schools of at least half a dozen countries were being shown, and that no one could know in advance about the important matters of the space and prominence to be given to any individual or group. There was concern about such questions, but no

more than was natural, since the results of the show might have a considerable influence on the future of men and movements.

Even within a movement there were great differences among the men. Time has accentuated the distinctions, but already in the earlier years of men as close together as Léger and Gleizes, one could see how separated were their points of view. The latter was all for the "modern school," pretty strictly defined. To Léger, as he told me at the time, the evolution of the period from earlier forms ought to be shown. "If you don't connect our work with that of the Impressionists, people will think that Cubism dropped from the sky one fine day, and that it might just as well go back there. But here, in this series of my own pictures, anyone can see the step-by-step progression of things—which is going to continue." Like his friend Brancusi, he does develop his work by degrees, the few themes being played on with an always new curiosity as to the combinations and relationships among themselves which they make possible.

People who demand social significance from art may at first see in this a sterile interest in solving puzzles, or in building up a system of esthetics, both activities being divorced from life, at least as far as concerns the daily round of existence. But where one finds a man as close to the movement of thought in his time as was Léger, the reproach fails. When, years after the Armory Show, the artist had his big exhibition at the Museum of Modern Art in New York, many a visitor had that proof of authenticity in the work which one gets in places like Haarlem or Toledo, where a single painter dominates the mind. Coming out of the museums in those two Old World cities it is common for people to exclaim over the fact that everybody in the streets has the look of a Frans Hals or a Greco. So with the Léger show: on leaving it, the pictures seemed to continue as one looked at the perspective of houses, the piling up of masses, the movement of figures.

Instead of the individuals painted by the older portraitists, the modern artist had rendered aspects of city life as a whole.

Another token of his quality was suggested to me when I was working for the acquisition by the Metropolitan Museum of Louis David's great picture, *The Death of Socrates*. By chance I had discovered that its owners were ready to sell it, after it had been in their family nearly a hundred and fifty years. I cabled home about the great opportunity, which the museum did not fail to utilize. Before sending off the photograph of the work, I showed it to Villon. We marveled at the exactitude of the forms, their clear-cut modeling and almost metallic finish. Villon remarked, "Léger has some of that." He has, and did he not possess as well something of the serious, even social, purpose implicit in David—the voice of the Revolution—my friend would not have been led to make the observation he did.

Perhaps it will seem that I am trying to justify a "modernist" by means of a resemblance in his work to that of a man consecrated by time. But in that Paris I am writing about the thing works in the other direction. These men, so intent on the life around them that they portray it by their non-realistic means, are not museum haunters like the hundreds of thousands of Americans who go to Europe in order to gaze on the works of the past. In their own country, when they have seen Niagara or the Yellowstone, they do not need to keep returning there even if, during a summer vacation, they do take pleasure in fine scenery. The French artist, having made acquaintance with the Louvre, has it as a lifetime foundation for his thinking—which is less concerned with the past than with the present. To be reminded how exciting the art of a Louis David can be, he usually needs to have it thrust into his interest through its being resumed by a contemporary like Léger.

That painter, as I have said, sees his problem along technical lines. Albert Gleizes has always sought inspiration in matters of

a more general, philosophic character. In 1905 he had been one of the group of six men who founded the Abbey of Créteil, a collectivist experiment that attracted much attention at the time. So many of these men have become world-famous since then that it is interesting to rehearse their names in order to see how solidly their later achievement is rooted in the hard thinking (and hard work) they did at this time, when all were under twenty-five years of age. The list, in the order given by Gleizes, comprises Charles Vildrac, René Arcos, Alexandre Mercereau, Georges Duhamel and Jules Romains.

In his account of the enterprise of which he was so considerable a part, Gleizes says, "Charles Vildrac had written a volume of verse in which, through beautiful images, he revealed the truth of the epoch. . . . A visionary, he described the future collectivist house wherein faith would flourish through the arts." The movement began with great enthusiasm, and achieved certain results for a year or so, even though material difficulties finally brought it to an end.

Gleizes has never ceased to believe that the need of the time is an expression through which many men can commune in rendering impersonal ideas, as they did in the mural painting of the great past. He has gone on with spoken and written propaganda for such an art, and has neglected no opportunity to put it into execution. It is significant that he thus rejoins his old comrade Léger. The latter, though his course has been through the great galleries of the dealers instead of along lines of collectivism, has come to regard success with his pupils as obtained when a spectator can mistake their work for his own. That means simplification of methods, and working out a technique accessible to any serious student. Later on, he may evolve a scheme of his own and doubtless will, if he has a personal message, but for the time— this present time—he will be dealing with ideas held in common.

Another man who stood close to those whom I have just been

discussing was André de La Fresnaye. His tall slender figure moves through that past of twenty-five years ago with the grace, the easy distinction of his painting. It had the qualities just mentioned, though it was above all a thing of profound seriousness, and represented a powerful effort.

I once asked de La Fresnaye whether his group had been associated from early times, or through the unifying influence of a teacher. He said "No," quite emphatically; they had found their works together at the exhibitions simply because the hanging committees recognized common tendencies among them; personal acquaintance with the other workers often came only as a later result. This is worth recording, I think, since the movement toward organizing the lines and planes of the picture appears so general among the strong workers who were coming up just before the war.

Among them, de La Fresnaye has sometimes been compared with Géricault, a century earlier. But I think this is largely because of the military subjects that interested both the earlier and the later master. It is not too soon to use the word about our contemporary, yet his temperament was not that of a great innovator and leader like Géricault. He had, rather, a certain poetic aloofness which went well with his aristocratic name and manners, cordial and simple as the latter were. His case recalls that of Jean Le Roy in more than one way. Both were peculiarly French in their combining of finesse and strength, both drew the elements of their modernism from a deep feeling for the art of the past, both died victims of the war, Le Roy in the field, as I have related, de La Fresnaye from wounds and disease. He was more than once discharged from the army because of them, and each time he went back into the fighting as a volunteer.

The courage he showed in the war continued as he went on with his work, under the shadow of the death sentence he had brought down upon himself through his heroism. It is a joy, how-

ever, to look at the drawings he made in that last period, and observe that their clear unshadowed beauty tells that no bitterness over the stopping of his work darkened the mind of this man who had every reason to live—youth, immense talent, the admiration of those about him, and a growing success with the world.

I did not meet him again in those few years that he survived the war, but, hearing of the gallantry he showed in his last battle, I was not surprised, for it was so evidently a quality of his in those earlier days. It went into the swift, powerful line of his figures, it went into the sober, determined piling up of the planes he composed with, just as his gentle elegance of speech was complemented by the color, suave and rare, yet positive and masculine, in his painting. Add to these gifts of sensibility the daring of that Cubistic and near Cubistic group and you have an idea of what made the fascination of the Paris I knew in those days that concluded my pre-war sojourns in the city. Some of its great quality is always there, but I believe the thing was particularly strong in the time which produced that big group of works I sent to America for the Armory Show.

XV.

SIMONNE

━━━━━━━━━━

It may seem strange to wind up the account of years spent by a young man in Paris without the mention of a woman, and indeed it would be a mistake to do so. Even though the story I am telling is not a personal one, but of the art life of the time, women play too big a rôle in art to omit them. It is rare for them to have this importance directly, by their own painting or sculpture. There are enormous numbers of women artists, and some of them are, of course, of very real merit. To note the average level of ability among art students of both sexes is often to come to the conclusion that women are more gifted than men. But I think that precisely the talent which causes the girl to outstrip the boy when at school, her faculty for accepting instruction and for going on so rapidly under impulsion from a teacher, is what works against her later on. When we look at mature production, it is not the qualities to be learned at school that we seek, but creative genius. And in the arts under discussion this seems to be given by nature to men almost exclusively.

To be sure, it requires a severe interpretation of the words to justify this statement, and only the rarest men measure up to such a standard. It is a mistake, also, to think that no other than work marked by creative genius has value and can give delight; the most cursory ramble through a gallery showing the Dutch school,

let us say, will recall the number of minor artists whose work would be the pride of any household that possessed it.

So the portraits of Olga de Boznanska must have given a deep satisfaction to the numerous people who have enjoyed the Polish artist's subtle feeling for character and the minor-key palette with which she gains her delicate effects. For a time I occupied a studio on the same landing as her own, and it was a pleasure, in the evening, to hear the sound of her piano. I think the one composer she played was Chopin, but that was part of a fine tradition of Paris, where her compatriot of the Romantic period lived and died, and where his music has always had so many admirers.

Through this memory of my gifted neighbor we can approach the greater women of the time, artists like Sarah Bernhardt and Réjane, and Yvette Guilbert—my own choice as the most wonderful of the three. I saw them only across the footlights, and it is for others to tell about them. But as one of the thousands who got inspiration from their work I can let them point, again, to other women who enter the field of the graphic and plastic arts more directly. Very near them was the extraordinary genius of Isadora Duncan, and it needs the utmost rigor of analysis to make one recall that even she was an interpreter rather than a creator. Indeed, the glory of her work, as with that of the great singers and violinists, lay in her subjecting herself to Beethoven, to Gluck or the other composers whose art she embodied for our eyes. No wonder that Rodin was mad about her, and not only he, but every artist I know who ever saw her dance.

And so we come to those collaborators of the great men, whose names are unknown to the world but who have their special share in the credit for giving it art. To see Corot noting on one study, "Umbrella Pines at Rome," and on the next one, "Marietta," is to play with the idea that a tree or a nude girl meant much the same thing to him—just a subject to paint. I choose the adorable landscapist as my illustration rather than another artist,

because I think that the latter-day appreciation of his figure-painting causes us to see, even in his case, that the girl made a difference in the work. We get values which we should have lacked if that little Italian had not looked along her golden body toward the young northerner.

I like to think that it was because Goethe knew about painting from actual experience that he could write "Das ewig Weibliche zieht uns hinan." For the poet and the musician there is of course a muse, often a personified muse, no less than for the sculptor and painter. But for the latter two, she is more immediately a part of the work. And what differences there are among models! One has a face and a figure that are simply faultless, and she bores you to the point where you invent an excuse for finishing the work long before you meant to. Another who scarcely seemed beautiful at all, in the beginning, becomes radiant, commanding, electrifying, as she throws off her wrap and takes a pose—her pose, that no one ever saw before, any more than he ever saw, previously, the picture that a good painter does of her. In the one case and the other there have been things nearly identical, but between the work of art and the near work of art the distance is simply infinite.

No one has ever called his book *A Novel Without a Heroine*, and even in such a book as I am writing there must appear, among the people I have known in the art world, at least one woman. So let it be Simonne. That is her real name—or half of it, which is all that is needed. I first saw her at one of the sketch-classes where one goes to keep up the practice of drawing from the figure and sometimes to get new models for work in one's own studio. After painting Simonne various times myself, I recommended her to my friend La Patellière, and his words about her expressed my own idea—"When I looked at her face I thought for a moment she was a child: then when I saw her figure, I knew she was a woman." And what a woman! Of a beauty that made the Greek things at the Louvre seem cold and heavy, until you got them

back before your mind again and came to your senses as you realized your folly in comparing mortal flesh and blood with their timeless perfection.

No, I deny that I ever did commit that particular stupidity. A mere fragment of Attic marble gives one the feeling of the great statue to which it once belonged. But Simonne was a woman, as my friend said, and with her a hand or a foot (perfections both) would be nothing in itself. Not even the whole girl—without that smile of hers that was a ray of sunlight in the studio, and her talk in which the child and the woman mingled, and her goodness, over which the mean and cruel things of life could not throw the least cloud (and the Lord knows that her fight to keep going and to help her small sister and her sick, widowed mother, was hard enough for her young strength).

And she was an artist. The beautiful things she did with her body are lost to the world, save for the representations which her collaborators, the painters and sculptors, made from them. The poses she took were a matter of art, instinct with the quality that came unconsciously with her race, her Paris, the poems and songs that could move her to tears, and the works at the Louvre where she constantly went, paying her hard-earned two francs for admission, if the temptation to enter could not be resisted till Sunday, when the museum was open without charge.

Whenever Maurice Prendergast wanted to express the utmost of his admiration for feminine charm, he would say, "She is just like one of those French girls." And there was no mistaking his accent: he had known someone like Simonne. For, rare as such a person is, even in Paris, the question is not of one woman, any more than with the painters and sculptors there is any question of reducing the whole matter to one man. There are never too many of either, but this book is here to tell that the race has not died out.

For instance there was Gabrielle, of whom I made mention

when writing about Renoir. I cannot claim to have known her well, more's the pity; but I am sure that it was not just her splendid beauty, not even the fine interest she took in looking after the material needs and comfort of the old artist that made him want to have her around. When she asked me what I did, on one of my first visits, and I answered painting, she exclaimed, "*Oh, le sale métier!*" Doubtless it was the *patron* himself whom she had heard inveigh against the "wretched trade," on days when his work went wrong—and just that one thought, so nearly impossible to arrive at from the sight of his pictures, ought to make the present testimony encouraging enough to justify all the time needed for reading through my pages.

It was not a matter of picking up phrases with Gabrielle, any more than of her being a joy to look at. If Renoir painted her so many times, coming back to her after having had other models, it must have been because she had a sense of the beauty of his work, and a pride in helping him with so great a thing; that made her a fine companion. The same was true of Rose Beurre, whom Rodin finally married. She had been "Madame Rodin" to visitors at the studio for decades, and one knew of the way she had got out of bed on cold winter nights to look after the damp cloths necessary for the sculptures, and so let the great artist have the sleep he needed.

Or, to go back to a woman who died long years before I was born but who comes back to mind irresistibly in this connection, what about Jenny Le Guillou? The words about her that Delacroix wrote from time to time in his *Journal* during nearly thirty years tell us what her noble character, her understanding and devotion, meant to the world in their effect on his work. And thousands of people who have visited his tomb in Paris have felt a thrill of gratitude to find that the stone next to his own marks the resting-place of the faithful friend. Unquestionably this would be because of an order of his. Unique individual that he was,

and isolated, even though Corot and Barye and Chopin were his friends, he was still expressing the mind of his time—the best of it; and that is what one realizes anew when one sees the great aristocrat and the woman of the people facing the aftertime together in this way.

An admirable passage in Elie Faure's *History of Art* tells how Italy is represented to us by Michelangelo, England by Shakespeare, Holland by Rembrandt, Germany by Beethoven. When he asks about France, he has to hesitate; no one individual stands out in such unique fashion, for this land does its work communally. And so he ends his chapter with the words: "The French hero is the cathedral." I am very sure that the reason why Maurice Prendergast saw his ideal of women among the French was that they know so much and enjoy so much of life and art that they play their part in both after the fashion of the countless anonymous workers who gave us the cathedrals, an expression of their country that is more than any one artist's production, for it sums up the thought of all.

My last night in Paris before returning to America for the Armory Show was spent with two students, a boy and a girl, who influenced each other in the poetry they wrote. I have not heard that her work has become famous (she died soon afterward), but it goes on, none the less, in the verse of her friend—who was Jean Le Roy.

XVI.

THE ARMORY SHOW

THE INTERNATIONAL EXHIBITION OF MODERN ART, TO USE FOR once the official title of the Armory Show, opened on February 17, 1913. It comprised some sixteen hundred works, though the catalogue (now a collector's rarity) listed far less than that number, whole sets of lithographs or etchings being set down as a single item, and many things arriving too late to be included even in a supplement. In addition the Association giving the show had me translate Elie Faure's long essay on Cézanne, which was published as a brochure, as were articles of mine on Redon and Duchamp-Villon. Had my duties at the armory not kept me busy from morning to night, there would have been endless work of the kind to do, for the curiosity of the public was insatiable and there were almost no spokesmen ready to answer questions about the new schools.

The paintings and sculptures were, of course, their own best spokesmen. For the many thousands of persons willing to look instead of talk the show offered sufficient material to permit one to follow the evolution of art down to its most recent forms. An unbroken historical line was traced by the exhibition, with Ingres and Delacroix as its beginning. Indeed there was one Italian drawing of the sixteenth century that showed, in the geometrical figures it contained, the mathematical basis on which the Old Masters built their work. But that was a chance loan from an

artist who had the work in his collection; the main line of development was from the nineteenth century—ending with the Impressionists—to the twentieth.

There were rooms of Cézanne, Gauguin, and van Gogh, and fine things by Seurat, Rousseau *le Douanier*, and other men who carried the visitor over the turn of the century. Of Odilon Redon we had a very large collection, and to my delight as I thought of the satisfaction his long-delayed success would give the old artist, his work sold in larger quantity than any other. To be sure there was Villon, whose percentage of sales was higher: of the nine things he had in the show, all nine were sold—and had I had more, there would have been buyers for them.

In all, over three hundred works found purchasers—an extraordinary number. No one anticipated such a result—the Association had counted on gate receipts alone as its source of funds to repay the art-lovers who had advanced money for the expenses. And certainly the turnstile kept up its song from ten in the morning till almost ten at night. In New York, then in Chicago, then in Boston (a dozen other big cities applied for the show in vain), the stream of visitors continued steadily, at times swelling to such an extent as to cause congestion in the whole building. We raised the admission price from twenty-five cents to a dollar in the mornings, so that persons desirous of quiet study might be undisturbed by the crowd that milled about later in the day. Even so, the room of the Cubists was always filled, and to have an unbroken view of the *Nude Descending a Staircase*, one had to await one's chance.

The paid attendance was, I believe, about a quarter of a million visitors, with as many more, it is estimated, in Chicago alone, on the free days demanded by the city's regulations for the Art Institute, which had invited the exhibition. The newspapers of the whole country took up the affair from the start, indeed long before the show opened, and already in New York we had visitors

from as far west as the Pacific; Chicago, of course, drew upon the whole central part of the country for its enormous attendance. Mr. Carpenter, the acting head of the Institute, was troubled. "We got you fellows here to boost our records," he said one day, "but I didn't think you were going to get them to a point that we can never reach again. I'm figuring what to do next year so that our statistics don't show too big a decrease. Maybe an aviation meet on the land alongside the building would do, if we held the thing in the cold weather and the crowd had to come into the museum, which would be the only public place near by for warmth and comfort."

If great numbers of the people who came to our show had no more interest in art than the visitors Mr. Carpenter talked of for the next year (sensational press-talk being no better a reason than bodily needs) the best of the country's thought, none the less, centered around the show, for the three months that it was open. I say this despite the fact that in New York it became a society event, in Boston the lower stratum of academic sterility assembled for scoffing, and in Chicago another bad element in the community was concentrated in the galleries by a curious circumstance.

The city was stirred at the time by a campaign against vice, and was ready to discover it in almost any place. An art dealer had just been arrested for showing in his window a reproduction of *September Morn*, a nude of the typical silly Salon variety. And so there was an unusual response when a clergyman wrote to the newspapers that he had been obliged to turn back his flock of Sunday School children at the head of the stairs in the museum. He had brought them to the place to be uplifted by art, as he did every year, but this time, instead of the Old Masters he had expected, he saw from the door that the rooms were filled with the degeneracies of immoral Paris; he demanded that the public be protected from them as he had protected his children.

[194]

THE ARMORY SHOW

The Vice Commission acted at once. I escorted its chairman, a nice old state senator, through the show. He wanted to see two things, above all a picture called *Prostitution* and the *Nude Descending a Staircase*. The former was a merely symbolic work in which a young woman was handed over by an older one to the devil, all three figures being fully clothed. The senator could not see any danger in it as the sinful acts of the young beauty were not being performed before the public, which indeed was warned against her and her fate. I was not greatly concerned about her fate myself for, lamentable as it might be, it was not so bad as the painting, whose withdrawal would have benefited the exhibition. The Duchamp picture, however alluring its title, disquieted the Vice Commission even less. For after one look at its tangle of "abstract" forms, it convinced the senator that it would lead no youth nor maiden from the path of virtue.

But we had been complained about and investigated, just like the establishments that had caused the vice crusade to start, and further publicity followed when the students at the Art Institute held a meeting of protest and a majority of them voted for condemnation. This was put into effect by the burning in effigy of one of Matisse's big nudes, also a figure representing myself, and (alas for the anti-climax—and for the mentality of those art students) an image of cheap little *September Morn*—which, of course, was not in our exhibition.

Thereupon, as later appeared, the report spread through the underworld of Chicago that here was a show of the "real thing" from Paris, and for several days we had a stream of visitors such as no other art exhibit ever had. The women, by twos and threes, were awful; the men were worse. The poor, furtive-looking girls, sullen and slatternly in most cases—not the bright, prosperous type, were the only disappointed people who came to the International. One of their men, a fellow with as ugly an expression as

I have ever seen, sized me up from a badge I wore as an official, and finally decided to speak his mind.

"It's a fake."

On my denying this, without too much emphasis, I hope, he replied:

"Say—I know smutty pictures when I see them; I've sold enough. What's the good of these?" and he pointed about the walls, by chance stopping at the very Matisse that had been castigated by the students, and was perhaps the cause of his visit. "Who's going to get any kick out of a thing like that? It's a fake, all right, and I got to hand it to you for pulling it. You've got my quarter and you're welcome. Anyhow I got my money's worth— not in your place, because I asked and found I could have seen this stuff any time. Say,"—relaxing a bit as he warmed to the memory of his discovery—"if you want to show anybody the good ones, take him down there behind the stairs. Figures—life size, some of them broken, and just white, but, gee! women with" (anatomical details and gesture of caressing) "and men with" (more anatomy and enthusiasm) — "I could hardly keep my hands off them." He had stumbled into the halls of ancient statuary.

The hint he gave me was useful. One old fellow had bored me with his remonstrances on immorality—and his inquiries as to where the really indecent things were to be seen. I had said there were none, but that only made him accuse me of hypocrisy: why should I hide away from him the things he knew were there, because he had read of them in the newspaper? "Now, I have a saloon," he said, "and I always say—if the men want to drink, they're going to do it, and if they want to go upstairs to the girls, they're going to do that. But let's not be fooled about it. You look like a decent young man; surely you're not going to tell me you approve of these immoral things," and he made a pretense of horror, but it was not very convincing even to himself as his eye

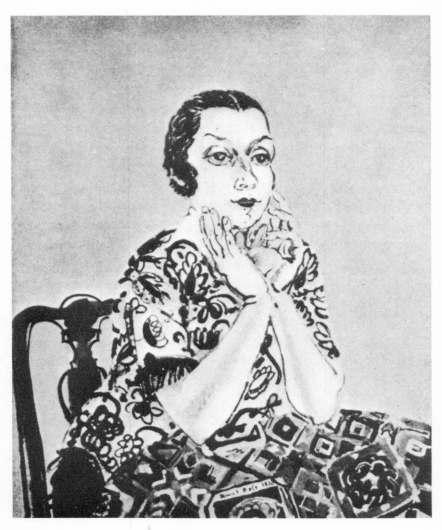

PORTRAIT OF THE ARTIST'S WIFE

Painting by Raoul Dufy, 1930, The Bignou Galleries

A SECTION OF THE ARMORY SHOW, 1913

rested on the strange modern things again. Where were the others?

"Well, I'll tell you," I said at last, "there are some things in this building that I think ought to be removed as injurious to the public. I think the pictures in this room are not at all harmful, but since you want to see the other kind, I'll show them to you," and, as he eagerly assented, I led him to the part of the Institute where the collections not removed to make space for our exhibition were still on view. There I showed him a life-size picture by Bouguereau, two nude women by the sea-side. He was triumphant—doubly so.

"Didn't I say you were a decent young man? Didn't I know you wouldn't try to fool me? I knew the stuff was here. This is a disgrace, and I'm going straight to Alderman Egan and tell him to have the police take it off the walls," and away he went. I don't mind telling today about the Chicago of twenty-five years ago, for its rawness has changed so immensely, and no place, I think, has made such strides in coming to an appreciation of modern art.

But it was brutish in its ignorance at the time. The day after I arrived there, a newspaper anticipated the effigy-burners in associating me with Matisse. A picture of his appeared alongside one of my own on the page with, underneath, two curious-looking images of human beings. The caption ran "Two of these Cubists are in Dunning" (the local insane asylum), "the other two are still at large. Can you tell which is which?"

New York had been different. It had laughed, but on the whole it had been good-natured, even friendly, and had bought over two hundred and fifty things, as against the fifty we sold in Chicago and Boston combined. To be sure, the artists of the older schools were pretty bitter; the ones in Boston were the worst. An old friend of mine, an official of the museum in that city, had come down to New York for the show, and I promised myself some pleasant visits with him during the month I spent in Boston.

Not seeing him about, I 'phoned the museum twice to ask him to lunch with me. On the last day of the show, one of the guards came to tell me the gentleman was outside. I said he should be admitted at once, but he declined to enter, and when I stepped outside and he said he had a cab waiting, I went off with him, as he said he could not come in. Then, with apologies, he told me that there was such strong feeling about the exhibition that he thought it wiser not to let himself be seen there.

One more such memory and I will finish with this phase of America's reaction to its first great contact with modern art; I have already indicated that it was by no means the only phase. Bryson Burroughs, the curator of paintings at the Metropolitan Museum, had been an early and enthusiastic visitor at the armory. He had tentatively reserved certain works for purchase by his institution, among them the Cézanne which was actually bought by him a little later. I did not know that Daniel C. French was calling on behalf of the Metropolitan one day when I was taking him around and so, since he asked about Cézanne, I directed his attention to other canvases than the one that Mr. Burroughs wanted.

"What qualities do you see in that?" he asked about a magnificent portrait of Mme. Cézanne lent to us by Sir William van Horne, of Montreal.

"Well, I am fortunate in speaking to a sculptor," I said, though without much conviction, I fear, "for it will be evident that the first thing about it is the quality of form. In my opinion and that of others there hasn't been any like that since the time of the great primitives—Giotto, above all."

Neither the tone of admiration in my mention of form nor in my mention of Giotto had any effect however, when Mr. French came to reply; his words registered very accurately in my mind; they were:

"I don't see that the Primitives, with the state of ignorance

of the time when they lived, are any excuse for a man's doing the same thing today."

After he had told me that he had come as a trustee of the museum, and I had shown him the Cézanne selected by Mr. Burroughs, a landscape, he agreed on that as less objectionable than the portrait. Going on to other rooms, he looked at a large bas-relief by Maillol, and when I told him that the artist's work was highly esteemed in Paris, he replied,

"Well, as St. Gaudens' father used to say, there isn't much difference between this thing and nothing at all."

To my thinking, Mr. French's opinions of Giotto, Cézanne and Maillol represent a state of ignorance not less than grotesque, especially in a man intrusted with authority at a museum. But two things deserve to be said about the matter. One is that his views were pretty much those of his generation; the other is that he stated them with the clearness I have recorded. What one really hates is ambiguity and compromise, the things dealt in by people who try to be on the winning side, whichever way the decision falls.

There was certainly no hint of such a mentality in the words of Theodore Roosevelt when he came to the show. It was on the day when William Howard Taft was leaving the White House, a circumstance to which his predecessor there had contributed by running against him on the Bull Moose ticket. I do not know whether the historic day had anything to do with the Colonel's "school is out" frame of mind, but certainly he seemed in happiest mood when going around the show with the artists. One of them, Bob Chandler, an old political colleague of his, rallied him on his conservative preferences. But his friend would hear nothing about Cubist pictures, which he compared, in an article he wrote on the show, to a Navajo rug in his house. He was on the right track, too, unless he meant that the Indian design was a poor form of art.

"Now there's the kind of picture I like," and he pointed out a sub-Whistlerian landscape without form or color. "When I stand at night in front of my place at Oyster Bay, that's just what I see."

"Yes, that's just what you see," rejoined the privileged Bob, "and that's just why I don't like the damn thing."

Still in high good humor, the famous man complimented Arthur Davies on a composition of figures he had in the next room. "All built up geometrically, Mr. President," said the painter, "just full of pentagons and triangles on the inside." "I dare say," answered the Colonel, "and I dare say the Venus of Milo has a skeleton on the inside, and that's the right place to keep it." The logic in that quick and original reply was shrewd enough but, beyond that, the words have always seemed to me a fine example of the urbanity developed by the public man in handling the statements of people with whom he differed.

Belle Greene, Caruso, Lady Gregory (the Irish Players were in town), J. P. Morgan (the younger), Otto Kahn, Henry C. Frick—all New York came to the show. Mr. Frick was deeply interested and wanted to buy a very good picture already sold, which the purchaser declined to relinquish to him. Also, had it not been for the adept handling of the dealer who came with him, Mr. Frick would almost certainly have bought our great Cézanne of the *Woman with a Rosary*. Had he done so, his collection would have had a different aspect from what it did when it was opened as a public gallery. I am sure, even, that had he acquired that masterpiece (a far more important work than the Cézanne purchased for his collection a quarter of a century later), his development would have gone along different lines thereafter.

Archer Huntington—one of the honorary vice-presidents of the show—explained to me that that was exactly why the dealer-friend of the collector had to prevent the sale. "You don't seem to realize that every foot of space on those walls means just so

many thousands of dollars to Mr. X.; if he lets you and your associates hang modern things there, where is he going to place his Old Masters? You fellows are proposing to take away his business."

What happened, of course, was that we opened up a new business for the dealers. It took time, but they saw that modern art had come to stay, and that there was money in it, once the market was thoroughly prepared. Later on, it became as active a market as that of Wall Street, with fluctuations of price, boostings, and shrinkages quite like those of the things so whimsically called securities.

The commercial moderns got to be so flimsy, in their rush for sales that often I regretted my share in creating the market. But that was bad reasoning. I still believe most strongly in everything I brought into the show (there were a lot more than that *Prostitution* picture that I disapproved), and I am convinced that every influence from the great things we had has been for the good of art. The matter comes back to George Moore's remark that if Raphael were to return to earth he would be proud of his influence on Degas, whereas if he saw a Bouguereau he would blush to see that he was concerned in the man's painting.

The essential effect of the big show was, of course, on the work of the artists. That it created a wider, more active audience for them was good, and better yet was its opening up the museums, which had previously kept to the past, or imitations of the past. Naturally the men who went the "easiest way," that of becoming little Derains, Picassos or Cézannes were lost, even when they achieved financial success by their more or less conscious disguising of their emptiness. But they would have been just little Innesses or Sargents otherwise, so it made no difference.

On the other hand, for a man like John Sloan, contact with modern art meant a steadily deepening insight into the difference between the essential realities of painting and the mere trick of

producing illusion. I take him as an example because of the strong work he had done before 1913. If the Armory Show and its offspring could mean so much to one already mature, how could it be other than pivotally important to artists in their formative years? The answer is to be seen in the look that American art has today as compared with that of thirty years ago. Very likely there were more great individuals among us then, as there certainly were in Europe. But the ingredients for producing greatness are beyond the imagination; all we can do is to furnish better surroundings and tools for the great man to use when he appears.

The Armory was the most potent factor in such an effort that the history of art in America has seen, save for the slow, general movement in developing our museums. The men who gave the show felt the thrill of contributing to the life of the time.

Other men felt it also. At a dinner given by the Association, toward the end of the show, Royal Cortissoz rose to respond to a line appearing on the program of the affair: "To our friends and enemies of the press." The dean of American critics, a title that he shared with James Huneker, Mr. Cortissoz might have been thought to be answering a challenge contained in the toast, for he had been the steady defender of the "established order" and very prone to support Ellis Island restrictions against newcomers; they had to be carefully examined, not to say fumigated, before being accorded admission to the land of art. Yet he had, from the first, seen how big a thing the Armory Show was, and when it opened had written that the members of the Academy might well come with their hats in their hands and ask the new society to show them how an exhibition ought to be given. So that it was no surprise for many when Mr. Cortissoz, with the easy grace and geniality characteristic of his writings, opened his remarks as follows:

"Gentlemen, you have no enemies in the press: you have only friends. Don't you remember the words that Pete Dunne gave

to Mr. Dooley at the time of the Boer War? 'I tell ye, it's a terrible thing, Hennessey, when ye come into camp of an evening, and have to scrape what's left of your best friend off of the side of your breeches'."

The last night in New York, after the public had gone home, there was a joyous parade around the whole building by the artists and their friends; the nice girls who had sold catalogues and done office work stayed on and were swung around in impromptu dances by fellows whom they had known before only as men engaged on a serious job.

' Champagne began to arrive and it let tongues loose in song and speeches. Someone ironically called for a good hurrah for the Academy. John Quinn sprang up, and his commanding figure caused a moment's pause as he said: "No, no. Don't you remember Captain John Philip of the *Texas?* When his guns sank a Spanish ship at Santiago, he said 'Don't cheer, boys, the poor devils are dying!' "

As regards the Academy, or academic art in general, the sentiment was premature, and always will be, very likely, for there will always be people to prefer such things. The vitriol in Mr. Quinn's remark distilled from the fact that the dead ideas would now sink to their proper level instead of occupying a position of authority.

The change has come about so considerably as to make the words of the good captain apply with quite sufficient truth.

XVII.

JOHN QUINN, JOHN BUTLER YEATS,
VICTOR MAUREL

OTHER QUOTATIONS, FROM THE WIDEST RANGE OF READING, WERE always ready to spring to John Quinn's lips when he needed them to drive home a point. They might be from the poets or the philosophers, or from the folk-speech of Ireland. "Ay—that'll make a dom fine fire—_when it burns_, as the little red fox said when he pisht on the heap of stones." The sardonic pause he made before uttering the words "when it burns" made one feel that doomsday was a good bit nearer than whatever event he was discussing. He had made several visits to the land of his ancestors and he followed the movements of thought there with the most eager interest. Or perhaps followed is not the right word, for he took an active part in the furthering of any number of Irish developments, the Abbey Theater particularly. On his walls hung paintings representing Douglas Hyde, William Butler Yeats, George Russell (AE), George Moore, and others whom he knew well. These pictures were, for the most part, the work of John Butler Yeats, the father of the poet; also by that painter were drawings of John M. Synge, including the original of the little masterpiece that faces the title page of the great man's plays, over the caption, "Synge at Rehearsal."

What an amazing place John Quinn made of that bachelor apartment of his on Central Park West! When Bryson Burroughs

went there in 1921 to borrow pictures for a modern show at the Metropolitan, he told with a gasp how, for several hours, workmen kept bringing in and removing paintings which he passed in review for his choice. And he saw but a small part of the collection. At its owner's death, three years later, it numbered some two thousand two hundred works. The total in 1921 must have been near to that, for, toward the end, Quinn had reached the point of buying for quality instead of quantity. Within those three years he had sold his library, including an important group of manuscripts, the proceeds being some two hundred thousand dollars. "That's for my old age," he told one person and another around town. "People think I'm going to spend that money for pictures; but I'm putting it away, I tell you. Just you watch me." And he shook an uplifted finger in severest warning against any doubt as to his virtue.

The watchers did not have to wait for any more than his next summer in Europe. The whole sum, and more money beside, was spent. It was well spent. For it bought Seurat's last great picture, *The Circus*; things by Cézanne, Redon, Henri, Rousseau, Derain, Rouault, Matisse, Picasso, Segonzac and others. All had been represented in the collection before, as were any number of the modern masters from Ingres to the youngest contemporaries.

In my first chapter I spoke of Quinn's belief in being of one's time. The chief interest of man being man, the chief art interest of the modern man should be modern art, he reasoned. Of a contemporary who went in for ancient things he invented the description: "He keeps his optics on the Coptics," which did not prevent his carrying his own interest backward in time. Always an admirer of Chinese art, he now approached Egypt—a part of that Africa he studied through his sculptures by the great Negro peoples, and he was well on his way to a knowledge of the exciting art of ancient America. When I went to Mexico in 1922, he was eager to have me get for him the work of its marvelous old races,

and an important group of Zapotec figures was a result of my searches—very difficult ones in that country, every one of whose inhabitants knows about art; a great number of them collect it—and few sell. The sculptures I mention went to the Detroit Museum from Quinn's house after his death.

I did my best to keep his collections together, and had they remained so they would have been a monument not only to the man, but to American intelligence and courage in the early twentieth century. There were other great modern collectors in the world, men like Stchoukine and Morossof, whose holdings, nationalized by the Soviets, now form the astonishing gallery of Moscow. But these men, like others in Europe and America, made their collections with the surplus of their fortunes, a matter of millions of dollars in each case. Quinn had nothing but his year-to-year earnings as a lawyer. And considerable as they were, he was nowhere near the class, financially, of those others, nor, by the same token, were they near his own in the spirit he showed.

He was not content to be merely an acquirer of things already produced. As he had had a part in the great literary and spiritual renaissance of Ireland, he wanted to work for the future in art, and so gave various men to understand that he would buy their work year by year, which he did. The knowledge that there was one man with such appreciation in the world (and therefore, possibly, more than one) was of immense importance to the artists.

And when I speak of the spirit Quinn showed in what he called "the sporting thing to do," it is necessary to add that besides putting the whole of his resources into art, for the purposes just described, he went beyond any other great collector I have known in relentless self-examination, discarding—with a laugh—his errors of earlier years, and driving always harder in his quest for the essential. Often he quoted Nietzsche's "Be hard," and he followed the advice, sometimes at the wrong time, though again

he could show a fine fidelity to good work that was no longer necessary for him but had meant something in the past of which he was so careless.

The years it included would reward the study of a biographer, especially one with the sense for inner evolution. As much as I know of the man's outer history, it was remarkable enough. At sixteen years of age he had been private secretary to John W. Foster, the governor of Ohio, who, three years later, when he became the head of the national treasury in Benjamin Harrison's Cabinet, took Quinn with him. The insight into politics and finance which began so early was sharpened by a law practice that extended to the realm of the banks and railroads, on the one hand, and to the inner circle of leadership in the Democratic party, on the other.

By 1912 Quinn was ready to name the candidate for the Presidency and, in that year when the Republicans were hopelessly divided, nomination simply meant election. Quinn's strategy carried his man, Oscar Underwood, to a strong third place in the party's voting, and from that he could easily have taken the step to the necessary majority, had the deadlock continued between Woodrow Wilson and Champ Clark, the two leaders. But then came the surprise of William J. Bryan's deserting Clark for Wilson, the "treachery that was paid for with the position of Secretary of State," as Quinn afterward described it. That was not his idea of "warfare," a word he often used about his legal work. He avoided politics thenceforth, saying it was a matter of mere buying and selling. He wanted a thing where men had convictions, and he found it in art. For his services at the presidential convention the one thing he asked of his candidate was that he arrange to have works of art freed from import tax at our ports. And as the tariff act of 1913 was in the hands of Mr. Underwood, when it came to an adjustment as between the divergent views of the Senate and the House, he was able to get art on the free list—a thing that had been attempted in vain for decades, the

answer always being that the rich should pay for their luxuries.

If J. Pierpont Morgan could do what he did in causing art to be accepted as an interest worthy of big men, John Quinn brought about a new advance in America's understanding with his idea that art is not a luxury, but a necessity. He was too astute to let that enter his testimony at Washington; even today, painting is still so much the "queer thing" for Americans (and other peoples) that they would not listen to any such talk. So Quinn went before Congress simply as a man who could not afford to buy Rembrandts, Raphaels, and the other "antiques" which were already on the free list (since they could not be produced here—at all events legally); he said that people of moderate means were being penalized while the rich got their things in free, and this appeal to democratic principles had its effect—and Quinn had a very broad smile. When the Republicans came back to power he was successful again, heading off a return to the old system, and insuring a continuation of the free access by Americans to the ideas of Europe.

In estimating the achievement of recent times it is necessary to take such matters into consideration. I spoke before of the greater number of important personalities among the artists a generation ago. But this may well be an effect of the simpler technical problems of the time. The attention that men have had to give to theory has absorbed energy which would otherwise have lent an air of importance to their work and carried it to greater completeness. Yet when one sees those two aspects of painting in the art of Frank Duveneck, for example, one feels that he paid all too dear for them by his acceptance of formulas taken over bodily from the past. The fact that his painting went downhill, as time passed, is explained only in part by the circumstances of his life and by his unpropitious surroundings in Cincinnati. The lack of a new outlook caused him to keep to his rut and to let his facile

handling buy him off from a search for the fundamentals—if he ever glimpsed them.

People outside the profession sometimes ask why so much importance is given to modern art, especially when everyone admits the greatness of the older schools. The answer is obvious to anybody engaged in the work, and so I was not prepared for the effect on an audience in Washington, one time, when I gave the explanation in a casual preface to my remarks at a convention of museum officials. I said, "The reason for an interest in modern art is very simple: that it is the only kind we can produce." There was a big laugh—as if I had said something naïve. So I went on: "Why, yes, I happen to prefer Greek art of the fifth century to any other; but I am not a Greek, and in the fifth century I wasn't even born. Any art I may be able to produce will be American and modern. Then, of course, will come the essential question: whether it is good, bad, or indifferent. American art and modern art include specimens of all three classes."

John Quinn understood that—indeed he had arrived at such ideas before the Armory Show, though his repeated and long visits there did immense things even for him. Previously, he had collected the work of men whom he knew personally, American, Irish, and English. He did keep on with the best of them, like Maurice Prendergast, but the Armory taught him that the real study of art is based on principles, not on personality. To be sure, as he was human, he continued to feel the influence of the men and women with whom he associated. Often it was a bad influence, for his judgment of people was faulty, as he came to realize with time, trusting more and more to his intellect instead of his emotions.

And this differentiation brings me to a word about my own attitude toward the people I write of here. I am told by some that I must not say anything about Pierpont Morgan because he was a capitalist; others would have me omit Diego Rivera because

he is a Communist (on that score the Stalinists would absolve me because Rivera has been expelled from the party and has been hospitable to Trotsky), the accusation against a third of my personages was that he did not act rightly in money matters, while another was immoral in sex relations. But all these questions are outside of my interests here, though I will admit that I was shocked when a man once told me that John Quinn was a big thief.

From the time of the Armory Show until his death in 1924, I had seen a good deal of him. There had been various exhibitions, of which I shall speak, and in planning them, Quinn had taken an active part. Unable to go abroad more than occasionally, he wanted the great things brought over here, and his work on the tariff question was indeed for the purpose he stated in Washington: that of making it possible for himself and others to have free access to the live thought of Europe. As I had been the one to send over the works at the Armory and as I was keeping up a certain amount of correspondence with my friends in Paris, he frequently had me write on his behalf to the men there, and so prepared the acquaintance he formed with them personally, at a later time. While the "hunches" he followed carried him from exaggerated generosity at one moment to exaggerated suspicion and closeness on other occasions, I never knew him to do a thing which could lend color to the ugly word thief, and I asked how any one could say such a thing about him. The answer given was that he was too close to Tammany Hall—which did not enlighten me completely, certain Republican stealings being prominent in the press just then.

I cannot judge the accusations mentioned above. But let us suppose all of them to be true—and about Quinn I know things which, if not crimes like the one I heard imputed to him, are regrettable enough. But I insist that to oppose writing of these men for such reasons is to be guilty of false logic.

JOHN QUINN, MR. YEATS, M. MAUREL

Usually people feel it to be so, even when speaking, and "rationalize" in order to cover up their tracks. Thus Rivera's work at Rockefeller Center was destroyed, according to the explanation made to the press, because the artist had introduced into it a portrait of Lenin. The real reason, as the officials stated privately, was that he had painted syphilis germs in his scene of the bridge-playing society folk (only a few years ago, the dread word could not be uttered in public). Yet even this account of the suppression was rationalizing. You may doubt my statement if you like, but from two persons who were in a position to get the facts, I know that underneath both of the assigned reasons was the real one: quite simply, a dislike of Rivera's painting as art. What was wanted was the work of Sert, and that painter did, in fact, consent to replace the destroyed picture by one of his own.

Some artists were surprised at his accepting the task; others found it quite natural for him to do so, judging his personal character from the weakness as decoration of his first work at Rockefeller Center. (The second one was even more foolish.) For myself, I see no reason to assign unpleasant motives to him either because of his action as a man, or his work as a painter. Why not just say that he has come to believe in it? Others do so, and Sert is doubtless no exception to the rule that an artist prefers to believe people—even stupid people—who say his work is good rather than those who call it worthless.

Difficult as it is for the public to decide such an issue, I continue to maintain that the only way to approach it is from the standpoint of art. Every other factor that is introduced leads to a befogging of the question. Thus, as I pointed out in my Ananias book, some people who do not like van Gogh's painting camouflage their art ideas by saying the man was mad, but when they come to Meryon, who was far more unbalanced, they pass over his mental condition. Liking his work, they disregard the question of his abnormality and are right in doing so, I believe, even

if wrong as to van Gogh. In so important a matter as sanity, indeed in all matters within the purview of the profession or its audience, the criterion of judgment we are brought back to is simply art.

I am positive that it has been my own standard in deciding whom to include and whom to omit from this book. Neither friendship with some of the men I write about nor disagreement with others on questions foreign to the essential one would have been a valid reason in the case. Nor should mistaken opinion be a bar. With the next two men of whom I want to speak I had deep-rooted differences of belief. But with them as with most people, practice was more important than theory, and what I regard as wrong ideas of theirs did not prevent me—even while they were living—from admiring what they were in themselves and in their work.

John Butler Yeats, whom I mentioned before as a friend of Quinn's, may not go down to posterity as a great artist, though he did some fine things; and such writing as I know of his seems a rather frail defense, also, against the action of time. Not even his talk, fascinating as it was to listen to, quite explains such an opinion as I heard from a man who knew both the father and "Willie" Yeats, and who considered the older man greater than the famous poet.

It was in his holding together of all phases of existence that Mr. Yeats was so wonderful; his art was that of living. When his children in Ireland began to treat him as an old man, he protested by running away from home to seek his fortune in America. Many a compatriot of his had done so before him—but not after passing seventy years of age! "As mellow as a ripe pear," to quote one of his own descriptions of a man, he was hailed by artists and writers in New York as a defender of their way of life. Did any one ever play the rôle more inspiringly? I think it was at that evening in Henri's studio when Mr. Yeats introduced us to the work of

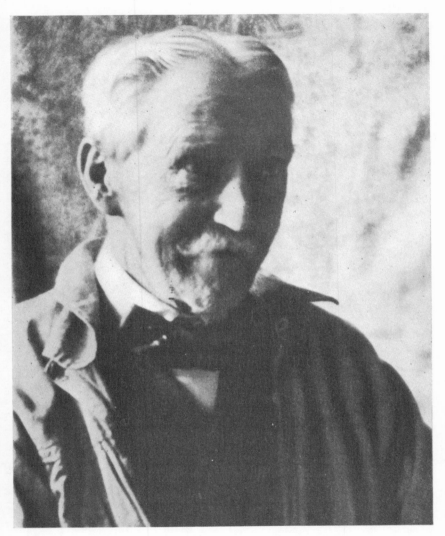

MAURICE PRENDERGAST *Photograph by M. D. C. Crawford*

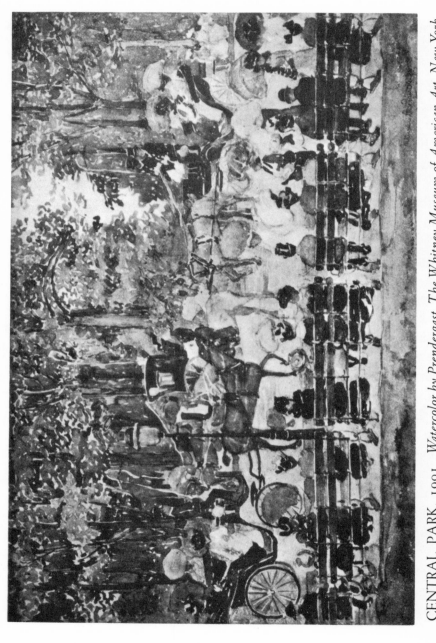

CENTRAL PARK, 1901 *Watercolor by Prendergast, The Whitney Museum of American Art, New York*

Synge, that he turned off for one of his innumerable asides, as follows:

"Oh, they're all very grand, they're all very grand and wonderful, these strenuous men, like Cromwell and Napoleon and Teddy Roosevelt [then the President], but let us always remember, now that we're among ourselves, just painters and poets together, let us always remember that they belong to the servile class."

One need not have arrived at the Chinese concept of the inferior status of soldiers, nor yet see them, with Delacroix, as "sheep in wolves' clothing," to appreciate the thrill that American artists felt on hearing their profession given the importance it always had in Mr. Yeats' talk. How he enjoyed the pleasure of his audience, how he enjoyed the cigar his black old teeth bit into, and what a mellow light warmed the wrinkles of his kindly and humorous face as he spoke in praise of his coffee and his whisky; "The first glass, well that's good. But do you want to know how you're going to feel in heaven? I'll tell you; just notice that golden glow that comes over you with your second glass of whisky. That's how you'll be feeling in heaven all the time."

Even when he would go spinning out a piece of philosophy one could not agree with, the old man's companionable charm prevented one from differing with him, out loud, in any case. I can recall having done so only once, and then it was by inadvertence. We were seated out-of-doors on a summer evening at Petitpas's restaurant, the scene being just as John Sloan has painted it on the canvas at the Corcoran Gallery. (Besides Van Wyck Brooks whom I mentioned before as being in that picture, there are Fred King, Sloan himself, and Mrs. Sloan. Also Alan Seeger, who died in the War, is the figure just to the right of the old sage to whom all are listening.)

On the occasion I have in mind he had been on one of his pet themes, the difference between English life and manners and

those here. "Now in England, if you said you were in favor of cannibalism and that there was nothing you enjoyed more than a good roast of human flesh, people would do no more than say, 'You don't tell me,' or, at most, 'Dear, dear, is that so?' whereas here, if you say the least thing out of the way, they take the windpipe out of you."

Soon after, the talk having turned to Claude Lorraine and Turner, Mr. Yeats was leading it again. I thought I had misunderstood something he'd said and asked, "But of course it's Claude you mean as the great man of the two, isn't it?"

Mr. Yeats looked from one person to another for comfort: never in his fourscore years had he heard that anyone, unless a perversely chauvinistic Frenchman, could put Claude above that idol of his lifetime. Yet there was his own warning about urbanity not ten minutes old, and it was piteous to have to mind the two circumstances in one speech. Finally he got it out: "Oh, blessed angels be with us—I'd so much rather you'd spoken for cannibalism."

Despite my having gone only further toward Claude's side of the question, my admiration for Mr. Yeats remains untouched by the differences in our ideas. He was of those whom Goethe meant in the second half of his axiom: "Little people pay with what they do, big people with what they are." There was something big about him, something that derived, perhaps, from the classical writers to whom he was so devoted. "What's all this about education?" he would exclaim. "Teach them their Greek and their Latin; the rest will take care of itself!" And, as our old friend adored quotations and stories, I may end up these lines about him with the words of an old peasant woman he brought out from the endless store of memories he had of his soil.

She used to do the cooking for a good priest who, returning from a journey and being not at all averse to a compliment, said to her, "Well now, Cathleen, tell me, did you miss the old man

when he was gone?" "Oh sure, Your Reverence, the whole time you were away, the air was the color of loneliness." That was true for many a one when Mr. Yeats started on his own last journey.

Victor Maurel had rounded out his long career as an opera-singer ("the greatest that France ever had," I was told more than once) when I made his acquaintance soon after the Armory Show. He was too old to accept artists he had not known before, but he was disquieted over the growing acclaim of some of them, and he borrowed my French version of Elie Faure's *Cézanne* to see if it could bring him any nearer an understanding of the new "rebel." I fear it did not, nor did our seeing together the painting which the museum had just hung. M. Maurel had reserves even about the two Manet pictures there. What he really liked was Meissonier's *Friedland, 1807,* though he felt that the figure of Napoleon was weak. "On that score I know I am difficult. Napoleon is too great for any artist to represent. But when it comes to painting, there is a man who knew his job!"

The strange thing was that the pictures M. Maurel had begun to paint, late in life, were far more akin to those of Manet and Cézanne than they were to Meissonier's. But he made no claims for his new art and when other people praised the instinct for beautiful color it revealed, he would say, "Oh, if I could do in painting what I did in singing. . . ."

Very emphatic statements indeed would have been needed to round off that unfinished sentence. Three continents had acclaimed him, and his success had a far deeper authorization than that given by an adoring public, for Wagner and Verdi had been alternates or even rivals in securing him for rôles in their operas. It was thrilling to come close to the two great composers as one did in hearing him tell of them. "When Verdi conducted a rehearsal, for example when we were getting ready for the première of *Otello* or of *Falstaff,* the place was like a temple. Once a singer asked to be excused for a day, saying he wanted to go to

his brother who was very sick. Verdi simply thundered at him: 'To the devil with that talk: here is where the work is!' Wagner was just as absolute. When we were doing *Tristran*, there was no detail that did not have to be gone over a hundred times—or more than a hundred—till that terrible man got what he wanted."

The thing those composers wanted—and that Maurel demanded of his pupils in later years—was immeasurably more than the ability to sing. "I always say I assume they can sing when they come to me. The question is what they *think*, how they understand the music, how they make their work creative. Otherwise it is just physical, dead—nothing. Lately a group of Russian singers at the Metropolitan were saying that Caruso is nothing but a voice. I put a stop to that talk. I said 'If Caruso were only a voice, you wouldn't have heard of him, he wouldn't be where he is today.' "

His own voice was gone, but while no one knew better than he what the physical thing is worth; no one, also, knew better how much the mental thing transcends it. So that if we did not see eye to eye in the matter of painting, I had the finest confirmation from a master of another art of the theories we were defending in our own.

XVIII.

AFTER THE ARMORY SHOW

———

OUR THEORIES STILL NEEDED PLENTY OF DEFENDING EVEN AFTER the Armory Show. They always will, for that matter: I remember one of the younger men at the Louvre speaking of the way Gérôme and Bouguereau had reached that institution from the Luxembourg at the same time when the Cézannes and the Renoirs were transferred. He said: "Of course the old hacks will go down to their limbo in time. But don't think it will be without effort on our part—or on the part of those who would like to retain them on the walls. The fight has to be kept up right along."

That was what we decided in New York, around the beginning of 1914. Even if Quinn had been completely correct about the sinking of the old Academy, a new one was ready to form. As a boy I once said "We may yet see academic Impressionists" (never having been in Europe, I did not know how much they were in the saddle already); after the Armory, we began to see the rise of academic Post-Impressionists and Cubists. The Germans have a good saying, "Where there is a dead animal the vultures soon gather." And when the various forms of art have outlived their vitality, the scavenger-artists of the commercial societies and of the dealers are soon attracted by the smell of blood. That it continues to flow healthily in the veins of the great men, those who survive and continue with the art of their prime, is the most wonderful of advertisements. "Cézanne is expensive

now, Duchamp's pictures have disappeared from the market: here is something just as good, much more agreeable for your walls, and sure to go up in value."

It is pretty safe to say that works so described do not go up in value—or even in price. But they do have their period of acceptance and, besides drawing attention away from the real artists, they cheat their purchasers. The antidote is the one which Matisse proposed that time he was asked what was needed here, and so we decided to follow up the International with more exhibitions. Only a few people would get the benefit of them at first, but in the long run a taste for real things in art would be strengthened.

Duchamp-Villon agreed to assemble in Paris a large group of works that would carry on the idea of the Armory through the season of 1914-1915. But then came the war, my friend was mobilized, as were all the other men of military age, and there was no one to carry out the plans and to ship the works to America. At first the beautiful shows we had planned seemed lost, but when the battle of the Marne had been fought and we felt sure, a few weeks later, that the Germans would not take Paris it was decided that I should go abroad and collect the promised exhibits.

Having a German name and being otherwise debarred from passing for a Frenchman even if I had wanted to, there was some anxiety about my getting into trouble, for the world was full of talk about spies, and many a man did find his way to a concentration camp, if no worse, for acting in a way that seemed suspicious to people in those days of excitement. Theodore Roosevelt sent me a letter addressed "To whom it may concern," stating that he knew me to be of an American family and going abroad on business of such value to the country that he hoped the officials of all governments would help me in it. Also I carried several hundred dollars in gold coin in a money-belt.

AFTER THE ARMORY SHOW

As the event proved, I never had to make use of my extraordinary precautions, though with the uncertainty of things when I left New York, they could not have been called excessive. My passport (something no traveler ever bothered with before the War) was all I needed when some policemen questioned me and a friend, very late one night in Paris, when we were sitting on a bench in a square; and my letter of credit gave me all the money I needed for my return passage, though I had to go to Liverpool to get home (on the *Lusitania*—it was one of her last crossings), for the German submarines were so active that one sailing after another was canceled at the French ports and even in England.

Yet Paris was very quiet, even cheerful. The chains that were to have held back German raiders were still in evidence at the gates of the city, but they did not weigh on the spirit of the people. The Louvre being closed, knots of men and women would stand in front of the art-dealers' windows to look at the pictures, which were still a necessity (even more than usually, for they were a symbol of the France men were fighting for); when I got together with friends, the discussions about the new schools, and the great old ones, would go on just as in the days before the war.

Matisse was past the age for active service and I saw a good deal of him in those days. In the Autumn Salon of the preceding year he had exhibited the portrait of Mme. Matisse which is now in the Museum of Moscow—to which city it had already departed. I knew it only by reproductions but thought it one of his really great pictures, as I still do, though I have never seen it.

"The photographs give the impression of a thing that came rather easily, perhaps in two or three sittings."

Matisse fairly slumped in his chair, at my words.

"I had more than a hundred sittings on it," he finally answered.

One morning after we had been talking art pretty actively for a couple of hours I looked at the time and said: "I didn't know

it was so late. I have an appointment and must be off in less than ten minutes."

"I'd like to do an etching of you."

"Fine. When shall I come?"

"I'll do it right now. I have a plate all ready."

"But I've got to meet M. Hessel for lunch. I've got to leave in five minutes or so."

"All right. I'll do it in five minutes." And he took out his watch and laid it on the table. Seeing that he was in earnest, I sat down. In five minutes, he had an outline drawing on the plate and a few strokes to indicate color and shading.

"That isn't serious," he said as he showed it to me, "I got interested in what you were saying about Rembrandt, and I wanted to set down an impression of you then and there. But come on Sunday morning and we'll have time for a real one."

I came on Sunday and found the little plate he had sketched, already nicely printed. There were some unimportant spots of foul biting in it, but as Matisse said, "I did not do those. God did. What God does is well done; it is only what men do that is badly done."

For three hours he worked over one plate and then another—there may even have been a third. Each time he took turpentine and washed off the drawing so as to be under no temptation, as he said, of biting it in with the acid. The morning was a failure from the standpoint of results (it is true that there were interruptions by friends in uniform who had to be eased out); but then we looked at the little five-minute etching, and it had just the life that the more heavily worked things had lost. It is a delightful piece of character and design—the best demonstration of the difference between quantity of work and quality of work that I have encountered.

Duchamp-Villon was in charge of a military hospital at St. Germain-en-Laye, where I visited him a number of times. Once,

when a wounded man was brought in and I saw that they were short-handed, I helped with certain sanitary measures that made me lean over the soldier while my friend extracted the bullet. Going over on the steamer some girls from the Presbyterian Hospital, volunteer nurses for the short war which was all that people expected, had been talking of operations, and as I had expressed interest in seeing one, a little blonde thing had said "Of course you'd faint, the first time; young doctors do, just like anyone else," which gave me a disagreeable feeling and made me determine not to see the bloody work. When I did—and it was a mean operation I went through with—I had no thought of folding up. As Quinn said afterward, I had imagined the thing so vividly from the talk on the ship that I had done all my fainting in my mind and did not have to do it again, bodily.

Just the same I was glad to get away from that place with its sights of mangled human beings, though I recall that, half an hour afterward, our lunch was as gay a one as I have ever had. When someone said a bitter thing about the Germans, one officer remarked "There we are, getting on that subject again," and it was dropped. There were other things to talk about. That was, of course, at the beginning of the war. Even if people were brave enough to keep their minds on the "other things," those ferocious years had perforce to leave their mark, cumulatively, and men could not go in with their earlier confidence that ideas and art are what count. Aside from the loss of men like Duchamp-Villon (and at his death one friend wrote me "the tower of our strength has fallen"), there was a sense of uncertainty, a need for new directions; and that fact should prevent the surprise people sometimes express over the circumstance that there has been a lull in the appearance of great new arts—which arose with such frequency before the war. The idea implied in the surprise I mention is that our time is to go on in a straight line from the nineteenth century—whereas there is every reason why it should not. Already

(and if we consider our losses and disorientation, the time since the war is not a long one) there are marked indications of new movement, which means health and strength again. Even should they work in a direction opposed to that of the preceding time— as Signac and others claimed—the world would be in no danger of stagnation.

Certainly those shows of the first War year told of energy that could be relied on, and that is far from exhausted even now. There was an entire exhibition of Matisse—with things distinctly an advance on what he had had at the Armory. Their daring (especially in one canvas where he was trying out Cubistic ideas) was balanced by the suavity of a series of etchings and lithographs, the forerunners of those pictures of a quiet beauty that has been the artist's ideal in later life.

There were, at another dealer's, important works by Derain dating from his early days of Post-Impressionism, besides some that were already Post-Cubistic. Picasso was shown in a splendid group of blue period and rose period works and others carrying the spectator along to the extreme of non-realistic art, which was the stage he was in at the time. There were magnificent de La Fresnaye pictures (he had been off at the front but his friend Paul Véra, who happened to be in Paris, had admitted me to the studio). Redon, Dufy, Rouault, and others had responded again to our call, and New York answered their confidence and proved that the enormous success of the Armory was no accident: Americans were ready to support a better art than what they had been offered before in current production.

XIX.

MAURICE PRENDERGAST

———

ONE SHOW WE ARRANGED OF WORK BY A NATIVE PAINTER AT THE same gallery as housed the Redons, Picassos, etc., gave the most inspiring evidence that Americans could no more than import modern art—they could produce it. The exhibition I speak of was that of Maurice Prendergast. Never did his beautiful painting undergo a severer test or show to better advantage than on those walls which had displayed the great Frenchmen of his time just a few days before. Strong as was the native tang to this down-east Yankee, he was perfectly at home between one exhibition containing masterpieces by Gauguin, van Gogh, and Seurat and the one that followed with men like Villon, Metzinger, and Duchamp. He was in place, and not only because he was of the same time as those other men shown, but because of the character of his work.

Much as he owed to his sojourns in Paris—and he had been going there since his youth—the inborn quality of talent was really the essential thing in his painting. One may follow it back to very early works and find that the artist was already himself in them— just as Matisse recognized himself in the picture of his naïve days in the provinces, just as the passion of Cézanne expresses itself in the limited color he had to use during his youth, and just as Corot—to take one more instance—offers in the firmness of his early painting the foundation on which, fifty years later, he

could safely base the lyric sentiment we associate with his name (and that is to be traced back to the beginnings of his art).

Prendergast's evolution was quite a different one. It was in his youthful work that vaporous tone and poetry predominated. Year by year and decade after decade, color emerged from the silver of the early pictures until in his old age the pigments kept all their fire, though the harmony of the pictures was utterly untroubled. In parallel fashion, the feeling in the work went on from the daintiness of some fairy figure by the sea to the sturdiness of those later renderings of the woods of Massachusetts and the stability of the figures that people their clearings.

The first American to appreciate Cézanne (I think that is true even in recalling Loeser and Fabbri who had stayed abroad permanently), Maurice Prendergast gave the finest example of the way to use the influence of his favorite master—"old Paul," as he called him, affectionately. Instead of the superficial imitation which gave to the exhibitions an increasing look of being "school of Cézanne" (to the disgust of that inveterate seeker himself), our painter got down to an instinct for structure, one that he found in his own mental equipment. It grew stronger on its nourishment from the art of the great Frenchman, whose influence he could accept so naturally that one almost needed to hear him acknowledge his source of direction in order to know whence it came.

Other arts were furnishing their check and balance for him. He cared for the Persians in both their painting and their ceramics. An old blue jar of theirs used to hold his brushes— which seemed, indeed, to have imbibed some of the magic of that Orient they had touched, and the quaint animals they traced in his compositions (which continue in the work of his brother Charles) certainly owe something to the delightful creatures of Persian painting. He admired frank juxtapositions of color as

the mosaicists handled it and, himself obtaining a supply of the little cubes of stone or glass, he tried some mosaics of his own.

But most of all he loved the fantasy of the early Italians and their summing up of form by a firm contour. There was always a photograph or two of their work on the wall of his studio, and their art was in his mind from his early years till that of his death (1924). As if in preparation for the gravity of that time, his thoughts were constantly upon Giotto in the last months of his life, and it seems to me as if each time when I called on him in those days, he would have a volume of Giotto reproductions across his knees.

I thought to round out this study of his with a Brueghel book I had lately bought, and I took it along to his studio one day. The northern master was almost unknown to Mr. Prendergast (he was not a great traveler—Paris, Venice, and a few other beloved haunts in Europe sufficed him), but he instantly saw that the elemental character of the Dutchman placed him somewhere near the man he had been dwelling with. He was taken aback to find that so great an artist had escaped him all those years, and I can still hear the tone of his voice, admiring and yet defending, as he said again and again, "He ain't Giotto; no that ain't yet Giotto."

But as the lovable figure of my old friend comes back before my eyes it is not as I saw him toward the end: I think of him as the man before his easel, "pecking away" as Charlie Prendergast would call it, eager and exhilarated as he "punched up" a canvas that might have seemed perfect before but in which he saw possibilities of greater depth, a hardier build, or more of light and richness. This work in the studio, which might have led to formula or repetitiveness, was varied by periodic spells of sketching from nature. To these we owe the truly amazing watercolors, things tossed off with light-hearted spontaneity, but strengthened each year, by research into the science of the picture,

his occupation during the months indoors. And so, a little bit as with Corot, the similarity of subject and tone in his work never spell monotony. Each time there is the freshness and surprise of the returning springtime.

"The best painting isn't done by boys," Mr. Prendergast said one time, "it's the work of mature men." Certainly his own mature work was his best, but there was always something of a boy's surprised delight in it as, to the end, there was always an unquenchable youthfulness in the man himself. He was hard of hearing, a condition which increased with the years, but he was far from complaining about it. "People have to raise their voices to talk to me," he once observed, "and that's why I get to hear only the nice things. If they have any mean things to say they're going to whisper them, not shout them out loud."

Elie Faure has remarked that "every being, even the lowest, contains within himself, at least once in his earthly adventure— when he loves—all the poetry of the world. And he whom we call the artist is the one among living beings who, in the presence of universal life, maintains the state of love in his heart." The words might have been written especially for the painting of Maurice Prendergast. Impressive as was the technical achievement which placed him on a level with the best of his contemporaries in France, the real feeling one got at his studio was of the happiness he had had in the sunlight, in the woods and the waters, and in the people (always young people) that he saw and painted. And the gay optimism he kept up about them was so genuine that it expressed itself through an always deepening reality in his work.

As with Ryder, there was the wonder of how this pure art could go on year after year in the American metropolis. But it is easy to exaggerate the importance of the rôle which money-making, haste and superficiality play in the life of New York and Boston, Mr. Prendergast's earlier home. Those cities saw the

genius of Emerson and Whitman as well as the activities of the traders. The artist's freedom has to be purchased in some way, either by himself or by people in his family who have made him independent. The latter case, happily, was that of Ryder and of Eakins; if they were not rich, they were able to keep to their real work.

Mr. Prendergast's circumstances were somewhat more difficult. His talent and his sunny disposition made people want to help him, from an early time in his career; but it was only very late that his pictures began to sell at all properly and let him depend on them for a living. In the long years before that, his great resource was the wood-carving and gilding which he and Charlie practiced with consummate skill. At Mrs. Jack Gardner's Venetian palace on the Fenway, in Boston, many a frame that looks as if it had never been touched since it left some Renaissance *bottega* owes its live forms to the Prendergast chisels and its burnishing and tone to the gilding tools of those Yankee craftsmen. Charles, the younger brother, keeps up the work today with his gesso panels incised in gay designs, with mat color, gold, and silver to heighten their effect. We shall never quite know, doubtless, how much we owe him for the years when his fidelity to Maurice was such a factor in sustaining the latter as he advanced with his deep and original art.

A record of the period I have witnessed would be blinking the facts if it failed to say that, on the whole, there was a grievously insufficient appreciation of Mr. Prendergast's work. Much as one wants to see American conditions in a favorable light, the truth is that after more than fifty years of residence in Boston, the artist had seen no picture of his acquired by the museum of his city, when he removed to New York; and for years after his death (when mediocre and even bad pictures were being bought in numbers by the Boston gallery) there was still no Prendergast on

the walls—a condition which one of the trustees of the museum spoke of to me as "a scandal."

If the best collectors in America were rapidly coming to realize the importance of the artist during the last years of his life and one of them, whose loan could not be refused, had placed a Prendergast on the walls of the Metropolitan Museum, that great institution refused to give a retrospective show of the painter's work after his death. When I urged it, with a reminder of the number of times the honor had been accorded to other deceased artists in the years just before, Bryson Burroughs, the curator, said, "It's no use for you to try any more: there is too much bitterness here about that one work of his that's hanging out there in the gallery."

Bitterness! In the face of a word like that (it was the exact one employed) I must still recognize the sincerity of the men who hated Prendergast's work, however much I impugn their judgment. But the old question of reasons for one's beliefs comes to the surface again. A man said to me once, "Where will modern art be when the claque, you and Roger Fry and the rest, are gone? I want to know how Cézanne will look then." The late painting of Renoir that his admirers think so immeasurably the best of his life is still unpopular: at the Metropolitan's show of his works in 1937 there were fifty-six pictures to represent the first half of the period covered and just six for the second half. That tells pretty closely about the judgment of collectors and of the Museum. How can a single individual like myself, even with the rest of the "claque," set himself up against such evidence? And how can I maintain that the museums were wrong and I right as to Prendergast? Even the fact that more and more public galleries have been acquiring the artist's work of late years is no proof: the older judges may have been right and the new ones swayed by a merely passing fashion. It is only after centuries that we can

begin to talk of the verdict of mankind—and even then there is frequent revision.

Meanwhile the best aid in reaching one's convictions is that which comes from a check-up of the impressions made by a given work when the mind has been refreshed by other contacts. You know best what out-of-door life means to you after having been shut up in the city for a season or two, and you get more perspective on American conditions if you have spent a period in other countries. It is from similar data that I can offer a certain kind of testimony on the present question. Returning from a three years' stay abroad, and having seen only European art, ancient and modern, during that time, I was rather dreading what I might think of American painting or, more exactly what discussions I should have with its nationalistic partisans. But I found, when I got back, that there were men whose work stood up so firmly as to give hope for the whole country and for its ability to bring forth valid art. The man who stood closest to the tradition I had been seeing, was Maurice Prendergast. And for me, if for no one else, that was real evidence. The time was eight and a half years after his death, so that I have no reason to question whether I was being influenced by his personality, by the "champagne," as one man called it, of his presence. It was the production that counted, not the man.

To say one more word about him, it is a satisfaction to remember that he knew the value of his achievement. In the last year of his life he was going over the bulletin of a semi-public collection that contained a number of his pictures. The publication announced the acquisition of works by several of the younger members of the Ecole de Paris, decadents of the great modern movements. It was one of the few occasions when Mr. Prendergast was moved to a severe judgment. "Those things are bad. I don't belong with men like that. If X [he shall be nameless here]

wants to put stuff like that in his gallery, let him take Prendergast out of it!"

To hear that was to get the thrill Elie Faure got in Aix-en-Provence, when he heard from a witness to the scene how Cézanne had burst out with the words: "Don't you know, all of you, that there is only one painter in Europe—myself!" It is not often that men are goaded hard enough to make them tear off the veil of decorum that society imposes, but at such moments we see the source of the faith that, in the teeth of hostility and indifference, keeps them to their work. In his own country and on his own level, Maurice Prendergast had the faith that sustained Paul Cézanne in a more difficult country and—to speak without lacking respect for our great artist—on an even higher plane.

XX.

THE INDEPENDENTS

"Ein grosses muster weckt nacheiferung und giebt dem *Urteil hoehere Gesetze.*" The grand line from Schiller comes back to me across nearly four decades, in the tones with which "the golden Werner" uttered it to his class in German literature, and the truth of it was borne out anew in America after the time of the Armory Show. The "great example" of the men I have just told of did "arouse emulation" (to translate those words of the poet even if I lose their resonance). There was no question of another International Exhibition, showing as it had the character of the whole modern period. The nature of that demonstration was such that it could not be repeated; the need was for an exhibition occurring regularly, year in and year out, which should bring together the public and the artists who felt the vital movement of the time. That was the statement of the case made in 1916 by Morton L. Schamberg, one of the strongest of our younger painters, some two years before his untimely death.

Many felt as he did, and their number was increased by the American artists returning from war-torn Europe, and also by men of the fighting or neutral countries abroad who sought the quiet of America. Among them was Albert Gleizes, recovering from the breakdown caused by months of bombardment in a fortress where he was one of the garrison; Marcel Duchamp came also at the time, his health having caused him to be rejected for

the army, though he had presented himself for service four or five times. Having seen the way in which, for thirty-two years, French art had developed through the activity of the Society of Independent Artists, they proposed the plan for one to their new friends here, and it was accepted.

The motto of the Paris body, "No Jury, No Prizes," became the very simple constitution of the American Society which has given an exhibition each year, beginning with the spring of 1917—when the show opened three days after the United States entered the war. There had been exciting months before the two events. When the scheme for the Independents was under discussion, the proponents of it thought a hundred or two artists might join: three hundred seemed a wild maximum to talk of. But with the success of the Armory Show and the number of people who had been kept out of the exhibitions, the enrollment for the first year swept on to nearly twelve hundred. In the twenty-two years since then it has subsided to an average of five hundred. This is partly due to the Depression, in reducing the artist's means and, on the other hand, to outlets for work afforded by the government in its relief measures. But the first show came as violently as the war itself and the unpredictable demands it made for space and money made heavy work for the artists who had to meet the need of the time.

I am speaking from first-hand experience in this book and, just here, from pretty drastic experience, for I was treasurer of the society from its founding. John Quinn, who did the necessary legal work, scolded me for remaining in the position, as I did for fifteen years more, but the work was important and too many men quit because it was also hard, and in many ways disappointing. Too many thought that the country would come forward with Cézannes, Seurats, and van Goghs just because it had a society of the same name and principle as the one where those artists had exhibited. But as was said by William Glackens, the

first president of the American society, it was not the Independents that produced those great painters; it was they who produced the Independents.

More than the individual artists, however, there was the tradition of a free art in France dating back to the Revolution; and it is the tradition to which every master of the last hundred years and more has belonged. What surprised many was to learn that Ingres, often thought of as representing the idea of absolute authority, is precisely the man who expressed the theory of the Independents more forcibly than any one else. In the circular announcing the formation of the American society of that name I quoted his report to the government in 1848, which I had come on, and the words may well be repeated here.

"A jury, whatever the method adopted in forming it, will always work badly. . . . I regard as unjust and immoral any restriction tending to prevent a man from living by the product of his work as long as he does not attack morals.

"What is your present Salon? A bazaar. You must open it to everyone. We must know how to adapt ourselves to freedom in its full extent, whatever may be its drawbacks."

It was not that the great artist looked on exhibitions of current work as a desirable thing. On the contrary, he hated them, as numberless other men have done, since most of the things in them are bound to be mediocre, or worse than that. But he recognized them as a necessary part of life and, even as he followed out the logic of drawing and painting with his magnificent disdain for compromise, he also followed out the logic of exhibitions in the implacable words of that report.

"Liberals" tried a different principle. In France they founded the "New Salon," the noble figure of Puvis de Chavannes heading it and giving it his fine watchword, "Make room for the young." Before fifteen years had passed it was indistinguishable from the "Old Salon," with which it amalgamated. In our country we saw

the same thing with the Society of American Artists which seceded from the Academy; twenty-five years later it had been officially absorbed by the older body. When William M. Chase, its first president, and the other progressives of 1881 founded the Society in that year, they were young, and eager for new influences—of the type they approved.

Roughly speaking, what they stood for was Impressionism. It was the best art of its time and, having gradually achieved success in the dealers' galleries, it was accepted by the Academy, so that the logical step was for the ex-rebels to come into the older and more firmly established institution. Mr. Chase remained as contemptuous as ever about academic painting of the Hudson River School variety; but he failed to see that the men of his group could be quite as academic—and as blind to new talent. The liberals, growing old, had become conservatives, and their juries were a Canute's broom that tried to sweep back the tide.

To abolish juries is not to insure men against getting old: Ingres himself grew old. He can scarcely be said to have grown intolerant, because he always was that, thank goodness; the fact is one of the explanations of his marvelous art. It will be noted that his words, above, do not ask for tolerance, but for fair dealing, which is a different thing. Abolishing juries and prizes simply means giving an equal chance to all artists. The American society went a step farther even than the French one, for it abolished hanging committees, placing the work alphabetically

This last idea was one proposed by Marcel Duchamp. For him it was doubtless an advance toward the nihilism of "Dada," the movement negating all things (including itself) which he took an interest in, some years later. Persons who had no talent but who had learned a certain amount about producing pictures or statues were admitted by the juries of the older exhibitions; all persons, talented or untalented, school-taught or unschooled, were admitted by the French Independents—who tried to divide

the sheep from the goats according to the lights of a "*comité de placement*"; the Americans let the public be the sole judge as to which were sheep and which were goats. It does that in a market-place, a "bazaar" to return to Ingres's word and, given time—which is to say prolonging the public until it is called posterity—there is nothing else which so nearly decides on questions of art. Even in the short view, the temporary decisions of a given period, the public decides, if it is given a chance. With Cézanne, for example, it was given no chance, for he could never get past the juries that gave or denied admittance to the exhibitions—though he submitted his work to them each year. Only when, late in his life, Vollard exhibited it in a one-man show was a beginning made in his rise toward public approval.

Meanwhile that precious commodity was open to numbers of men at the Salon who, as everyone agrees today, were not artists at all. Therefore to say that the Independents, in opening their doors to anybody who cares to enter, are really not fair to artists (since the latter are placed on the same level as non-artists) is scarcely to condemn the No-Jury principle: The Salon or Academy contains a majority of non-artists and a minority of genuine men who chance to be accepted; but the best are excluded with what (frankly) are the worst.

The No-Jury show admits the worst things—grotesque riff-raff —but also the best, which are to be seen nowhere else. Small wonder, then, that Robert Henri, with his profound sense of the problems of art, should have arrived at the point of saying, as he did, that there were just two institutions of importance in New York: the Metropolitan Museum—where the great pictures are preserved, and the Independents—where they are prepared. Yet its "freedom to the fullest extent," to return once more to the words of Ingres, is not yet understood by artists or public. The former see only their immediate, material advantage in getting into more popular shows; the public—save for a few open-minded, adven-

turous persons—wants its art well chewed and digested before giving it acceptance. That is no reason, however, for a cessation of effort by people who believe in freedom. It has been the salutary force in every great man throughout the period since the French Revolution, the event which marks the end of the era of authority, royal or corporate (the real authority, that of the masters, is not represented by either kings or academies) .

Among the older artists in 1916, those who felt a duty to the art of the country—and they were usually our best men, were friendly to the Independents. At a dinner to the press, Frank Crowninshield, who presided, introduced "the mammoth and the mastodon of American art." And he went on, "You probably did not know that these two prehistoric monsters are still alive, yet here they are, Mr. J. Alden Weir and Mr. Childe Hassam."

Mr. Weir, because of his position in the Academy, had felt obliged to withdraw from the presidency of the group that gave the Armory Show; but he said he wished the new society all success, and it was not simply the geniality of that fine old American painter that made him speak so: he could see that the Independents were a dragnet to bring to the light things that the older exhibitions and the dealers had no place for, their work being with the men who have arrived. His father was that Professor Weir under whom Whistler had studied drawing when a cadet at West Point, his brother was that other professor who was the head of the art department at Yale. And so our painter carried on something of the tradition of the families of artists that were frequent in the past. In the famous old building on Tenth Street where his studio was, he had good memories to bring forth after the day's painting was done. One was of the time when he was copying a Velasquez in the National Gallery in London and Whistler came and commended his work, not knowing till Weir told who he was, that the young man he wanted to encourage was a son of his old teacher in America. Or he would speak of

Manet, or Jongkind whom he cared for deeply (and whose picture he acquired for the Metropolitan), or of this new fellow Cézanne, that he had never met but that his pupil, Egisto Fabbri, was so mad about.

Mr. Weir was a yea-sayer, and he looked on the good sides of new movements. Mr. Hassam saw them too and his great success was largely a result of his having brought the technique and even something of the vision of Monet and Sisley to America at an early time. That was why Crowninshield, at that dinner, could treat Hassam as a legendary figure. Both he and Mr. Weir remembered their days of adventure with new forces, and could feel young again at the sight of men who were striking out once more.

It was inspiriting to have their support, even if it was merely in the form of good will. The man who put his shoulder to the wheel as president of the Independents was William Glackens. He had felt the importance of the Impressionist movement as had Weir and Hassam, but, younger than they, had been able to combine the light and color learned from the great French moderns with a more personal sense of nature and humanity. Years of illustrating had sharpened his observation of character and given a fluency of line to his drawing that did not exist in the more static pictures of the generation before him.

And something of this sense of movement in his work, something of that free play of form against form through which he carries on the teaching of the late Renoir pictures even more than through beauty of color, has made Glackens a constant force for renewal in American art. When commercialism in magazine illustrating got control in the field, he concentrated his effort on painting, which was his natural bent, anyhow. And whether by the quality of the pictures with which he made such a striking note in the older exhibitions, or by his participation in every forward-looking group that appeared—the "Eight," the show of 1910, the

International, and then the Independents—he has steadily lent his influence to better conditions in this country.

Let me hasten to say that this interest in the general advance has been accompanied by development in his own work—which may well be a result of his keeping his mind open to more than personal problems. Just within the past year, at a competition where Glackens was one of the men to decide the awards, I had occasion to notice the way in which his penetration to essentials imposed itself on the judges more and more as the afternoon wore on and we came to agree with the opinions he advanced, unaggressively but firmly. The same manner of thought goes into his own painting and explains the way one discovers more and finer qualities in it with each new exhibition he holds.

Like his close friends, the Prendergasts, a man who can savor the special quality of Paris, its wines and its food, he gets a new lift with his work by making an occasional return to the country that meant so much of inspiration to his early days. There is the matchless light of the Midi, there is the silveriness of old villages in the Ile de France, there are the children playing in the gardens of the Luxembourg (and I think those adorable gardens have made him love and paint Washington Square, the one place in New York that keeps an Old World character). And always a delight to our artist are the boulevards and the chestnut-trees; and there are women who keep alive the race painted by Manet and Degas and Renoir, and there are artists who keep alive the race of those great men.[1]

[1] The foregoing passage on Mr. Glackens was written before there was even a hint of his sudden death, in May, 1938. No change in any of the wording has been made subsequently.

XXI.

GEORGES ROUAULT, AMBROISE VOLLARD

———

AMONG THOSE WHO BEST CONTINUE THE LONG TRADITION OF
France, there is Rouault. How little he has changed from what
he was thirty or forty years ago, when he was one of the fiercest
of the *fauves!* But how we have changed—"we" meaning the world
in general; for if the public did not buy as much as a sketch by
Rouault at the Armory, Glackens—like his old comrades-in-arms,
Sloan and Henri—saw the bigness of the work, as I well remember
from conversations I had with them at the time.

According to Rouault's own notion of himself, he has not
changed in seven hundred years. "You think of me as a man of
today, but I am not a man of today. I am a man of the time of
the cathedrals." And that is as true in the matter of essentials—
his character and his art, as it is impossible in the matter of his
date, thereby defining the idiomatic word *boutade*, a jesting way
of concentrating ideas that suits the Gallic humor particularly.
But Rouault goes back to an even older France than that of the
Gauls, for he is a Celt, a Breton, and his ancestral province is as
opposed to change as are its rocks and its sea.

No wonder that his art can carry on the genius of the image-
makers of the old cathedrals. Long before I learned that, in his
boyhood, he had been apprenticed to a man who made stained-
glass windows for ecclesiastical purposes, I saw, as others have,
that Rouault's painting is a continuation not only of the color

sense that thrills us in the great church interiors but of the design as well. And this is by no means just a question of the simple spacing and the strong outline: what counts is the idea, and that is what gives to Rouault's figures the impressiveness of the sacred (or profane) personages one sees on getting a nearby view of the windows. From afar they seem of the realm of pure esthetics, form, and color. But look into them at close range and they become "story-telling-pictures"—of the grandest kind.

I had a fine proof of Rouault's relationship to them in this respect when a friend consulted me once about a scheme for a decorative ensemble he was trying out in his mind. Having had a violent love affair with a Gothic statue and having made it his own, he wanted to give it a worthy setting. The idea was to lead up to it by a series of paintings showing the Mater Dolorosa as the supreme image of the Christian faith. But who could do such pictures today, he asked, true religious art having died out. My answer was that there was still one man who continued it: Rouault. This brought forth an exclamation of dismay:

"Isn't that just the way things go? You think you are in nearly complete agreement with a man, and then he comes out with an idea as startling as that! My beautiful virgin—and those heavy black things, clowns and stupid judges and street women?"

But I was able to show him a Christ head by the painter, which had in it such sorrow for those caricatures of the human race, and which told its tale in such magnificent style that he—being a man of culture—was convinced that the spirit of the old-time artists was still in the world.

If it was no longer in the commercial studios that supply architecture, sculpture, and glass for churches, neither was it in those that supply painting for the commercial exhibitions and the dealers. And so, like Matisse—as much a student of the past as himself and with him a comrade in that atelier of Gustave Moreau's which saw so much of the best teaching of the time—

GEORGES ROUAULT, AMBROISE VOLLARD

Rouault found himself classed as one of the "wild beasts." He is perfectly aware that he belongs with the men who got that name by the fierceness of their reaction against reaction, but he always demanded that his genuine traditionalism be recognized for what it is.

So that if Paris had a big laugh when Rouault presented himself as a candidate for election to the Institute, he, at least, insisted that his place was there, though he knew as well as anyone else what the probabilities were—his failure to get even a single vote. Still his claim had to be acted upon and there was one sponsor he gave who, if not a personage in the academic world, was yet a power that the gentlemen of the Palais Mazarin would consider with very serious respect. This was Vollard, whose extraordinary career as a dealer had made him a marked figure not only of Paris but of the world.

His instinct for seeing genius where other men saw only the ridiculous had made him take up Cézanne when no one else would, and if he did not back his ventures with Gauguin, van Gogh, Picasso, and others, as tenaciously as he held on to his Cézannes till the great rise in price occurred, he was known as the shrewdest judge of the movement of taste among all the men who watched the turns of the market. It was known that in Rouault's generation that artist was his special choice and that his financial support had allowed the painter, so long unpopular, to go on steadily with his work.

Why should not the great strategist put himself behind some "reasonable" art, thought a member of the Institute as he prepared to call on Vollard when Rouault's candidacy sent him for a (more or less serious) investigation of the qualities of the *fauve*. Besnard, the academician in question, was beyond good and evil in a financial way himself, but there was a young lady in whom he was interested, and his idea was that the dealer could make

her reputation, in the way he had done with so many less desirable artists.

Coming to my studio one day, and still choking with laughter over the result of his action, Rouault told me of the scene he had just witnessed, that of Vollard on the horns of a dilemma. Obliged to be polite to Besnard because of the famous man's power in the matter of his friend's pretensions to a seat among the "forty immortals," Vollard must escape the trap that his wily visitor was spreading around him. He said he was old, and that he no longer took on new artists, just keeping the work of those he had in his residence and avoiding the labor of exhibitions and the risk of new investments.

Besnard, after considering Rouault's pictures a little more and finding some compliments on their color, returned to the matter which really interested him. He did not insist on a purchase of the young lady's work: the one thing he considered necessary was for M. Vollard to see it. That request could hardly be refused, so a visit to make acquaintance with the pictures was arranged. And once in their presence, and in that of the lady, a few appreciative words had to be squeezed out; there is always something one can say. Besnard was delighted—and since, as he had anticipated. The works were liked by M. Vollard, and since the latter had written such enchanting books on Cézanne and Renoir, think how he could now advance the interests of another worthy artist if he would do just an article, just a little article, on this new and so hopeful painter! In the ample store of excuses appropriate to such occasions, the expert (as the French call dealers) managed to find no means of eluding his pursuer this time, so an article by M. Vollard on the fascinating young lady was forthcoming.

It began with a statement that one of the surprises of his lifetime was his being asked to write it, and he told that he had been taken to the artist's studio by M. Besnard. When the brief

and grudging little scribble appeared as the preface to a catalogue, "the master" (as Vollard termed him) added some lines of his own to explain how much more had been meant by the eminent writer in the modesty of his expressions. Rouault, who had never had to blush over any such modesty of Vollard's, told all this with the Parisian's love of a joke, especially if he has had a share in playing it. Fortunately Vollard himself could see the fun of the thing—a while afterward—and could recognize that the situation in which he had been the victim came from that humor in his painter which is simply the inseparable complement to the tragic sense in Rouault's work, the two together making it so real.

Like all the artists of my generation and the one before, I had stopped before Vollard's shop on the Rue Laffitte to look at the pictures in the window and, if possible, to discern those on the walls inside. I had bought from him a few of the lithographs by the great moderns he published, and had induced friends to get a couple of pictures by Cézanne; but the prices for that master's work had already gone up because of the Havemeyer purchases and, later, Glackens had added fuel to the flame by the things he got for Dr. Barnes, in the days before the latter did his own buying. And so Vollard knew that his market in America was going to develop, without any aid from me. Yet when he was in the right mood he could be cordial enough, and when I approached him for works to include in the Armory Show, he let me have quantities of splendid things.

It displeased him that I got Cézanne's *Woman with a Rosary* from one of his competitors, and he declined to let me have any more. (Had Mr. Frick actually bought the masterpiece at the exhibition, Vollard would have been the gainer, for he owned or controlled most of the Cézannes available, having mutual and signed agreements with his early purchasers to turn the paintings back to him if they wanted to sell within a stated time.) But upon my accepting that painting from another man,

he assured me that he had no more pictures—they were all on loan in Holland, in Germany, in Russia. Only when the ship with our collections had sailed and there was no chance to send anything more to the show, did he begin to fetch things out of his back room again. One day I remonstrated that he had told me he had nothing left. Vollard ruminated for a moment on the mystery of these conflicting circumstances; then he found the explanation:

"Why, you see, I lied."

With the most fertile mind in Paris when the question is one of delicate intuitions, apparently innocent queries, and guarded replies, he loves the luxury of saying what he thinks. Once I came upon him pacing up and down a street in sight of his shop; I passed the time of day and went off. On my return to the spot, a quarter of an hour later, and finding him still there, I stopped to chat with him. He said "I am just watching my door for some people to get out. They have an appointment with me, but today I couldn't stand the idiotic things they always say. I know I should be too rude, so I had better be out." Perhaps when he had summed things up in such a sentence as "Picasso is either a genius or he is nothing," the people had tried to compromise, and that is one thing Vollard will not do.

Either a specimen of paper for one of the books he publishes is right or it is wrong; in the latter case no search for the right paper is too difficult, just as no corrections of typography are too costly, and no destruction of prints from a plate can delay publication of a work too long to be worth the effort, money or time that must be expended in making those matters what they should be. Having seen artists at work for over fifty years, he knows that Duchamp-Villon was exact in defining the life of an artist as a process of perfecting; and so the books he produces being his own art-works what are effort, money, and time for, if not to achieve perfect things?

Perhaps I should have said that his publications are examples

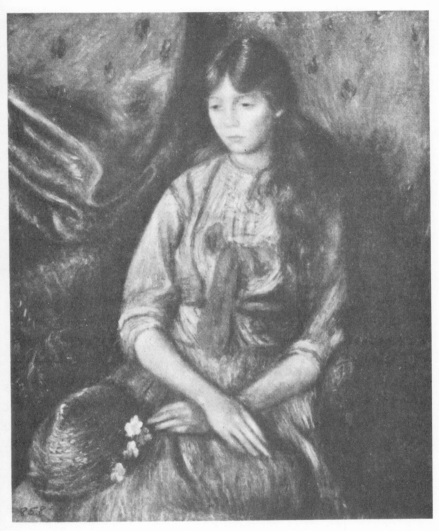

PORTRAIT OF A YOUNG WOMAN *By William Glackens*
Courtesy of the C. W. Kraushaar Art Galleries

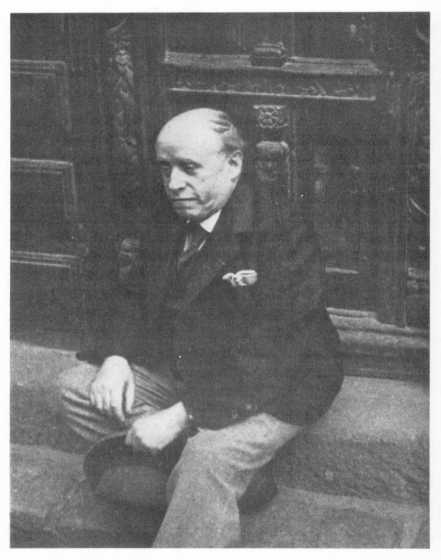

GEORGES ROUAULT *Photograph by Pierre Matisse*

of his craftsmanship and left the phrase works of art for the books he writes. I am not enough of a reader to have much right to an opinion on literature, but there are at least passages in Vollard's *Cézanne* and *Renoir* that seem to me to demand rating as among the permanently valuable achievements of our time. When he was preparing the former of those books I asked him what its nature would be. "Oh, it does not pretend to be much," he replied. "I don't go in for art criticism, I leave that to others. I saw the man, I saw him often; I have tried to cinematograph him."

But the moving picture, like the "still," is mere reproduction —very wonderful indeed as a feat of science but zero in the scale of creation (it is Charlie Chaplin or Louis Jouvet, not the photographer, that we admire). Vollard is admirable many a time when he has no great subject to tell of. The woman in the book on Renoir who tells with excited indignation that when her husband was off in the country his mistress in Paris continued to get her monthly allowance "for doing nothing at all," is made an epitome of bourgeois morals by the art of Vollard, as he makes you know her, hear her voice, see her hat, her rings, her apartment —none of them being mentioned.

It was one of his bits of understatement merely to say that he cinematographed his people; for that gave the idea that all he did was to turn the crank of a movie camera. The selective talent of the stage director would have been a more exact parallel to offer; and how much a matter of his own personality his picture is! We can grasp the fact as we read Gerstle Mack's book on Cézanne. Its incontrovertible details about Zola show the relationship between that writer and his friend the painter to have been quite different from what it was made out by Vollard in the account he gives of his visit to Zola, masterly as is the satire in that piece of writing.

He was doubtless carried away by partisanship as a Cézanne admirer. Nothing that can diminish his idols in any way will be

tolerated by him; they must be kept above the plane of lesser mortals. "How could you be so naïve as to want to ask Degas for help with your exhibition?" he asked me at the time of the Armory Show. "It's a lucky thing for you that he was not at home when you called. He hates exhibitions and would have told you so, and pretty straight, too." I don't believe that. Degas had a reputation for being peppery (I never met the great man), but I think his long career had shown him too much of the good there is in exhibitions for him to have refused help, or at the very least advice, to a man from the country which gave him such early support and where he might well have wished to see certain tendencies succeed and others fail.

There is, as I have shown, a jealous side to Vollard, but there is also a generous side. And it comes out in the most appropriate place, very often; I mean in his liking to gratify interest in fine works when young artists show that they care for such things. Diego Rivera tells of standing enthralled by a Cézanne in Vollard's window. The dealer stood behind it and presently took the picture away, putting another Cézanne in its place. Diego stared at that for a while, when Vollard replaced it with still another, keeping up the process for a space of time that the Mexican artist estimates to have been over two hours.

It would be simply too far-fetched for anyone to tell me that business acumen had anything to do with what Rivera calls the "one-man show that Vollard gave for me alone." He was just a young artist (as one could see) who liked good pictures. And I know too many penetrating remarks that the old connoisseur has made when showing me things to have a shade of doubt as to the profundity of his understanding or as to the reality of his love for his possessions. It is a pet vanity of my own that I have yet to find a person to whom he has shown certain Renoirs that he has brought out for me on two occasions, paintings that I verily believe to be the ones of ultimate quality. He thinks so, too, and,

though there are doubtless many persons who have seen them, among his numerous visitors, I know two great dealers who buy from him and who have not seen the works; as far as I can learn, they have never been exhibited or reproduced. Renoir is peculiarly close to the affections of Vollard, and it may well be that these are among the paintings that, in his phrase, "people will have to tear away from him," at the end of his career.

XXII.

SOME GREAT COLLECTORS

═══════

THE PASSION FOR PICTURES WHICH TOOK VOLLARD AWAY FROM his profession as a lawyer and has remained the dominating factor of his life could be made the subject of a book like *Cousin Pons*, the delight of so many a collector. What examples of the splendid study and enjoyment celebrated by Balzac were to be encountered in those years I spent in Paris! There is Doctor Viau, who at one time had eighty Daumiers—and I will wager that they were all genuine! A man who could be fooled would not have had that tone to his voice when he said to me, "I am so old—it doesn't matter now when I die. But suppose I had gone off before that Delacroix exhibition at the Louvre: that would have been a misfortune."

And Henri Rouart. To go through his house was to see painting as the finest achievement of mankind; and to talk with him was to know a man worthy of living among such treasure. There was a Goya (Sir Hugh Lane bought it at the sale in 1912, after M. Rouart's death, and I think it is now in the National Gallery of Ireland). Leo Stein used to call it the most beautiful picture in the world, and it was because Henri Rouart, when a young fellow, acted out his admiration for it that he got the work. The former owner, a testy old gentleman, finally said: "Look here, if you want to stare the eyes out of your head looking at that woman, take her along with you. I've had enough of this business in my

place." More than half a century later the old eyes of the collector would still dwell lovingly on the little pink-and-green roses of the lady's dress, on the pearliness of her skin, and the Spanish blackness of her hair.

But he had other pictures; for example, Corot's *Dame en bleu*, dating from the seventy-ninth (and last) year of the master's life. It was bought by the Louvre at M. Rouart's sale, a few months after the museum had acquired that other masterpiece by the painter, the *Femme à la Perle*. After these twenty-five years, having seen both pictures acquired at about the same time, I confused them temporarily, and wrote that the last-named work comes from M. Rouart's house. It was from the Dollfus sale, as I discovered soon after, but there is a circumstance about it of such interest that I hope the reader will be indulgent over my leaving what I had written about the *Femme à la Perle*, even though it should not have been mentioned in this connection. Derain said that it could hang next to the *Mona Lisa*, and at once all Paris became aware of the extraordinary relationship between the two works. Corot may have seen a da Vinci quality in his lovely model (her name, Berthe Goldschmidt, is preserved) and consciously given her the pose of the sitter in the masterpiece by the Florentine.

I doubt that, however; the case is probably like that of a certain Barye figure which is identical in pose and almost in outline with a great Greek work. We know, however, that the modern artist did not receive any influence from the classical bronze because the latter, unique of its kind, was still buried in the earth for a third of a century after Barye died. My explanation of the phenomenon lies in the words of that magnificent critic, Théophile Silvestre, "Barye did not imitate the Greeks; nature had made him an Athenian." And I think Corot did not try to paint another *Mona Lisa*, his divine instinct simply led him to a result parallel with that of the master of the past.

QUEER THING, PAINTING

That *Dame en bleu* was just one among what I remember as over seventy Corots that M. Rouart had around him. And such glorious things by Delacroix—and such numbers of them there were in his house, others by Théodore Rousseau, by Daumier, and by less famous but still admirable men of the nineteenth century. As to works by Degas, one simply lost track of them. The painter was a life-long friend of M. Rouart's, and every Sunday he was there for dinner. People have told me that it was one of the sights of the world to see the two old boys together, each of them as opinionated as he could be, ready to battle to a finish for his ideas, and always finding new material for a tussle with the old comrade across the table. M. Rouart, though he had big business interests, found time—like the extraordinary Canadian railroad builder and art-collector, Sir William van Horne—to do a lot of painting himself. He modestly treated it as that of an amateur, but it had very genuine merit and personality, and of course it was an incomparable aid to him in matters of judgment.

I remember a most beautiful St. Peter by El Greco that, historically, had been the first work by the master to tell Manet, Cézanne, and others of the wonderful art of the Spanish-Greek. Everything, almost, had some such story connected with it. I have never been in a house where the pictures took a more active part in the life of the place.

Of a similar quality in its art, though of nothing like the same extent, was the collection of Oskar Schmitz in Dresden. It had been formed over a period of over twenty-five years, during which Mr. Schmitz enjoyed the friendship of the Durand-Ruel family, through whose expert hands so much of the great art of the nineteenth century has passed. When I used to call at the house, Mr. Schmitz had become nearly blind, but the years in which he had looked at his pictures every day had so marked them in his mind's eye that he could speak of them as if they were clearly in his sight, and would ask you to observe this detail or that, which

memory alone permitted him to describe. Since then I have had the experience of hearing the same type of remarks from the late Henry Goldman, in New York. Totally bereft of his eyes as he was in the last years, no hint of that fact could be had from his conversation regarding the pictures before him. They were more vividly present for him than for anyone of less understanding. As I think of other old men whom I have known and who have spent their last years in dull and lonely inactivity, I am proud of the "queer thing" of which I write for carrying across the terrible barrier of blindness.

But not all collectors are old. I think of Richard Goetz who, still in middle life, has been buying pictures for some thirty years. When a work by Géricault turns up, he is ready to go after it at once. Great as is that favorite master of his, few people dispute with him the acquisition of a Géricault, for the painter's work is so various and so rare, the imitations of it are so numerous and often so clever that collectors and museum men usually give everything in the field a wide berth for fear of being taken in by a school piece or a copy. This will, of course, change when connoisseurs have become more certain as to the special qualities of the man. The opportunities for study of him are limited, in America almost non-existent. He died young, leaving but a scant production, though its power is such as to influence the whole after-time.

Mr. Goetz, one of those ardent and generous Germans who loved Paris before the war, had, in his earlier time there, brought together a mass of Géricault material, including masterpieces. As enemy property it was put up at auction after the peace treaty, and the choicest pieces were bought by the Duc de Trévise, the greatest collector of Géricault today (or yesterday—for his own possessions were sold, in turn, two days before I write these lines). Like others, he was chivalrous in letting Mr. Goetz, who returned to live in Paris, buy back what he could, out of resources diminished to a small fraction of what they had once been. The duke,

when I knew him, was president of a society the purpose of which is to preserve from ruin the churches, châteaux and other great things that tell of Old France. It may be that this interest has led him to sacrifice the splendid works of a later time. They will be taken care of, at least, which is a more important matter for an art lover than actual ownership.

The great collection of the older French schools in the Paris of my day was that of M. David-Weill, whose eighteenth-century pictures were sold in 1937 and exhibited in New York (such of them as were not immediately acquired by European galleries), during the present season. Remembering the delight in his possessions shown by M. David-Weill as he guided my wife and myself through the marvels of his house, I was at a loss to understand how a man of his great fortune had come to sell. I afterward learned that it was in order to collect again, the space on his walls made free by the departure of his eighteenth-century works being destined for things of the seventeenth and nineteenth centuries, which periods he had come to prefer. That made the matter clear: I can understand giving up pictures for the sake of the excitement in acquiring more interesting ones, and I agree that his new possessions will be of schools even finer than that of the eighteenth century. I cannot imagine a real collector's giving up his things—unless under pressure of necessity.

It would be ungrateful if I did not include in even this partial list of art-lovers I have known some mention of the first one I met in Europe. This was the painter H. W. Mesdag, in The Hague. Aided by his wife, also an artist, he had brought together a choice group of pictures, of the Barbizon and modern Dutch schools for the most part, which he turned into a museum. It was a pleasure to see the old couple in their studios, adjoining the exhibition-rooms, and to realize that painters could own pictures. Mr. Chase did, of course, but I think rather few of the younger generation of our painters even want to collect (money is scarcer

nowadays, to be sure). In Paris, a dealer once challenged me to name any well-known artist who did not buy as well as produce pictures, and it would have been hard to find such a case. It is one of the reasons why the painting in Paris is good—men know it must be, so that it can be lived with.

Mention of that house in The Hague, just before, makes me think of Amsterdam and an even more interesting house there, where I stayed for a brief visit. It was that of the van Gogh family, and it was full of pictures by the great painter. Just over my bed hung the masterpiece of his Dutch period, the *Potato Eaters;* there were earlier things and later ones, down to the very end of his career.

We had often had visits in New York from Mrs. van Gogh-Bonger, the widow of Theodore van Gogh, that noble brother of Vincent's who, by his financial support, had rendered possible the astonishing work. Mrs. van Gogh-Bonger was herself of a character which gave her a worthy place beside those two men, and it is to her that the world owes the preservation and dissemination of the paintings. In America, where her son represented a Dutch business house, she went on with the translation into English which she was making from Vincent's letters. The presence of the family here led to the splendid van Gogh exhibition which New York saw in 1920. If few works were retained by American collectors, it was because the time was not yet ripe for either the paintings or the writings, though I tried to get a publisher for the latter. Mr. B. W. Huebsch was ready to undertake the presentation of a part of the very extensive material, but to have offered the whole mass of it then would have meant certain failure. The van Goghs knew that that condition would change: they had believed in the work when no one else did, and they had already seen a great part of the world come over to their side.

Our affection naturally goes out most of all to those collectors who have had faith enough to help artists at the time when they

need help. But even if such support and patronage is the most creative, the action of men who bring together groups of fine works is very important also, particularly if their holdings are turned over to the public. Personally, I should have preferred to see Mr. Frick's magnificent pictures given to the Metropolitan, but there is something to be said for the small collection, and perhaps, as things are today, the great museum would not have had the suppleness to move promptly and acquire such things as the Frick gallery has bought: the amazing works by Ingres and David and—above all—the not less than sublime thing by Piero della Francesca. Certainly one cannot imagine a governmental body doing such a thing. People who believe in public ownership must therefore give other evidence of virtues in their scheme before one can agree that art has any place there. Some other matters do, as everyone admits.

Till now it is private initiative that has done the great things in art, as far as America is concerned. If we had to wait for our national or local officials, Europe would have absorbed in its museums any number of things that are now on this side of the Atlantic, and that are needed here immeasurably more than they are abroad. So that whatever the motives or the character of our collectors, the country owes them an immense debt, provided only they buy fine things. How fine they can be is discernible above all at the house of Mr. Grenville L. Winthrop in New York.

For my own part I enjoy his collection more than I do that of any other private gallery in the world. It is not to be compared with Bridgewater House in London, less because of the incredibly great pictures there by Titian and Poussin, Raphael and Ruisdael, than because that collection comes down from the past. It has none of the excitement of one like Mr. Winthrop's that keeps on growing under our eyes. He does not paint the pictures by Perronneau and David that he has, nor make the magical Prud'hon and Ingres drawings; but he makes the collection, and has made it so

different from almost all others in America that his originality has at least a distant kinship with that of the artists I tell of in these pages. To be sure, they create objects, whereas the collector merely assembles them. But he does so in response to ideas, his ideas; and by his presentation of the evidence, he carries his thought, and that of the artists, into minds capable of receiving them. Even such minds will not grow rightly unless they are given the material they can feed on, as a plant needs water and sunlight.

XXIII.

ROGER FRY, JULIUS MEIER-GRAEFE, ELIE FAURE

I THINK THERE CAN BE LITTLE DOUBT THAT THE COLLECTORS DO more for the understanding of art than the critics. Yet when we come to a writer of the scope, the depth, and the beautiful clarity of Roger Fry, we have a rare being indeed. George Moore used to speak of the way a certain number of good critics could change the whole face of the art world in England. But there is no sense in speculating on such a possibility, because critics of important talent—I will not mention genius—are scarcer than fine artists. How many such critics do we count as we look back across the centuries? And, at that, one knows how people love to talk about art, and write about it.

The day when Roger Fry lost patience with the Metropolitan Museum, picked up his hat and walked out, was a bad one in the history of America. Not that in the time when he was curator of paintings here the great knowledge he already had was anywhere near what it became later on. But even at this time he could write his superb article on Ryder, and he would have developed, if not so much as he did abroad, had he remained in New York. The city would have been carried on with him, both of them in the current of the time, that he sensed more and more fully. And no one in America, I believe, understood it as he did. What was so splendid was the roundness of his culture; a mere glance at the

subjects he treated in his books—Giovanni Bellini, Claude Lorraine, Mohammedan art, Mexican art, Renoir, and Rouault (to choose from random memories) —tells of the ideal type of museum official, the one who grasps more than details, who sees the whole of things. Yet I say this only to balance it with a reminder of the illuminating authority with which he wrote of one special subject after another in his astonishing range.

This was not simply because—being a painter, and one who has left some beautiful works—he approached the different arts with the intimate knowledge of a fellow professional; he was a representative of that great scholarship of England which has given the world such insight into the classical tradition of literature, on the one hand and, on the other, has made possible the marvelous collections of the National Gallery and the British Museum.

To be sure it has been misapplied by the academic men of the country in ways more flagrantly foolish than any to be found elsewhere, I think. The revolt against such abuse renders Englishmen who recognize false ideas for what they are a bit prone to extremes, and Mr. Fry, coming at a time when the Augean stables were in particular need of a cleaning, did represent his time in this respect, rather than all time. His magnificent work with the modern exhibitions in London (to some extent models for our own Armory Show, a year or two later) did not make him lose sight of the greatness in the older schools of painting, and of course the more exotic arts were easily connected by him with those that had been developing in Paris.

It was to the Greek tradition, because of the way it had been misappropriated by the academies, I believe, that he could be unjust. Late into the night, one time at St. Tropez, we kept hammering away at a discussion of the Greek genius. He compared the drawing on Hellenic and Persian vases to the advantage, at least occasionally, of the latter; and when we got around to Dela-

croix and his renewing of the classical quality—as I maintained he did—Mr. Fry was opposed to the whole line that stems from Greek painting. I know (or I am convinced, if you prefer) that we should have agreed in time. Years might have been necessary, but then people ought to count in longer periods than they do when the development of ideas is in question.

I believe that men possessing good faith, sufficient intelligence, and the opportunity to know the arts must come to agreement on all but the most minor details, given time. If that factor had not resolved the difference between Mr. Fry and myself (the only one I know, but a considerable one, to be sure) the reason may be that I am wrong. For the present I cannot entertain the idea, preferring to think that my friend would have swung back to the Greeks. Renoir never let them, but cared always more deeply for their art. And perhaps that would have persuaded Roger Fry, as he went on with the later work of the master. In association with Bryson Burroughs he had bought the beautiful portrait of Mme. Charpentier and her children for the Metropolitan Museum; and in his house in London he showed me another early Renoir, one he owned, and which he compared with Holbein for the drawing of all the outlines—those to be followed if the head were turned, and which were rendered quite as well as the particular profiles visible in the pose as it was. The observation—one I have never heard before or since—proved anew how Mr. Fry could combine a lively originality with his profound acquaintance with the masters.

What he did for England was to some extent parallel with what Julius Meier-Graefe did for Germany. Both were acutely sensitive to quality, both had general ideas besides, both wrote brilliantly. But whereas Roger Fry remained essentially of his country, with the leisurely good breeding that holds a balance between cordiality and reserve, Meier-Graefe had the internationalism of those who live long in Paris. He took Dürer's words

about "freezing for the sun of Venice" as typical of German nostalgia for the classic lands. The critic's journeys to Spain, Egypt, and Greece brought forth books on those countries that proved how he, and the Northern man in general, could enter the life of peoples so far removed from everything at home.

I think he was more successful in doing that than he was in understanding America, but perhaps it is unfair even to mention his trip over here. It was a very brief one, arranged by Mr. E. Weyhe, the book and art dealer, as a birthday present to celebrate Meier-Graefe's attaining the age of sixty. I doubt that he would have got much more from the trip, even had it been longer, and less filled with receptions, lectures, visits to collections and such matters as overcrowd the time of famous travelers. Meier-Graefe was a man of the Old World, and for so many of the type, the new country meant big fortunes—not always well employed, big spaces not yet successfully planned for—by people whom they consider only as displaced Europeans, and who are therefore to be understood, logically, through comparison with conditions in the old countries. Persons with such ideas do not see that the New World is only coming to birth, and that it will form its own style.

Meier-Graefe felt the growing chaos in Europe and his sensitive mind read deep into the reasons for it by means of his knowledge of modern art. But with all his splendid enjoyment of nineteenth-century painting and such of it, like Renoir's, as was prolonged into the twentieth, he was unable to see in it any promise for the future, nor—to the best of my understanding of his words—did he even feel a sufficient vitality in the present time to give him confidence that it would carry over to new fruition. America, to him, was immature as a source of such confidence, and I myself admit that the reasons our country can offer for such faith are still very tentative.

But the real cause of the German critic's pessimism was, precisely, his enthusiasm for the art of his own day. He had cared for

it with the spirit of discoverer—and to an extent, he was that, if one looks on the period in its entirety rather than on any particular figure in it. His love for the older men made him unjust to the younger ones.

But what admirable things he said about the artists of his century! His conversation simply sparkled with the continually repeated flashes he threw upon the subjects he discussed, and in his books he showed the writer's talent of channeling his fiery thought out to the point of his pen. His German opponents—and a frequently caustic wit brought him many of them—might say that his style was journalistic, but that certainly was not true of all his work. When he approached a subject about which he felt deeply—as, above all, in his book on Delacroix—he could deal in the most appropriate fashion with the *maniera magnifica* of the great artist (the Italian words, indeed, are the title of the last chapter of Meier-Graefe's book on him). And at the end of his history of modern art, a work he wrote a second time some twenty years after publishing the earlier version, there is what seems to me a really splendid thing. It is a vision of some sort of Elysian Fields where artists of all centuries and all parts of the world come together. As the book has not, to my knowledge, appeared in English, I will translate a short passage here, lamely enough, doubtless, for I see words for which we have no equivalent. He speaks of the figures that pass before him in the enchantment:

"They are no phantom creatures, no ghost from *Hamlet*, no light-effect of the theater. The men of the past move about with the men of our day, offer them the key words of their mysteries, receive other words in return, and are equally involved in the giant web of the action. They act. Courbet and Manet are approached by proud Spaniards who, now, are not proud at all. . . . A great circle of Venetians forms around Delacroix. Everybody looks to him. A big dark fellow with a broken nose offers brushes and palette. They want Delacroix to paint. We feel like climbing up

[260]

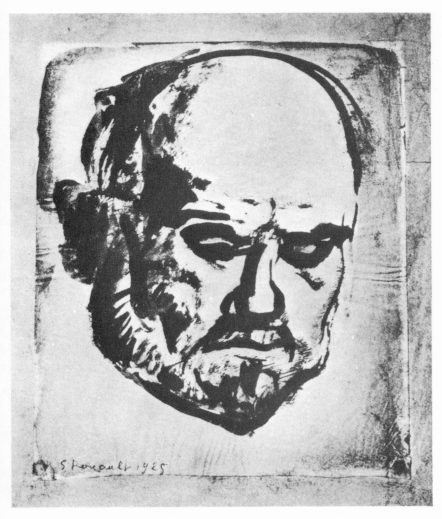

AMBROISE VOLLARD *Drawing by Georges Rouault, 1925*

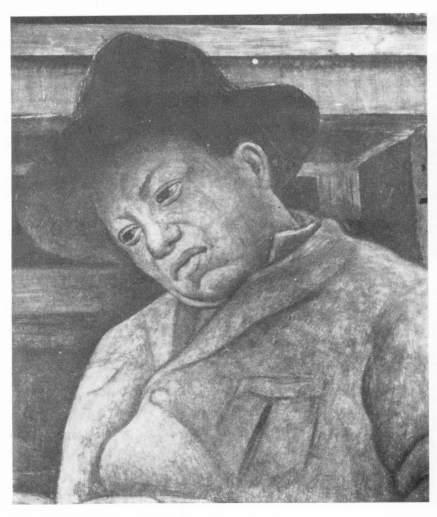

DIEGO RIVERA, SELF-PORTRAIT, FRESCO

on the benches. Rubens appears. Light goes from him as he laughs. And now, such a lovable old man, slight and shrunken, his hands gnarled with rheumatism, shows to Rubens a girl with round breasts. Of a sudden, four—no five—such water nymphs are before us, blue-eyed and with radiant skin. The glow in the laughing countenance of Rubens and the glow on the skin of the girl bodies unite and are a single thing. The stage lightens. . . . The action knows no end.

"Strange, how this criss-crossing of time and space causes no confusion in the onlooker. Not alone that, but it lifts from his soul a thousand confusions that had troubled him. Every time that another boundary is cleared by the action, there falls from us another shackle, the strength of our eyes seems increased and the beat of our heart, and our power of understanding, loving and producing."

The relationship between the mind of Roger Fry and that of Meier-Graefe, which I spoke of, rests in part on the affirmation by both of them that art is one thing and that breaking it up by periods and countries is against its nature. But the man in whose work the idea is felt most strongly is Elie Faure. I came to know him through his essay on Cézanne, and I still remember the evening in 1910 when I read that brochure, for it was one of the few times that I have exclaimed aloud at a something on a printed page when there was no one else present. The author had said a thing at once so necessary and so daring that I can still hear the "Whew" that I let out—and then realized that it was addressed only to the walls of my studio. Two years later when I read the passage to Arthur B. Davies he had me translate the whole essay for publication at the Armory Show. I give the lines once more:

"Men do not draw well or ill, any more than they write well or ill. In drawing or in writing, one says something or one says nothing, one repeats without emotion ihe words over which others trembled with ardor as they pronounced them, or one goes forth

to seek from the mingled form and spirit of things, certain new characters that shall stir in us sensations which are strong to the extent that they tally with the unknown sources opened up every day in adventurous brains by the incessant evolution of the world."

He knew about evolution and wrote of it in the inspiring essay on Lamarck that appeared later, with the one on Cézanne, in a volume called *The Constructors*. The things built by these men (Michelet the historian, Dostoyevsky the novelist, and Nietzsche the philosopher, formed the rest of the group) were not simply their own works, but the modern mind and character. Some months after my reading the *Cézanne*, a friend took me to hear M. Faure lecture. It was before an evening class at another of those institutions of volunteers for public instruction, like the nightschool I had myself been attending, the one where I took Jean Le Roy. The subject discussed by M. Faure on this occasion was *Architecture, the Social Art*. Like his other lectures at the University of the People, it furnished him material for his *History of Art*, of which two volumes, those on the ancient and the medieval periods, had appeared. I read them, and found that the immense knowledge they contained was constantly in a hand in hand relationship with the audacity which had let the author affirm that men do not write well or ill—that they say something or they say nothing. And all through was testimony that the something is not really said until it is said with art. On the lecturer's invitation, I went to call on him.

The only name of Faure I found at the address he gave me was that of a doctor, and soon I was among a group of patients awaiting treatment. When it came my turn to be admitted to the inner room I found that the physician really was my art critic. The voluminous writings were done in the spare time of a busy practice, one that was rendered easier, however, by the writer's brother, Jean Louis Faure. This surgeon—the greatest in France,

ROGER FRY, MEIER-GRAEFE, ELIE FAURE

I have often been told—saw to it that there were regular hours and substantial vacations for his brother. It was for this reason that those important books could be given to the world.

More interested in the diagnosis of a case than in tending it through the period of recovery, Elie Faure's mind worked in somewhat the same way on the questions of art. His pleasure was in cutting through to the essential lines of a period or a personality; he left to others the writing of detailed biographies or minutely documented historical studies. He read them, however, and was duly grateful to the men of an archeological turn who furnished the material for a comprehensive view of things.

"I have the eye for synthesis," he once said to me. It was when he was planning a trip around the world, late in our acquaintance, and I was arguing that it was better to see a few places thoroughly than a large number hastily. (His leave of absence from the hospital he served would not permit too prolonged a time for travel.) The trip was the great topic of conversation at the house for months before he left. "Now how much time is it that you are going to have in Cairo?" asked someone. "Half an hour," interposed Charles Pequin, hastily. The general laugh that followed did nothing to diminish Elie Faure's admiration for the delicate and pure art of his good friend, the painter who had made the sally.

The critic could afford to let people chaff him about the quickness of his decisions. In the last volume of the *History of Art* there is a series of parallel illustrations that prove his power of analysis. Each pair of pictures shows how Greek art and French art followed the same evolution over hundreds of years; the changes from the primitive state, through the heroic period, to that of more subtle forms goes on in identically the same way, as a response to an identical development of society in the two lands.

When I showed the plates to Miss Gisela Richter, the curator of classical art at the Metropolitan Museum, she was so struck by

the accuracy of the thought that she said it would be a big task
for the whole staff, with its great resources in the collection of
photographs, to work out the result which here was due to the
mind of this one man. And, at the time, she had not read the
accompanying text, which explained why the art-forms followed
so intimately the development of the social structure of the two
peoples. The author had offered his illuminating argument
through the terms in which, above all, he had received it, which
is to say in terms of the objects. The case finely illustrated the
distinction between the book-minded and the eye-minded, some-
thing that Meier-Graefe more than once insisted on.

Almost as soon as I got home for the International in 1913, I
began to try to have published an English translation of that
History of Art. From my first reading of it, I came to the con-
clusion that it was the book that America needed most (I was
about to say the art book it needed, but decided before I inserted
the word that it was of all books the most necessary for progress
here). Often people have spoken of it as sound and fury, Gallic
emotion, steam and smoke. I know something about that ques-
tion, having translated the five volumes, as I had to, the publishers
insisting on it since I wanted them to bring out the work. The
criticism is not unfounded, but having admitted so much, I will
call it a half-truth, anyhow.

The important matter is not the smoke but the fire—a thing
that most of the "factual" histories completely lack. That is why
they do not kindle the reader, why they do not thaw out the
frozen ground which our country has got to break and water
before an art of our own can grow in it with any chances of being
at home and getting its roots deep and wide. And that heat of
Elie Faure's, which does send out clouds of steamy expressions,
reaches an intensity where it causes flashes of light to go forth
from his pages, not a few times, but thousands of times. I come

[264]

back to the word that Havelock Ellis used about Faure's chapter on Gothic: he called it unsurpassable.

The first firm I took the book to was the one where our eminent critic, William C. Brownell, had presided over the reading of manuscripts for some thirty or forty years. In all that time, he told me, with scholarship and kindliness mingling as always in his judgment of things—he had never so bitterly regretted his inability to get a book accepted by the house, as he did in this case. For seven years the same refusal kept up, as I offered the *History* to one publisher and another.

When Thomas B. Wells finally took it for Harper & Brothers, he said it was because they needed an important and substantial book for their list. He added that the Faure book would not sell —that they'd be happy if they got their investment back in twenty-five years. They covered it in one year—and I had proof that the public is not the undiscerning creature that publishers (and picture dealers) make it out to be. I admit that they sometimes have good reason to do so.

The immense success Elie Faure had in America was not what caused me to be so well received at his house on my return to France, for nothing could have exceeded the cordiality there in the early days when there was no question of my translating his book; I had never done one before. We met on the basis of ideas and admirations held in common; I saw his three children grow up and marry, and the grandchildren come along. I had witnessed such scenes as the one when Zizou, his charming daughter, danced into the room, exclaiming: "Oh, papa, the good news that I read in the paper: Elie Faure's books are going to be translated—into French!" With the certainty that every son of France has that his native language is the finest, the most glorious, in the world, and that his own use of it is a thoroughly good one, I leave it to the reader to imagine the effect on a French author of a speech like the foregoing one. To be sure, Zizou is a being to whom a father

—especially that one—would pardon anything, but I think he needed all his reserves of humor to gild his pill, one that had been administered to him before in other forms, and not quite deservedly, according to some judges of literature.

From his native place in the Dordogne country, we went in his automobile for a trip that showed, in French provincial life, the qualities which are so necessary as a complement to acquaintance with Paris. He himself knew the provinces in the intimate way that makes him really wonderful when he writes of the history and art of his own country.

But Paris was the place where Elie Faure lived most of his life and where he forgathered with the great artists of his day. I once asked Renoir about him, and got the reply, "Why, he's my doctor," and when I spoke of the essay on Cézanne, Renoir said, "It's the one thing on that painter which exists." Very likely he had not troubled to read much of the big mass of other material about his old friend: it simply didn't "exist," in the sense of having any validity.

Although with the writers discussed in the pages just preceding, I have made some departure from my program, which is to speak of men rather than their production, or my idea of it, I want to go one step farther and say that, even previous to Elie Faure's death in the autumn of 1937, each time that I have looked back over his work I have had a sense of contact with a vital and dynamic thing. It is no evasion to say that the future alone can decide how high it is to stand as philosophy and as literature. I say that despite many things that I disagree with, notably in his judgment of latter-day developments. Like Meier-Graefe, he continued to write on the recent men after he had gotten out of touch with their evolution. Roger Fry, alone among the three men, continued to broaden in his ideas of contemporary art. Faure's horizon, however, did extend, but more in the direction of international affairs, racial studies, etc. Art always had a share in his thought on

such matters, and I am convinced, as regards his older writings, that a vast number of passages are going to stand the test of time and survive as things of great beauty and of deep truth.

Though he appeared to be in good health, as a rule, there were moments when anxiety about him was justified. Yet the end came unexpectedly, at least for those of us at a distance. He was horribly disturbed about the wars in China and Spain. For the former country he had long entertained the profoundest admiration, and he abominated the Japanese aggression there. For Spain, probably more than for any other land save France, he had a feeling of quite passionate devotion. Greco, Velasquez, and Goya were names he placed among the highest in his beloved art of painting, and *Don Quixote* was for him the greatest book in literature. (Among French writers, his favorite was La Fontaine.) The last book he wrote (or perhaps the next to last—both appeared after his death) was a cry of protest against the Fascist invasion of Spain, a thing which he recognized for what it was from the first days of Franco's rebellion. Each piece of bad news from the Peninsula struck him like a knife, and it may well be said that, living at the tension he did, and dying at the age of sixty-four, his life was shortened by the repeated impact of such blows.

XXIV.

JOSEF STRZYGOWSKI, BERNARD BERENSON

———

I AM WILLING TO HOLD TO WHAT I SAID ABOUT COLLECTORS DOING more for the development of art ideas than the critics do, but it is beyond question that our time is one of profoundly important writing on art. In the record of it, a figure so outstanding that it will have to be reckoned with for a very long time to come, is that of Josef Strzygowski. I had heard of him for many years; even a casual reading of art history, especially of the movements leading to or from Byzantium, is bound to make one know his name. But his influence on thought began so many decades ago that I imagined him to be dead, or, if living, to be ninety years old at the very least. What was my surprise, then, on meeting him when he visited America in 1922, to find that he was then scarcely in the middle sixties. The explanation, very simply, was that he had begun to write when very young; before he was thirty he had become a force in changing Europe's conception of its past.

He was brought to this country by a group of learned institutions headed by Harvard and Princeton, and gave a variety of lectures, several of which I heard. The gift for striking upon ideas undreamed of by other scholars, one which had distinguished him from his beginnings, continued unabated down to the days I speak of, and his audiences, or certainly many of the persons in them, were electrified by his daring conjectures as to matters like the movements of races across the globe, the rise of architectures,

and the existence of a northern and a southern genius, at all periods and in all countries. To hear him was to get a new idea of the excitement of intellectual pursuits. Small wonder that universities in all parts of Europe were rivals for the honor of his presence, if only for limited periods; small wonder also that other savants were on the watch to find chinks in the armor of his erudition, for, very humanly, they felt themselves diminished by his flights of thought which, they often claimed, were based more upon fancy than upon fact. Yet even they had to admit that some of his theories, which at first sight seemed wild enough, had proved to be perfectly solid.

As usual with celebrities on a visit here, Americans had heavy demands to make on his time, but he was determined to remain human and to see the people whom *he* wanted to see and not just those who wanted to lionize him. Artists and scholars were more in his line than the rich and powerful and his secretary, being a friend of my wife's, thought a simple home dinner with us would be a welcome contrast for him, after all the official functions he had to attend.

The evening was a great success. Our small boy reminded him of his own children in Vienna. It was so long since he had had rye bread and beer that he consumed them in quantity and with gusto. We played a Haydn quartet on the phonograph and he loved it. Knowing the difficulty of many men of his generation with modern art, I was for keeping the conversation to ancient things, but he wanted to see the studio and, spying a Picasso etching on the wall, he suddenly climbed up on a couch to get a closer view of it, heedless of what his heavy shoes might do to the velvet cover which had been spread out in honor of his visit. Housefurnishing stuff was outside his department, but Picasso interested him—and vividly.

The one thing I asked was that he find time to go with me to my friend Brummer, the dealer in antiquities. After calculation as

to the hours in her appointment-book, his secretary found some fifteen minutes for a flying call, a couple of days later. I met him at the gallery, where Brummer had some specially interesting material on hand at the time. Here was something to Strzygowski's liking, especially when he heard that a rare piece came from an excavation that his host had conducted himself. "That is the real excitement. I know what it is: I am an old hunter."

The two men began to talk, and the talk got very interesting. But the secretary said:

"Herr Professor, you are expected. We must go now to the house of Mr. So-and-so."

"Phone him that I can't come."

"But, Herr Professor, he is very important; he may contribute to the fund for the institute."

"In that case phone him that I am sick."

After half an hour the secretary, having glanced at her book again, said: "We must start. Mrs. Such-and-such said she would be at home for you at this time."

"Tell her I can't come."

"But the rector at Upsala asked you to call on her."

"That's all right. I'll explain to the rector next December when I go to Upsala to lecture. Why, don't you see, this piece comes from Asia Minor, and it throws light on those things from Siberia. I may never be able to see these objects again if I go now. No, it's impossible; I can't leave."

And so it kept up—the quarter of an hour he had meant to stay lengthened into more than two hours, with one grandee after another put off with whatever explanations could be found. Strzygowski, as usual, had his mind on essentials. They had been the study of his lifetime, they had made him what he was; everything else could wait; the chance to see deeper into his work could not.

About a year before Strzygowski's visit to America, I had some

meetings in New York with another writer on art whom I had heard of since my boyhood. Bernard Berenson, though he did not mature so early as the famous Austrian savant, had published important books as a young man, and his position in the world of scholarship was pivotal. A classmate of his at Harvard has told me that in college days he was already pointed, unmistakably, toward his studies in Italian painting, a subject that had been of deepest moment to his alma mater and the museum of Boston, the city where he had grown up.

Going abroad, he naturally made Florence his residence, for his instinct, even more than his training, told him that the Tuscan capital would put him at the center of the greatest tradition of all painting. (I stopped myself in writing this, to avoid the too easy use of the words "painting in Europe." That of the Orient, great though it is in many respects, cannot be compared with our own in scope and in value, as I am always more thoroughly convinced.) I had been taken by Leo Stein for a visit to Berenson's house at Settignano, one time when the writer was away. On meeting him many years afterward, my best memory of his collection was a madonna by Baldovinetti. The lady has apparently undergone a change of paternity in the course of time, as have so many in old pictures, but it will be seen that her beauty, which is entrancing, has by no means suffered thereby.

Mr. Berenson's delicate health forbade his having long conversations, so that many things I should have liked to talk over at our first meeting had to be postponed, some of them for years. But I did speak of that madonna, and asked him if he still had it.

"Why shouldn't I have it?" he asked, quite energetically.

"Oh, you must be surrounded by temptations. I didn't know whether you had felt like holding on to it all the time."

"I've never sold a picture in my life—save this little saint here, and then to oblige the friend at whose house I am staying now."

"Well, of course I didn't mean temptations to sell: I meant

temptations to buy—for example when you make a discovery of some unknown masterpiece. I didn't know but that you could have got the Cimabue on the wall in front of us."

"I might have; but I wouldn't give up that madonna to own even the Cimabue."

The latter picture (now in the Mellon Collection in Washington) had been a chief cause in our coming together. It had been loaned to the Metropolitan when that museum celebrated its first span of fifty years by an exhibition. I had written of the event for *The Freeman*, the most brilliant weekly that American journalism can show in all its history, I believe. A copy of my article had fallen into Mr. Berenson's hands and he was particularly interested by my accepting the attribution of the painting in question to Cimabue—a man whose very existence was denied by many critics. His own article in support of the title had not yet appeared, and so any testimony whatever for his side of the case would add up, quantitatively, in any event. He inquired of several people about the author of the article and, after three among them had telephoned me, I went to call on him.

Many a good discussion, *viva voce* or by correspondence, has followed that first one, when I so nearly spoiled things by a reference to the possibility of his selling. It was but natural that he should feel some sensitiveness on the point. Having for years been consulted by museum officials, collectors and dealers, his word was sufficient to change the market value of pictures from practically nothing to sums running into the millions, or from millions to practically nothing. And so no end of people, above all those who distrust art anyhow, had made furtive allusions to him as a figure in the vast mystery of the commerce in art works—a thing as devious as the pictures themselves were glorious (if properly authenticated). As John Quinn once remarked, the world of expertizing was divided into more or less equal halves between Wilhelm von Bode and Bernard Berenson, and that world is one

where the utmost circumspection is needed. An article by Roger Fry, one dealing with a sensational book on Rembrandt, contained the words, "It would be ungracious and ungrateful to Dr. van Dyke if one suggested that he is of that class of persons who rush in where angels fear to tread," but the rejection by practically every one of the professor's attempt to be the arbiter of so difficult a subject bears out Mr. Fry in his characterization of the would-be iconoclast.

In speaking of that ill-advised author as I do, no thought is in my mind of the material advantage that Dr. van Dyke might have attained if he had succeeded in making himself the court of last appeal on Rembrandt's paintings, drawings, and etchings, though they represent investments adding up to some fantastic figure. To indulge in such suspicion is merely to prove one's incapacity to deal with the real issue: one judges a man's work, finds it good or bad, and leaves money matters outside the door. Does not an art expert need money? someone objects. He does. And a doctor needs money. But if you cannot feel confidence that your doctor is working to lighten your ills and not just to lighten your pocketbook, I advise you to look about for someone who can choose a good doctor for you. And be sure to pay him; he cannot live merely on his reputation, which is supposed to be the great reward of the art expert.

Rembrandt also worked for money, and he had plenty of uses for it, one of them being the "extravagance" of buying works of art to live with. But no one looks on his desire for gain as a reason to question the value of his pictures. It is the work that counts. We judge of his honesty by the record at the museums, not by the record of the court that declared him a bankrupt. Why then should not the writer on art find his means of earning, and earning well? The real issue, which I touched on before, is his competence, and the world has got to learn to decide whether it is great or small. Charles Loeser used to say that the trouble with Ameri-

cans was that they preferred to deal with an incompetent man of "pure" character rather than one who knew his job but who would make money from them. And Loeser was both an American and outside of any pecuniary temptation.

All this chatter about money applies to the people who chatter about Bernard Berenson, and not to the man himself. For all who consider the essential thing about him—his writings—he stands like a lighthouse, throwing a broad beam across the art of Italy first of all, and then passing on to other matters round about, in what may seem an incidental way but that really shows a need of his inquiring mind. It is not without significance that the first book in English to mention Cézanne (as far as I have observed) was one of Berenson's, over forty years ago, on the Italian painters of the Renaissance. And in later life he continues to widen his grasp.

XXV.

SOME ART DEALERS

HAVING INSISTED THAT PAINTERS AND CRITICS BE JUDGED BY THE art they have to offer, I now take the extreme step of using the same criterion when the question is that of the dealers. Very few of them come off well under the test. Most of them do well enough if they comply with the usual demands made of them, which are simply that they be honest and that they carry the type of goods most in favor at the time. But there is, occasionally, one or another who has ideas of his own and who holds to them, whether the public backs him up at once, or whether it does not. Vollard, as we have seen, is such a man. Kahnweiler, the early friend of Derain, Picasso, Braque, Juan Gris, and Léger, is another. Back in the days when the Impressionists were thought to be crazy, Durand-Ruel was the man who had vision. The fact that it made a fortune for him and his sons and his grandsons takes away nothing of his merit (to give a last glance at my argument about "pure" intentions).

But an attitude toward art like his is by no means confined to the men whose business is with the modern schools. It may perfectly well occur among dealers in ancient things. Indeed, the finest example I have seen of complete absorption in quality is the one furnished by Joseph Brummer, whose trade is in works dating from the Renaissance back to the earliest times, though he is better known to the public of New York through his mag-

nificent exhibitions of the recent sculptors, men like Rodin, Maillol, Duchamp-Villon, Despiau, Brancusi, and Pompon, beside painters like Seurat, Derain, Villon, and Segonzac. He shows the modern works because his own career includes very important years as an artist. They continue through his splendid effort to hasten appreciation of the great men of his time. The expenses of bringing to America and sending back big masses of material render impossible any profit on such enterprises; and the clientele for his ancient works is so far from being swayed by the modern "radicals" that the shows do not constitute advertising, as they would for a dealer owning a stock of such works.

I am not trying to make Brummer appear indifferent to business advantage; his colleagues look upon him as one of the keenest minds in their difficult field. I simply start the account of him with a fact which proves that he sees further than business advantage; and with that fact in mind the reader may be better able to judge the rest of his record. It began, as far as I am concerned, soon after he arrived in Paris, the same year that I did, which is to say in 1904. His native place is in a part of Jugo-Slavia that was Hungary before the war, and where the soil still gives up relics of the time when it was held by representatives of the Greco-Roman civilization. So that Brummer began his interest in ancient art during boyhood, when he saw statuettes, coins, lamps, etc., that the peasants plowed up in the fields. Soon afterward came his urge toward modern art, that is, toward producing art, and when we met in a Paris atelier, the two fierce interests were about evenly balanced in his mind. At the school he worked hard, drawing from the model; at the Louvre he worked hard to know better the meaning of the masters, especially those of classical times.

With its thirty-five thousand art-dealers, Paris offers simply endless opportunity to the collector, even one of the most infinitesimal means. Brummer bought what he could, sold in order to buy more, and finally, the impulse to own works of art gaining

the ascendancy over the need to create them he took the plunge and became a dealer. I remember his first shop, in 1910, a tiny place in a ramshackle one-storey building. But then as now, the important thing for him and his clients (with Rodin among the earliest of them) was the quality of his possessions.

At first they had to be of minor importance, for in order to buy great things, capital was needed, or the rare stroke of luck. Of money he had almost none, and obtaining the fine things that could occasionally be bought for little was possible only for one who watched, decided, and acted with the boldness and speed of a hawk. Paris was full of hawks—but Brummer turned out to be the eagle among them. (I know that there will be little smiles of deprecation at my saying this about my friend; but ask even his rivals of those early days or the later ones, ask museum men about him, and you will see that I am soberly exact. A mere list of what has gone from his hands into the great public or private galleries of Europe and America would be the best proof.)

The romance of his rise is to be read in terms of his energy and his connoisseurship, but above all of his love for the things he deals in. Nowadays there is a vogue for stories of racketeering among art-dealers. I am sure that many of them are true, since a majority of the people who buy are inferior in knowledge, taste, and character, the sellers must meet them on their own ground, and practice every trick of the sharp buyer, the dishonest restorer (if not forger), and the smooth salesman. But again the belief that these ugly sides of the profession dominate it only shows how much the public has to learn about art. Attributing to artists the indolence, jealousy, immorality, and impractical dreaminess which are indeed to be found among the lower types of painters and sculptors, it cannot understand the fine men, whom it ac- counts for by such a cliché as "divine inspiration." And when Baudelaire explains that "genius consists in working every day," the world replies that he was a satanist or, as one well-known

critic said lately, a charlatan. And a similar misunderstanding hedges about the integrity and the knowledge of the dealers whom one respects.

Once more the touchstone is that of art. The vaguest of words, as I am sure many a reader has objected with an irritation increased each time that I declare art to be the test of things, slightly differing in the conception of it held by different epochs and individuals, it is no myth, I firmly believe, nor yet a relative thing—true or false according as you look at it. And it can be defined—it is being defined, always more exactly—by the museums, as we add to them and subtract from them.

In the process of doing so the dealers—the best of them—are factors of such importance as to exceed that of the directors and curators, save in the case of the men of rare genius, like that of Bode. And no one knew better than he how many of the triumphs of acquisition for the museums are due to the daring and the knowledge of the commercial men who dig into the various mines (or slag-heaps) of the art world to bring up the treasures of the past and the present.

I have told a very little about one of the greatest dealers; this sizable book would be too small to give details about the tens of thousands of objects Brummer has handled, about their history in Chaldea, Egypt, Greece, Rome, and all the later places, besides Negro Africa and the America of the ancient peoples. Above all, there would be the human side of the story, of which I know only a small part: his contacts with the inheritors of the old civilizations, with people in Europe (often other dealers) into whose hands the great things of the Continent have passed, then his relationship with the collectors he has sold to, but—best of all, to my thinking—the living artists whom he has helped to go on with their work.

Other figures in his field come back to my mind also. I think of André Schoeller and his passion for the art of Barye. In that

artist's seventy-nine years of life, he produced a great deal. But in the course of time the number of bronzes bearing his name has been increased by an uncountable number of casts issued by more or less scrupulous persons. At their best, as with the examples made from the molds which Barye was forced by poverty to sell, the pieces not touched by him may still be very good, though lacking the authority, the stirring quality, of a work from which he chiseled away the imperfections of the casting, reinforcing blurred lines and giving the work a patina like that of the great bronzes of the past. At their worst, when copies of copies of copies, the things are a shameful and cruel slur on the memory of one of the noblest of artists.

It has been far from the whole of M. Schoeller's life work to distinguish the degrees of excellence in the Barye casts that come up for sale, but his is always the deciding word when there is question in such matters; and many a dealer who is a sufficiently sure expert in ordinary cases, will submit a problem to M. Schoeller when it is a question of knowing just how much of the work on a bronze is from the hand of Barye, how much from his assistants (I will not say his imitators). In the galleries of this dealer who, for thirty-odd years, has had the confidence of the greatest collectors of Paris, you may see heavenly things by Delacroix and Ingres, Corot and Daumier and Renoir; but what is unique is his collection of Barye.

There are models in wax and in plaster, bronzes of which no duplicate exists, veritable originals, since the great man took some piece already done and reworked it completely with his sharp tools, his buffers, and all the other means of giving beauty to metals that he had learned to use as a boy in the jeweler's workshop—things of a tradition going back to Cellini and beyond him to the master craftsmen of antiquity. And you will see drawings and rare lithographs—and those glorious works in oil and water-

color of which Barye did a certain number, things that are among the glories of his magnificent generation.

I think of Charles Bourgeat who, like Brummer, entered art-dealing by way of the studio. A fellow student with Matisse in school days, then a worker in the art of lithography, his love for beautiful things finally led him to share his great knowledge with others through the gallery he opened. His own practice on the lithographic stone made him peculiarly sensitive to the mastery of Redon—and extraordinary things by that artist have been bought and sold by him. Those words of the marketplace have no bad echo when I use them about M. Bourgeat. Again the question is that of quality, what he buys and sells, what he recommends above all. Too quiet and gentle to have carved out for himself a place among the moguls of his profession, he is apt to have those delightful things that are not "important" enough for the big collector. I owe to him a little landscape of the late eighteenth century that has been wonderful on my wall, as it was on his own. He could buy it because the moguls missed its pure note—like that of a Claude Lorraine, as I said—"or like a Greek bas-relief," added M. Bourgeat.

"How charming he is," said an art-lover in Paris.

"Lui—mais tout à fait Vieille France!"

XXVI.

MEXICO: JOSÉ CLEMENTE OROZCO, DIEGO RIVERA

—————

IN 1918 I WAS INVITED BY THE UNIVERSITY OF CALIFORNIA TO deliver the art lectures of its summer session. The visiting professor of Spanish literature had an apartment in the same building where my family and I rented one, and by degrees we became friends. Pedro Enriquez-Ureña is his name; his father was at one time the president of Santo Domingo. California was a more sympathetic place for my delightful and learned neighbor than the snowy region of Minnesota, where he had been teaching, but he longed to get back to Spain or to Mexico, where he had occupied a chair at the National University, the oldest in the Americas (that of Lima has some claim to the title, but it is impaired by periods when the institution has been closed).

Early in 1922 I had a letter from Sr. Enriquez-Ureña, who had meanwhile returned to the University of Mexico, and was acting as its secretary. He invited me to give a course there that summer, on the lines of those in Berkeley, where he had sometimes dropped in for my lectures. I wrote him a long reply saying that my pen was moving at top speed, that I was not even glancing at a dictionary or grammar book, and that he could thus renew his memory of my Spanish; I could not prepare carefully worded lectures, but would have to run along with such expressions as I was using in those pages, so that if he persisted in his

invitation, he would have to take responsibility for the wrongs I should do to the language of Castile. He had me come—and I was eager to go.

The Mexican room of our Museum of National History had long been a source of deep pleasure to me, and I thought my study of the collections there had prepared me for what I was to see in the country itself. But that was one of my mistakes, and a big one. The impact of those tremendous works in Mexico City was not simply greater than I had dreamed, it was a new horizon that opened up for me. I wrote to Elie Faure that New York seemed by comparison a mere prolongation of London, Paris, and Berlin: for the first time in my life I felt myself to be in the New World.

And it was not only the ancient things that made me say that, but the life of the capital, particularly as it centered around the university. Of this life I found that Sr. Enriquez-Ureña was one of the leading forces. Reputed to write the most beautiful Spanish of all living authors in the countries of that language, his teaching had formed the mind of a number of the men who remade Mexico after the overthrow of the old Diaz tyranny. A counter-revolutionary movement had driven him to the United States— and to the mechanized routine of a language teacher there. No wonder he had been glad of the freer atmosphere in which we first met, and of a chance to talk literature and art!

He had to leave for the Argentine, soon after my arrival in Mexico, having been "borrowed" to build up certain courses in a university there, but before going he made me acquainted with some of my new colleagues, among whom Octavio G. Barreda and Eduardo Villaseñor have remained among my warm friends. Both went from the university (a government institution) into other branches of the national service, both were consuls at different places where I picked up with them again, both have the deep interest in cultural matters that is so general among the public

men of their country. I once heard a speech that ex-President Calles made in New York, when he said, "The internationalism that reposes solely on a materialistic basis is a delusion and a lie."

To Sr. Enriquez-Ureña I also owe my introduction to Don Ramón Mena, the professor of archeology, who admitted me to the course he was giving on his subject. It was of the most vital interest, not only to myself, but to his Mexican auditors, because the ancient grandeur of the country, so hateful to the Spaniards, and still unappreciated in the days of Diaz, was a symbol for the men of the Revolution, which word designates for them not simply the great liberation from Spain, a hundred years ago, nor any one of the subsequent steps toward freedom, but the continuing process of obtaining the full rights of human beings, abroad as well as in their own country.

Everything was for the Revolution: men's enthusiasm in teaching people how to read and to write, the beauty of the new buildings, the cheap editions of the classics, popular dancing and music, and the restoration of pyramids and temples. I doubt that latter-day Russia can show the spirit of new life I saw in Mexico, and I know that the land of the Soviets has no such idea of art. The scholarly and the political interest in Mexico's past was, I found, of less importance to the people than was their pleasure in the ancestral objects simply as wonderful things, admirable things, whether or not "beautiful" would have been their word for them. I could not surmise what went on behind the impassive faces of the peasants I saw every day in the museum as they stared at the objects in the glass cases. Usually they were silent during their long and careful scrutiny, and when they exchanged a few words among themselves it would be in an Indian language.

But I know that when I told Luz Perez, a girl who posed for me, that there was a stone mask with fine inlay of turquoise and coral at the Museum, she could hardly wait till the next morning

to go and see it. Yet she was a simple villager, who sold vegetables in the market. And though her beauty made her a favorite with the artists, it was not from them that she got her love for the old sculptures. It was from her soil, as I saw when I visited a little place remote from any city influence and, entering the school-house, found that a large part of the teaching, given by the two Indian girls comprising the staff, was based on a collection of idols. It was added to, from time to time, as the father of one pupil or another plowed up some piece of special interest. Yet the two "professors" were deeply interested in what I could tell them of modern education in the United States.

Even this meeting of the old and the new was less impressive to me, however, than the combination, as I saw it, in Professor Aguirre, one of the officials of the Museum. A pure Indian by blood, as I was told, his looks bore out the statement for me, and when he spoke to the country people in their own language, they evinced none of the distrust they showed toward the Spanish-speaking men from the university. I noticed this on a trip to San Francisco Acatepec, the little town with the beautiful church—but no school. My colleagues wanted to arrange for the founding of one, but the villagers were opposed to the idea, until Sr. Aguirre explained its advantages to them in the Nahuatl tongue.

Once he took me for a long walk in the country. We left the capital at five in the morning and had breakfast at the ancient city of Tezcoco, where we also bought materials for lunch. Then we struck out toward the hills. Pointing to a certain peak, my guide said, "Let's climb that one." It looked like any other, but as we swung around a vast wall of rock, I stopped in amazement. The whole top of the mountain was carved. There were great chambers in the stone, there was a sort of throne, there were baths (which an aqueduct filled with water, in ancient times), there were admirable sculptures of animals. I turned to my friend —who wore a broad smile of pleasure at the effect produced by

his sudden surprise. But a more experienced person than I could have been taken aback by the "Baños de Netzahualcoyotl," one of the astounding things of the Republic. They were a favorite resort of the philosopher-king, in the old time, and here, looking across the valley to the great volcanos, he would write his poems. Only a little imagination would have been needed to think of Porfirio Aguirre as belonging to that half-legendary time. Yet he was at home in New York and in Berlin, having been adviser to the museum men of both cities.

We went on till evening, over some of the roughest country I have ever traveled, steering our course by the line of the mountains when there was no path, and often just leaping from rock to rock. At one time (the only one all day, if I remember) we came on a tiny group of houses, and stopped in one of them for a rest and a talk. As is so much the rule in Mexico, the man there had a small collection of local idols. Sr. Aguirre said I was from a long way off where they had no such things. The mountain man asked me to choose one as a keepsake. I did, for he really wanted me to. The piece turned out to be a very rare one—a sculptor's trial model. We got back to Mexico City for a late dinner. But the day in that exhilarating air had been too full of great things to talk about for me to want to go to bed at once, and we rambled about the quiet streets till ten o'clock. As I had left home at four in the morning, Sr. Aguirre said I was a good walker, which means something in that Indian country.

The most assiduous visitor to my lectures was José Clemente Orozco. He had not yet done any large pictures, but his revolutionary cartoons had been a great force in the papers, and he had made some extraordinary water-colors of scenes from popular life. A stay on our side of the border, when his political party was in defeat, had shown him a little of non-Mexican art, but neither that nor what he saw on a subsequent visit to New York, nor a trip he made to Europe, still later, has had any effect on his work,

as much as I can see from the outside. Everything he saw or heard, however, became material for very active assimilation into his mind, and so—indirectly—into his art. Yet it remains completely indigenous; in fact I think it grows more so (without his making any effort to reach such a result). Neither colonial Spanish nor Indian, still less European or North American, it is, as he said of his people during our first days together, Mexican—something of the new race brought about by the amalgamation of many older ones.

The powerful blood and the powerful art of the original Americans dominate in Orozco's painting, and this is what gives the exotic and fascinating note to his superb frescoes at Dartmouth College. That institution did a splendid thing for itself in obtaining them, and in obtaining for its staff and students the presence of the thoughtful and deep man who painted them directly on the walls. Orozco's presence in our country was important to a far wider audience than the one he reached immediately at Dartmouth, whither his frescoes have attracted thousands of visitors—often from the most distant places. And so I think those responsible for his sojourn in that New Hampshire college town are entitled to immense credit for making the venture they did. It is one of the signs of hope for our country when old New England traditions show that they still have the elasticity to adjust themselves to new ideas, as they did long ago when prophets of a wider horizon appeared on their soil.

Orozco is such a one, whether he has a plan for the future or not. His retelling of old legends is certainly impressive; there are passages of great beauty in his painting, and there is—obviously (too obviously?)—tremendous strength. His gaunt assertion of a native American element in painting (he will tell you that the very methods of his fresco are traditional on our continent) must be a cause for confidence in the New World on the part of those who see Europe as outworn. About that last point I do not agree

at all—to say a word for my own opinion on the question—but I retain a strong admiration for the man who may perhaps be regarded as the clearest demonstration of the Pan-American thesis.

I had known the work of Rivera for some ten years before going to Mexico. It had been shown in New York by Marius de Zayas in one of the earliest of our "modern" galleries. Rivera was in Paris in my time, but I did not meet him there, though—curiously enough—I had been one of the causes of his coming. The fact developed one evening in his house when we were swapping memories of Madrid. He had gone there, like so many Mexicans, because it was the great city of the land of his ancestors—or a part of them, very much as London is the first place that many an American wants to see.

"Did you ever know a young Madrid painter named de la Rocha?" I asked.

"Luís de la Rocha? *Ya lo creo,* he was one of my best friends."

"And he was one of mine."

After a moment of reflection Rivera said:

"In 1906—no, it was 1907 or 1908—de la Rocha got a letter from an American in Paris urging him strongly to come there; he said that the whole modern movement was in Paris and that we were wasting our time in Madrid every day that we did not get ahold of it. He spoke of Cézanne and Matisse and Picasso, and he said things like what you said at San Carlos [where I was lecturing] the other day. Were you that American?"

I was—and though de la Rocha did not get to Paris till some years later, Rivera came very soon, incited, as he said, by the phrases of an unknown man—whom he was not to see for fifteen years, and then on his own native soil. Though he has been away from it during a number of sojourns in Europe, he belongs to it as completely as does Orozco. The latter has far less of the European strain in his ancestry than has Rivera, but I pass over that fact in explaining the differences between the two; I have no confi-

dence in matters of race as explanations of the characteristics of individuals—at least in any way that we can trace. One has so many ancestors, and a drop of blood from one who lived centuries ago and whom nobody living ever heard of, may be the determining one in a personality, and in the life-course resulting therefrom. See how utterly different two brothers can be—with an absolutely identical descent.

At all events, Rivera had been to Spain and had been thrilled by its masters. On seeing a certain work that Thomas Eakins did in Spain, he exclaimed, "It's like a Velasquez." (You may think, reader, that this was a random remark—but wait till you see the picture!) He had been to France and had gone from Impressionism through a penetratingly intelligent study of Seurat, to the later schools, and so to the last reaches of pre-War Cubism. He had been to Venice and, without lack of admiration for its Renaissance masters, had got his great lesson from the Byzantines. "There have been two moments in my life when I felt the strongest emotion—one was at the death of my child, the other was when I saw the things at St. Mark's." He had been deeply impressed by the majesty of Giotto and Piero della Francesca, and had decided that fresco was the supreme art of painting. Then, in Naples and Pompeii he had studied its use in the hands of the Greeks, and decided that they were very near in their conception of it to the ancient fresco painters of the Aztecs or Toltecs.

The first time he was in New York—it was only for a day—I insisted on his taking time for at least a brief visit to our museum. My chief interest—for myself—was to hear what he would say of our Pompeiian paintings.

"Don't you think they stand with the very fine ones?" I asked.

"Not only that, but they are of the great modern school of that time. Things were just as they are now: there were two clear

groups—that of the men who copied the past, and that of the men who painted the life around them—as in these divine things."

With such knowledge, he returned to Mexico. His reputation, already well established at home, enabled him to get his first big commission for a mural work, on which he was engaged when I arrived. Other men took up the idea, and walls were being plastered and painted with an inspiriting activity. "It's like Florence in the great days," observed Diego. It was, and the work went on for years, crescendo, over the big spaces of buildings in various cities. Reproductions of the pictures by Rivera himself, by Orozco, and others, appeared in the United States, and Mexico became a place of pilgrimage for artists and art-lovers.

San Francisco was the first place to invite Rivera to do a wall in our country. Then followed Detroit, and finally New York. The grand evenings of talk and songs and picture-seeing that we used to have in Mexico City in 1922, were renewed. While he had been on the magnificent Detroit job—it contains some of the finest passages in his whole production—I visited the city for a lecture I was giving there, and so had a chance to mount on the scaffolding with him and see a fresco in progress. When I was in Mexico he was working in encaustic, a totally different method and far from equaling the beauty that can be obtained from the union of the color and the wet plaster.

Later on, in New York, he invited me to try my hand on a panel that his assistant prepared for me, and I understood from experience what excitement there is in doing work in a contest with time: in order to finish the day's painting before the plaster dries—when no added touch is possible—everything must be thoroughly prepared beforehand. Sketches tell the painter what he is to execute; yet there will always be a wide margin of development, mental and technical, which allows the final handling to be spontaneous and inventive. In this book I have hitherto refrained from talk about my own painting, but it is germane to the subject

of Rivera's mural work to say that the year which I spent over the design and execution of a big fresco for the New York City College was a rich and exciting year. Aside from the sober splendor of the material used, there is the constant thought that what one does is not simply for oneself, or for the intimate entertainment of the few persons who are all that see most easel pictures; one is made to think that the painting is for the eyes of all the thousands of people who may enter a building.

And so the very nature of the work induces consideration of the rôle it is to play in human society; the moral or political significance of a given subject brings one to thoughts that are not necessarily present to the mind when painting is carried on as a means of dealing with the great problems of form and color— which made such urgent claims throughout the modern period.

To return to Detroit and that narrow strip of boards where I climbed up to see Rivera's work near by: we looked across the court of the museum he was decorating and got a fine ensemble view of the great wall opposite us; he began to speak of his idea in painting the automobile plant there depicted. "You see what I had in mind when I did those big machines, with the hot metal and the line of men below, don't you?"

I did have a notion as to the more than human forces he was evoking. I knew, from the days in Mexico, how machinery fascinated him, and I remembered how, down there, he had explained to me that a composition by Rubens works on exactly the principles of drive and resistance that govern the workings of a machine. And so I could imagine the intoxication it was for him to spend a year in this city of machines, to make studies of them in their power and speed, and to associate with the men, from Henry Ford and Edsel Ford to the simplest workmen, who controlled the marvelous things. Yet I confess that I did not hit on the thought that Diego had in mind.

"You were down in our country and you felt the grandeur

of the old gods that our people carved on the pyramids and on the mountains. Those big figures are just the same as these"—and he pointed to some mechanisms in his picture: he had indeed given them a startling resemblance to the gods of death, of waters, of the moon—once you noticed it. "Those forces go on in the world, especially in America, which is all one place, anyhow. They use our products here as material for manufacture, and a lot of the workmen are Mexicans. I am at home in every way."

He was, and he felt so when he came to New York. His remarkable talent, his rich temperament, his culture, the romance about him, his daring philosophy, his long period in Russia after he had gone there as a representative of the Communist party of Mexico to celebrate the tenth anniversary of the Soviet Republic, all made him a marked figure. The press took up his doings, especially as this protagonist of Marxist ideas, who had made fierce caricatures of Wall Street people, and of capitalist society—its leaders and its failures—was now to decorate Rockefeller Center, at the very heart of the system he said must be replaced.

It is outside my purpose and competence to discuss at any length the unhappy outcome of the meeting of the two conceptions of things. It was such a meeting, though, as I have said on an earlier page, the destruction of Rivera's big mural in Radio City was the result of a narrow idea of art, and not of hostility to a political philosophy. With other artists, with clergymen, educators, writers, and scientists, I made such moves as I could to save the fresco, in the time between Rivera's enforced stopping of work on the panel and its demolition by the managers of the building. Those who took part in the protest were not moved solely by admiration for his art nor by the desire to prevent an act which would count so heavily against the record of benefactions that the Rockefellers were building up through their many gifts

to the world. Their impulse to do so was a thing to foster out of the merest self-interest, if nothing better.

Two grievously wrong ideas were taught by the affair: that art was private property (if a Rivera picture could be destroyed with impunity at the will of its owner, then a Renoir or a Rembrandt could); also there was the notice served on American artists that unless in their great new urge toward mural work, they kept to the "safe" platitudes of the generation before them, they might expect the treatment which Rivera got. In fact, the lesson was not only for Americans. Frank Brangwyn, the English painter, had to change his picture of the Sermon on the Mount at Radio City in order to conform to the managers' idea of the clearness with which the founder of Christianity might be shown in a commercial building.

Rivera made one of his typical observations about the affair; he said, "This is the nineteen hundredth anniversary of the act of Jesus in driving the money-changers from the temple; it is quite natural that they should now drive Him from their temple," that of Mammon, I suppose he meant. But since the big office building is not a place of worship, Rivera's parallel is not strictly accurate, and doubtless even he was simply taking the opportunity for a witty gibe. None the less, his remark brings home the fact that business will not let either art ideas or religious ideas stand in its way. If artists want the pay of commerce (Matisse and Picasso declined it in the case of Radio City) they have now been told that they must accept its conditions. Clergymen are probably in the same boat, but their place in it was determined so long ago that most of them keep to the chaplain's rôle, and leave management to the owners.

I believe that we may not place on the Rockefeller group all the blame for the destruction of the Rivera mural, some of it, I think, falling to the artist because of his provocative imagery. But it seems to me that the worst offenders were those Communists

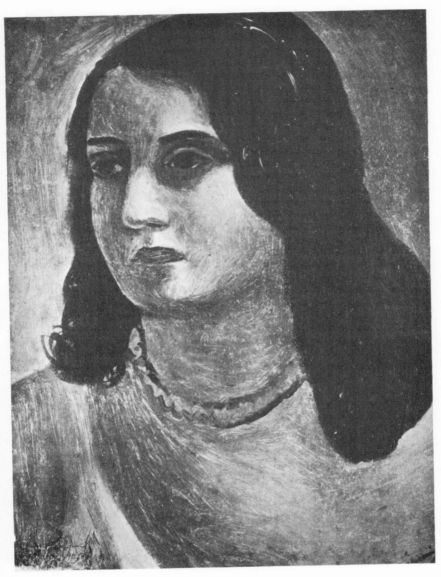

HEAD OF A WOMAN *Painting by André Derain*

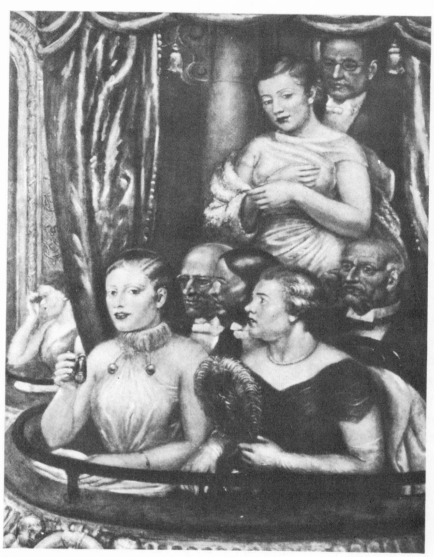

THE BOX PARTY *Painting by Kenneth Hayes Miller, 1936*
The Whitney Museum of American Art

who, by a night-and-day campaign of incitement, misled Rivera into a position where he antagonized the ideas of a majority of Americans. His advisers might as well have pushed him out in front of an express train in order to demonstrate how the juggernaut of capitalism takes lives. Perhaps he is right in saying, as he has since done, that the affair brought his philosophy before thousands of people who would never have seen his fresco on the wall. But I believe that those thousands were already on his side, and there is no great point in preaching to the converted.

What should have resulted in a superb affirmation of the nature of true mural painting ended by doing more harm than good to the public in general, and to the artists. A large number of the latter took their medicine so meekly that, after a little hesitation about the decency of exhibiting in Radio City, soon after the destruction of the mural, they came into a big show arranged there. Others refused to do so, though cajoled and even threatened by the representatives of the exhibition with blacklisting at museums. Among the goodly number of those who stayed out were John Sloan, quite characteristically, José Clemente Orozco, who put aside personal grievances against Rivera the man, in order to stand up for the artist, and Gaston Lachaise, whose withdrawal was especially significant because he had executed an important sculptural decoration on the building.

One good effect of the affair was the series of pictures of American history that Rivera painted for the New Workers School in New York, the one big fresco of his in that city. A "Hymn of Hate," one person described it, because of its excoriation of oppressors, whom the painter followed from the time when the Indians were robbed till today when—in his judgment—the same process continues with the mass of humanity, it does contain other phases of our story: splendid tributes to Jefferson, to Emerson and Thoreau, John Brown and Lincoln, besides the leaders of the proletariat. Mussolini and Hitler are shown in their baneful

[293]

rôle—which the passing of time has made only more horribly clear than Rivera showed it to be. But from the standpoint of art the lesson of the work is even stronger and surer. There are passages so learned and powerful as to make them for a long time ahead what they are already—a stimulating and salutary influence on the many artists and laymen, who come to study these walls.

XXVII.

GINO SEVERINI, ANDRÉ DERAIN, AMÉDÉE DE LA PATELLIÈRE

A COMPANION OF RIVERA'S DURING PARIS DAYS WAS GINO SEVERINI. Born at Cortona, in southern Tuscany, he was of a Latin country, and therefore nearer in culture to the French than a German or an American would be; even so there was, in his case as in that of his Mexican friend, something that kept him from being absolutely at home in Paris. The city is hospitable; everyone has a chance there; the French are pleased when the proper approach to their activities is made by foreigners, but few of the latter ever take root thoroughly. Severini, after some thirty years of residence, with a French wife, and a predominating influence of Paris on his painting, has returned to Italy and, to stay, I imagine.

My acquaintance with him began in 1911 or 1912, at the time of the Futurist exhibition in Paris. He was, to my thinking, the most talented member of the group, though Boccioni, who died in the war, had more of the dynamism of the new Italy, and I have met one man, anyhow, who preferred Carrà. But Severini knew more than the others about the great central tradition of modern art and, despite what I said of his persistent Italianism, he saw things pretty much like a Parisian, and profited by what he saw. At all events, there was none of the secret rancor against France that one often finds with Spaniards and Italians coming to Paris and not recognizing that the immense past of their countries

[295]

does not entitle them to authority over the present—which has different problems from those of the time of a Greco or a Raphael.

Futurism was, along the lines of art, an expression of Italy's demand for a place in the sun. Its manifesto spoke with admiration of what the later French masters were doing, but also with surprise at their persisting in what it called a static conception of the world and the picture. In reality the "movement" that the Futurists brought into their crudely drawn and barbarously colored pictures was only a carrying over into physical representation (and therefore into greater incongruity) of that free play of the image whereby the Cubists tried to give an equivalent for the functioning of thought. The effort of the Cubists was due to an extreme of theory and, healthy as that effort was at its time, the results of it could not correspond with the experience of more than a very small minority of people. The big men among the Cubists passed on to other forms of painting, derived from their earlier investigation, but tending to a more naturalistic convention.

Severini, staying on in Paris, took part in this evolution, and benefited by it in unmistakable fashion. His active mind had always found an outlet in writing, and in 1921 he published a book, *Du Cubisme au Classicisme*, with a subtitle "the aesthetics of the compass and of numbers." It is the most thorough study, the most able and personal recasting I know of what Jean Marchand calls the "quantitive side of painting." Such calculating has a history going back to the Egyptians, and including any number of the masters since then. Severini, with his clear intellect and his love for the great past of his native country, was well fitted to perform the service he has rendered in this and in other writing.

Still the good neighbor of the French painters (it was he who first took me to the studio of Dufy, next door to his own), he keeps on with his task of finding an agreement between the ancient and the modern, as, for example, in the enormous work

he has done in the decoration of churches. The traditional figures and symbols of religious art are handled with a modern inventiveness that takes away none of their dignity, while the mathematical basis of architecture is evidently an acceptable, natural thing for one who has gone through the discipline of Cubism.

When I have lectured on the art of our day, I have almost always found myself reserving for the last the lantern slides after the painting of André Derain. At more than one point in the history of the time he might have been mentioned first, for his conscious departure from naturalism in drawing and his strongly heightened color were among the chief factors in Post-Impressionism at the turn of this century, while the idea of Cubism came to Picasso and Braque from the research of Derain, as one may see in Apollinaire's book, if one has not to hand the first-hand testimony of the pictures.

It is difficult, then, to see the reason for Gertrude Stein's fling at Derain and his admirers when she speaks of their being able to appear "modern" in liking him, though he always carries along a safe smell of the museum. It would almost seem that she was siding with people who claim to see a basic difference, or even a contradiction, between modern and ancient art. Having fun with one of these, who had written in opposition to a book of mine on the subject, Bryson Burroughs once said, "He evidently thinks that at just four in the afternoon on Friday, the first of April, of such and such a year, art ceased to be ancient and started to be modern."

Derain certainly does not think so. The pleasure of a talk with him is the pleasure of refreshing one's sense of the continuing reality of the masters. It is a matter of his voice and his unassumed conviction in talking of his blessed Louvre, where you move about with him, now pausing before the Rubens masterpiece of the *Education of Marie de' Medici*, now seeing the same kind of painting in the *Judgment of Paris*, Derain's favorite among the

works of Watteau, or one of them anyhow, for in the next breath he will speak of the *Jupiter and Antiope*.

It is a very soft impeachment indeed to accuse him of carrying along something of the museums in his work. And I am sure he would not defend himself by saying that he had just shown Watteau, in the *Judgment of Paris*, making use of his *souvenirs de musée* (Cézanne's phrase for pictures of his own in which he used elements from his study of the classics). I think I have never heard Derain defend or attack in any discussion of art. Why should one? One enjoys certain pictures and therefore likes to recall them to the mind of one's friend; perhaps he can help, by his own enthusiasm, to clear up some final point. Derain will say, "You know, when I stand in front of Delacroix's *Massacre at Scio*, I think that's the greatest thing he ever did, but when I look at the *Women of Algiers*, I think it's that one."

Now there is a reasonable and profitable thing to talk about. Or as to that Watteau picture again, suppose someone hadn't noticed how modern is that figure of Venus receiving the apple; you could point out the fact to him, and demonstrate it by showing that it differs from a Rubens figure by the same live freshness of vision that distinguishes Jean Goujon's Diana from the Cellini nymph in the next room that was doubtless the later sculptor's source of inspiration. (It is I who am making up this latter argument; to tell the truth, I don't well remember what Derain said about the Watteau. Probably he just mentioned it and heaved a sigh of adoration from the depth of his huge frame.) I do recall, though, what he said of a show of the Byzantines: "They are the people who invented bad taste. It's the kind of thing you admire when you haven't seen it. Negro art was that way, too. We used to be mad about it until all those quantities of things arrived here. Then we knew better."

Or suppose, on the other hand, you should ever meet one of those people who don't like Delacroix and Watteau. There are

such people, but what is there to say to them? Wouldn't it be much better to sit down at the organ and play some music; so Derain does just that, or he opens a bottle of wine or he rolls a cigarette (the machine-made ones you get at the tobacconist's being squeezed so tight that they don't draw as well as a hand-made one).

Of course, you know, everybody has bad days in his life, and for a painter there are times when everything seems to go wrong. A great resource at such moments is to have some works of art around the house. Derain has got into financial straits often enough because a Corot or a Le Nain or a Gothic thing or a Greek thing cost more money than he had at the bank and he signed some paper or other so as to be able to buy the piece, after which he had to turn out a whole lot of work to pay off on that paper. And perhaps, after some excitation like that, and with the *gueule de bois* (which is French for Katzenjammer) you have, on waking up in the cold gray dampness of the morning after, life looks like a very stupid business, and neither the Louvre nor a furious auto drive, nor a motor-boat, nor the help of Bacchus, is of any avail. But he always swings out of these black moods and every year sees something, a number of things, that go beyond even the noble stuff he had done before.

It reaches back to his very beginnings. That time in 1914 when I was gathering the pictures for our shows in New York, Derain had been wounded and was in a hospital. His wife was, therefore, especially anxious to sell things, the dealers being out of funds (or off at the front), and she hauled out one picture after another as we tried to decide what might have success in America. On my exclaiming over the superb quality of a certain landscape, she said, "Why, that's of 1899! He was only nineteen when he did that," which was proof again that men are themselves from the beginning, and explanation again of the authority that Derain has had from his earliest years as an artist.

QUEER THING, PAINTING

My orders were to borrow things, not buy them for the shows, but, having a bit of money of my own, I did buy one picture. And outside of the pleasure I have had in seeing it on my walls ever since, I had the satisfaction of hearing Alice Derain's account of the visit she had been able to make to the hospital behind the lines. It wound up by her saying, "And now when he's well enough to get out, they're going to let him drive an ambulance, and I'm so glad. I never did rest easy with the thought of André in the trenches. He's so big, they wouldn't dig one deep enough for him; his head would always be sticking up over the top. I dreamt that."

One more of those bad dreams of the war came true, years after, when La Patellière died in 1932. I remember that the last time I saw Derain was at St. Germain des Prés when that other good painter, his friend and mine, was buried from the old church. His studio had been right near it, in the Rue Visconti; Derain had been just around the corner in the Rue Bonaparte; from Elie Faure's balcony one looked right across the Boulevard to the old square tower, and from its bells Delacroix had heard the last music of his life just as he was about to die in what was once a part of the ancient abbey of St. Germain.

La Patellière's life had dragged on like de La Fresnaye's, with operation following operation, as the doctors attempted in vain to clear his system of the effects of the wounds he received during those ghastly years. His physical disabilities, like those of de La Fresnaye again, did not prevent his going on in a steady advance. He was even gay in his talk, as when he told me the story of that most glorious Ingres picture in the museum at his home town of Nantes, and how it happens to be there.

It seems that there was a very naughty young Vicomte de Senonnes who had so distressed his family that they sent him to Rome to be rid of him. He was given a letter to Ingres, whose severe character, it was supposed, would be a help to him in keep-

ing to the straight and narrow path. But one time when the Vicomte came to the studio, Ingres was painting a very beautiful Italian model, and the young man, "in order not to unlearn his good habits," as La Patellière put it, made love to her at the first possible moment. This time, however, the affair came out differently from the other ones, for the girl married him. He took her home to Nantes, and also the portrait that Ingres did of her. And that is why you have to travel to the Breton city if you want to see the masterpiece, as you certainly do. It was in Paris in 1911 for a great show of Ingres's work that I had the luck to see.

I have never been to Nantes, as I greatly regret to say, for the picture I speak of is not the only one of its class in that place. I know this from the catalogue of an exhibition I saw some years ago in Paris of "Chefs d'Œuvre des Musées de Province." Nantes loaned, among other works, a marvelous portrait of Marie Mancini, the actress, by Mignard, a picture by that Georges de la Tour who has been the great rediscovery of recent years, two paintings by Tournières, another of those grand men of the seventeenth century whom we are coming to appreciate better, and an enchanting "Jeune Femme" by Donat Nonnotte. You never heard of the artist? No more had I till I saw this picture; he is not represented in the Louvre. But even that unimaginable place cannot cover the whole of French art, any more than Paris is the whole of France. The other Nonnotte in the show came from Orléans; the catalogue says he was born at Besançon and died at Lyon.

La Province! The word is dear to Frenchmen, in the way that a kindly home town is dear to people in our country, too, even if the town does not contain a museum with good pictures, which some of our smaller cities are now getting. In France you simply have to see the provinces; I know a little of them, but it takes a lifetime to know them all. In any event, that museum of Nantes had so formed the mind of La Patellière that when he entered the

Julian Academy in Paris, only a short time before the war, he
could not be misled by the bad teaching at the famous school,
but stuck to the masters he had learned to know at home and
whom he found in dazzling profusion at the Louvre—just across
the river from the studio in which I knew him.

And so when he got back to work after the years of his mili-
tary service and the long period of his first convalescence, he was
ready to paint good pictures. My acquaintance with them began
when I noticed a small gray canvas signed with his name, at the
Luxembourg. After various inquiries, I discovered a little shop
where his pictures were on sale. The dealer told me how, one day,
a gentleman came into the gallery and, after looking about, se-
lected a modest work, and said, "I'll buy that." Laying a visiting-
card on the table, he added, "Please send the picture to the
Luxembourg." Not knowing what the request might mean, M.
Bernier, the dealer, glanced down at the card. On the bit of
bristol he read Edouard Herriot—who was the Premier of France.

La Patellière was, however, almost unknown when he died
(a picture in the Luxembourg does not count for as much as many
people think). Villon could not recall him when I would mention
his name, but I had the satisfaction of getting a letter from Villon
—a good judge, as well as good artist—when a retrospective show
of La Patellière's work was held. And my friend, who is also
completely frank when he differs with anyone on art matters,
said I was right, that La Patellière really did represent a return
of great painting, after the dearth of it we saw in the post-war
period. Villon's words gave me the same pleasure I had when
I heard his opinion of Rivera's work at the time of the French
painter's trip to New York. I had spoken of another artist and
had said that some people thought him the bigger man of the
two. Villon answered without hesitation: "Non; X. est très bien,
mais ce Rivera m'a secoué les tripes!" I hate to quote some-
thing in another language, but that last phrase is more than I can

render adequately. It means that the painting of the Mexican had stirred him tremendously.

Taking leave of France, as far as this book is concerned, with the work of La Patellière, a man who is no longer among us, I have no sense of writing mainly, of the dead. I know that is the fact, so many of the men I discuss having gone over the mountain, as the Japanese put it. But the work is there and it goes on: there are men to carry it along once more. In an article I wrote on that retrospective show of my friend's, I quoted a thing he once said to me, "On entering the Louvre, I see in the work of Titian and Rubens and Rembrandt the confirmation of what I am seeking in my own pictures." Does that sound too self-confident? Not to me. All the big men have known what their work was; above all they have known that there is one great tradition, whatever place in the line of it their individual effort had reached. My experience in France sums up with the statement that the tradition is still yielding splendid results.

XXVIII.

WILLIAM R. VALENTINER, GISELA M. A. RICHTER, BRYSON BURROUGHS

———

THE PROBLEM IN OUR COUNTRY IS, AS IN OTHER COUNTRIES, THE double one of holding to tradition and of adding to it. But to hold to it we have got to know it, or feel it, and our opportunities for that have been limited. In a frontier cabin there would probably be a Bible, with the works of Shakespeare soon to follow, when a town of any size had grown up. So that there was, from the very first, the material for an understanding of literature here, and Van Wyck Brooks, in *The Flowering of New England*, has shown how important our scholars, critics, and creative writers of the early nineteenth century were, even when compared to the best in Europe. This was, in part, due to their inherited instinct, their native talent, but also to their having been able to know the masters of literature.

For the fine arts there was no parallel for this anywhere in America until a comparatively late date, and even now there are vast stretches of the country where no good picture is possible to see. There are reproductions in books, to be sure, and they have kindled the imagination of many a person, but that is almost the maximum one can hope for from them. Original works are needed, and they cannot be imagined by persons without experience of such things, even though the expert can judge so much from a photograph.

VALENTINER, MISS RICHTER, BURROUGHS

The hope of the country is still very largely in the museums. Just today I was looking at the work of a most accomplished young painter, a man of immense native ability, vigor, and honesty, but I doubt that he will ever do much of lasting value, because he seems to know next to nothing of the purposes of his craft. When one finds such a case in Europe, the reason lies in the bad judgment of the artist or in the school where he was trained, not in the lack of opportunity to know art, for there is some of it nearly everywhere. As Dufy once observed to me, when you have seen the little museum at Aix-en-Provence, not to speak of the churches there, you understand why Cézanne, isolated as to human contacts in his city, could go on so steadily during his long sojourns there.

Looking now at art conditions in this country and the men who are building our future, it seems to me that the most important among them is, very decidedly, William R. Valentiner. I can hear murmurs of protest as soon as those words leave my mouth— I can even hear a strong tone of indignation. He makes mistakes, I am told; he makes snap judgments; he is a European by birth. How can he be a first-rate director for an American museum? The man who asks that question is really not worth bothering about, and the answer to the other people is as clear as daylight when one adds up Dr. Valentiner's positive achievement, to compare it with the record of things he has missed on.

Plenty of men avoid making mistakes—minor ones; but often they do so at the price of being what the Spaniards call zeros to the left. Put a zero to the right of a figure one, and it becomes ten; put a zero to the right of that and you have a hundred; but put a dozen zeros to the left of a figure and it remains just as small as it was before. Without wanting to labor the point or use too grand a word about our friend, I do want to pay my disrespects a bit more to nonentities who try to hide their empty records—from themselves or from others—by criticizing men who

really do things. Elie Faure used a good phrase about such people when he said, "They spend their time watching for fleas on the lion's mane."

Dr. Valentiner's work at the Detroit Museum includes activity in providing a reservoir for developing the institution in the future, through the private collections of the city. All told, his has been one of the great achievements in this field. In less than twenty years he has changed things in Detroit from small, meaningless fragments (and those of a merely local importance, as a rule) to make them yield a vision of a surprisingly wide range of the world's art, and to represent it by adequate, often brilliant, examples. His early career as an assistant to Dr. Bode, when that genius was building up the museums of Germany, prepared him for dealing with problems of the older schools, but Detroit wanted more than that, as I have found out myself on visits there. And Dr. Valentiner was able to respond enthusiastically to a demand for guidance along the lines of modern art, because he had developed a very vital interest in it himself.

That was something that few, perhaps, suspected when he began his career in America as a member of the staff of the Metropolitan Museum. Yet some did—those who got to know him personally around 1909, the year in which he arranged the Dutch section of the Hudson-Fulton Exhibition. Composed of works by Rembrandt, Hals, Vermeer and others as universally accepted, the success of the showing might seem, great as it was, to have been necessarily restricted to matters of the past. But that reasoning involves the old error of seeing ancient things merely as an index to bygone periods: they are quite as important as an expression of our own period, for, as Egisto Fabbri pointed out, the fundamental ideas of mankind do not change, and a thing that has rendered them deeply enough at one time will continue to do so at all times. And so those Dutch classics, presented by a man with

a sense of the movement that is essential in the modern period, became the livest kind of thing once more.

Dr. Valentiner continues with such a program in Detroit. To be sure, a liking for the big names of art, characteristic of a period not yet ready to go beyond reputations, not ready to appreciate what they should be built on, keeps demanding that he suddenly bring forth great masters, every so often, and sometimes the names are open to debate. But as Bryson Burroughs remarked about such an acquisition at the museum in New York, "Even if we have to give up the name, we've got the picture." The main point is that it be a good one—though of course the name has its effect on the price paid. There is, for example, a work at Detroit catalogued as Louis David. I could not see that master in it and wrote to Dr. Valentiner that it might be David's pupil, Gros—a very great painter in his own right. The reply came back, "It's quite possible; I'm willing; I had to give it some name; when I bought the picture in Paris it was called Goya, but that was certainly wrong."

It is tempting to go on to memories of other conversations, during the course of the last thirty years, of jolly dinners where one topic jostled another to get a moment of discussion before the pace of the talk swept by something else; or perhaps we meet for a brief exchange of news in the anteroom of a dealer who has brought over an important work; or one time it was at the *Conservation* of the Louvre, where Dr. Valentiner was going on with his monumental work of cataloguing the drawings of Rembrandt and his school, which means, above all, deciding that thorny question as to which are Rembrandt and which are school.

The thrillingly live nature of such a work is stressed in my mind through a remark made by Dr. Wendland, another German museum man, as we chatted for a moment before the drawings in that delightful room which the Metropolitan reserves for them. "This is better drawing than that," said Dr. Wendland, pointing

first to a Rembrandt and then to an Ingres. He did not say that the former was a better drawing, which might have meant a more valuable example than the other; he said, "better drawing," which means a greater conception of the art, and is a tall claim when Ingres is the other man involved, but I am willing to put in my own opinion here and say I agree.

I started to resist temptations to isolated anecdote, and then gave in and told one more (it happens to concern a subject that I think supremely important, however). What I am really trying to do in these pages is to balance the account, in the early part of this book, of the America I saw in my boyhood and youth with a viewing of conditions today, particularly in the field of painting, the appreciation of it and the significant practitioners of it.

Perhaps, in considering this subject, I give too much importance to the matter of museums, but I do not think so. It's not that I have—quite literally—no recollections dating back farther than those of the Metropolitan Museum, my father having worked there, from time to time, beginning with its earliest days. Even this sentimental tie does not cause me to suspect prejudice in myself as to the institution's share in the life of the country. It is the greatest single force in determining the direction of art here.

Therefore, after the publication of my *Ananias*, I was glad when I heard that Dr. Robinson, the head of the Metropolitan, had seen the book in the way I had hoped for. One of the trustees had come sizzling into the office with the words, "What do you intend to do about this attack on the museum?" to which the director replied, "I shall do nothing unless you can show me that Mr. Pach really has attacked the museum. He dislikes certain things here, so do I, and so do you. Mr. Pach is a friend of the museum's, and he has a perfect right to say what he disapproves in it."

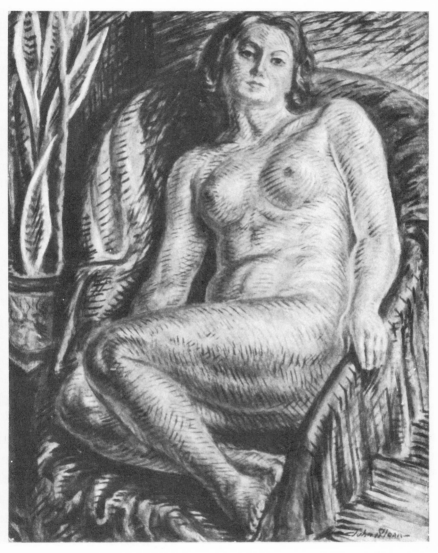

BLONDE ON CRIMSON CHAIR *Painting by John Sloan, 1933*

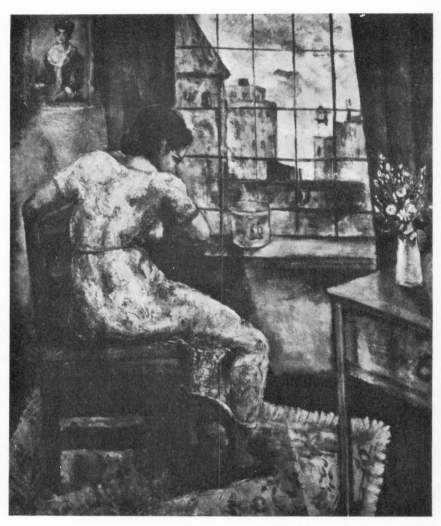

GIRL AT A WINDOW *By A. S. Baylinson, 1934*
 The Metropolitan Museum of Art

Other officials take the position that criticism, to be valid, must come from within an institution of the kind. But aside from the fact that those who go there for information and enjoyment may well point out needs which it has not yet met or even considered, the pressure of outside opinion is at times on the side of people within the walls, who need help from the public to bring about measures of genuine progress that were obstructed by persons more influential than themselves. Encouraging free expression about the museum's work is therefore the democratic way of proceeding. It was Dr. Robinson's, and I think no one ever considered him lacking in firmness when it came to deciding or following out a policy that had been discussed and adopted. Certainly his work in building up his own department, that of classical art, showed the fullest consistency and conviction.

The wonderful group of Greek, Etruscan, and Roman works at the museum has been carried to always higher levels by the present curator of the department, Miss Gisela M. A. Richter, and nowhere in the museum does one feel more strongly the life there is to art than in these galleries—precisely because mumbled distortions of the message of the classics have been heard so much more than the clear voice of the ancient genius—which reaches us through the inspiring tone of these collections. Doubtless it takes a while for the average visitor to feel the differences among ancient works, but once he does, he will go through our gallery in New York with a continually heightened sense that every object there is in place, and increases the effect of the whole.

And sometimes one goes through with a visitor who is not average. I think I shall always remember the time when I pointed out a certain small vase to Frieda Rivera, the wife of Diego Rivera. She was not learned about Greek things, but the way her eyes devoured every element in that little masterpiece—its noble form, the whirling stripes of decoration on its flanks, and

the hair's-breadth nicety of the tiny figures decorating its rim—told of the rightness of this art, since a painter of so distant a tradition as that of her native Mexico, and a modern with only her admirable instinct to guide her, could apprehend the quality of the new-found work, and instantly get the joy of it.

But it is one thing to respond so to a piece set in a conspicuous place by itself in a great museum, it is quite a different thing to make choice after choice with felicitous results, when a thousand inferior or undesirable objects surround the one which should be bought, and do their utmost to confuse judgment upon it. How has Miss Richter arrived at such certainty of decision as she displays? I think she gave the answer, without imagining for a moment that she was doing so, during a conversation in which I happened to share.

Someone was talking of the action of an archeologist of international reputation, and said, "How could he ever have done such a thing?" It was not against any law, it could not, indeed, have seemed reprehensible to certain important persons who would, otherwise, have rebuked him, but it was not the fine thing to do. "I think he did not feel that, and act differently," said Miss Richter, "because he does not come of a family of scholars."

Perhaps no one present, including herself especially, thought of what the words told about her own early surroundings. The remark was made with such an air of saying a thing quite obvious—once it was mentioned—that I also did not immediately think of the background of Miss Richter's studies. I do not know at all fully about the various members of her family who have followed the arts, but it is many years since I began to follow the achievements of her father, Dr. Jean Paul Richter. When, in a year or two, the world will receive the fruit of his enormous labor in making Leonardo da Vinci accessible to us, it will also understand more about the atmosphere of scholarship which prepared our curator for her own work.

VALENTINER, MISS RICHTER, BURROUGHS

I once spoke of it to Bryson Burroughs, and said I wished the department of paintings could decide things on the criterion of merit alone, as is done with Greek art. Of course I knew that I was talking of an impossibility; but one may always propose an ideal, even if it cannot be followed in a consistent way. Mr. Burroughs recalled Delacroix' words about people's self-restraint in pronouncing on most arts because they know that, for those, real study must precede judgment, and then he quoted the concluding sentence of the artist, "But, of course, painting is a thing that everybody understands."

The idea denounced by that sarcasm is no less generally held today than it was in the time of Delacroix, and it is one of the reasons why the case of the department of paintings and that of the classical works cannot be compared. But Mr. Burroughs went on to point out the difference between things that have had many centuries to reach their true appraisal and those of modern times, when opinion goes one way now, and a quite opposed way twenty years later. How could I speak of anybody's applying the criterion of merit before a long, long time had passed?

"Well, Mr. Havemeyer did it," I replied. "In many cases, he and Mrs. Havemeyer bought things right out of the artists' studios. And look from the modern stuff here at the museum to what he has. Most of our collection represents the modern decadence [this was a good many years ago, and the reader must refer back to my early pages on the museum of those days], while his collection represents the modern genius."

"You forget that he did what he did in his own house."

"All right, but this is my own house, and I don't see why I can't have pictures in it just as good as his."

"Oh yes, Walter, but it happens to be the house of some other people, too."

His whole life as a curator was passed with that principle—essentially the right one—before his eyes, as if carved in the wall.

There was always a possible give-and-take aspect to it, and that gave him hope that if he gave in on ten, twenty, or thirty decisions, the other people would give in the next time, on a point that *he* especially believed in. Thus there was the case of an *Odalisque* by Ingres which he coveted for the museum. He proposed it, but he was told that it could not be bought without the committee seeing it. The picture was in Paris and it was known that the owner would not send it over on approval, which was very unfortunate, to be sure. However, Mr. Burroughs did not give up, but arranged with Henry Walters for that collector to buy the picture for his gallery if the Metropolitan did not, and so the *Odalisque* came to New York.

Happening in at his office on the day when the lovely lady was to be voted on, I took part in the fun of setting a little stage on which her perfections were to make their full effect. We borrowed some velvets from the Renaissance department, to serve as a background; we studied the best lighting, and the right distance at which to arrange chairs in front of our treasure. I said, "They can't refuse it." Mr. Burroughs was equally optimistic, his conviction overflowing in words of an unwonted gravity. "There is only one gospel, there is only one truth, there is only one Ingres!" I managed to come back the next day to give and receive a handshake on the acquisition over which he had worked for so long a time.

"Well, we got it!" I said.

"No, Walter, Baltimore gets it."

"They refused that Ingres? They couldn't! But why?"

"Because, as they told me, it isn't well drawn."

To understand what the words meant to him, it is not enough to think of the career of Ingres—eighty-seven years of such single-minded striving as is hardly to be found in another case; it is necessary to know the career of Burroughs, going to Paris as a young man and studying in an art school where Ingres was revered

as the greatest master of drawing that France has produced. And
our curator never departed from that idea—no, not even when
the super-experts of drawing had made their pronouncement.

Of course, he could have done what his immediate predeces-
sor, Roger Fry, had done—which is to say, resign. But simply to
have gone back to painting (or rather to give all his time to it—
for his mornings had been his own and he had continued his
personal work steadily), would have meant turning his back on
precious opportunities to serve the great institution, and some-
times they resulted in success. Among the most notable of his
achievements was his building up the museum's large and beauti-
ful group of works by Thomas Eakins—something Mr. Burroughs
began while the painter was still alive and could see his first solid
step toward success; the other artist's conviction about him went
on and grew stronger till the last year of his own life, when he
acquired the masterpiece of Max Schmitt in the scull. By then
the rest of the country had learned to know the greatness of
Eakins, but in the early time, Mr. Burroughs and his museum
stood alone in their defense of the "academic" man.

The gentle triumph of our friend's long effort was a peculiarly
appropriate one. Never a man to indulge in the foolishly easy
theory that the under dog is always the best one, he did have a
settled distrust of current fashions in art, "the thing that the
Park Avenue crowd goes in for," and he kept on the watch for
talent in the byways of the art world.

His position gave him opportunities, also, to do another kind
of defense work, as one afternoon, when I saw two very grand
ladies in his office, intent on getting the museum to accept a big
canvas by a very bad painter to whom they were devoted. A gift
is a greater danger than a purchase, for the latter can go into
the discard, once people are convinced of its worthlessness, but
donors have long memories—and long powerful arms, most often
—so that they are apt to make sure that no disrespect is shown

to the reputation of their artist, or to their own generosity. Among the debts of gratitude we owe to Mr. Burroughs is one for the adroit diplomacy through which he kept our walls clear of the enormous "ham" I saw that day; and the case is typical of endless others.

During the quarter-century of his stewardship at the Metropolitan, a large number of great acquisitions were made and, collectively, they form an anonymous monument to him. None among them is more remarkable than the pictures from the Hermitage. When it became apparent that the Soviets would sell from their national museums, Mr. Burroughs showed himself to have the vision proper for one in his post by saying that it was a moment for determined action: works brought together by Peter the Great, Catherine the Great and other tsars, were going to leave Russia anyhow, and the right place for them was in public galleries, and not the private hands into which a number have gone. He wrote me that he believed the opportunity justified so bold a measure as buying out of the museum's capital, not merely its income. The result of his enthusiasm was our getting our first Watteau (still our only one), and these two miraculous little panels by van Eyck. While Mr. Burroughs' instinct and training took him above all to the schools of the classical lands, his culture made him fervently interested in the masters of the north. After his visit to Prince Trivulzio's collection in Milan, he told me, with breathless wonder over the illuminations preserved there, that he thought he had discovered Hubert van Eyck, the half-legendary brother, whom various critics give up entirely.

It is to be hoped that his studies on this subject are in the form of full and publishable material. Not only will it be valuable in itself, but it will give his friends another insight into the compensations afforded by a position that was frequently a difficult one. To be sure there is his own painting to which he was able to devote himself, and in a period when artists can so rarely live

by their work, it was something—and no small thing—that he got so much time for the occupation he loved so well. In many a thing of his—frescoes like those at the Century Club as well as easel pictures—there are qualities which must have rewarded him with very great satisfaction.

But the hours he gave to painting were not at the expense of the museum. I am sure, on the contrary, that the institution was a very real gainer by his outside work, not alone because his technical practice helped to keep his eye fresh for the decisions on genuineness and periods, which he had to make with great frequency, but because the chance to paint was a day-by-day reminder that the great object of his study at the museum was the creative faculty.

To be sure, the search for that could not be pursued at every moment. There was routine work, there were problems of adjustment with other members of the staff and with the trustees. The late William Sloane Coffin, who was one of the most admirable presidents of the Metropolitan, once told me of a question he put to a member of the staff there, "Do you think that a trustee has any use except to find money for your purchases?" He had his own answer to the question: that the trustees are typical of the public, and so give to the experts already to hand opportunity of knowing how the people of the city and even of the whole country feel about the art offered for their enjoyment. Collectors themselves, very frequently, they represent an upper level of popular taste, though in some cases, conscious both of their wealth and of the number of people with ideas like their own, they do typify the bad side of democratic rule, its tendency toward the average thing instead of the great thing, its refusal to trust the man who devotes his life to the special subject and who says that the average thing goes dead, in time, while the great thing continually grows as a vital force.

It is not interest in the museum that is lacking with the diffi-

cult trustees (as a friend of mine remarked, these bankers, law-yers, and the rest give to the institution hours that money could not buy); what they need is knowledge of art—to fall back on that word once more, and this time I will answer people who say I must know all about it since I keep demanding that others do. But I do not claim such knowledge for myself, nor expect it of other people. All one can ask is that men keep on seeking; also that, recognizing the fact that they do not know certain things, judgment on these must be left to those who have given them the best study.

What I most admired in Mr. Burroughs was not his patience with arrogant people or even with dishonest people, such as dealers who tried to impose on him with stuff they knew they were misrepresenting. (Once, at least, it was only at the last moment that his instinct told him that a certain picture was a forgery.) The finest thing about him, in my opinion, was the way he re-tained faith in his museum work when he found so little of the quality among the artists.

Even if they could enjoy the masters, the constant effort of too many of them was to get more space in the institution for themselves, and room after room was given to them on the ground of "Americanism." One picture after another was acquired, not on the basis of merit (save as compared with other works of the kind), but to help in the development of American art. It was the difficult task of Mr. Burroughs to keep such a balance as he could between the two points of view, and he performed it in the conscientious manner he had for all his work.

It may be asked whether I mean to disapprove the purchase of American works for our museums. Certainly I do not, but I maintain that the galleries should apply the same standards to American artists as to others—and for the benefit of the artists, primarily. Already one hears words of discouragement and protest from our people, professional and laymen, about the showing we

make at the museum, and these feelings will increase the more our acquisitions are based on ideas of patriotism or of relief for the needy. The government is doing immense things for art; it is keeping numbers of valuable men alive, and is getting in return a quantity of material for which there is use and need. The help that the museum can render is that of making Americans realize how thoroughly their art can stand on its merits. But it can do so only if it is acquired with the same care for quality that gave us our French pictures, for example. The confidence engendered by the sight of galleries of really good American art will be worth immeasurably more than all the material help the museum may afford if it purchases American work on other than artistic grounds, or if it stimulates such purchase by the public.

This is one of the many questions on which museum officials should be left free of outside influence. Far more than half a century of hard thinking has gone into the development, in America, of ideas as to what the country's museums should do. Only a man like Henry W. Kent, the Nestor of his calling, knows what has been accomplished through the vision of his associates—the men of large affairs and the specialists of the arts—in whose activity he has had so important a share. Whole new fields of usefulness: in education, in industrial matters, and in public service generally, have been opened up. Questions like these must be dealt with by persons who keep themselves abreast of the rapid changes in the various fields.

The depression, enlisting government support for artists on the basis of their need and of the country's need for them, may turn out to be a landmark in the history of our art. Already we can see it as a healthier thing than the feverish boom time that preceded it. Braque and Dufy are two of the men abroad who told me that they were glad that the wild buying of the pre-depression time had ceased. Years before the crash, Marcel Duchamp, with his usual sensitiveness, had inveighed against the

"prosperity" of the artists. He compared their output to the money that was being printed and to the issues of stocks. "They are bad issues, if not yet like the inflation we saw in Germany; and the pictures men are painting just keep pace with the currency and the securities."

Not only was the picture-market flooded with hasty or even bad work (often by men who had shown themselves capable of better things) but pictures for which there was no market followed the lines of the work already a success. No wonder that people got to looking for sincerity among the men of no schooling at all, the "primitives" (a bad title for them, since both the primitives of the early Renaissance and those of the barbarous races are the most skillful and finest artists of their times and countries). No wonder that the interpretation of modern art should be extended in all directions: to industrial production with its clean surfaces and definite forms, to painting in which scientific research into the subconscious is the one element of interest, and to the fantasy products of abnormal persons.

All of these things have some relation to phases of the great arts. But to isolate a phase and try to make it stand up as a whole art is to indulge in such bad logic, like writing unconnected words and calling them literature because Shakespeare, for example, employs nonsense rhymes to give special effects in passages where the thought demands such sensuous relief. He would not be Shakespeare if his whole work, or even a single play by him, or a single sonnet were that. And without comparing Picasso and Shakespeare, we may recall the painter's insistence that his pictures are always a faithful rendering of nature—which he respects too much to offer imitations of it, as the counterfeiter produces his valueless or even harmful coins and bills.

Probably Elie Faure was right when he said that the example of Picasso had been the most dangerous one for artists cut off from their age-old support from the mass of humanity. In Russia,

a wild attempt is being made to reëstablish the connection, by making the artist a part of the governmental apparatus for propaganda. In America, a very similar type of painting is produced by men who think to approach directly the untutored workmen and farmers by making pictures of objects easily recognizable by the latter groups, or of scenes from local history and occupations. Only the subjects count in such work: they are supposed to do duty for idea, for construction, harmony, and the other classic qualities.

From this pseudo-popular art, the disoriented section of our period turns to another kind of collecting which is scarcely preferable. There have always been people absorbed in the past, and we know what magnificent things they have sometimes brought together. But the work of the masters and even the near masters has been exhausted, to a great extent, by the museums—the old ones and the great number of new ones. And so the dealers were hard put to it to supply the demand for ancient works, especially with the increasing rôle of art objects as a form of investment or speculation. Quantities of old things of no merit, or even new things, were doctored up and sold over the names of great artists. To do this, since the buyers had no judgment, certificates of authenticity accompanied the objects. I mentioned to a dealer one of the writers on art who furnishes such papers and was told, "Oh yes, I know him; he's a two-cigar man." On my asking what that meant, he said, "Such experts are divided into two classes: those that you can buy with one cigar, and those that you can buy with two cigars."

XXIX.

LATTER-DAY AMERICA, KENNETH HAYES MILLER, A. S. BAYLINSON

I HAVE DESCENDED INTO VARIOUS OF THE SWAMPS OF PRESENT-DAY phenomena—modern and ancient (if I may temporarily apply those words to production that is almost outside the purview of art). I dislike seeing such work, for it can make one forget the great things of which it is a travesty, and so I dislike to talk about it. But it is so considerable an element in the present time that I could not pass it over in silence. And then it is almost necessary as a means of understanding certain other things to which I may now address myself.

They are at a far remove from the *epigoner* of the academies (the men attempting to do in one time the work that owes its vitality to the ideas of a different time); they are equally far from the commercialists of all kinds, and from the decadents. These Neo-Realists (to coin a word for them), seek to go on with the work of the masters through an understanding of the drawing, color, and composition of the great schools, but apply the qualities to a present-day vision of things. Derain has done this with an immense and creative freedom; La Patellière was following the same line in his own way; Rivera may be counted as one of the group that extends to every country (I have seen interesting Swiss painting of the kind, though I know of no first-rate man in the Swiss school as yet); John Sloan, digging always deeper into the

principles of form and color while holding so firmly to his old love of the world and its people, is another whose solid achievement is a sign of hope; and there is a mass of less definitive work in Europe and America to tell that there is health in us.

One phase of the renewal is a heightened interest in the materials and methods of the masters. Just as the use of drawing and color by the men I speak of differs from that of academic naturalism in terms of vitality, so the new inquiry into technical processes has next to nothing in common with the idea of fresco, tempera, glazes, etc., among the men who treated them as a fetish, unconnected with nature and vision. When taken as a means of dealing with experience, they are another matter entirely.

A man who exemplifies the older attitude has always given attention, among other things, to the setting of colors on the palette. It can be quite a fascinating business. Delacroix, whose complicated palettes are preserved for us, made a veritable ceremony of laying out his colors in sequences and combinations. He writes of his excitement over his colors. But he also used them. The gentleman I have in mind does not: the setting of the palette is an end in itself for him!

Not so Kenneth Hayes Miller. He was a teacher at the art school where I was a student, and in those days he was just becoming aware that the direct painting generally used in the later nineteenth century was not the thing for him. He investigated by his own experimenting the older processes of the craft, and the instruction he gave over a period of thirty-five years was increasingly directed to the development of a logical method of work. With many of his pupils all that survives is the method, but then one may not blame a teacher if his pupils happen to be devoid of the mental resources that would give them something to say in the language they have learned.

Admiring most of Mr. Miller's work, I do not feel embarrassment in saying that some things of his seem to me more like

language practice than like the uttering of a thought, an emotion, a conviction. But even here it is easy to go astray. That research work which is going on in studios all over the world (and Matisse remarked at a recent exhibition that the technical side of the young men's painting is better than that of his contemporaries in their early days), is a most valuable part of the renaissance of our time. And just as Thomas Eakins was only "the teacher" to many who did not see the great power of the man—a genius, William Glackens called him—so it is easy to overlook the rôle of personality and of live tradition in the work of Mr. Miller.

I asked him about the portrait he did of Albert P. Ryder, a quarter of a century ago, the one reproduced in this book. He said that what he had tried to render was the grandeur of the old artist's character. He has gone immeasurably beyond the quality of painting in that early work, but the concern with life and truth which was the basic thing in the picture still provides him with his starting-point today. Much frequenting of museums has created impressions in him too powerful to permit any notion that life and truth can be carried on without knowledge. "In his whole career, a genius could not, by his own effort alone, learn to foreshorten a human foot," he once said. That is part—a tiny part—of the knowledge that innumerable workers have heaped up for us. In its totality it forms what Mr. Miller lovingly refers to as "our beautiful art of painting," and that is what he talks of, dreams of, and produces.

It is not, by any means, a mere matter of the processes he has studied so carefully. Beyond that goes his long meditated penetration into the great problem of design. For some people the word brings up the idea of a flat surface, like that of textiles; Mr. Miller's conception of it is so far from the two dimensional thing that he often thinks of his work as sculpture with color. And that applies not alone to the single head or figure but to works like the recent one having the deep spaces and varied lights

of a department store interior, or another with groups of skaters in a landscape.

To many a person it will for a long time seem over-severe, as Poussin still does to those who do not know him well. How can Mr. Miller's admiration for that master be reconciled with his caring so much for Rubens? The two names were for a long time offered as typifying mutually destructive forces—but it was the theorists who made the two masters so oppose each other. That was not the idea of Delacroix—"the greatest of modern painters," according to Mr. Miller, nor the idea of Renoir, another favorite of the American artist. I refer back to those words I quote on an earlier page where Renoir tells of the years he needed before he could really appreciate Poussin. One reason why we love the man who seems, superficially, to go no further than brilliant representation of youth, light, and feminine charm, is that the "Impressionist" was willing to give the time he speaks of to the Louvre, and to the order and design which he came to see in his glorious ancestor of the seventeenth century.

Not all the studios that make up our strength today are the scene of such hard thinking as Kenneth Hayes Miller has devoted to his work. Thoughtful people are valuable, but those who let instinct be their guide may also do fine work. (It goes without saying that, just as no artist is purely classical or purely romantic, the two qualities of intellect and instinct must both be present, to one degree or another, in every valid work.)

Among studios where I go, one that I always enter with pleasure is that of A. S. Baylinson. He is a worker, and every week sees him hammering away at the vigorous canvases that decorate his walls. "Hammering" is pretty nearly the right word, for his work seems wrought out of some tough metal that calls forth all the manly strength of his art. The paintings are almost always based on drawings, and so, "modern" as they are, they carry on the old tradition of preparatory studies. Not that he is thinking

of the painting ahead of him when he makes the beautiful things that result when his swift pencil runs over the paper, and modeling with red and black chalk follows. He has a girl in front of him, he draws her; memories of the masters, ancient but above all modern, are somewhere in the back of his mind (a long way in the back) ; another work is born.

A former studio of his was destroyed by a fire which cost him the whole of his early work, save the few things he had sold at the time. That was only a new reason for him to go on, and harder than ever. John Sloan once said, "I am not so much interested in the man who is paid to paint as I am in the man who pays to paint."

Baylinson is such a man, and around him have always been a number of others. A pupil of Robert Henri, that artist's class had successors in various forms for some thirty years, with teaching dropped out, until it is now "Bayli's night bunch," a group of workers who come together twice a week to keep up drawing from the model. During the day they may be practicing artists with their own studios, like George Constant, to single out— perhaps unfairly to others—a man of beautiful talent; or they may be working in an architect's drafting-office, or in a lithograph plant, or some such place. Two canvases by members of the "bunch" were bought by the Metropolitan some months previous to the present writing, and they are among the good acquisitions there.

That last statement represents my own opinion, evidently, but I have material to confirm it. Thus, there were the words of a French lady of great distinction and judgment who came to this country with an official mission some years ago. She and her party were shown all sorts of institutions—universities, factories, etc.— and they had a conference with Mr. Coolidge, who was then President. Naturally her journey included visits to our museums, where she looked particularly at the work of American artists,

since they were largely unknown in France. I asked her to save time for an evening visit to Baylinson's studio, where she saw the work of men among whom most were earning their living during the day, at whatever came handy. Only a few were full-time professionals, but the lady—who has on her walls in Paris veritable masterpieces by men from Corot down to the younger artists of today—declared that that studio gave her more of an insight into American idealism than anything else she had seen while in this country.

I am sure that the words would have been echoed by Max von Recklinghausen, who often used to come there. He was a scientist, whom George Westinghouse brought to this country to carry on research work at the great plant. A German nobleman of profound culture, one who knew classical literature thoroughly, he was deep in the most abstruse mathematics, had ideas of engineering as applied to economics, and could talk music on almost equal terms with Kurt Schindler, that well-beloved leader of the Schola Cantorum, who later went to Spain to continue his studies of the folk-music that no other country can rival.

Of all Recklinghausen's interests, the greatest was painting. He had had friendships with artists in Munich and Paris, and once he was comparing their condition with that of the men here, exemplified by Baylinson and Morris Kantor, the two whose pictures I referred to as bought by the museum this season. No one could have dreamed of such a thing then, for the two young artists were employed at the hardest kind of labor to keep alive—and to have nights, Sundays, and holidays for painting.

"In Berlin, in Paris—anywhere in the old country—those men would be a success. They would live by their work, badly of course, at first, but they wouldn't starve. In this rich country that's just what they would do. And the worst of it is that I can't see any hope for them in the future."

One of our old crowd, George McKay, had actually died of

starvation. With his big muscles, he had always been able to pull through, previously, by work at blacksmithing, a trade he had learned thoroughly in his native Scotland. He would save up money to paint for a year or two, and he did it admirably; I have a couple of sketches I got from him, and they are eloquent of the fine talent that was lost when he died. Apparently he could not find work, the last time, as promptly as on other occasions, and on the first day when he did land a job he just managed to get back to his room after his hours of heavy effort. There he collapsed from exhaustion, not having had any food for some days, according to the statement of the doctor called in—too late—by the landlady. I suppose he was too proud to let us help him, as we should so gladly have done.

The same thing would have happened to any of the "bunch" who tried to live by painting, but Baylinson and Kantor were finally taken out of their wasteful day jobs by the subsidies of kindly people of means who had come to realize the talent of the two men; both of them are now teaching at the largest art school in New York.

In my opening pages I said I had no pity for artists as long as they can go on with their work. I come back to the idea here at the end. Suppose they don't have much money: wouldn't it be impertinence, in the real sense of the word—which means irrelevance, to mention such a thing in telling of their work? In a given case it's Uncle Sam that pays the expense; well, let him. Where do he and his nephews and his nieces get so much for their money as they do here? Many of them are realizing that their new investment is the best they could make; their descendants certainly will, and will be the more proud of their country.

Lately we have had exhibitions to celebrate the two-hundredth anniversary of the birth of John Singleton Copley, and we have been able to see how magnificently he compares with the masters of the English School at its best—as it was in his day. Fulton and

Morse, who follow him in time, are not important for their great inventions alone, they are admirable artists. Vanderlyn produced some superb work, though discouraged by the lack here of appreciation for it. Eakins and Ryder did things to place with the important art of their century. Prendergast's quality, as I have said, stands with that of the great Frenchmen of his generation. Glackens and Sloan, Miller and Baylinson carry on the story again—and I have not even glanced at numbers of others, famous or little known. We have lots of them, and there are more, maybe better ones, on their way: men who have given and will give to the American School a quality that our people will be proud of, and for long.

But that is not what those artists had in mind. They wanted to paint, they had to. Evenings when alone and thinking things over, or on a walk in the country or along the waterfront or through quiet streets, they may have worked out some explanation for their impractical activity. Perhaps the sight of other pictures may have started them on it, and throughout their lives the masters of their art were the greatest wonder they knew. Yet the real urge did not come from without, from the pictures or the people or the waterfront, the country or the streets. It came from some memory farther back, from that instinct which gave us, as Mr. Chase used to tell, the most ancient record of our race. And now it gives us our most modern record—and always the truest one.

XXX.

EPILOGUE BY WILHELM BUSCH

BUT THOUGHTS AS SERIOUS AS THESE OUGHT TO BE SPOKEN MORE lightly, and so I call in the aid of an artist who could put such matters into proper form. I regret that the words have to be given in a foreign language, but no one can translate the poem fittingly, as I am convinced. So I will give the simple facts of its meaning after quoting the verses in the original. By accident, in sketching their content, I struck on the rhyme of 'that' and 'cat.' In the German, the sound is just as simple—"like buttermilk googling out of a jug," to quote Huckleberry Finn. With such an ear for language, he might have rendered, in the English it deserves, the following philosophy of life and art. It is that of Wilhelm Busch and forms part of a volume which he calls *Kritik des Herzens*. Perhaps the greatest of all humorists of the pencil, I imagine the charming title for his little book—*The Critique of the Heart*—makes it a sort of gay pendant to Kant's *Critique of Pure Reason*. Here is the poem:

> *Es sitzt ein Vogel auf dem Leim,*
> *Er flattert sehr und kann nicht heim.*
> *Ein schwarzer Kater schleicht herzu,*
> *Die Krallen scharf, die Augen gluh.*
> *Am Baum hinauf und immer hoeher*
> *Kommt er dem armen Vogel naeher.*

EPILOGUE BY WILHELM BUSCH

Der Vogel denkt: Weil das do ist
Und weil mich doch der Kater frisst,
So will ich keine Zeit verlieren
Will noch ein wenig quinquillieren
Und lustig pfeifen wie zuvor.
Der Vogel, scheint mir, hat Humor.

(I translate just the bare statements:
A bird is caught on the bird lime; he flutters hard but cannot fly home. A black tomcat creeps toward him—sharp of claw and fiery of eye. Always higher up the tree he comes, and always nearer. The bird thinks—Well, so that is that: I furnish food for Thomas Cat. But that is no reason to waste my time; I must trill a little song yet, and whistle merrily as I have always done. That bird, I'd say, had a sense of humor.)

Now imagine those ideas in terms of delightful verse and you have what seems to me the perfect epilogue for a consideration of men who give their lives to the queer thing that painting is.

Bryson Burroughs used to quote the phrase of the old lama in *Kim*, "We are all bound to the wheel." The Oriental sees things in that fatalistic way, and his words are impressive. But I still think that a better image of humanity is that bird singing in the face of oncoming death. And the reason why the artist is so much liked by mankind, after all, is because his is the song that, telling of its courage, is taken up by other voices and then still others, away off in the big trees and in the bushes and in the open spaces, where some singer goes darting up in a sudden flight till the eye can see him no more, and his note seems just to come out of the sky.

THE END

INDEX

Aguirre, Porfirio, 284-285
Allston, Washington, 58
Anshutz, Thomas, 44
Apollinaire, Guillaume, 155, 297
Arcos, René, 183
Armory Show, The, 17, 52, 177 et seq. 192 et seq.

Barnes, Dr. A. C., 243
Barreda, Octavio G., 282
Barye, 114, 115, 119, 146, 191, 249, 278-279
Baudelaire, 154, 277
Baylinson, A. S., 323 et seq., 327
Beethoven, 191
Bellini, Giovanni, 257
Bellows, George, 48
Berenson, Bernard, 25, 271 et seq.
Bernhardt, Sarah, 187
Besnard, Albert, 19, 241
Beurre, Rose, 190
Binyon, Lawrence, 69
Bode Wilhelm von, 70, 272, 278, 306
Boldini, G., 37
Bonger, A., 167
Bonheur, Rosa, 72
Bonnard, Pierre, 155, 166
Bouguereau, W. A., 40, 197
Bourdelle, E. A., 85
Bourgeat, Charles, 280
Boznanska, Olga de, 187
Brahms, 165
Brancusi, Constantin, 169 et seq., 276
Brangwyn, Frank, 292
Braque, Georges, 123, 128, 148, 275, 297, 317
Bregler, Charles, 65
Brooks, Charles V. W., 56
Brooks, Van Wyck, 56, 213, 304
Brownell, William C., 174, 265
Brueghel, 225
Brummer, Joseph, 269-270, 275 et seq.
Burroughs, Bryson, 198, 204, 228, 258, 297, 307, 311 et seq., 330
Busch, Wilhelm, 329
Byzantine art, 29, 70, 75, 117, 298

Calles, Plutarco Elías, 283
Carpenter, Newton, 194
Caruso, Enrico, 200, 216
Castagno, 70, 96
Cellini, Benvenuto, 279, 298
Cesnola, General L. P. di, 75
Cézanne, Paul, 12, 20, 24, 36, 39, 44, 49, 54, 83, 92, 93, 101, 107, 109, 113, 116, 121, 127, 148, 157, 167, 176, 177, 192, 198, 199, 205, 215, 223, 224, 228, 237, 241, 242, 261, 298, 305
Champaigne, Philippe de, 119
Chandler, Robert Winthrop, 199
Chardin, 119
Chase, William M., 10, 20, 31 et seq., 77, 88, bis, 93, 99, 234, 328
Chaucer, 63
Chavannes, Puvis de, 15, 127, 233
Chopin, 191
Clarke, Sir C. Purdon, 75
Cleveland, Grover, 67
Clouet, 34, 41
Coffin, William Sloane, 315
Cole, Thomas, 58
Coleman, Glenn O., 57
Constant, George, 324
Copley, John S., 29, 39, 58, 326
Corot, J. B. C., 30, 111, 113, 165, 187, 191, 223, 226, 249, 279, 299, 325
Corrard, Pierre, 155
Cortissoz, Royal, 202
Courbet, Gustave, 100, 122, 260
Couture, 152
Crowninshield, Frank, 236

"Dada," 234
Daumier, Honoré, 42, 152, 248, 279
David, Louis, 92, 103, 182, 254, 307
David-Weill, D., 252
Davies, Arthur B., 44, 52, 118, 157, 177, 200, 261
Davis, Erwin, 35
Dawson, Manierre, 157
Dean, Bashford, 77
Debussy, 136
Degas, 176, 201, 246, 250

INDEX

de Kay, Charles, 114
Delacroix, 103, 110, 111, 115, 128, 141, 149, 167, 190, 192, 213, 248, 257, 260, 279, 298, 300, 311, 321, 323
Delaroche, Paul, 111
Derain, André, 54, 129, 131, 159, 205, 222, 249, 275, 297 et seq., 320
Despiau, Charles, 276
Detaille, Edouard, 7
Disraeli, 22
Dostoyevsky, 262
du Bois, Guy Pène, 118
Duchamp, Marcel, 22, 47, 139, 147, 155 et seq., 195, 223, 231, 234, 317
Duchamp-Villon, Raymond, 137, 139 et seq., 218, 220, 221, 244, 276
Dufy, Raoul, 152, 155, 173 et seq., 222, 296, 305, 317
Duhamel, Georges, 183
Dumas, Alexandre, 8
Duncan, Isadora, 187
Durand-Ruel, 11, 27, 250, 275
Dürer, Albrecht, 168, 258
Duveneck, Frank, 208

Eakins, Susan M., 64
Eakins, Thomas, 17, 30, 33, 51, 52, 58, 65 et seq., 66, 288, 313, 322, 327
Eble, Mr., 6-7, 88
Ellis, Havelock, 265
Enríquez-Ureña, Pedro, 281, 282, 283
Eyck, van, 35, 314

Fabbri, Egisto, 94 et seq., 224, 237, 306
Fairchild, Nelson, 80
Faure, Elie, 106, 143, 145, 192, 215, 226, 230, 261 et seq., 300, 306, 318, 321
Ford, Edsel, 290
Ford, Henry, 290
Fortuny, 35
Fouquet, 35
Franco, Francisco, 126, 267
Frédéric (le père Frédé), 135
French, Daniel C., 198
Frick, Henry C., 28, 69, 200, 243, 254
Frost, Arthur B., 84
Fry, Roger, 44, 61, 75, 228, 256 et seq., 266, 273, 313
Fulton, Robert, 326
Futurists, the, 15, 98, 295

Gagnat, Maurice, 105
Gamba, Carlo, 91
Gardner, Mrs. Jack, 28, 227
Gauguin, Paul, 47, 83, 141, 148, 178, 193, 223, 241

Géricault, 128, 184, 251
Giorgione, 110
Giotto, 3, 39, 117, 118, 198, 225, 288
Glackens, William J., 44, 50, 52, 54, 232, 237 et seq., 322, 327
Gleizes, Albert, 182, 183, 231
Goethe, 188
Goetz, Richard, 251
Gogh, Vincent van, 2, 12, 20, 54, 118, 127, 141, 148, 193, 211, 223, 241, 253
Goldman, Henry, 251
Gosset, Dr., 146
Goujon, Jean, 298
Goya, 125, 164, 248, 267, 307
Greco, 15, 41, 94, 125, 181, 250, 267
Greene, Belle da Costa, 200
Gregory, Lady, 200
Gris, Juan, 126, 275
Gros, Baron, 92
Guilbert, Yvette, 187
Guys, Constantin, 50, 152

Hals, Frans, 31, 39, 181
Hamerton, P. G., 13
Hammerstein, Oscar, 31
Hassam, Childe, 236
Havemeyer Collection, 28, 44, 122, 243, 311
Heem, J. D. de, 119
Heine, Heinrich, 174
Henri, Robert, 42 et seq., 52, 55, 64, 77, 80, 99, 118, 212, 235, 239
Herriot, Edouard, 302
Hindenburg, 137
Holbein, 258
Homer, Winslow, 27, 33, 50, 99
Horne, Sir William van, 198, 250
Houdon, 174
Huneker, James G., 202
Huntington, Archer M., 200
Hyde, Douglas, 204

Independents, the, 47, 54, 178, 232 et seq.
Indians, American, 53
Ingres, J. A. D., 21, 94, 111, 128, 192, 205, 233, 254, 279, 300, 308, 312
Inness, George, 58

James, Jesse, 45
Japanese art, 40, 43, 77
Jongkind, J. B., 237

Kahn, Gustave, 136
Kahn, Otto H., 200

INDEX

Kahnweiler, H. D., 129, 275
Kantor, Morris, 325
Kent, Henry W., 317
King, Edward, 74
King, Fred, 213
Kuhn, Walt, 179

Lachaise, Gaston, 293
La Farge, John, 27
La Fontaine, 174, 267
La Fresnaye, Roger André de, 184 et seq., 222, 300
Lamarck, 262
Lane, Sir Hugh, 248
La Patellière, Amédée de, 188, 300, 302, 303, 320
La Tour, Georges de, 301
Laurencin, Marie, 142
Le Corbusier, 143
Léger, Fernand, 181, 275
Le Guillou, Jenny, 190
Le Nain, the Brothers, 147, 299
Leonardo, 3, 110, 119, 141, 167, 310
Le Roy, Jean, 87, 131 et seq., 184, 191, 262
Loeser, Charles, 36, 88 et seq., 224, 274
Lorraine, Claude, 214, 257, 280
Luks, George, 44, 50, 52

Mack, Gerstle, 245
Maeterlinck, 136
Maillol, Aristide, 17, 84, 199, 276
Mallarmé, 146, 165
Manet, Edouard, 9, 34, 45, 103, 152, 165, 215, 237, 260
Marchand, Jean, 8, 296
Marinot, Maurice, 142
Marquand, Henry G., 34, 75
Masaccio, 39
Matisse, Henri, 14, 21, 24, 29, 54, 72, 83, 98, 116 et seq., 144, 145, 159, 166, 177, 197, 205, 218, 219, 222, 223, 280, 292, 322
Maupassant, Guy de, 42
Maurel, Victor, 215
McKay, George, 325
Meier-Graefe, Julius, 104, 105, 113, 152, 258 et seq., 264
Meissonier, 35, 215
Melville, Herman, 63
Mena, Ramón, 283
Mercereau, Alexandre, 169, 183
Merovingian art, 70
Meryon, Charles, 211
Mesdag, H. W., 252

Metzinger, Jean, 223
Mexican art, 199
Michelangelo, 2, 91, 96, 171, 191
Michelet, 262
Mignard, Pierre, 301
Miller, Kenneth Hayes, 321 et seq., 327
Molière, 152
Monet, Claude, 28, 36, 98 et seq., 107, 113, 129, 140, 237
Moore, George, 13, 34, 35, 55, 201, 204, 256
Moreau, Gustave, 119, 240
Moreau-Nélaton, 102
Morgan, J. Pierpont, 28, 67 et seq., 95, 117, 200, 208
Morse, Samuel F. B., 327
Mumford, Lewis, 63

Nattier, 112
Nietzsche, 206, 262
Nonnotte, Donat, 301

Ogihara, Moriye, 77 et seq.
Orozco, José Clemente, 285, 293

Pequin, Charles, 263
Perez, Luz, 283
Perronneau, 254
Perugino, 112
Philip, Capt. John, 203
Picasso, Pablo, 14, 20, 23, 72, 118, 123 et seq., 131, 141, 149, 161, 166, 205, 222, 241, 244, 269, 275, 292, 297, 318
Piero della Francesca, 95, 117, 254, 288
Pissarro, Camille, 36, 129, 140, 168
Plutarch, 120
Poe, Edgar Allan, 164
Pollaiuolo, 70, 72
Pommier, 154
Pompeiian art, 70, 288
Pompon, François, 276
Poussin, 111, 113, 254, 323
Praxiteles, 1
Préault, A. A., 123
Prendergast, Charles, 223 et seq.
Prendergast, Maurice, 44, 52, 189, 191, 209, 223 et seq., 327
Prud'hon, 254
Pythagoras, 156

Quinn, John, 4, 17, 69, 94, 144, 166, 203 et seq., 232, 272

Racine, 133
Raphael, 1., 23, 40, 70, 75, 105, 111, 112, 128, 161, 201

INDEX

Recklinghausen, Max von, 325
Redon, Odilon, 28, 60, bis, 128, 163 et seq., 192, 205, 222, 280
Réjane, 187
Rembrandt, 8, 29, 39, 41, 56, 107, 121, 160, 167, 191, 273, 292, 303, 306, 308
Renoir, Pierre, 105
Renoir, Pierre-Auguste, 19, 25, 28, 29, 36, 44, 84, 101, 104 et seq., 117, 141, 148, 153, 163, 174, 190, 228, 237, 246, 257, 266, 292, 323
Richter, Miss Gisela M. A., 263, 309 et seq.
Richter, Dr. Jean Paul, 310
Rimbaud, Arthur, 156
Rivera, Diego, 24, 61, 130, 209-210, 246, 287 et seq., 302
Rivera, Frieda, 309
Robinson, Edward, 308, 309
Roche, Juliette, 165
Rockefeller Center, 291 et seq.
Rodin, Auguste, 28, 42, 81, 104, 140, 164, 170, 187, 276, 277
Romains, Jules, 183
Rood, Ogden, 149
Roosevelt, Theodore, 67, 199, 213, 218
Rouart, Henri, 248
Rouault, Georges, 2, 22, 117, 155, 205, 222, 239 et seq., 257
Rousseau, Henri, 171, 193, 205
Rousseau, Jean Jacques, 43
Rousseau, Théodore, 250
Rubens, 70, 110, 128, 290, 297, 303, 323
Rude, François, 103
Russell, George (A E), 204
Ruysdael, Jacob van, 83, 119
Ryder, Albert P., 33, 60, bis, et seq., 66, 77, 87, 226, 322, 327

Salmon, André, 143
Sargent, John S., 33
Schamberg, Morton L., 231
Scheffer, Ary, 111
Schiller, 87, 231
Schindler, Kurt, 325
Schmitz, Oskar, 250
Schoeller, André, 278-279
Seeger, Alan, 55, 213
Segonzac, André Dunoyer de, 179, 205, 276
Seguin, Armand, 178
Senonnes, Mme de, 301
Sert, 211
Sérusier, Paul, 166
Seurat, Georges, 11, 47, 54, 115, 167, 174, 193, 205, 223, 276, 288
Severini, Gino, 129, 295 et seq.
Shelley, 63
Signac, Paul, 47, 118, 222
Signorelli, Luca, 39, 93
Silvestre, Théophile, 249
Simonne, 188 et seq.
Sisley, Alfred, 101, 129, 237
Sloan, John, 44, 49 et seq., 64, 170, 201, 213, 239, 293, 320, 327
Sloan, Mrs. John, 53, 213
Stchoukine, 166, 206
Stein, (family), 14, 116, 143
Stevens, Alfred, 37
Stevens, Wallace, 87
Stevenson, Robert Louis, 34
Stieglitz, Alfred, 28, 43, 177
Strzygowski, Josef, 268 et seq.
Stuart, Gilbert, 39
Synge, John M., 55, 204

Teniers, 102
Tintoretto, 41
Titian, 39, 107, 108, 111, 303
Torrey, Frederic C., 163
Toulouse-Lautrec, H. de, 15, 128, 148
Tournières, Robert, 301
Trévise, Duc de, 251
Trivulzio, Prince, 314
Tucker, Allen, 95
Turner, J. M. W., 3, 214
Twain, Mark, 11

Underwood, Oscar, 207
Utamaro, 45

Valentiner, William R., 305 et seq.
Vanderbilt, Cornelius, 72
Vanderlyn, John, 327
Van Dyke, John C., 273
Velasquez, 10, 30, 110, 236, 267, 288
Véra, Paul, 222
Verdi, Giuseppe, 215
Verhaeren, 136
Veronese, 110
Viau, Dr., 248
Vildrac, Charles, 183
Villaseñor, Eduardo, 282
Villon, Jacques, 21, 103, 139, 143, 147 et seq., 182, 193, 223, 276, 302
Vlaminck, Maurice de, 129
Vollard, Ambroise, 84, 94, 104, 105, 107, 116, 155, 176, 235, 241 et seq., 275
Vollon, A., 38
Vuillard, Edouard, 166

INDEX

Wagner, Richard, 109, 115, 215
Walters, Henry, 312
Watteau, 152, 174, 298, 314
Weir, J. Alden, 33, 35, 95, 236 et seq.
Wells, Thomas B., 265
Wendland, Dr., 307
Werner, Adolph, 86, 231
Weyhe, E., 259
Whistler, J. A. Mc N., 30, 33, 34, 102, 236

White, Miss A. E., 53
Whitman, Walt, 43, 63
Winthrop, Grenville L., 254

Yeats, John Butler, 55, 204, 212 et seq.
Yeats, William Butler, 55, 204, 212

Zayas, Marius de, 287
Zola, Emile, 42